# MIRROR
# TO THE
# AMERICAN
# PAST

$$\frac{5}{17^{50}}$$

# MIRROR TO THE AMERICAN PAST

*Hermann Warner Williams, Jr.*

A Survey of American Genre Painting: 1750-1900

NEW YORK GRAPHIC SOCIETY
GREENWICH, CONNECTICUT

International Standard Book Number 0-8212-0444-0

Library of Congress Catalog Card Number 78-154329

First published 1973 by New York Graphic Society
Ltd.
140 Greenwich Avenue, Greenwich, Conn. 06830
Printed in Japan

Designed by Ray Ripper
Graphic production by Frank De Luca
Composed in 10 on 11 Garamond with Baskerville
display by JD Computer Type Inc.
Printed and bound by Dai Nippon Printing Co., Ltd.

# ACKNOWLEDGMENTS

The writer wishes to acknowledge with deep appreciation the assistance rendered him by the library staffs of the Fogg Art Museum, the Art Room of the New York Public Library, the Frick Art Reference Library, the Library of Congress, the National Gallery of Art, the National Collection of Fine Arts, the Archives of American Art, the Boston Athenaeum and the Corcoran Gallery of Art.

Among the individuals who have been helpful on various aspects of the research are Chase Viele, Donald D. Keyes, Clement E. Conger, William H. Gerdts, Harry D. Berry, Jr., David B. Lawall, Leon A. Arkus, Francis Grubar, Eugenia Calvert Holland, Nina Fletcher Little, Patricia Hills, Edward H. Dwight, Frederick B. Robinson, Louisa Dresser, Harold L. Peterson, John Howat, Theodore E. Stebbins, Jr., John Wilmerding, Marchal Landgren, David McKibben, William R. Johnston, Elizabeth Clare, Victor D. Spark, Robert C. Graham, Rudolf G. Wunderlich, Stuart P. Feld, Penelope P. Behrens, Robert Vose, Morton Vose, Peter Davidson, Kenneth Newman, Clyde Newhouse and E. J. Rousuck.

A special debt of gratitude is due Marius B. Péladeau, who read the entire manuscript in draft form and made many valuable suggestions for its improvement. For editing the text, I am indebted to Abigail Booth, who saw the task through with energy and care and in the process made helpful suggestions which greatly enhanced clarity of content. Gretchen Glicksman undertook final preparation of the manuscript with professional thoroughness and patience. Inga W. Heck indexed the text, assisted with the illustrations, and read portions of the text in various drafts. Dorothy Phillips read sections of the final manuscript. Judy Goald conducted the voluminous correspondence required to assemble the archives of almost one thousand photographs for study. Louise A. Siegel, Ellen Gross Landau and Barbara Butturff made valuable contributions in research for photographs and typing the manuscript drafts. The final manuscript was typed by Julie Lea. The selected bibliography was prepared by my wife, Alice F. Williams, who temporarily abandoned the role of housewife to resume her former profession with an enthusiasm for which I am most appreciative.

H. W. W., Jr.

FOR

H.C.W.
A.F.W.
S.W.B.
P.P.B.
and
R.P.W.W.

# CONTENTS

# PREFACE

This study is not presented as a definitive history of genre painting in America. A selective survey of our genre painting from its genesis late in the eighteenth century up to the close of the nineteenth century, it brings together in roughly chronological order many—by no means all—of the practitioners of this form of painting. The time for a full-scale historical study has not yet arrived, because all the material needed for critical evaluation has yet to be assembled—a sad commentary on the state of American art scholarship. There are comparatively few catalogues in print of American paintings in public collections. And the only American painters specializing in genre whose work has been published in detail are a few of the most important figures, such as Mount, Woodville, Ranney, Henry, Bingham, Homer and Eakins. The literature on American art is full of tantalizingly brief references to other painters who worked in the genre area, even if only occasionally. In general their works have not been gathered together, studied and published. Perforce, scholars engaged in research in the broad field of genre have formed judgments on these painters based on the handful of examples in public collections. It is impossible, under such limiting circumstances, to evaluate the accomplishments of these neglected men with adequate perspective, or to arrive at fair and demonstrable conclusions.

Scholars are badly in need of information on works of American art in the possession of families, town libraries, historic houses, colleges, historical societies, private clubs and other institutions throughout the country. Some valuable work has been done in this area in the past, especially by the Frick Art Reference Library in its early days, by the Archives of American Art and by a number of museums, such as the Metropolitan Museum of Art, the City Art Museum of St. Louis and the Corcoran Gallery of Art. The exhibitions and scholarly catalogues—for example, *Life in America, 1939, Mississippi Panorama, 1949, American Processional, 1950*—which resulted from research conducted by these museums, although they are now twenty to thirty years old, are still invaluable tools. Several other art museums have had exhibitions of more limited scope, covering material to be found in a particular city, state or area. A recent one, sponsored by the Vermont Council on the Arts, located 275 paintings of merit in Vermont homes.[1] But much more of this time-consuming, painstaking work remains to be done before we shall have achieved a corpus of works on which to base truly definitive studies.

This pictorial anthology is not intended to be a general survey of nineteenth-century American painting, and therefore little space has been devoted to elaboration of the broad trends of stylistic change, which have already been so well explained in general and period histories. Also, because of the availability of such excellent histories of American art as those by Barker, Baur, Flexner, Larkin, Richardson and others and of the biographical dictionary compiled by Groce and Wallace, biographical information concerning the artists has been abbreviated. The principal places

where an artist worked have been indicated, when this information has been deemed to have bearing on his subject matter. In cases where an artist is virtually unknown and references are to be found only in obscure sources, such biographical information as can be assembled has been included either in the text or in the notes.

In the interest of convenient reference, each artist mentioned in this text, however long his productive career, is discussed in a single chapter, rather than dividing his work into early and late periods over several chapters. Winslow Homer is an exception, however, because of the extraordinary dissimilarity in his approach to genre in his early and in his late paintings. In general, artists sharing a common point of view or discipline are grouped together, even when chronological order is strained thereby. Since the time spans of Chapters III through VI are overlapping, the decision to assign an artist to a certain chapter has sometimes been arbitrary.

Wherever a painting is cited in the text, its date follows the title. If the precise year is not known, but a date may safely be approximated, as for example because of a painting's inclusion in an exhibition, that date is indicated as *circa* (c. 1852). In the case of an undated painting where research by the present owner has determined an approximate date, the approximation is usually indicated by giving a range of execution (1826-28), or, when the approximation is looser, by *circa,* which implies a date within five years before or after the date cited. In the case of undated paintings where the present owner has given no opinion about date, the writer, on the basis of the internal evidence of the painting, such as costume, accessories and style, has supplied a tentative date in round numbers (c. 1815), again implying a five-year range on either side. This emphasis on supplying a date is based on my belief that if the study of American painting is to take its rightful place as a discipline equal in importance to the study of European art, such basic information is indispensable. The date when a painting was finished is important in any study of an artist's whole work or of that artist's relationship to his predecessors and successors.

One of the difficult decisions in the planning of this book concerned the illustrations. The sheer number of artists discussed, only a little under one hundred and fifty, created the problem: with two exceptions there were none who seemed not to require at least one reproduction. In many instances several illustrations were needed to show a painter's range of subject matter or his development. This was especially true of relatively obscure artists. Wherever possible, unfamiliar works and artists have been favored in the illustrations, for in my judgment it is of greater value to document artists whose works are hard to find in reproduction, than to re-document already famous artists. Further, an effort has been made in the selection to omit paintings which are well known. This policy has sometimes led to the inclusion of relatively minor works of some artists while their acknowledged masterpieces are absent.

To stay within manageable dimensions, only paintings in oil by American artists are discussed. This decision has eliminated all but incidental reference to prints, drawings, watercolors and sculpture. For the same reason, certain broad categories of painting have also been excluded. On the basis of technique, amateur and professional primitive artists have been omitted. On the basis of content and subject matter, paintings of Indian life, paintings deriving their subject matter from literary sources and paintings which depict, by the process of antiquarian research, events of everyday life of bygone times have been omitted. Furthermore, foreign genre scenes painted by Americans living abroad are not included. And since they cannot be considered American painters, the many foreign artists who visited this country, painted aspects of its life and then returned to their native lands have been omitted. A fuller explanation of these omissions is perhaps in order.

The primitive painter has provided us with invaluable pictorial records of American life, often both aesthetically satisfying and informative as social history. No survey of life in the United States can ignore the works produced by the primitive painters who flourished in large numbers during the 1800's. Every hamlet and village had its Jan Steen, Pieter de Hooch or Louis Le Nain. They were of both sexes and all ages, and there was a steady supply to replace those who died. Some were prolific, others worked at picture-making only occasionally. No doubt some took themselves seriously—and one should remember that in remote areas, where invidious comparisons could not be made, even slight talent could shine like a star. Others painted only for their own enjoyment, or from an inner compulsion to record some facet of life that had special meaning for them.

One type of subject which these craftsmen often depicted was the event of local topical interest. Before the introduction of the photograph, the urge to record—if not for posterity, at least for the benefit of the living—catastrophes and accomplishments of unusual local importance was widespread. There are many paintings which set down, with a wealth of interesting detail, fires, floods and frolics which were, for a time, the talk of the town. The body of primitive work is so large that only a separate study could do it justice. While in general the primitive painter has been left out of this discussion, rare early examples have been included in Chapter I as an indication of the importance of this branch of genre art from Colonial days onward.

The omission of paintings of the life of the indigenous inhabitants of this country by such important American artists as George Catlin, Seth Eastman, Alfred Jacob Miller and John Mix Stanley is based on two considerations: that these paintings, despite their merit as works of art, are basically of ethnological significance, since they rarely show the intermingling of Indian and white cultures; and that this exotic genre has already been well explored in a number of studies.

Literary genre is not discussed in these pages be-

cause it does not depict contemporary life but life twice removed from actuality—screened first through the mind of the writer and then modified by the painter's imagination. Frequently the time depicted is far removed from that of the artist. Thus, John Quidor's (1801-1881) marvelous translations of Washington Irving's and James Fenimore Cooper's tales are missing from these pages.[2] One exception has been made in the case of Charles Bird King's *Rip Van Winkle Returning from a Morning Lounge* (Fig. 34) because its setting is unusually representative of contemporary American life.

Reconstruction of scenes of American daily life of past eras became popular in the mid-nineteenth century, increasingly so at the time of the 1876 Centennial. Many painters found in it a profitable source of income. E. L. Henry (1841-1919), for one, continued to paint eighteenth-century scenes until the close of his career and even collected antique vehicles to aid him in his antiquarian studies. But however careful and conscientious in his researches an artist may be, in painting images of a time other than his own he inevitably fails to capture the ambiance of the scene. Paintings so produced lack one of the few absolute essentials of true genre painting: that subject and artist be contemporary.

A number of important late nineteenth century American painters, such as Mary Cassatt, John Singer Sargent and some painters of the Munich School, such as Frank Duveneck, have been left out. In almost all cases those omitted have avoided American subject matter and instead concerned themselves with depicting European subjects when they worked in the genre field.

Under most circumstances, a survey of life in the United States would take full advantage of the work done by foreign artists who during their sojourns here recorded American customs and manners. But since this survey is concerned primarily with the development of American genre painting as an important branch of our native culture, foreign artists who returned to their native lands have not been included. A fascinating book could be written on this theme; starting with John White and Jacques LeMoyne de Morgues, a steady succession of visiting foreign artists, including Degas, have caught the look of the native American and his country with fresh and candid eyes.

The advent of lithography as a medium for commercial printmaking was roughly coeval with the development of a market for genre paintings. By the 1830's lithographic firms were active in all major American cities, producing a broad range of pictorial lithographs. The earlier examples, when colored at all, were tinted by hand with washes of watercolor, but the technique for color printing was soon developed and thereupon garish colored lithographs became available for mass distribution at prices within the reach of all. The largest print was equivalent in size to the average cabinet-size painting and, framed, held its own on the wall as well as a painting. In the middle years of the nineteenth century, firms such as Currier & Ives

offered an enormous variety of subjects, many of them scenes of everyday life. The lithographic firms drew upon contemporary painters, either directly commissioning specific subjects, or reproducing already completed paintings. The influence of the popular mass-produced colored lithograph on the course of American painting is a factor of considerable importance. These prints helped to build and sustain the climate of taste which provided patronage for painting. While the genre lithograph is not a topic which can be explored in this text, occasional references to this interrelationship are made so that its importance will not be overlooked.

Another aspect of genre which has been intentionally omitted is sculpture. Our concern is primarily with painting, but to leave the impression that there was no genre sculpture would be both unfortunate and inaccurate.

Because of the expensive materials used in sculpture, ownership of it was, in the early years of the Republic, limited to the well-to-do. Nevertheless, the desire to own sculpture was prevalent and was far from satisfied by the limited nature of what was available.

The early woodcarvers, who made the handsome ornamental carvings for ships, houses and shops, occasionally sculpted figures engaged in some limited form of daily activity. The well-known shop sign of a ship's officer taking a sight with his sextant (Whaling Museum, New Bedford, Mass.) and the polychromed whirligigs which indicated the direction of the wind and often ingeniously showed men engaged in some homely task such as chopping wood are examples of this form of genre sculpture.

Late in the nineteenth century a trend developed toward anecdotal sculpture. One finds such subjects as a horse-drawn hack with the driver on the box wrapped up against the cold—a subject more pictorial than sculptural. The trend continued into the twentieth century when, for example, Bessie Potter Vonnoh (1872-1955) did a number of small sculptures of female figures seated on chairs, reading or engaged in other polite family activities. Even Eakins did reliefs of genre subjects: *Woman Knitting,* 1881 (The Corcoran Gallery of Art) and *Spinning,* 1882-83 (Pennsylvania Academy of the Fine Arts).

The greatest exponent of genre sculpture came upon the scene about 1860 in the person of John Rogers (1829-1904), the originator of the "Rogers Group," the mass-produced statuary which was as popular as it was widely disseminated.[3]

Rogers's multiple copies of his bronze originals satisfied the popular hunger for statuary. While his groups did not strive for the classical ideal which motivated Hiram Powers (1805-1873), they were easily recognizable as professional. During the era of the "Rogers Group," from 1860 to 1893, some eighty thousand plaster copies of his compositions were sold. They rivaled in success the Currier & Ives lithographs and were to be found in the "front room" of almost every middle-class American home which had any pretension to culture. General George A. Custer even had two of Rogers's Civil War groups in his quarters at Fort Abraham Lincoln in the frontier

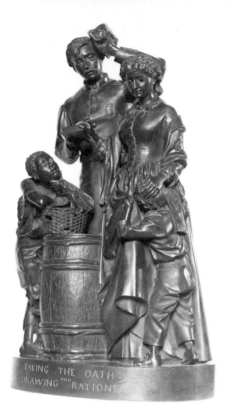

I John Rogers, *Taking the Oath and Drawing Rations*, 1866. The Corcoran Gallery of Art, Washington, D.C.; Gift of The Honorable Orme Wilson.

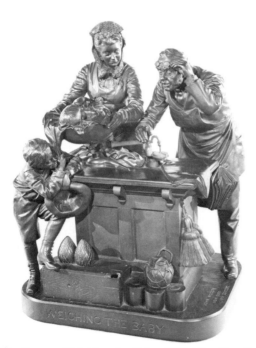

II John Rogers, *Weighing the Baby*, 1877. The New-York Historical Society, New York.

Dakota Territory.

Rogers cannot be said to have been a great creative sculptor. But in his own way he was a phenomenon, an innovator whose success was perhaps largely attributable to the fact that he launched his program at a propitious moment. His product was conceived and manufactured for a mass market on the commercial principle of "large sales and small profits." He succeeded in satisfying the innate craving of a large segment of the American people for plastic art at a price it could afford—from six dollars to fifteen dollars for each putty-colored plaster group.

Rogers was a contemporary of Winslow Homer, and his early work, like Homer's, was devoted to subjects related to the Civil War. His war-oriented groups included such titles as: *The Picket Guard*, 1862; *Camp Life: The Card Players*, 1862; *The Camp Fire: Making Friends with the Cook*, 1862; *The Town Pump*, 1862; *Sharp Shooters*, not dated; *Union Refugees*, 1864; *Mail Day*, 1864; *Returned Volunteer: How the Fort Was Taken*, 1864; *The Wounded Scout: A Friend in the Swamp*, 1864; *Wounded to the Rear: One More Shot*, 1865; and his acknowledged major work, *Taking the Oath and Drawing Rations*, 1866 (Fig. I).

As a genre sculptor, Rogers's themes after the war related mostly to the home and to rural life. *Weighing the Baby*, 1876 (Fig. II), is typical. Some of his characters were drawn from the class now termed the underprivileged: itinerant peddlers, organ grinders, charity cases seeking medical assistance. They are presented with only the barest trace of a reformer's zeal for social improvement. The life that Rogers shows is one in which the individual is master of his destiny and, however grim the circumstances, has an underlying confidence that he can improve his lot. In this Rogers was in harmony with the contemporary resolve to ignore the darker side of life.

There are certain paintings which have elements of genre without conforming to the essential characteristics of that type of painting.

One of these is the representation of an actual event which occurred at a known place on a known date and involved persons who are identifiable in the painting. This is a variety of history painting and not, strictly speaking, genre. The history painting says this event happened *once*, whereas what is shown in a true genre painting *occurs often*. *Exhuming the First American Mastodon* (Fig. 17), by Charles Willson Peale, is one example of this kind of tangential genre. There are others.

In eighteenth-century England there was a considerable vogue for painting scenes from contemporary stage productions. A very prolific painter in this area was Johann Zoffany, who painted David Garrick and other great actors of the period in scenes from the popular plays which filled the London theatres. Understandably there was no similar movement in this country, since theatres were few and far between. However, in some of the rare American portraits of actors, they are posed in the attitude of a character before the appropriate stage set. One of the earliest of these is Charles Willson Peale's *Nancy Hallam as*

*Imogen in "Cymbeline,"* 1771 (Colonial Williamsburg). According to Charles C. Sellers the background, with the entrance to a cavern in a rocky cliff on the left, and a distant prospect of a mountainous landscape with a glimpse of water on the right, probably reflects the actual stage set at the New Theatre, Annapolis, where the production was presented.[4]

Forty years later, another American painter, Thomas Sully (1783-1872), painted similar portraits. His *William Burke Wood as Charles De Moor,* 1811 (The Corcoran Gallery of Art), for example, represents a moment in the drama *Die Räuber,* by Schiller, which had considerable popularity in the United States as well as in Europe. Sully in this case puts the actor in costume, reclining at full length in a romantic landscape which may represent a stage set. Grouped around Wood are six other actors whose presence increases the illusion of an actual performance.

There are, however, few surviving American paintings which carry on the English mode of showing the full stage peopled with actors. As such canvases depict an actual event occurring at a known place and time and include presumed portraits of several actors, technically they cannot be placed within the limits of genre. A rare example, *A Scene from Sheridan's "School for Scandal,"* c. 1800-1810 (Fig. III) is by William Dunlap (1766-1839), who divided his interests and passionate enthusiasm about equally among painting, writing and the theatre. It shows a moment from the play as it was presented at the Park Theatre in New York.[5] The elaborate stage set, the posturing actors, give us an insight into the character and quality of the American theatre in its infancy.[6] Sully's and Peale's portraits also give us fleeting glimpses of this special aspect of early American life. It is a strong temptation to extend the definition of genre to include them, but it is one which must be resisted.

Landscapes with figures sometimes pose a problem of classification. Many of our early landscape painters included figures to give scale and human meaning to their scenes of nature. In most cases the figures are so incidental and small in scale that the painting's classification is obvious. In a few cases, however, the figures are fully as important as the landscape in the total composition. This is the case with Jerome B. Thompson's *Haymakers* (Fig. 110), making it possible to place that work in either category. Generally speaking, however, the artist's primary motivation and intent in a given work can be recognized without difficulty.

Portraits, in addition to those already mentioned dealing with actors in costume, can on occasion, notably in conversation and group portraits, approach genre. This is especially true where a number of figures are engaged in some homely pastime in a natural setting. In fact, it is conceivable that, should the identity of the individuals be lost, such a work might not be recognized as a group portrait. A few group portraits have been included in this book and illustrate some of the possible variations. As examples, there are George H. Story's *Library at "Winyah*

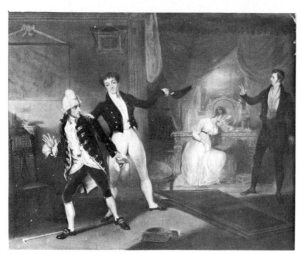

III William Dunlap, *A Scene from Sheridan's "School for Scandal,"* c. 1800-1810. Theatre Collection, Harvard College Library, Cambridge, Massachusetts.

*Park'' with Portraits* (Fig. 154), where the Colonel is shown in the process of having his portrait painted, and *Four Wine Tasters in a Cellar* (Fig. 108), by an unidentified artist, which depicts a group of experts sampling wine in a dimly-lighted subterranean room.

One encounters other variations from the norm of portraiture which are still more difficult to categorize. One of these is, for want of a better phrase, the souvenir or memento painting, in most cases commissioned from the artist by one of the individuals portrayed in the picture. Several examples are included in this book. There is the interesting early canvas by John Greenwood, *Sea Captains Carousing in Surinam* (Fig. 5). A century later Johannes A. S. Oertel painted *Woodruff Stables, Jerome Avenue, The Bronx* (Fig. 95), probably on commission from the owner of that well-known livery stable. Probably even the horses are portraits. *Interior of George Hayward's Porter House* (Fig. 143) by E. D. Hawthorne and William J. Stillman's *The Philosophers' Camp in the Adirondacks* (Fig. 114) are further variations. Whether these paintings, and several others discussed in the text, are genre or not is open to argument. The reader will have to decide for himself.

The preceding paragraphs outline the general form of this survey, indicating the reasons for some of the omissions as well as touching on a few of the perplexing questions that have arisen in the course of its preparation. This study has very forcibly brought home to the writer the realization that American art offers boundless opportunities for further exploration, and that a varied, rich and exciting body of work still awaits rediscovery or reappraisal. It is hoped the reader will find in the pages that follow some of the same pleasure and satisfaction the writer had in preparing them.

H. W. W., Jr.

# INTRODUCTION

In the course of the last several decades, the literature on American art has been enriched by a number of monographs on still life, landscape and marine painting, as well as by many perceptive general histories and definitive biographies. No one, however, has tackled the subject of genre painting in this country from its origins through the nineteenth century. This is perhaps not as surprising as at first glance it might appear. For genre as a categorizing term is ill defined and, although it is fascinating in purely pictorial terms and in the insight it gives into contemporary intellectual and emotional interests and attitudes, its scope is not precise and its boundaries are blurred. The historian-author can find himself nearly defeated before he has begun by the problem of deciding what body of American art truly represents its genre tradition.

The blank or questioning expression which appears on the faces of persons, even some quite at home in the jargon of the arts, when the word genre is mentioned, is of surprisingly common occurrence. This is readily understandable, for the word is loosely used and broadly interpreted.

The literal translation of the French word *genre* is *kind* or *species.* Over the years, however, *genre* has come to mean a type of painting. To this day it remains an art historical term ''meaningless to some, misunderstood by others and basically pointless.''[1] English has no equivalent for the implications of the French word. The closest we can come is the cumbersome phrase *scenes of daily life,* or *anecdotal,* or *narrative* painting—no one of which is satisfactory. Indeed, if the word genre evoked a clear image, as do most other art-defining words, such as *still life, portrait* or *landscape,* or even more recently coined phrases like *action painting, hard-edge, shaped canvas,* the vocabulary quandary could be solved. Since no substitute can be offered for the poor, derivative French we must perforce continue to employ it.

While the problem of supplying the right word seems insoluble, providing a definition is not. Of course with a word as inscrutable as genre, definition is especially susceptible to personal interpretation. Here is the writer's definition:

*A genre painting is an artist's commentary on a commonplace everyday activity of ordinary people, painted in a realistic manner. The artist must be contemporary with the scene depicted. The subject should not be of an extraordinary nature or of infrequent occurrence, but one which arises often and naturally from the nature of the circumstances. A genre painting portrays the labors, pleasures and foibles of anonymous people in the course of daily work and leisure. There should be no incongruity, and every incident should be typical: that is, characteristic of the time, the place, the social class, the age of the participants and their vocations, down to the last details of clothing, expressions, accessories and background. The participants, although appearing as individuals, will be composite types but not lifeless*

*stereotypes. A genre scene may have a cast of dozens or of only one. People, caught in some homely moment of life, dominate genre scenes. The true theme of a genre painting is not the incident, but the human condition. The genre painting's source of strength is the rapport between seer and seen, calling for the establishment of a bond of sympathy—based on a familiar response to the human situation presented. Thus a genre painting may be frivolous or profound, a pictorial pun good for a quick laugh, or a moving statement of some eternal truth, refined from the mundane circumstances of daily experience.*

As genre painting depicts the ordinary activity of ordinary people, it is necessarily contemporary. It can be reportorial, didactic, moralistic, romantic, humorous, satirical, sentimental, poetic. It cannot be derived from literature, nor depict the life of an earlier era, or of an imagined future. It cannot be allegorical, religious, symbolic or ideal, unless this purpose is so camouflaged that its character is not obvious. There are no limitations on its aesthetic qualities. In the hands of a great painter, a genre subject may rank with the finest products of man's creativity.

Let us dispatch at once the insupportable idea which has had some currency, that genre is a lower form of artistic expression. That attitude is a vestige of the outmoded pecking order of categories which assigned first place to history painting and ranked all other forms of painting on a descending scale of merit. There are minor, secondary and, indeed, tertiary genre painters, as there are in all fields of painting, but genre itself is not a subsidiary branch of painting. To confirm this fact one has only to recall that while Winslow Homer is rarely termed a genre painter, almost all his work (except his pure landscapes) falls into this subject category. The same is almost equally true of that other great nineteenth-century artist, Thomas Eakins. It seems we have in the past countenanced the fallacy that the descriptive terms ''great'' and ''genre'' as applied to a painting are mutually exclusive.

Genre, being essentially a commentary on some aspect of daily life, offers many approaches to the artist, for genre is not only a type of painting but also an attitude. Thus it involves not only what an artist sees, but his personal, subjective way of seeing. The artist, being a mirror to his own time, imparts through his pictorial concept of a selected activity his own preconceptions and attitudes and those of his peers. Consequently, the scene he paints reflects and is colored by personal or group prejudices, which vary from one individual to another. There are, however, painters who maintain a considerable degree of objectivity and who inject their personalities into their canvases as little as possible; they are concerned with visual appearances only. While they may select and reject components for artistic reasons, they do not alter the basic facts to make a point. Another group of painters, not content with literal representation, are moved by the social implications of their subject matter. Their reaction, whether it be of humor, pity

or anger, is incorporated in their paintings' mood and content. Yet another group, which feels impelled to moralize, uses genre as a medium for teaching the lessons of the virtuous life. Others, finding in the dilemmas of human existence much that is venal, corrupt and debased, use satire to expose the foibles of their contemporaries. Some, not taking matters so much to heart, instead find in our failings a robust and earthy humor. And as will be all too obvious, especially in the years following the Civil War, a regrettably large group transformed genuine sentiment into sentimentality. These sometimes competent but always dull painters pull at heartstrings and produce lumps in throats by depicting the simple pleasures of childhood, the plight of the elderly, the contrast between rich and poor. Yet others raise the commonplace to the level of poetry by finding in the ordinary the symbol of a universal truth. Within the loose framework embraced by the term genre, we are dealing with a special type of artistic expression that may be interpreted in many ways.

There is no type of painting more generally popular than genre. Its appeal stems directly from some of our deepest human concerns. Its fascination is the same that impels the clerk, on the way back to the office after lunch, to linger at a knothole in the hoardings to watch the excavation for a new building; man has an inherent curiosity about activity of any sort, and each of us is by instinct a critic of every other man's life style and the art which depicts it.

Beyond the enjoyment which individual genre paintings afford, there is the subtler statement they make as a continuing thread in our social history. The artist's free choice of subject matter, considered both positively and negatively, sheds light on shifting social attitudes. By their very nature, paintings of daily life are influenced by the personality and environment of their creators. It is the artist who chooses his subject matter from the wealth of possibilities open to him. It is he who imposes on the subject a conscious or unconscious interpretation. And while ideally there should perhaps be no exaggeration of fact to sustain the artist's personal bias, this objectivity is rarely attained. These individual variants and the rich variety of fare they provide are among the factors which make the study of genre painting rewarding. They give the social historian an invaluable tool for the study of sociological patterns. For example, one can trace attitudes toward the Negro in various sections of the country at various times. The frequency with which certain themes are used—or ignored—is a gauge of popular interest and changing social pressures. Studying shifts in the artist's selection of appeals to emotion reveals society's changing attitudes, of which the most marked example is the change from the light-hearted, uncomplicated, often humorous approach of the 1830's and 1840's to the humorless, moralistic and sentimentalized view of life which developed after the Civil War.

Artists have always had the happy faculty of ignoring the artificial classifications which art historians invent. Since true artists are free spirits,

they create to satisfy themselves and not the specifications of others. Thus it happens that paintings often combine various pictorial elements in varying proportions—landscape, seascape, portraiture, history and even still life frequently coexist with genre. It is virtually impossible to adjudicate some of these melanges. In the final analysis it is unimportant; only to the cataloguer is it significant to place a given work of art in a category. Others are satisfied with the work of art for its own sake. Thus, while it is necessary to define genre painting and to indicate the scope of the term, it is more rewarding to study and appreciate the myriad variations which the creativity of American artists has produced within its outer limits. ☐

# CHAPTER

# The First Frontier

We are prone to overlook the fact that America has always had a frontier where civilization stops and the wilderness begins. In Colonial days the eastern seaboard was in every sense a real frontier, its settlers faced with the problems of food, shelter and physical safety. Drought and frost imperiled crops essential to existence. Fire and tornadoes threatened houses and barns. Depredations by Indians, wild animals, pirates—even raids by our civilized neighbors, whether Spanish, Dutch, Swedish or French—were always either occurring or threatening. The margin between life and death was slim. Luxuries like decoration for homes were out of reach for all but the rich elite, and in certain sections were suspect on religious grounds, if not, indeed, forbidden.

Security and affluence came in due time, however, especially to a fortunate few who from various sources acquired real wealth. As the eighteenth century advanced toward its midpoint and the frontier receded, more and more householders could afford the luxury of painted overmantels and wall paintings to supplement ancestral portraits, or an occasional mezzotint ''landskip'' to grace their paneled walls.

With an untutored hand but a sharp eye for telling incident, the unidentified artisan painter of the *Van Bergen Overmantel,* c. 1750 (Fig. 1), provides a pertinent example. This panoramic view is an inventory of the life of an established frontier home. Within the neatly fenced enclosure surrounding the mansion are herds of cattle, horses and sheep, barns and fodder storage. A wagon carries farm produce to market and horsemen gallop briskly along the roadway, while a family of Indians stalks enigmatically across the pasture. Farmhands are at their chores, carrying water from the well and tending the livestock. The elegantly attired proprietor and his lady stand in front of their modest but substantial dwelling observing their numerous progeny. The painting is a

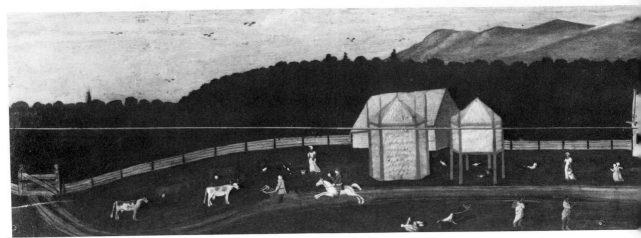

1. Unidentified artist, *Van Bergen Overmantel,* c. 1750. New York State Historical Association, Cooperstown, New York.

record of achievement and a manifestation of the ever-present human quest for a measure of immortality. To today's viewer, the unbroken fence of forest and mountains which forms the background to this parade of figures and buildings is a reminder of how closely the wilderness still pressed on civilization a century after the earliest settlements were founded.

Professional painting in the Colonies was largely, although not exclusively, limited to portraiture. So we must look to portraits to detect the first strivings of the artist to break away from the omnipresent phiz. How boring it must have been to paint a succession of heads and shoulders of complacent middle-aged housewives and merchants! No wonder ambitious painters whenever there was an excuse, began to embellish backgrounds with real or fanciful architectural or landscape detail. Sometimes, no doubt, this was done at the urging of the sitter, who wished to show posterity his vocation or the house he had built. The portrait of *William Stoughton,* c. 1700 (Fogg Art Museum), by an unidentified painter, also shows the large building bearing his name which still stands in Harvard Yard. Others wished to perpetuate the memory of their deeds of military valor. John Smibert's (1688-1751) *Sir William Pepperrell,* 1745 (Fig. 2), includes a view of Louisburg fortress, whose capture won the sitter honor, money and fame. Ship captains and merchants were fond of having the ships that had brought them wealth included in their likenesses. A typical example is Smibert's *Peter Faneuil,* c. 1742 (The Corcoran Gallery of Art), in which the self-satisfied merchant is depicted with a portrait of one of his vessels in the distance.

As the century advanced it is possible to see some evidence that, at least among a certain, perhaps small, proportion of the populace, there was growing acceptance and appreciation of this development. At the same time one notices that portraits tend to become less stereotyped as they begin to include revealing detail about the sitter and his everyday calling. The

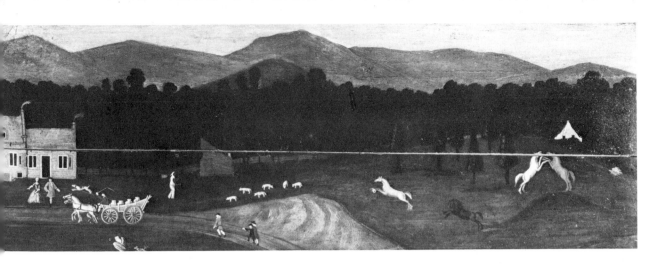

2. John Smibert, *Sir William Pepperrell,* 1745. Essex Institute, Salem, Massachusetts.

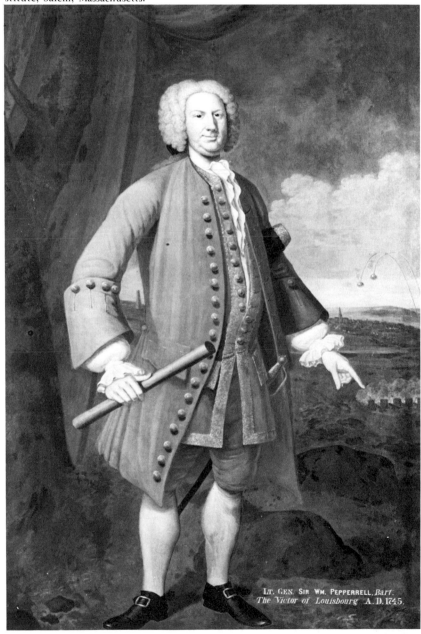

LT. GEN. SIR WM. PEPPERRELL, Bart.
The Victor of Louisbourg A.D. 1745.

elements of genre are certainly present in John Singleton Copley's (1738-1815) well-known portrait of *Paul Revere,* 1768-70 (Fig. 3), the great Boston silversmith and engraver. Here we are presented with a master craftsman, arrayed not in his Sunday-go-to-meeting clothes but in his shirtsleeves and plain waistcoat, unfinished teapot in hand, pausing to look unselfconsciously at the beholder. It took a man of independent character like Paul Revere to choose to be painted plying his craft; an average, conformist colonist such as Faneuil felt more secure portrayed in his powdered wig and the richly embroidered waistcoat of a wealthy middle-class merchant and landowner. Winthrop Chandler's (1747-1790) likeness of *Captain Samuel Chandler,* c. 1780 (National Gallery of Art, Washington, D.C.) depicts in the background a lively cavalry skirmish in which Captain Chandler had participated. It, too, demonstrates a breaking away from the conventional studio pose by the inclusion of a story-telling element.

An outstanding example of this trend to particularize portraits by placing the subjects in a specific personal setting is Ralph Earl's (1751-1801) *Elijah Boardman,* 1789 (Fig. 4), although there are many others one could cite with equal point. Here we see an elegant and successful draper with his stock neatly displayed on shelves awaiting the customer. Most of the elements of genre painting are present, except intent.

Of all surviving early Colonial paintings, the only one that approaches true genre is John Greenwood's (1727-1792) *Sea Captains Carousing in Surinam,* c. 1758 (Fig. 5). This large canvas, which, according to Alan Burroughs, was probably executed for a tavern club, is an action-packed group portrait. Burroughs also states that many of the captains, all of whom probably hailed from Rhode Island, are identified. Capt. Jonas Wanton sags in drunken stupor; Capt. Ambrose Page vomits into Wanton's pocket; Capt. Nicholas Cook, future Governor of Rhode Island, holds a long pipe; Capt. Esek Hopkins, future commander-in-chief of the Continental Navy, raises his wineglass.[1] It is apparent that the artist's primary aim was to caricature a notable drinking bout rather than to record the likenesses of those present.

The painting's vigor and earthy humor make up for the artist's inadequate grasp of the finer points of perspective and drawing. While the actual site of this convivial convocation was Dutch Guiana, the event could as well have taken place in any major seaport on the Atlantic coast. It is a fascinating record of the boisterous, hard-drinking life of the mid-century— executed very much in the spirit of Hogarth's engraving *Midnight Modern Conversation,* c. 1732. In those days it was usual for a gentleman to open the day with a liberal tot of rum and to follow it at frequent intervals throughout the day with libations selected from the wide variety of punches, wines and beer available.

Of the considerable number of group portraits or conversation pieces which have survived from the eighteenth century, there are a few which go far

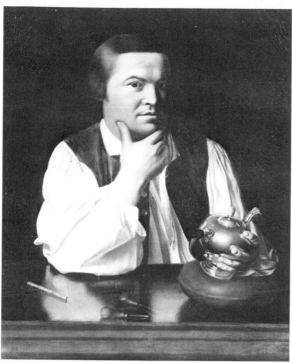

3. John Singleton Copley, *Paul Revere,* 1768-70. Museum of Fine Arts, Boston; Gift of Joseph W., William B. and Edward H. R. Revere.

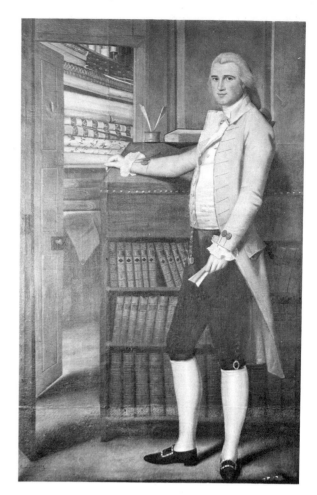

4. Ralph Earl, *Elijah Boardman,* 1789. Collection Mrs. Cornelius Boardman Tyler.

5. John Greenwood, *Sea Captains Carousing in Surinam,* c. 1758. City Art Museum of Saint Louis.

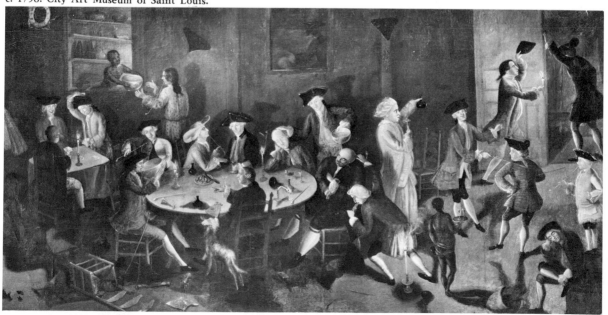

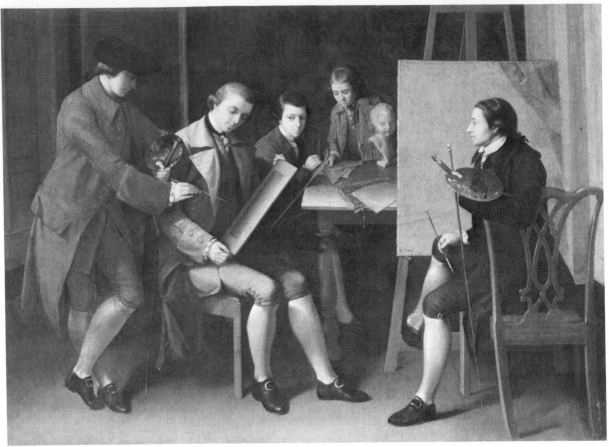

6. Matthew Pratt, *The American Academy*, 1765. The Metropolitan Museum of Art, New York; Gift of Samuel P. Avery, 1897.

enough outside the usual confines of portraiture to verge on genre. Such a one is *The American Academy,* 1765 (Fig. 6), by Matthew Pratt (1734-1805). Here we see the expatriate American, Benjamin West, instructing a group of young Colonial painters, a few of the many who over the years flocked to his London studio. Pratt is the man whose drawing is being criticized by West; the others are unfortunately unidentified. In 1788 William Dunlap (1766-1839) completed his *The Artist Showing a Picture from* Hamlet *to His Parents* (Fig. 7). While there is no gainsaying that it is a rather static triple portrait, the subjects are engaged in a shared activity. The same theme, an artist showing his work, reappears in the next century as a genre subject from the brush of William Sidney Mount and others.

As we have seen, American Colonial portraiture, while basically patterned after the fashionable models of the society painters of London, shows a tendency to break away from the set formulas of routine British portraits and to seek greater freedom of costume and setting.[2] There can be little doubt that to a degree this tendency reflects the impact of the American environment on the artist.

Three other factors probably also contributed to preparing the ground for a native school of genre painting. Of these, the great change brought about by Benjamin West in the approach to painting contemporary history is by far the most significant. Cheap and popular topical prints also dealt with contemporary events and may have helped to create an awareness of the new area waiting to be explored. The third factor is the pervasive presence of the pictorial signs which hung outside the shops and taverns of the New World in a profusion which, because of their present rarity, can only be imagined.

The event which more than any other brought about the rise of a native school of genre painting was the appearance of Benjamin West's (1738-1820) *Death of Wolfe,* 1771 (National Gallery of Canada, Ottawa). For the first time in western art a painting commemorating a dramatic historical event depicted

7. William Dunlap, *The Artist Showing a Picture from "Hamlet" to His Parents,* 1788. The New-York Historical Society, New York.

8. John Singleton Copley, *Watson and the Shark,* 1782. The Detroit Institute of Arts; Gift of Dexter M. Ferry, Jr.

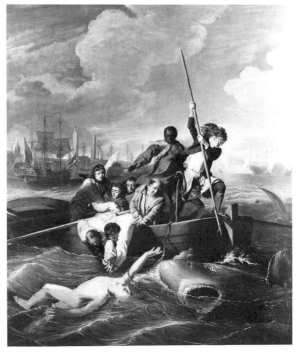

the participants in contemporary dress rather than in pseudo-classical costume. This was, for its time, a daring break with tradition. Because of its instant popularity and the wide distribution of prints made after it, the *Death of Wolfe* caused an artistic revolution. The logical extension of this breakthrough would be to raise to equal importance paintings of a non-historical nature in which the figures were shown in contemporary dress and settings—provided, of course, the canons of the grand manner were duly observed.

Another expatriate American, John Singleton Copley, who had lamented the absence of opportunity to paint history in the Colonies, followed West's lead. In 1779-80 he painted *The Death of the Earl of Chatham in the House of Lords* (Tate Gallery, London) which showed that American sympathizer as he was stricken in the act of denouncing Britain's policy toward her rebellious colonies. Copley took another step toward genre when in 1782 he painted *Watson and the Shark* (Fig. 8). In this dramatic canvas (one of several versions), the subject is not one of

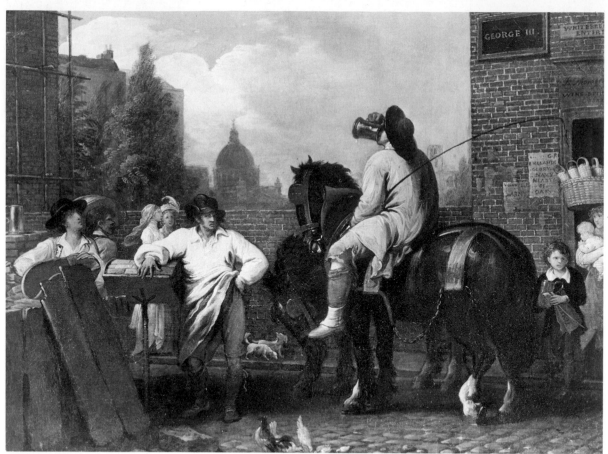

9. Benjamin West, *The Old George Inn*, 1796. Hirschl and Adler Galleries, New York. (Color plate I)

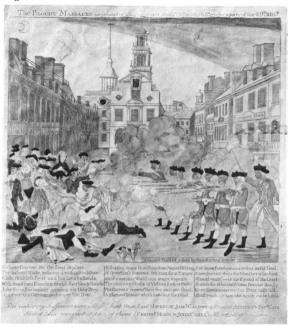

10. Paul Revere, *The Boston Massacre*, 1770. The Metropolitan Museum of Art, New York; Gift of Mrs. Russell Sage, 1910.

national importance, but merely an incident—a swimmer being rescued from attack by a shark. The painting demonstrated that history painting is not necessarily restricted to grand events. It was but one more small step to paintings showing people occupied with their daily activities.

West, Copley and, after the Revolution, John Trumbull seized upon the basic human appeal of contemporary history and, by presenting it in major works which observed all the artistic criteria requisite to the grand manner, elevated it to a position of respectability. By the end of the eighteenth century the public was beginning to accept figures in contemporary dress, in action, as a perfectly normal form of art.

Since so many American artists studied at one time or another with their eminent and hospitable countryman Benjamin West, it is hard to understand why none of them appears to have been influenced by his delightful, if rare, excursions into genre. *The Old George Inn,* 1796 (Fig. 9), which captures the

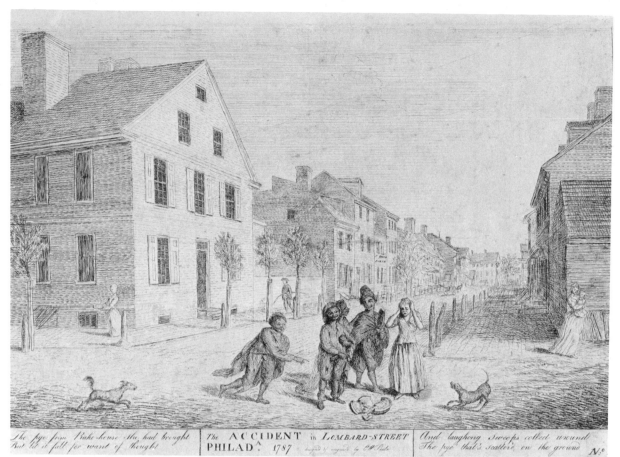

The pye from Bake-house she had brought / But let it fall for want of thought | The ACCIDENT in LOMBARD-STREET PHILADᴬ. 1787 | And laughing Sweeps collect around / The pye that's scatter'd on the ground

11. Charles Willson Peale, *Accident in Lombard Street*, 1787. Henry Francis du Pont Winterthur Museum, Winterthur, Delaware.

bustling street life of London, might well have appealed to his young students and have encouraged them to essay similar subjects on their return to Philadelphia, Boston or New York.[3]

It is in the nature of mankind, or at least of a sizable segment of it, to revel in pictures of current events— the more horrendous the more appealing. This interest, exploited to the full in eighteenth-century England, was catered to as well on this side of the Atlantic. The cheap prints which were the principal vehicle for satisfying this appetite were published in smaller quantity in Colonial America than in England only because the Colonies did not possess the technical facilities for professional-quality print production and distribution. The outstanding American example of such prints is Paul Revere's engraving of the Boston Massacre of 1770 (Fig. 10). Here is propaganda pure and simple, but it and other later prints (e.g., Amos Doolittle's four engravings after designs by Ralph Earl of the British expedition to Concord and Lexington) are also examples of prints produced to satisfy the popular demand for pictures of topical events. They may well have helped pave the way for the eventual acceptance of pictures of activities of a non-historical nature.

Charles Willson Peale (1741-1827), who is rarely thought of as a printmaker, in an etching dated 1787 appears to have been the first American to depict a genre incident. This print, *Accident in Lombard Street* (Fig. 11), is known in only a few examples.

The etching, one of a projected series of four intended to show the principal streets of Philadelphia, bears the inscription:

> The pye from Bake-house she had brought
> But let it fall for want of thought
> And laughing sweeps collect around
> The pye that's scatter'd on the ground

The artist's own house is shown in the foreground, and it is probable that the little girl is his daughter Angelica, for, as Edgar P. Richardson has noted, ''It would be characteristic of Peale's strong domestic affections to choose a subject from his own family life;

29

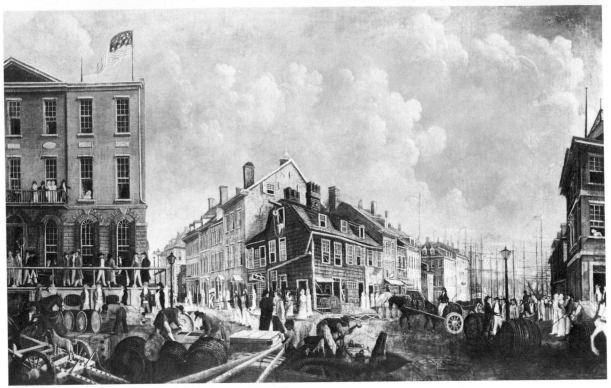

12. Francis Guy, *The Tontine Coffee House*, 1797. The New-York Historical Society, New York.

equally characteristic of his endlessly experimental nature to have produced the earliest etching done by an American painter, and the earliest genre street scene of an American city."[4]

The production of a print was no easy task even in a city the size of the Philadelphia of 1787. Peale found it difficult to obtain polished copperplate and was forced to make the grounds on the plates himself, a process which, because he was without much experience in the technique, he found extremely time-consuming. The entire operation from start to finish devolved on Peale himself. The amateurishness of the finished print is testimony both to his lack of expertise and to his determination. Because there was no established system of print distribution, he even had to handle the sales himself. Peale offered the print at "Price one quarter of a dollar," yet in the tight money situation of the struggling United States he had little success in finding a market; that is why so few impressions of the etching are in existence today. This etching was Peale's final attempt to make printmaking profitable.

Francis Guy (c.1760-1820), who came to this country from England about 1795, shows traces of an interest in genre in some of the cityscapes and views of country seats which were his specialty. His portraits of towns and residences reflect the interest of Americans in their own physical appearance as it broadened to include their surroundings. Not infrequently these early topographical landscapes, whether by Guy or by his contemporaries, include in subordinate roles small groups of figures engaged in commonplace activities, such as fishing, boating or hunting. Of all these, Guy's *The Tontine Coffee House*, 1797 (Fig. 12), is without doubt the liveliest example. It is rich in detailed vignettes of New York urban life just before the turn of the century and serves as an example of all the earlier and later topographical landscapes which, although their function was to record bricks and mortar, went beyond to indicate something of people's daily lives.

Throughout the long struggle to break the monopoly of portraiture, considerable importance must

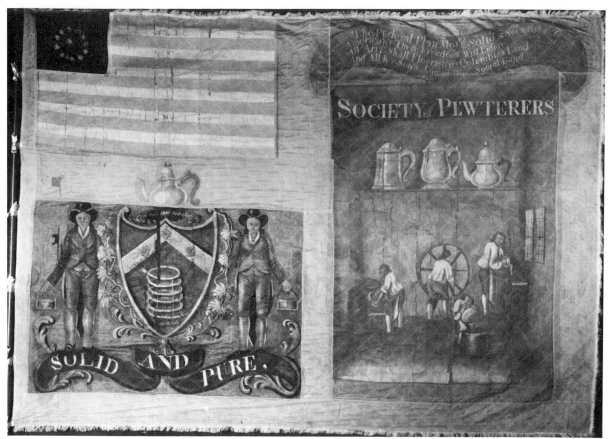

13. Unidentified artist, *Flag of the Society of Pewterers, New York*, 1788. The New-York Historical Society, New York.

be given to the subliminal influence of the humble sign painter. As the Colonial period progressed, this artisan produced increasingly elaborate and pictorial signs to call the public's attention to the taverns, silversmiths, pewterers and other tradesmen in cities, towns and even frontier villages. The closest thing to a picture gallery in Colonial times were the streets in the commercial section of a city.

The sign painter not only made signs, but also painted military flags and decorated the panels of coaches, fire engines, drums, banners for guilds of craftsmen (Fig. 13) and peculiar domestic accessories.5 His customers encouraged him to develop wit, originality and a freedom in representing his subject not as readily countenanced in the field of portraiture. Many painters started on the road to becoming artists through the practice of this utilitarian craft. As late as the nineteenth century, sign painters were the first teachers of many young men who went on to become artists of importance 5

It was in all likelihood a sign painter who turned his

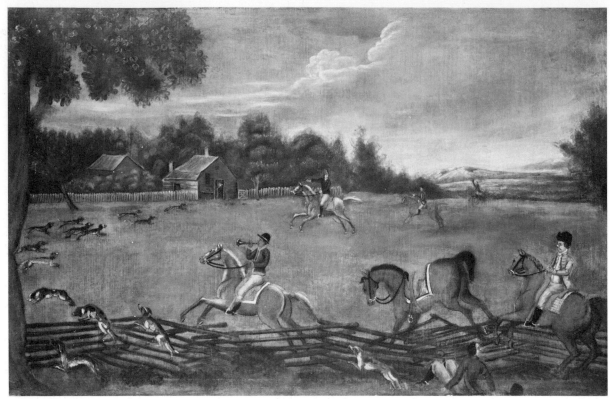

14. Unidentified artist, *The End of the Hunt,* c. 1800. National Gallery of Art, Washington, D.C.; Gift of Edgar William and Bernice Chrysler Garbisch.

hand to *The End of the Hunt,* c. 1800 (Fig. 14). This painting shows one of the typical pastimes of the Southern colonist, whose pattern of life closely approximated that of the English country gentleman. This unknown painter was probably willing to apply his talents to any branch of the arts as opportunity offered. Colonial newspapers, especially in the South, were full of the advertisements placed by these jacks-of-all-trades—such as this announcement made to the citizens of Charleston in 1766:

> Warwell, painter, from London, intending to settle in this town, begs leave to inform the public that he has taken a house on the Point, opposite Governor Boone's and next door to Mr. Rose's, ship-carpenter; where he paints history pieces, altar pieces, landscapes, sea pieces, flowers, fruit, heraldry, coaches, window blinds, screens, gilding. Pictures copied, cleansed, and mended. Rooms painted in oil or water in a new taste. Decorative temples, triumphal arches, obelisks, statues, etc., for groves and gardens.[7]

If the artist of *The Old Plantation,* c. 1800 (Fig. 15), was not also one of this class of utility painters, he

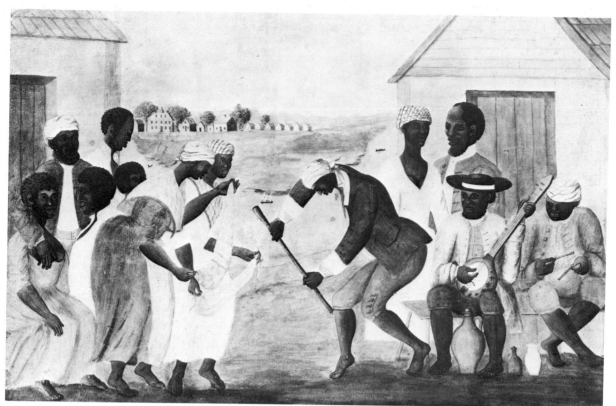

15. Unidentified artist, *The Old Plantation,* c. 1800. Abby Aldrich Rockefeller Folk Art Collection, Williamsburg, Virginia.

was probably one of the countless gentleman amateurs who dabbled at painting and who sometimes picked up the rudiments of drawing from one of the many teachers who advertised for pupils. This scene is in many ways extraordinary. The subject does not fit into the narrow range of those acceptable as adornments of a gentleman's residence. While the Negro is frequently included in Colonial portraits as a symbol indicating the wealth of the sitter, it was unusual to show slaves, or indeed working-class people of any color, at their trades or amusements as this painting does.

The painting which might claim the title of being the first genre painting executed in the United States is *A Boy Holding a Cat to a Mouse,* c. 1795, by Jeremiah Paul (active 1791-1820). The cruelty implied by the title is in the spirit of mid-eighteenth-century Britain, where bear-baiting and similar pastimes had a popularity not matched in this country after the birth of the Republic. Unfortunately the painting cannot be located, but it is known to have

been in the first exhibition of the Columbianum in Philadelphia in 1795—the only genre subject among a number of landscapes and still lifes and, inevitably, portraits by almost two score painters.

Jeremiah Paul was one of the founders in 1795 of Philadelphia's Columbianum, an organization of artists set up on sound republican principles and adapting to American specifications the ground rules of the successful example afforded by the Royal Academy. It was at once a school, an incipient museum (there was no collection), and an exhibition hall for the annual display of contemporary art.

Paul painted one other genre subject, *Four Children Playing in a Courtyard,* 1795 (Fig. 16), basing the composition on an English engraving of an earlier period.

Most of the art that hung in American homes during the Colonial period has been lost. Some works perished in the disastrous fires which destroyed portions of almost all towns and cities at one time or another. Others were taken out of the country when families migrated, as after the Revolution when the Tories were forced to flee. Still others were intentionally destroyed because they were decayed, damaged or simply obsolete in terms of fashion in furnishing. Probably others exist today, but remain unrecognized because there is no evidence to establish their Colonial provenance. Hence the false impression persists that Colonial art objects, especially paintings and prints, were as scarce then as they are now.

The truth is that there was a great deal more art in the Colonies than is commonly believed. There were dealers in paintings whose stock of old masters and copies of old masters found its way into many prosperous homes. Print sellers also sold considerable quantities of imported prints, including Hogarth's satirical genre subjects. Mail-order works of art were imported by wealthy merchants and planters like George Washington, whose permanent representatives abroad acted as agents in supplying anything their employer needed. Painted and carved signs decorated shops, bridges and taverns. The Colonies were far from an artistic desert. Still, the eighteenth-century Colonist was unready to implement his desire to have a record of the activities which occupied his waking hours, and in general there were only few and faltering attempts in this direction.

The widespread discontent with British Colonial policy culminating in the Revolution ushered in a new era. Although the War for Independence was essentially a political conflict, its successful conclusion affected the whole range of American attitudes. The Revolution fostered the rise of a new social order and fundamentally changed people's philosophical and psychological outlook. The newly independent citizens were anxious to steer their own course and to celebrate their new identity. Artists found new avenues open to them, although years were to pass before these avenues could be fully explored. □

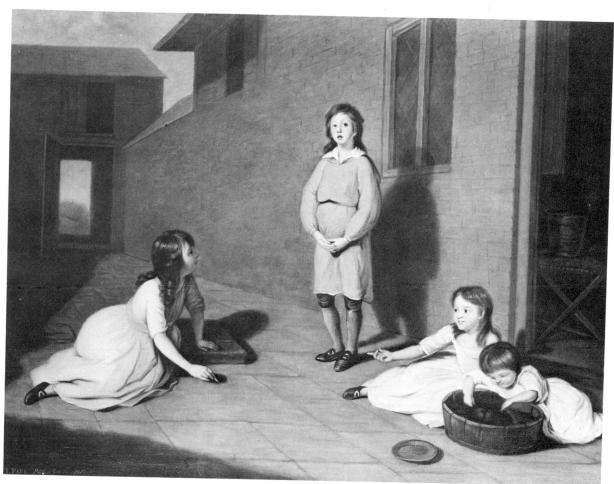

16. Jeremiah Paul, *Four Children Playing in a Courtyard*, 1795. Private collection.

# CHAPTER 2

# Land of Promise

By 1800 Colonial attitudes and patterns had been swept aside by an aggressive national pride. This pride, which visitors from abroad—Mrs. Trollope for one—frequently found obnoxious, stemmed from the dramatic success which crowned the new experiment in government and led to the acceptance of that government as a full and equal participant in the community of nations.

The new spirit was bound to be reflected in a change in attitudes toward art. Yet the fear that luxury and its concomitant, decadence, would sap republican virtues inhibited any dramatic change. Practicality continued to be America's guiding principle, and in art only portraits fulfilled this requirement. That the climate was unpropitious for innovation is demonstrated by Trumbull's lack of success in finding support for his projected series of twelve engravings depicting decisive events in the Revolutionary War. Although he had the encouragement of Jefferson, and Adams's help in selecting the subjects, he had to abandon the project in 1794. This failure is but one example of the frustrations the artist suffered during his struggle to establish his place in American society and to expand the range of his subject matter.

With few exceptions, all the artists who painted genre subjects between 1800 and 1825 did so infrequently, leaving only isolated examples among the body of their work. Their interest in exploring new areas of subject matter, although endorsed in principle, was not yet matched by a tangible response in patronage. America's intellectual leaders, a number of artists among them, were convinced that American customs and manners did not possess the qualities of antiquity and picturesqueness that were among the essential attributes of serious painting.[1] Nevertheless, the painters who made the first tentative steps toward capturing the character and appearance of contemporary American society were among the most distinguished of the period.

As we shall see in the following pages, the painters' views of the contemporary scene provide fascinating illustrations of American social history, although

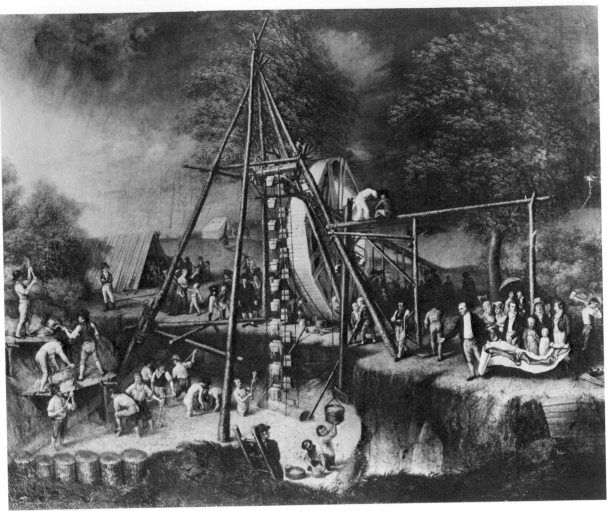

17. Charles Willson Peale, *Exhuming the First American Mastodon,* 1806-08. The Peale Museum, Baltimore; Gift of Mrs. Harry White in memory of her husband.

taken as a whole they are a significantly limited record. The life that is shown is, by and large, that of the upper classes, which retained much of the aristocratic way of life inherited from the Colonial past. The laboring class appears but once, in a view of a scythe factory by Bass Otis. Allston, Dunlap, Sargent and Morse give us random glimpses of the social elite of the cities, whereas Krimmel, King and Fisher concentrate on the life of the well-to-do tradesman, farmer and traveler.

In comparison with later genre paintings, little attention was given to developing the full flavor and atmosphere of the scenes depicted. There is a tendency in the work of Sargent, Fisher, King and Krimmel to aim for the overall effect, rather than the development of intense and accurate characterization of individuals and their psychological interrelationships. It remained for the next generation to study more closely the types of individuals best suited to realistic representation of the themes of their paintings.

As might be expected, the extraordinarily versatile Charles Willson Peale, in addition to producing the first genre print of an American street scene, mentioned in the preceding chapter (Fig. 11), also did a number of paintings which, although they defy exact categorization, show a decided inclination toward genre.

Of all the artists working in the new republic, only

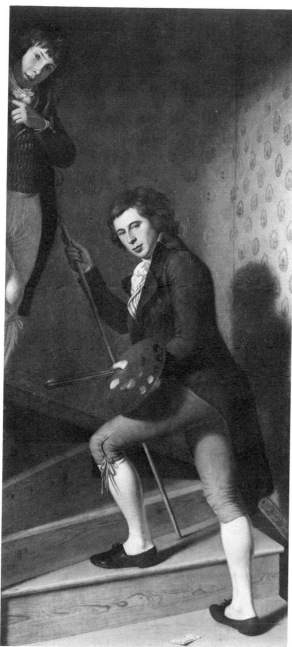

18. Charles Willson Peale, *Staircase Group,* c. 1795. Philadelphia Museum of Art; George W. Elkins Collection.

Peale could have produced *Exhuming the First American Mastodon,* 1806-8 (Fig. 17). This painting—one of the early masterpieces of American art—is a strange and subtle combination of several pictorial elements: group portrait, topographical landscape, topical report and history painting. But primarily it is a record of an event of exceptional scientific interest.

It is hard for us in this blasé age to appreciate fully the excitement which this discovery occasioned in 1801. Everyone got in on the act, from President Jefferson, who authorized the use of military equipment, on down. It was America's first organized scientific expedition, and it was Peale who organized it—personally investing more than a thousand dollars, a tremendous sum at that time.

The site of the find was John Masten's Ulster County farm near Newburgh in the Hudson River valley of New York. Peale's canvas conveys something of the excitement of the excavation: the benumbed diggers in the icy water (they had to be fed tots of grog to keep them going), the threatening sky, the operation of the ingenious treadmill pump. In describing his painting, Peale wrote his old friend Benjamin West that he had "introduced upwards of fifty figures . . . yet the number of spectators in fine weather amounted to hundreds. Eighteen of my figures are portraits. . . ."[2] Along with a number of scientists of the day, Peale included most of his large family, and himself, appropriately posed in the act of directing the dig.

The painting is not, however, an absolutely factual record, since not all the individuals portrayed were on the scene at the same time. The important personages are arbitrarily arranged with an eye to the telling of a complete story. In its informality and objective realism this painting exemplifies the independent outlook and freedom from traditional artistic restrictions which an artist of Peale's caliber could enjoy in the cultural climate of the new republic.

Peale's artistic independence and vitality are nowhere more clearly demonstrated than in his paintings of himself or of his children, in which he breaks away from those conventions of portraiture which decreed that the subject had to be immobilized in a setting having the character of backdrop. Peale elevates portraiture from composites of separate, static pictorial elements to paintings where person, action and environment are integrated. The famous *Staircase Group,* c. 1795 (Fig. 18), with its trompe l'oeil effect, is perhaps the best of these. Even *The Artist in His Museum,* 1823 (Pennsylvania Academy of the Fine Arts), has overtones of action. The proprietor of the museum, who is Peale himself, holds back a curtain (putting Grand Manner drapery to work) and reveals the interior and the extensive collection; his gesture invites the viewer to enter and explore, perhaps under his personal guidance.[3]

An isolated early example of genre in the comic vein is found among the works of Washington Allston (1779-1843), whose name stood for all the qualities that Americans found admirable in the art of painting throughout the nineteenth century. *The Poor Author*

*and the Rich Bookseller* (Fig. 19), which has been dated 1811,[4] is completely foreign to the sobriety Allston's art exhibited in his mature years.[5] Here Allston's approach to his subject is obviously satirical. He extracts a biting humor from the comparison of the overstuffed publisher and the lath-thin author, who is about to be literally swept out of the office by the husky young clerk. It is a finely realized painting, and the effects of light in the subtly painted interior are extremely well handled.

It is thought that the composition derives from an English print of the period.[6] Certainly it reflects the influence of the eighteenth-century English vogue for humorous satire exemplified by Hogarth and later by Rowlandson.[7] Even though it may not be a wholly original concept, as a social document the painting provides a graphic idea of the appearance of a Boston publisher's office in the opening years of the nineteenth century. It is also probably the earliest surviving genre painting to be done in this country. As Edgar P. Richardson points out, such good-natured satire was an important element of the romantic movement in America and in contemporary literature appears in the writings of Washington Irving, Thomas Green Fessenden and others.[8]

The first artist working in this country to show a sustained interest in genre was not a native-born American but an emigrant from Württemberg, Germany, who arrived in Philadelphia in 1810. John Lewis Krimmel (1789-1821) was then twenty-one years old and endowed with extraordinary sharpness of vision which, abetted by brushes of exceptional smallness and a high degree of manual skill, enabled him to finish his pictures with exactly precise detail. During the ten-year span of his working career before his untimely death by drowning in 1821, he produced the first body of paintings concentrated on showing aspects of American life. He became enraptured with what native American artists, with the exception of Peale, had passed over as commonplace and unpicturesque: the street scenes and city life of his adopted home. To support his family, he also painted portraits.

It seems likely that the young Krimmel after his arrival in Philadelphia saw some of the famous engraved views of the city produced by William Russell Birch (1755-1834), an earlier emigrant to this country from England. Indeed Birch's engraving *High Street, From the Country Market-place Philadelphia: with the procession in commemoration of the Death of General George Washington, December 26th, 1799,* 1800 (Fig. 20), may have provided Krimmel with the basic formula for his out-of-door genre paintings. Birch's engraving contains these elements: a crowd of small figures, a particular event, an identifiable location—all of which Krimmel was to employ in his city scenes. Some engravings in Birch's series of Philadelphia views show particular sites with fewer figures, but follow essentially the same format.

Probably one of the earliest of Krimmel's paintings is his *Fourth of July in Center Square,* c. 1810-12 (Fig. 21). As might be expected on such a holiday, the

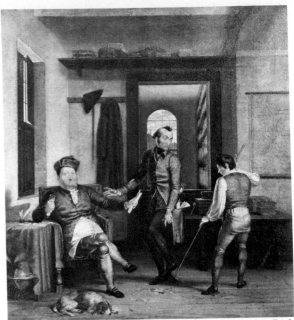

19. Washington Allston, *The Poor Author and the Rich Bookseller,* 1811. Museum of Fine Arts, Boston; Bequest of Charles Sprague Sargent. (Color plate II)

20. William Russell Birch, *High Street, From the Country* ▶ *Market-place Philadelphia: with the procession in commemoration of the Death of General George Washington, December 26th 1799,* 1800. Philadelphia Museum of Art; Given by Mrs. Walter C. Janney in memory of her late husband, a former trustee of the Museum.

21. John Lewis Krimmel, *Fourth of July in Center Square,* c. ▶ 1810-12. Pennsylvania Academy of the Fine Arts, Philadelphia.

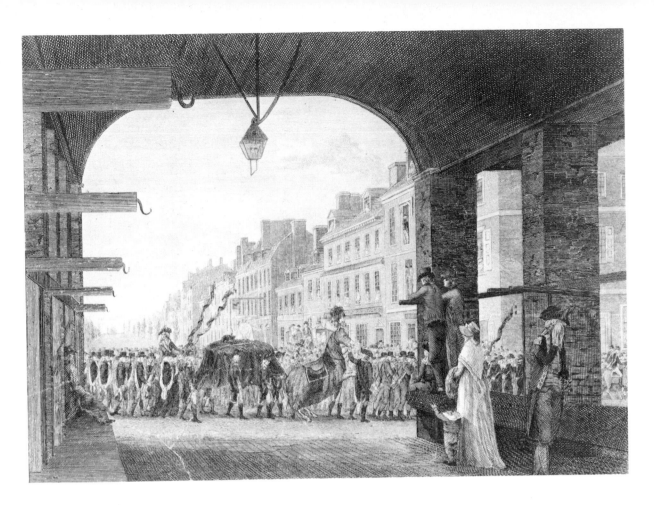

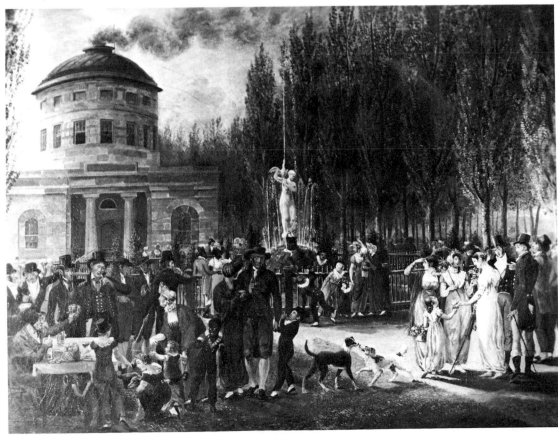

41

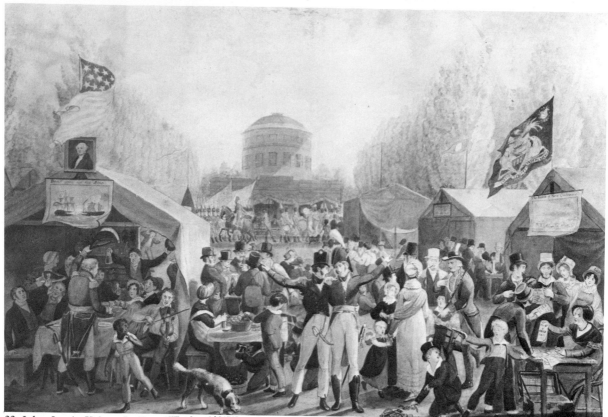

22. John Lewis Krimmel, *Fourth of July Celebration in Center Square, Philadelphia,* 1819. The Historical Society of Pennsylvania, Philadelphia.

people gathered near William Rush's fountain *Water Nymph and Bittern* are dressed in their best attire. The ladies are turned out in the latest French mode, and their escorts match them in elegance. Taking advantage of the festive occasion, a vendor of liquid refreshment does a thriving business. A variety of social classes are depicted, so that the painting avoids the appearance of a fashion plate. Nearly ten years later, in 1819, Krimmel did a watercolor *Fourth of July Celebration in Center Square, Philadelphia* (Fig. 22) which uses the same theme but with a notable difference. Instead of the rather sedate, polite gathering of the earlier view, the crowd is boisterous if not, indeed, rowdy. Apparently well before the advent of Jacksonian Democracy, Americans had adopted the unaffected and exuberant manners (sometimes described as vulgar) with which they have been identified into the present century.

All Krimmel's Philadelphia out-of-door scenes have specific localities as backgrounds for the events he depicts. *Election Day at the State House, Phila-delphia,* known through an unfinished and undated engraving, shows in the background an impressive range of Colonial buildings in addition to the State House, whereas *The Procession of Victuallers,* known through an aquatint of 1821, shows the business section of the city. Another of Krimmel's lost paintings, known only through an engraving by J. Hill, is *The Conflagration of the Masonic Hall, Chestnut Street, Philadelphia,* 1819. Human nature changes but little and, while they were dreaded in those days when techniques of fire fighting were primitive, fires were exciting events which drew crowds then as they do today. Hill's engraving shows a good-natured crowd watching the efforts of the volunteer firemen to stem the blaze that destroyed the building.[9]

Krimmel apparently had two formulas for his genre work, the out-of-door format just mentioned, and the box type which he used for interior scenes. He perhaps derived his interior formula from the popular paintings of Sir David Wilkie, with which he would have been

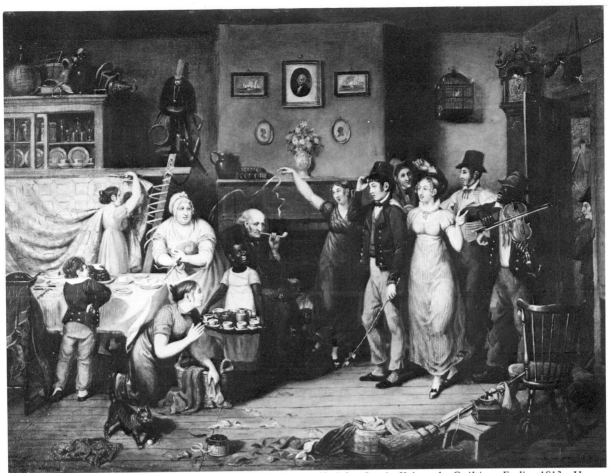

23. John Lewis Krimmel, *Quilting Frolic,* 1813. Henry Francis du Pont Winterthur Museum, Winterthur, Delaware. (Color plate III)

familiar through the prints made after them.[10] One such domestic scene, *Quilting Frolic,* 1813 (Fig. 23), demonstrates that our female ancestors were not quite the neat housewives we have been led to believe they were. All sorts of household objects—baskets, broom, fabric—litter the floor, while the hostess, aided by a little Negro girl, is preparing to serve a repast. On the other side of the room a Negro fiddler is about to start the dance. An attempt at characterization of the guests is made, but the faces appear stereotyped.

*Interior of an American Inn,* 1813 (Fig. 24), is somewhat more successful in its characterizations. The local inn or tavern, with its taproom, is frequently the setting for genre scenes which reflect the fact that it was the center around which much of the life of a community revolved. Here the stagecoach stopped, man and beast were refreshed, and news was transmitted and collected. When a stage arrived it was a bustling scene, as here, with the locals having a social tankard and the new arrivals trying to attract attention to their needs.

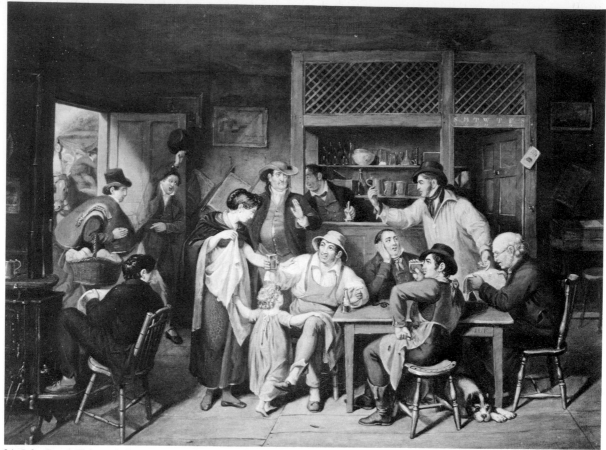

24. John Lewis Krimmel, *Interior of an American Inn*, 1813.
The Toledo Museum of Art, Toledo, Ohio; Gift of Florence
Scott Libbey, 1954.

*Country Wedding,* 1814 (Fig. 25), shows the dozen
participants in the cozy interior of a farmhouse clut-
tered with a variety of domestic still-life objects,
some of which—the paired silhouettes, the grand-
father clock, the footed vase with flowers—also ap-
peared in *Quilting Frolic.* This informal gathering
gives us a glimpse into the simple life of average
Americans in the early years of the last century, when
marriages were more often celebrated in the home
than in a church. The officiating clergyman has been
identified as Bishop White, owing to a remark in the
deed of gift of the picture to the Pennsylvania Acad-
emy of the Fine Arts. If, however, one compares
the old gentleman with a pipe sitting before the fire-
place in *Quilting Frolic,* the white-haired man on the
extreme right of *Interior of an American Inn* and the
clergyman in *Country Wedding,* one finds the
resemblance striking. Beyond a doubt, the model, a
stereotype for an elderly gentleman, was the same in
all three paintings.

Krimmel died before he received the full recognition

due him, and therefore he did not attract a coterie of
students and followers to carry on a school of genre
painting in Philadelphia. We shall see later, however,
that his work, through the medium of reproductive
prints, may have had a certain influence on the
following generation of artists, notably William Sidney
Mount.

An unidentified contemporary of Krimmel's
produced a singular view of *A Ceremonial at a Young
Ladies' Seminary,* c. 1810 (Fig. 26). The anonymous
painter was not as gifted as he was ambitious. He
undertook a composition of some thirty-seven figures
in a verdant outdoor setting—a not inconsiderable
problem even for an experienced painter. That the
composition is static and unimaginative does not
lessen the painting's charm, however. It is a delightful
evocation of a special day in the school year, perhaps
the last day of the term. The picture was found in
Virginia and probably shows the entire student body as
well as the faculty of a school in that area. The school
appears to have specialized in the art of music, judging

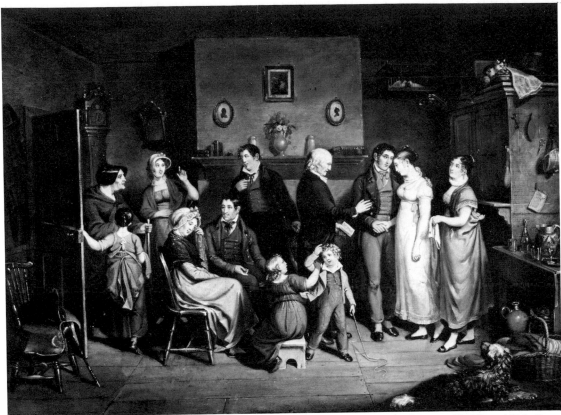

25. John Lewis Krimmel, *Country Wedding*, 1814. Pennsylvania Academy of the Fine Arts, Philadelphia.

26. Unidentified artist, *A Ceremonial at a Young Ladies' Seminary*, c. 1810. Collection Edgar William and Bernice Chrysler Garbisch.

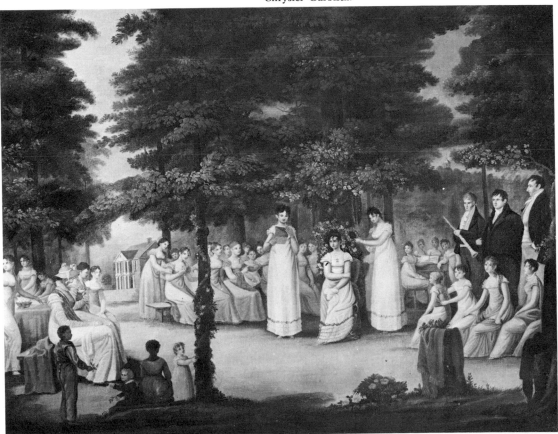

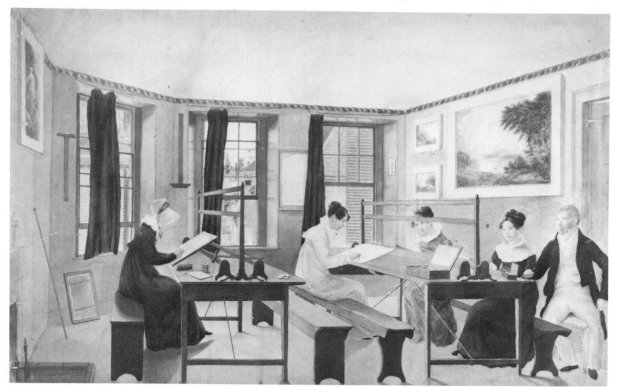

27. Unidentified artist, *Drawing Class*, c. 1815-20. The Art Institute of Chicago.

by the professor who holds a clarinet and the group of young ladies around a spinet. It is probable that the painter was himself the instructor in drawing at the school. Young ladies in this period were expected to exhibit skill in music and needlework, and in drawing and painting in watercolor, among other accomplishments. Krimmel, who held a post as professor of drawing at a young ladies' seminary in Philadelphia, lost it for refusing to comply with the headmaster's order that he execute the work of those pupils who lacked talent so that the parents would feel satisfied with their daughters' accomplishments.

Another and even more delightful view of feminine education in process is *Drawing Class,* c. 1815-20 (Fig. 27). Four young ladies are industriously applying themselves to the task under the supervision of a male instructor, possibly John Rubens Smith (1775-1849), son of John Raphael Smith, the English mezzotint engraver.[11] The artist of this work is also unknown, but the period in which it was painted can be identified by the costumes of the subjects. The studio's low

ceiling, characteristic of dwellings in a cold climate, suggests the scene took place in a northern community.

Few surveys of American art fail to mention Henry Sargent's (1770-1845) paintings *The Dinner Party,* c. 1821, and *The Tea Party,* c. 1821-25 (Figs. 28 & 29). These are the only genre paintings Sargent produced. Apparently the earlier painting's critical success led Sargent to repeat the theme, but favorable opinion was all that was to be forthcoming from Bostonians of the day. Encouragement in the form of patronage never materialized. Sargent gave up adventuring in new fields of subject matter and confined his work largely to portraiture.

Both these large canvases show aspects of upper-class life in Boston during the Federalist period. *The Dinner Party* is said to represent the dining room of the artist's own house in fashionable Franklin Place during a meeting of the Wednesday Evening Club. All the furnishings are in the Hepplewhite style. In the sequel, *The Tea Party,* Hepplewhite, having become

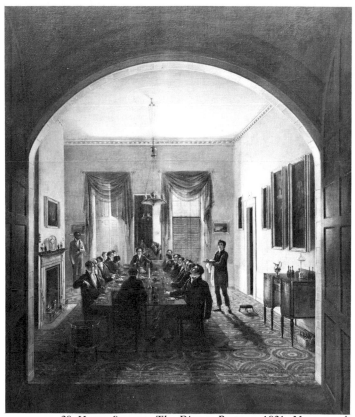

28. Henry Sargent, *The Dinner Party*, c. 1821. Museum of Fine Arts, Boston; Gift of Mrs. Horatio A. Lamb in memory of Mr. and Mrs. Winthrop Sargent.

29. Henry Sargent, *The Tea Party*, c. 1821-25. Museum of Fine Arts, Boston; Gift of Mrs. Horatio A. Lamb in memory of Mr. and Mrs. Winthrop Sargent.

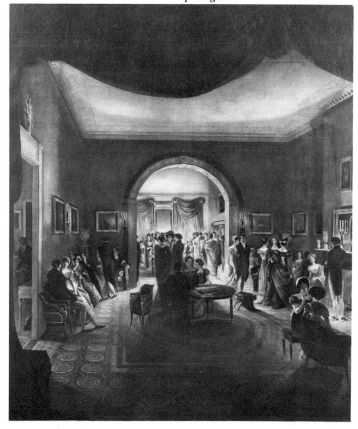

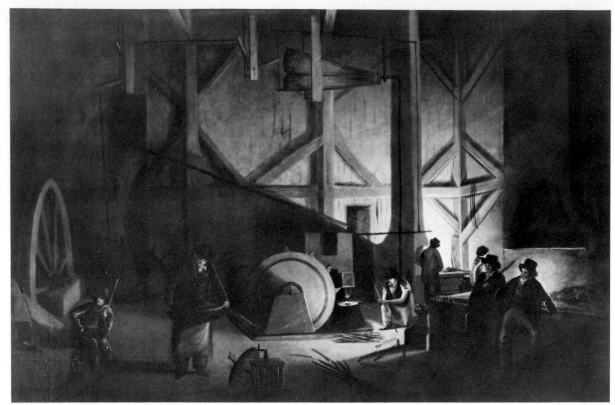

30. Bass Otis, *Interior of a Smithy,* c. 1815. Pennsylvania Academy of the Fine Arts, Philadelphia.

obsolete, has given way to the newly popular Empire style. The Englishwoman Mrs. Basil Hall, who visited Boston in 1827, recorded her impression of a similar gathering.

(Boston, October 11, 1827) We went from Mrs. Ticknor's bodily to a rout at Dr. Bigelow's, really a rout, and a very pleasant one, no formality nor dullness of any kind and everyone moved to or fro as their inclination prompted them. There were refreshments of various kinds handed round, and the Ice instead of being in one great pillar was in glasses, as is the fashion in England. At Albany I was told that this is considered very *ungenteel,* their favorite phrase, for in America everything is genteel or ungenteel. Champagne is a never failing sequel to the refreshments at a party, and at their dinners they have it likewise, only instead of being placed on the table and drank with their neighbours it is handed round between the first and second course. There is very little claret and less port. No claret is ever put down after dinner, occasionally there may be a bottle during dinner along with the Sauterne or Vin de Grave, but that is all. Madeira is their wine, and they pique themselves particularly upon it. [12]

Bass Otis (1784-1861), although born in Bridgewater, Massachusetts, passed most of his active career in Philadelphia. His chief claim to fame is as the author of the first lithographic print made in this country, but his special interest here is that he was the first American artist to paint a factory in operation. At an early age Otis was apprenticed to a scythe-maker in Bridgewater, a center for gun-makers and other fabricators in iron. This early experience may have prompted him to paint *Interior of a Smithy,* c. 1815 (Fig. 30), a large canvas that won acclaim when it was shown at the Pennsylvania Academy of the Fine Arts. So far as has been ascertained, this is Otis's only venture into the genre field, for his other located paintings are portraits and a few landscapes. As such it has special significance, not only as a rare instance of escape from the confines of portraiture, but also for its subject. Various operations connected with the manufacture of scythes are going on in different areas of the heavily framed barnlike structure. Yet the workers are individuals working in the old craft

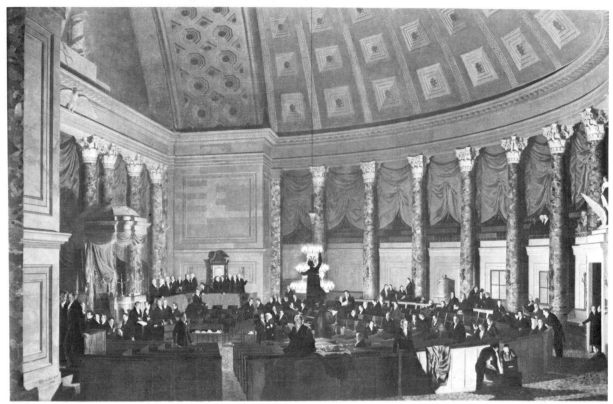

31. Samuel F. B. Morse, *The Old House of Representatives*, 1822. The Corcoran Gallery of Art, Washington, D.C.

tradition; there is no trace of the techniques of mass production which were to change the character of labor and of our society in the following quarter century. An interesting detail is that each man wears his personal headgear (despite the fact that the group is indoors); this is the era before the development of specialized work clothes.

*Interior of a Smithy* is a remarkable painting for much more than its value as historical document. It is a major work of creative art. Otis has successfully concentrated on representing the effect of the artificial light. The eerie glow of the forges and the cast shadows are consciously employed to dramatize a commonplace scene, which in the contemporary mind had none of the mysterious quality Otis perceived.

The difficulty of making a work of art conform to a definition is demonstrated by a painting such as Samuel F. B. Morse's (1791-1872) *The Old House of Representatives,* 1822 (Fig. 31). How is this work to be categorized? It shows members of Congress going about the routine business of opening a night session

of the House. Nothing spectacular is happening; no anecdote is being related for our amusement or moral improvement. Rather, it is a record of how the thronged chamber looked in the year 1821 complete with individual, if tiny, portraits of some eighty-nine representatives and one Indian. It is not an historical painting in the usual sense, like Jacques Louis David's *Tennis Court Oath* or Copley's *The Death of the Earl of Chatham in the House of Lords,* for Morse did not choose a climactic moment, although the actors and setting are authentic. To call the painting a group portrait seems ridiculous. Yet the emphasis on portrait figures and atmospheric lighting remove it from topographical rendering. Perhaps it is as well to leave it unlabeled.

In painting it Morse was concerned primarily with its money-raising potential as an exhibition piece to be viewed upon payment of admission by, he hoped, a large and enthusiastic public. Unfortunately the venture met with limited success. This was sad for Morse, since he had invested fourteen hours a day for

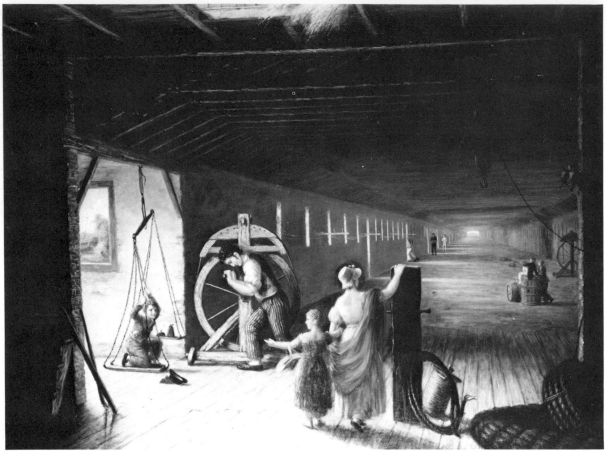

32. Charles Bird King, *The Rope Manufactory*, c. 1825.
Hirschl and Adler Galleries, New York.

almost a year on the canvas and had secured the backing of no less a personage than President Monroe, who gave Morse the use of a room adjacent to the House Chamber in which to paint his miniature portraits. So there it is—a magnificent failure but an invaluable American document.

About ten years after he painted *The Old House of Representatives,* Morse essayed this type of painting one more time in another large canvas, *Exhibition Gallery of the Louvre,* 1832-33 (Joe and Emily Lowe Art Center, Syracuse University). It also was painted as a money-making venture and failed to produce the income expected. Morse, who obviously based his painting on similar works by the eighteenth-century Italian Giovanni Paolo Pannini, thought of it as an aid to education. Here was a chance for Americans unable to visit the galleries of the Louvre to see some of its greatest masterpieces—and all for the price of a silver coin. Morse's scientific turn of mind asserts itself again: whereas previously he had recorded the members of the House of Representatives, now he ac-

curately catalogues in miniature thirty-seven of the old masters hanging in a gallery in the Louvre. The later picture moves a little into the area of genre by the inclusion of figures of copyists and visitors in the foreground, but again without anecdotal intention.

Morse's contemporary Charles Bird King (1785-1862) although born in Newport, Rhode Island, was a resident of Washington from about 1815 until his death. He is today best known for the portraits of Indians painted in his Washington studio, but on at least two occasions he ventured into genre.

His *The Rope Manufactory,* c. 1825 (Fig. 32), is another of the rare paintings showing an aspect of American industry in its earliest days. It is obvious, however, that King was not intrigued by workmen and their activity, as Bass Otis had been. He elected to show the ropewalk at a time when the workmen were not plying their trade. What fascinated King were the cavernous interior and the solution of the problems of perspective and the changing quality of the light. The figures are present only to give scale, not to elucidate

50

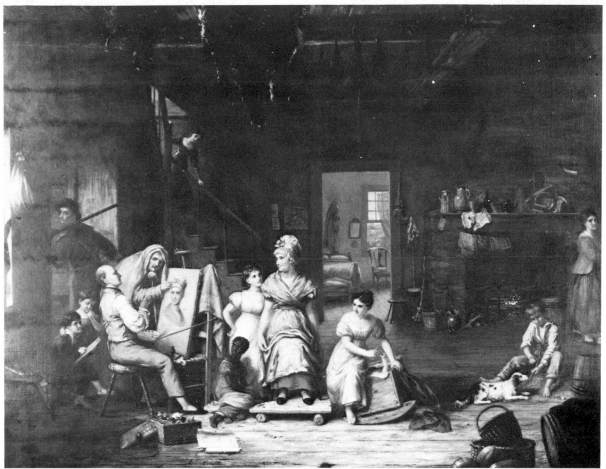

33. Charles Bird King, *The Itinerant Artist,* c. 1813-25. New York State Historical Association, Cooperstown, New York. (Color plate IV)

the process of rope-making.

King's other known genre work, *The Itinerant Artist,* c. 1813-25 (Fig. 33), is more fully realized as a painting. The itinerant portraitist of the nineteenth century is frequently encountered in contemporary literature. One cannot help but sympathize with him over the difficult conditions, portrayed in this canvas, in which he had to work. That likenesses were produced at all is a triumph of the determination of those indomitable painters.

Literary genre, since it does not usually mirror contemporary life except as it reflects popular tastes in fiction, has not been considered germane to this discussion. King's *Rip Van Winkle Returning from a Morning Lounge,* c. 1825 (Fig. 34), however, is an exception, because in this canvas we see what might well have been a typical slum dwelling of the period—a subject which by itself would have been unacceptable at the time. The ramshackle furniture, the curtainless windows, the missing stair railing, the general clutter and disorder provide a probably unexaggerated picture

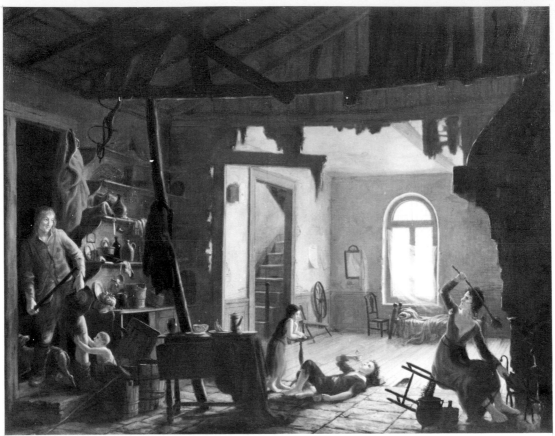

34. Charles Bird King, *Rip Van Winkle Returning from a
Morning Lounge,* c. 1825. Museum of Fine Arts, Boston;
Bequest of Maxim Karolik.

35. John Archibald Woodside, *The Country Fair,* 1824.
Collection Harry T. Peters, Jr.

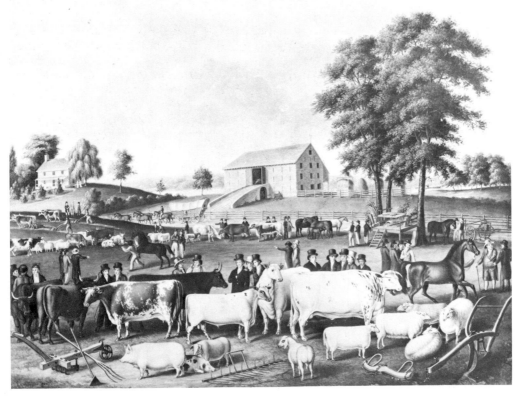

of the domestic circumstances of an indigent family of the period.

Painters of genre were not always artists as well schooled as Morse and King, both of whom had studied abroad with Benjamin West. Significant contributions to the development of genre painting were made in all periods by amateurs, by craftsmen such as sign and ornament painters, even by sculptors. One such gifted craftsman was John Archibald Woodside (1781-1852). He was by trade a painter of ornamental signs, whose works for inns, shops and fire engines were much admired in Philadelphia, where he lived. He had higher ambitions, however, and between 1817 and 1836 exhibited still-life and animal paintings in the annual exhibitions of the Pennsylvania Academy of the Fine Arts. For its naive qualities, its inherent sincerity and its simple charm as an inventory of prime livestock, his *The Country Fair,* 1824 (Fig. 35), is one of the most endearing records of our past. It is interesting to note that in 1808 Woodside painted a copy of Jeremiah Paul's *Four Children Playing in a Courtyard* (Fig. 16), discussed in the preceding chapter. The present owner of Woodside's copy is unknown.

Alvan Fisher (1792-1863) remains relatively obscure among the painters of the early nineteenth century. He was the archetypal Yankee, and his approach to the problem of making a decent living from the products of his brush was completely businesslike. By applying his native intelligence and indefatigable energy, he succeeded in making a better-than-decent living. With the acumen of a twentieth-century merchandiser, on at least six occasions he organized auction sales of his surplus work. He encouraged purchases on the installment plan, placed work on consignment in cities as far from his Massachusetts base as Natchez, Mississippi, and traveled to many areas of the country to execute commissions—or in search of popular subject matter. Further, his output was prodigious; his notebooks record that he sold nearly a thousand canvases between 1826 and 1860.[13] Notwithstanding his contemporary commercial success and the very considerable professional reputation he enjoyed in the Boston area, where he was considered the equal of Thomas Doughty, Francis Alexander and Chester Harding, he has failed to attract commensurate critical attention in our century. As our first native-born painter to specialize in genre subjects and to engage a wide audience for them, Alvan Fisher is entitled to more than the slight notice that has been given him.

Fisher made his home in Dedham, convenient to Boston, where he found many of his patrons, and which was from 1827 until his death a showcase for his work in the exhibitions held by the Boston Athenaeum. In 1810, at the age of eighteen, he determined to make a career for himself in the field of art, for which he had displayed a natural inclination since childhood. His early work was strongly influenced by his first and only teacher, John Ritto Penniman (1783-c. 1837). Penniman was one of those painter-craftsmen mentioned in the previous chapter

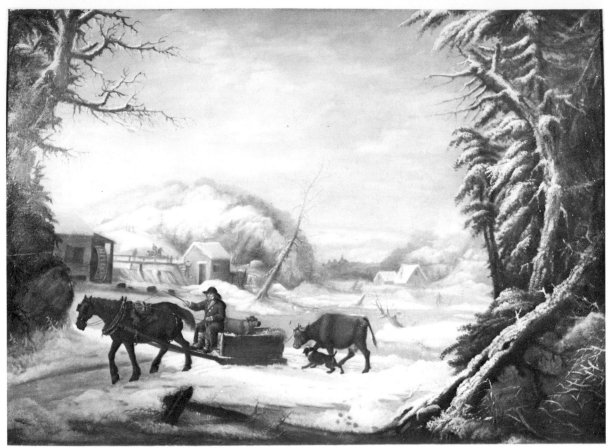

36. Alvan Fisher, *Winter in Milton, Massachusetts*, 1815. The Montclair Art Museum, Montclair, New Jersey.

who turned his hand to any job that came his way—painting ornamental decorations for special occasions, military standards, city views or easel paintings of sporting subjects [14]—all in a rather mechanical artisan style. Some of his signs, such as that over the door of the Engine House on Mason Street, Boston, which depicted the engine and firemen on their way to a fire, were practically genre paintings in their own right. [15] Fisher studied with Penniman for more than two years and, by 1814, had launched out on his own to make a living painting portraits. While still under Penniman's influence he had begun to paint the landscapes and country genre which were his lasting contribution to the development of American painting. A fire screen showing two country men in conversation, dated 1813 (collection Mr. and Mrs. James Otis), stands as perhaps his first originally conceived genre composition.

Fisher was quite conscious of his role as an innovator; he wrote to William Dunlap, the painter and pioneer American art historian:

I then [1815] began painting a species of pictures which had not been practiced much if any, in the country—with scenes belonging to country life, winter pieces, portraits of animals, etc. This species of paintings being novel in this part of the country I found it to be a more lucrative, pleasant and distinguishing branch of the art than portrait painting. [16]

Three of Fisher's earliest genre landscapes, *A Farmer in a Pung*, 1814, *The Treaty Envoys*, 1815 (both, collection Mrs. Edward Stanley Emery, Jr.), and *Winter in Milton, Massachusetts*, 1815 (Fig. 36), are winter scenes. At this early date comparatively few landscapes were being produced in America, so it is even more remarkable that Fisher should have chosen to paint the frozen countryside with its ice-covered trees rather than the verdant greenery of spring or the brilliant foliage of autumn—the more popular seasons for landscape art. These paintings by Fisher anticipated by some thirty years the wintry landscapes which won George Durrie acclaim.

As is to be expected, these early efforts are rather

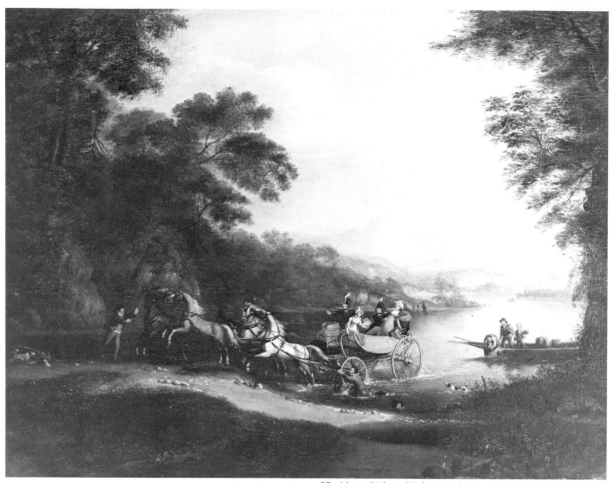

37. Alvan Fisher, *Mishap at the Ford,* c. 1818. The Corcoran
Gallery of Art, Washington, D.C. (Color plate V)

stiff and awkward, displaying more painstaking effort
than inspiration. Fisher's competence as a draughts-
man steadily improved, and before he was thirty he
was capable of turning out such accomplished paint-
ings as *The Rescue Party,* 1818 (collection Mr. and
Mrs. H. James Stone), and *Mishap at the Ford* (Fig.
37) which, although undated, appears stylistically to
belong to this period.[17] One of his best efforts, this
sprightly canvas shows the technical skill with which
Fisher was able to render almost microscopic detail
without impairing the overall effect.

In line with Fisher's practical attitude toward the
artist's calling, he would accept commissions to do
portraits of prime specimens of livestock, such as
Henry Clay's prize bull, *Orzimbo,* c. 1841 (collection
Mr. and Mrs. John Fisher Sullivan). What appears to
be his most successful painting of this type is *Eclipse,
with Race Track,* c. 1825 (Fig. 38). From the 1840's
to the 1860's, Edward Troye specialized in painting
thoroughbred horses, but Fisher was ahead of him by a
good many years in capitalizing on the potentialities of

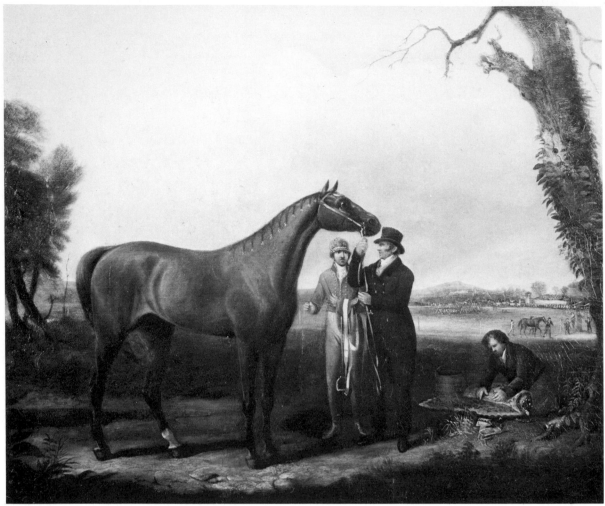

38. Alvan Fisher, *Eclipse, with Race Track*, c. 1825. Munson-Williams-Proctor Institute, Utica, New York.

this subject area.

As he developed as a painter, Fisher's style became less hard and tight. The change is especially apparent in his work after his return from a trip to England and the continent in 1825. While abroad he particularly admired the work of Edwin Landseer, whose influence can be detected in his later choice of subject and style. A vein of sentimentality—so frequently the English, German and American artist's response to the romantic movement—is also apparent in the work Fisher did after his return from Europe. In *Courting*, 1839 (collection Dr. Thomas W. Christopher), this tendency is still restrained; indeed the bucolic scene of youthful dalliance amidst the cows is treated, perhaps unconsciously, with just a touch of humor. In his late paintings Fisher displays an unfortunate tendency toward mere decorative illustration. This comes out in such canvases as *Riders on a Beach*, undated (collection James O. Welch), and *The Seaside*, 1853 (Fig. 39), in which the exaggerated elegance of the horses and riders has a quality of overrefinement and

artificiality which also characterized the heroes and heroines of the romantic novels of the day. Fisher was not a man to throw away a successful idea. If a subject sold, he would paint, with minor variations, another canvas on the same theme. The two paintings just mentioned are examples of this recurring semi-duplication of subject matter.[18]

The proportion of genre painting in Fisher's total work is impossible to estimate accurately, for unfortunately no complete record of his prolific production over a fifty-year career has been published. Further, since many paintings are presently unlocated, it is hard to generalize with assurance on the quality of his production. Though he did considerable work in landscape and portraiture, Fisher must be considered one of the earliest native-born Americans to devote substantial effort to genre. That he himself regarded it as a significant part of his work is clear from his letter to Dunlap, in which he wrote:

I believe, sir, you have not seen a class of my paintings, such for example as the Escape of Sergeant

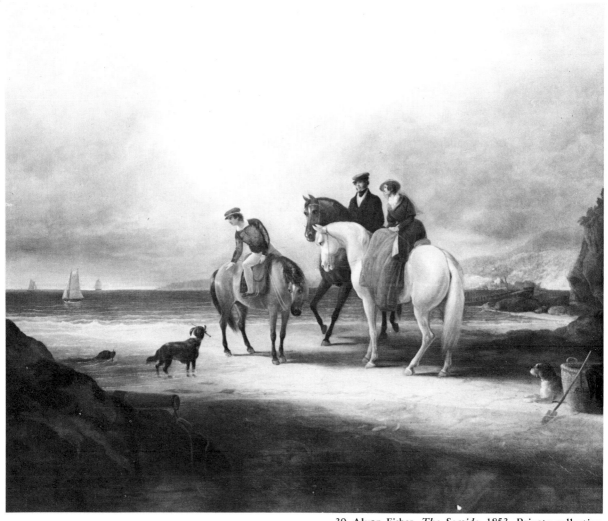

39. Alvan Fisher, *The Seaside*, 1853. Private collection.

Champ, Mr. Dustin Saving Children from the Savages, The Freshet, Lost Boy, etc. As these paintings and many of the like were painted to order for gentlemen of this city, it is this class of pictures that has been as advantageous as any other to my reputation as an artist.[19]

The corpus of genre work produced in the first twenty-five years of the nineteenth century in America is small indeed. In fact, only two of the artists mentioned in this chapter, Krimmel and Fisher, produced more than occasional examples. No claim that there was a cohesive school of genre painting in this period could be justified. The works described in the preceding pages have no common ground in subject matter, style or backgrounds of the artists. Perhaps the only concern their authors shared was a not unnatural desire that their investment of time and effort bring appropriate financial return. Ventures by certain artists into the business of charging admission to view their paintings—works specifically conceived to appeal to public curiosity—demonstrate that financial motivation was an important factor in the introduction of genre painting into American art. It is a significant comment on the American cultural climate at this point in history that without exception these ventures were commercial failures. Only the canny Alvan Fisher was successful in turning a profit from the new themes in his paintings.

The artistic record of the first quarter of the nineteenth century in America is largely a record of the painters' battle with the forces of politically inspired ideology and the inertia of public habit. Some few won; most, like Samuel F. B. Morse, lost. By 1825, however, the dominance of portraiture had been challenged. All the areas of subject matter—landscape, still life, history, marine and genre—which Americans were to pursue so successfully in later years had been introduced in significant examples.☐

# CHAPTER 3

# The Age of the Eagle

From 1800—indeed, starting somewhat earlier—until the close of the Civil War, the device of the eagle, symbol of the Republic, was seen everywhere. It appeared in inlays on Federal furniture, on brass drawer pulls, on stoneware and porcelain, on whiskey flasks, on buttons and in carvings for ship stern boards, billetheads and figureheads. The eagle was engraved on the silver medals presented to star pupils in grammar schools and on printed trade cards. The swords of both Army and Navy officers had eagle-head pommels. Hardly a public building was not graced by a carved and gilded eagle over the principal entrance. Inside churches the traditional evangelical-eagle support for the Gospels was transformed into the symbol of the state. This omnipresent display of the symbol of our hard-won independence was an outward manifestation of the state of mind which guided all aspects of the development of the United States, political, economic, social, moral and artistic—national pride and confidence. Nationalism, which was from the start of the nineteenth century the dominant characteristic of our culture, reached its apogee in the 1820's.

At the beginning of the century's second quarter Jeffersonian Democracy was giving way to Jacksonian Democracy. The common man was coming into his own. Independent in opinion, self-satisfied if not smug with his government's success, the native American rather self-consciously proclaimed that he was at least as good as any subject of a foreign monarch. He was also firmly convinced that in the United States one had only to stir one's stumps a little to make a smashing success. There was nothing demeaning about working in the fields, doing country dances in a barn or meeting a perhaps motley collection of fellow citizens in a wayside tavern.

The territorial boundaries of the country had expanded enormously. A combination of political stability, economic pressures and characteristically American restlessness spurred the first concentrated westward migration. The untamed American wilderness had been a fearsome apparition to the uneasy

settlers of the seventeenth and early eighteenth century who were accustomed to the more domesticated and thickly settled Europe. By the early nineteenth century, due to the increase in population which spread islands of civilization fairly evenly over the land, and because of the knowledge which came with exploration and generations of experience of adaptation to the rigors of pioneer life, Americans' response to their land had changed to awe, affection and pride.

As the nation and its people moved out over half a continent, the life styles of the population diverged increasingly. This is the period when the distinctions between easterner and westerner, merchant and farmer became significant. Americans no longer shared experience or appearance; consequently for the first time they had reason to be curious about each other. What easterner and westerner, city man and country man did share was pride in himself and his land; the artist and the patron of the arts were fully part of this consensus.

In comparison to their Colonial predecessors, the generation of painters born soon after the Revolution was out of touch with the art theory of European academies and its ranking of subject matter on a rigid value scale. This freedom from European intimidation, combined with individuality and pride in American achievement, turned artists to depicting their own country in their own terms. The same influences produced the ultimate incentive for the establishment of a new cultural direction: patronage. Cultured and moneyed Americans not only accepted American themes in the arts, they actively encouraged them. At last the climate was right for the growth of a native school of genre and landscape painting.

There is no question that the period from approximately 1825 to the opening of the Civil War was the golden age of genre art in this country. This period embraces the best work of the acknowledged masters in the field: Mount, Woodville, Bingham and Ranney. They drew their inspiration from the scenes with which they were familiar—in Long Island, Baltimore, Missouri and, in the case of Ranney, New Jersey and Texas. Each in his way captures the essential character of the area he painted—so that we may be transported back through time and space, and for a time be a Long Island farmer, an urban Baltimorean, a sportsman on the Hoboken marshes or a lonely trapper on the great Missouri River. This chapter is largely devoted to discussion of these justly celebrated masters of the earliest true American genre painting.

Surrounding these men is a circle of other painters who added depth and variety to the picture of our country, and who, by their sheer numbers, attest the fact that genre painting had become a dominant concern in American art. Some might have been figures as important as Mount or Bingham had they specialized in genre subjects; others lacked the essential spark of genius which makes a Mount, a Bingham, a Woodville a hero to both art lovers and

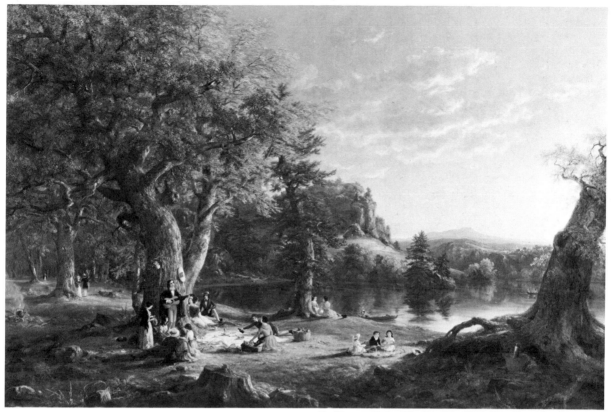

40. Thomas Cole, *The Pic-Nic,* 1846. The Brooklyn Museum, Brooklyn, New York.

historians. So little is known about some of these others, so little of their work has survived in fact or record, that we are uncertain as to their capacity and contribution. The following chapter surveys a selection of these artists—but by no means all of them.

It may seem perverse to open this discussion of the artists of the first native school of genre painting with Thomas Cole and Asher Brown Durand, leaders of the Hudson River School—the headwater of American landscape art. Yet these men, perhaps the most generally admired painters of their day, helped to strengthen the place of genre painting in American art.

The painters of the Hudson River School, which developed chronologically parallel to the rise of the native school of genre painters, were rarely concerned with events of everyday life. To be sure, figures frequently appear in their scenes, but they are always subordinated to nature. Notwithstanding the small scale of the figures, they were necessary elements in the concept of the paintings. These landscapes, even as

genre paintings, promoted a philosophy as they told a story—a story of man's encroachment on the wilderness, of the sublimity of nature, or of the contrast between the power of elemental forces and man's weakness.

Thomas Cole (1801-1848) was raised on the Ohio frontier. For all practical purposes he was a self-taught painter. It was his unspoiled eye that first captured the spirit of the untrodden native hills and launched our most famous school of landscape painting. All his paintings are pure landscapes—with one known exception, the recently rediscovered *The Pic-Nic,* 1846 (Fig. 40), which justifies his inclusion in this study of genre painting. Here, more than in any other of his paintings, the figures play a sufficiently important role that they must be conceded a share in the spotlight with the landscape. This delightful canvas in praise of nature in her sunny hours epitomizes the transcendentalist philosophy. Man and nature are in harmony. The subject through which this is expressed is a contemporary and reasonably commonplace event,

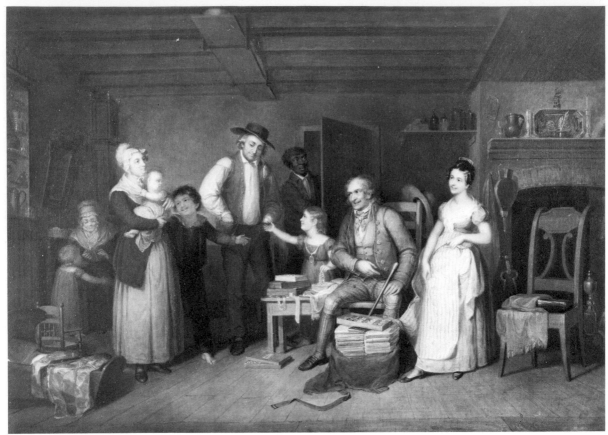

41. Asher Brown Durand, *The Peddler Displaying His Wares*, 1836. The New-York Historical Society, New York.

rather than the romantic, fictionalized scenes which Cole often favored.

Asher Brown Durand (1796-1886), one of the most gifted and innovative landscapists of the Hudson River School,[1] was also a genre painter of considerable interest, although not of great productivity.[2] In a number of important canvases which must be considered primarily as landscapes, he introduced figures which have more purpose than simply to give scale and movement to the composition. The most notable of these is, of course, *Kindred Spirits,* 1849 (New York Public Library), which shows Thomas Cole and William Cullen Bryant standing on a cliff in the Catskill forest. Another is *Haying,* 1838 (collection Hirschl and Adler Galleries), where the figures are again more than minor adornments of what is essentially a landscape.

One of his rare genre canvases is *The Peddler Displaying His Wares,* 1836 (Fig. 41). The composition and setting are the conventional ones found with minor variations in the work of Krimmel, Mount,

Woodville and others. The large fireplace with cluttered mantel, the sparsely furnished, utilitarian room—obviously used for a variety of purposes—represent the living standard of a typical farmer of the period dwelling close to the long-settled Atlantic seaboard.

*Dance of the Haymakers,* 1851 (Fig. 42), is without question Durand's most successful genre work. It is a poetic summation of American rural life before the Civil War, when the farm was still the predominant way of life for the great majority of Americans. It is a paean to simple bucolic pleasures. The hearty and carefree farmhands and lasses are dancing merrily; the elegant figures of the proprietor and his lady, mounted on horseback, observe but do not participate in the festivities. The scene could as easily represent an English Lord of the Manor and his yeoman tenants. It is presented essentially from the point of view of the eighteenth-century aristocracy, already an anachronism in northeastern America.

In 1845 Durand exhibited the landscape *An Old*

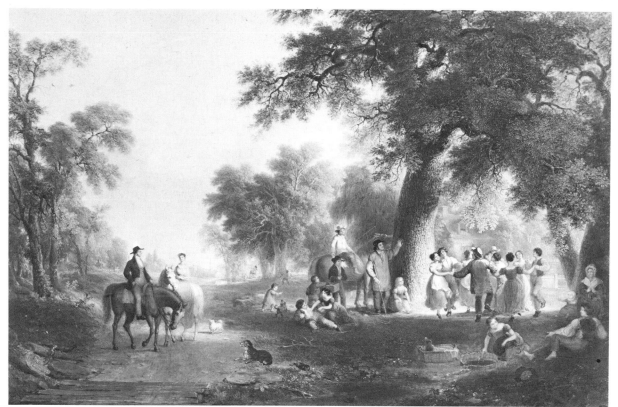

42. Asher Brown Durand, *Dance of the Haymakers*, 1851.
Collection Mr. Webster and Mr. Douglas Collins. (Color plate
VI)

*Man's Reminiscences* (Albany Institute of History
and Art), an attractive and little-known example of his
skill, which, despite the title, is not a genre painting.
The following year, *Landscape Composition, The Old
Man's Story,* 1846 (New York art market) which,
again despite its title, is a genre subject, was shown at
the National Academy of Design.[3] It reflects a love for
country life, typical both of the period and of Durand
the painter. Life is seen as a happy, carefree existence,
secure as the prosperity with which the bountiful
country rewards its stalwart citizens. The anecdote is
of slight significance, being merely an encounter
between a stately old white-haired gentleman, who
bears a startling resemblance to George Washington,
and five homeward-bound children, to whom he
recounts an enthralling tale.

Other painters and paintings associated with the
Hudson River School might be mentioned in the
context of a study of genre painting. Worthington
Whittredge (1820-1910), for example, one of the later
generation of Hudson River artists, painted a number

of interiors with figures, such as *The Old Nurse,*
1866 (collection Frederick W. Whitridge), or there is
Jasper F. Cropsey's unique view of a Cunard state-
room of 1856 (collection Mrs. John C. Newington).
These paintings, however, are not many in number,
nor are they especially interesting, being in most cases
similar to the generally superior produc-
tions of artists who specialized in genre themes.

Acceptance of genre had become so general by both
artists and the public after the 1820's that a number of
artists whose special concerns lay elsewhere oc-
casionally essayed genre subjects. Besides the Hudson
River School landscapists just mentioned, other
painters associated with the New York area may be
cited.

Henry Inman's (1801-1846) reputation rests
primarily on the portraits which made up the bulk of
his work (and produced what was, for his day, a
handsome annual income of ten thousand dollars[4]).
Perhaps as a change from the endless succession of
sitters, he occasionally turned to other types of paint-

ing. His three excursions into the field of genre are: *The Newsboy,* 1841 (Addison Gallery of American Art, Phillips Academy, Andover, Mass.), *Dismissal of School on an October Afternoon,* 1845 (Museum of Fine Arts, Boston), and *Mumble the Peg,* 1842 (Fig. 43).

As do his portraits, Inman's genre pictures suffer from a diluting prettiness and sentimentality. In catering to the genteel tastes of the upper middle class he inevitably lost sight of the verities, and we are left with a sense of loss that the substance of his paintings does not match his skill.

*The Newsboy,* his first exhibited genre painting, is a prototype of the sentimentalized street urchins who earned J. G. Brown a handsome living in the late 1880's and 90's. A single figure—of an appealing youngster with an armful of papers beside a statue of a bronze sphinx—it is as insipid as the description suggests.

*Mumble the Peg* shows a confrontation of a country bumpkin and a city dandy, the sort of contrived anecdotal subject that appealed to the gentle readers of *The Token* and other gift books which sold by the thousands to the prosperous middle class and were the coffee-table books of their day.

*Dismissal of School on an October Afternoon,* the last painting Inman did before his death, shows the typical American district school—but hardly typical American schoolchildren. Inman permitted himself no naturalistic observation of children. The homeward-bound pupils are posed in a compact group and behave in an altogether-too-angelic manner. If, however, one disregards this obvious flaw, the painting possesses charm and gaiety. Inconspicuously, the sign over the schoolhouse door reads ''I CRANE''—none other than the famous Ichabod. This is a light-hearted and endearing touch.

George Harvey (c. 1800-1878) is best known for his interest in and gift for capturing the effects of light in the ever-varying atmospheric conditions of the American climate. While his major identification must be with the luminist school of American landscape painting, the fact that he frequently included figures in the foreground of his small paintings gives reason for his inclusion here. *The Entrance to a Coal Mine Near Wheeling, Virginia,* c. 1828, (collection Frank H. Woods, Jr.) is a rare glimpse of coal mining before it became a mechanized industry. The beautifully painted *The Apostle's Oak,* 1844 (Fig. 44), shows some seventeen young boys playing games during recess at a country school. This painting is typical of Harvey's delicate touch, a legacy from his earlier career as a miniature painter.

William Page (1811-1885) was a unique personality among his artist contemporaries. Exploring the technical possibilities of his medium—an unusual concern at that time—he developed a highly personal style which contrasted heavy impasto and thin washes. In his use of color he achieved by means of underpainting and glazes a fluid intermingling of pigments very unlike the routine areas of local color employed by his contemporaries. In addition he was eloquent in ex-

43. Henry Inman, *Mumble the Peg,* 1842. Pennsylvania Academy of the Fine Arts, Philadelphia. (Color plate VII)

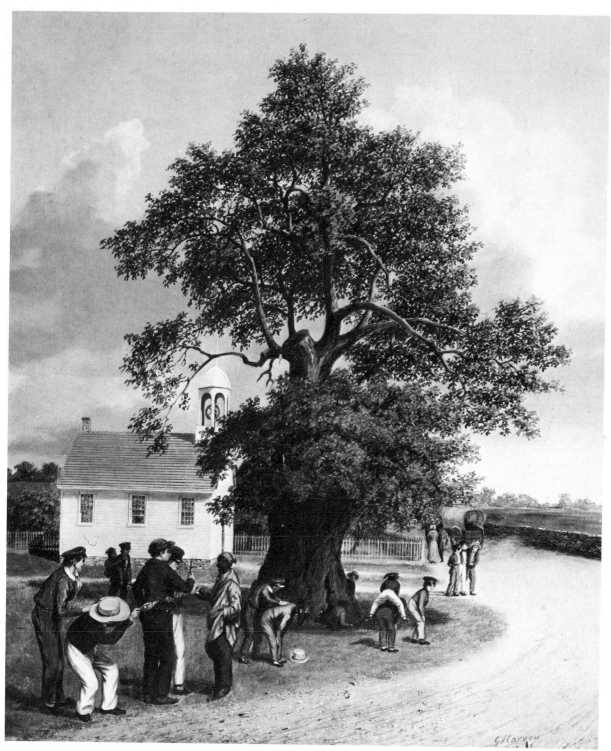

44. George Harvey, *The Apostle's Oak,* 1844. The New-York
Historical Society, New York.

45. William Page, *The Young Merchants*, c. 1834. Pennsylvania Academy of the Fine Arts, Philadelphia.

46. Otis A. Bullard, *Loading Hay,* 1846. Newhouse Galleries, New York.

pressing his theories on painting. He used his talents primarily as a portraitist and as a painter of unorthodox subjects in the grand manner, but completed at least one canvas which may be termed genre. *The Young Merchants,* c. 1834 (Fig. 45), shows a newsboy with a young girl who has sold out her basket of strawberries. Obviously Page was unconcerned with characterization of the specific subject; he has used the two potentially picturesque street vendors simply as vehicles for painterly effects, design and expression of mood. As such the painting is unique in its period, a remarkable forecast of the distant future.

Otis A. Bullard's (1816-1853) first artistic training was as apprentice to a sign and wagon painter in Howard, New York. In 1842 he settled in the city of New York where, with the assistance of other painters, he spent four years in producing a large panorama of the city which he then took on tour. He was a prolific portrait painter and was said to have completed over nine hundred likenesses. He also tried his hand at genre subjects, some of which, perhaps

because of a similarity in subject matter but certainly not in style or technique, have wishfully been attributed to William Sidney Mount. *Loading Hay,* 1846 (Fig. 46), shows the semi-primitive style Bullard practiced. Each blade of hay is carefully and separately painted so that the hayrack looks surprisingly like an angry porcupine. The more Mount-like subject of Bullard's *No Luck,* 1850 (collection Norton Asner), with its two weary young sportsmen clearly disappointed at taking no game, has an unpretentious charm.

The full flowering of genre in this country dates from the rise of the young painter William Sidney Mount (1807-1868), essentially the first American painter to devote his major efforts to this branch of painting. By temperament, he was ideally suited to genre. Like most American painters of his period, he painted portraits as a steady source of income, but this was not his forte. Nor was he capable of painting historical subjects in the grand manner. His single effort in this direction, a study for a proposed large

47. William Sidney Mount, *Rustic Dance after a Sleigh Ride,* 1830. Museum of Fine Arts, Boston; M. and M. Karolik Collection.

canvas of *Washington Crossing the Allegheny,* 1863 (collection Miss Kate Strong), shows his inability to cope with such subjects.

Mount happened to come along at just the right time. His brand of genre, having at its center the common man, was eminently in tune with the widespread interest in American subjects of Americans from all walks of life. Mount felt an urge to search out for his brush subjects which we now recognize as elucidating the tenets of Jacksonian Democracy. His adherence to these principles shows in his often-quoted remark "Paint for the many, not the few." He followed his own advice. None of his paintings are devoted to the cosmopolitan society of the city with which, through friendship with wealthy patrons like Jonathan Sturges, he was well acquainted. On the contrary, Mount gave all his attention to the rural life of the Long Island countryside, depicting his friends

and neighbors making cider, dancing in tavern and barn, sharpening an axe, trading horses, talking politics, courting, haying or otherwise engaged in the activities which made up their daily experience.

Mount often worked out of doors and was much concerned with the problems of light and atmosphere. He even designed and built a portable studio which provided shelter from the elements and freedom to observe and paint. He gave careful attention to his pigments and sometimes used natural earth colors which he picked up on his walks. He was a student of perspective and mathematics, as well as of the practices of earlier painters, and constantly compared his work with theirs in order to improve. None of this is surprising: Mount was a serious artist, not merely an illustrator turning out scenes of everyday life in response to popular demand.

He was in no hurry to put brush to canvas, for he

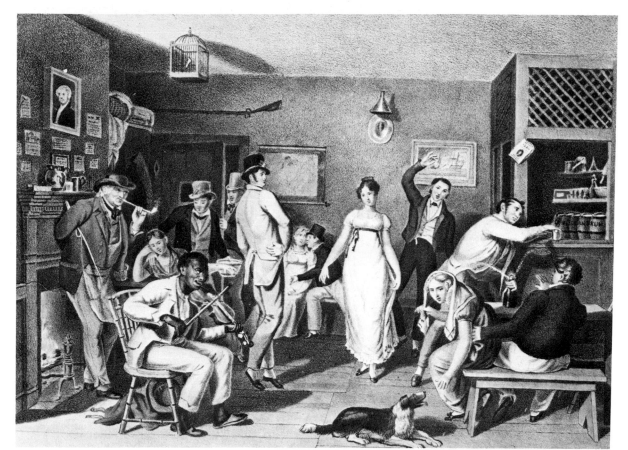

48. Lehman and Childs, after John Lewis Krimmel's *Dance in a Country Tavern,* c. 1820. Kenneth M. Newman, The Old Print Shop Inc., New York.

was not in the business of manufacturing pictures. Sometimes he would mull over an idea for a painting for months or even years. Before he started to paint he had figured out in his mind the most appropriate time of day, the proper setting and details of accessories, but more importantly, Mount would have planned how best to convey by pose, gesture and expression the exact shade of meaning he intended others to perceive in his figures. All this was, of course, in addition to having arrived at a solution to the unity of the overall composition, the spotting of lights and darks and the organization of the passages of color. Mount approached each painting as a challenge, and put into each the concentrated attention of a true craftsman and artist.

Mount's success was almost instantaneous. His earliest surviving genre painting, *Rustic Dance after a Sleigh Ride,* 1830 (Fig. 47), despite its lack of sophistication and its obvious technical crudities, is imbued with a joie de vivre that is immediately appealing,[5] as much so to Mount's contemporaries as it is today, for when it was shown at a major New York exhibition it made his reputation. Through the similarity in composition, detail and subject matter, one may presume that Mount had seen John Lewis Krimmel's *Dance in a Country Tavern,* either in the original or in the lithograph[6] which was published about 1820.

This lithograph (Fig. 48) displays many parallels to the compositional elements in Mount's painting: the stage-set interior, the appropriate still-life elements, the arrangement of the figures to lead the eye to the central dancer, and, perhaps most significant of all, the Negro fiddler. In subject, spirit and composition Krimmel's painting is clearly the artistic ancestor to Mount's *Rustic Dance.*

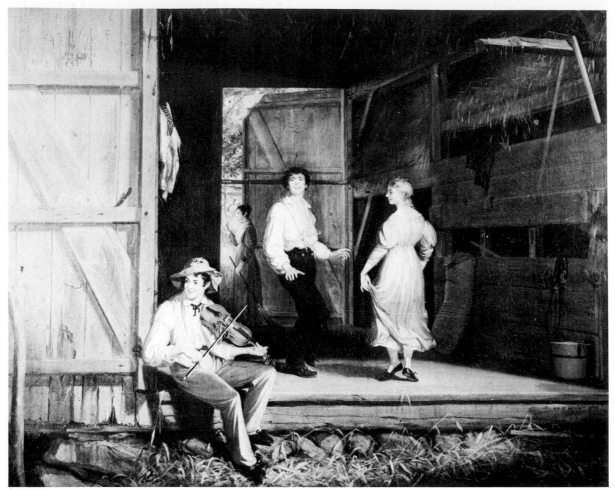

49. William Sidney Mount, *Dancing on the Barn Floor*, 1831.
Suffolk Museum and Carriage House at Stony Brook, Long
Island, New York; Melville Collection. (Color plate VIII)

Having hit upon a successful formula, Mount
pursued it quickly with other canvases which are
variations on the same general theme. He made steady
progress in perfecting his art. *Dancing on the Barn
Floor*, 1831 (Fig. 49), shows the greater assurance,
better draughtsmanship and finer color attained in the
short span of one year. While it retains the contagious
vigor and liveliness of *Rustic Dance after a Sleigh
Ride*, it is a much more polished performance on all
levels. By 1835, when Mount painted *Truant
Gamblers* (Fig. 50), he had reached his full, mature
powers.

Mount, who could have been a landscape painter of
the first rank, in addition to his outdoor scenes painted
interiors when the weather was too cold to permit him
to paint ''on the spot.''

*The Long Story*, 1837 (The Corcoran Gallery of
Art), is one of a series of fine interior scenes which
includes *The Sportsman's Last Visit*, 1835 (Suffolk
Museum and Carriage House, Stony Brook, N.Y.),
*Winding Up*, 1836 (collection Mr. and Mrs. Malcolm

E. Smith), *Raffling for the Goose*, 1837 (The
Metropolitan Museum of Art), *The Painter's
Triumph*, 1838 (Pennsylvania Academy of the Fine
Arts), and *The Card Players*, c. 1855 (Fig. 51). These
paintings demonstrate his skill in handling interior
lighting effects—a skill which owes quite a bit to the
Dutch Little Masters of the seventeenth century.

There is never any ambiguity about Mount's
anecdotal paintings; the story can always be read at
once from the painting and requires no supplementary
explanation. Mount did not usually draw on literary
sources for subjects. His only such essays are three
early paintings: *Christ Raising the Daughter of Jairus*,
1828 (Suffolk Museum and Carriage House), *Saul and
the Witch of Endor*, 1828 (National Collection of Fine
Arts), *Celadon and Amelia*, 1829 (Suffolk Museum
and Carriage House), after James Thomson's *The
Seasons*, and the later *Who'll Turn the Grindstone?*,
1851 (Suffolk Museum and Carriage House), taken
from Charles Miner's *Essays from the Desk of Poor
Robert the Scribe*, published in 1815. He jotted down

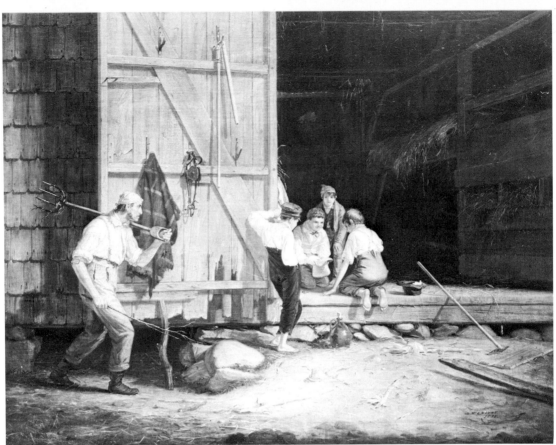

50. William Sidney Mount, *Truant Gamblers*, 1835. The New-York Historical Society, New York.

51. William Sidney Mount, *The Card Players*, c. 1855. Reynolda House, Inc., Winston-Salem, North Carolina.

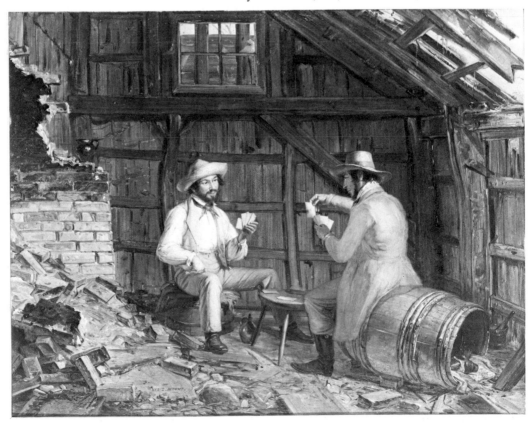

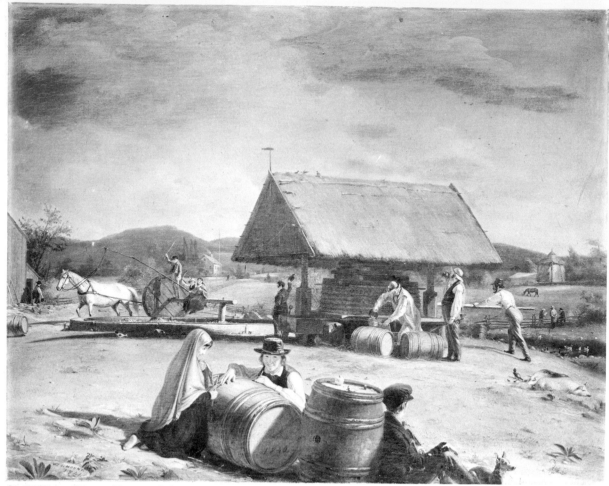

52. William Sidney Mount, *Cider Making*, 1841. The Metropolitan Museum of Art, New York; Purchase, 1966, Charles Allen Munn Bequest.

a note to paint a picture after G. P. Morris's poem "Woodman, Spare That Tree," but never got around to it. He rightly preferred to rely on his own rich and varied fund of ideas.

There is little in Mount's work which reflects contemporary events and nothing which reveals in him a reformer's fervor. His subject matter avoided anything which could be interpreted as editorializing about ephemeral events. He was by nature an observer of his fellow man and a philosopher, not a propagandist. Mount's painting *California News*, 1850 (Suffolk Museum and Carriage House), relates to the Gold Rush of 1849, but he never touched on the question of slavery, which was the burning national issue throughout his mature years. Neither is the Civil War, even in its purely local impact, a subject for his brush. The closest he ever came to a topical social phenomenon was an oblique reference to the temperance movement. And even that is open to question, for *Loss and Gain*, 1847 (collection Hon. and Mrs. J. William Middendorf II), does not clearly take a

position on the liquor problem. An old man, while climbing over a fence, has dropped his jug and can't reach it quickly enough to stop its contents from running out; he is distressed but not desperate, tattered but not degenerate. The title is more moralistic than the painting.

In 1841 Mount completed one of his major canvases, *Cider Making* (Fig. 52). The painting could serve as an illustration to a handbook on the making of cider in the 1840's, but its charm is in its pervasive spirit of innocent delight. It is a sunny picture. The young boy and girl in the foreground sipping the freshly pressed cider from the keg through straws are having the time of their lives. Yet there is no cloying sentimentality in them or in the other figures to disturb the unity of mood. *Cider Making* is a painting not easily exhausted. One can explore it almost as one would an actual landscape, finding delightful little vistas and groups of figures scattered here and there.

But however delightful one may find *Cider Making, Eel Spearing at Setauket*, 1845 (Fig. 53), is Mount at

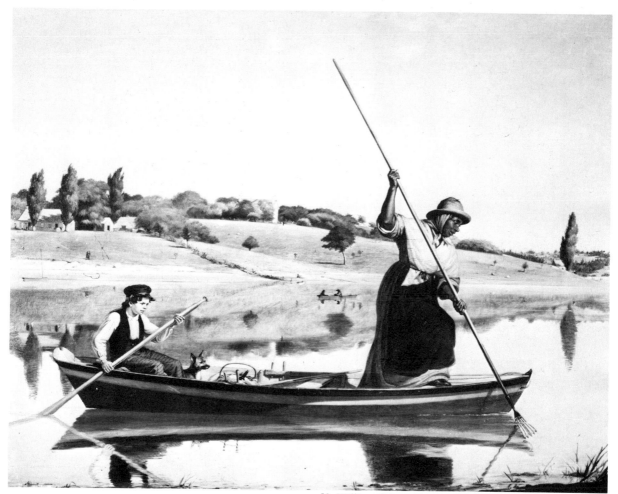

53. William Sidney Mount, *Eel Spearing at Setauket,* 1845. New York State Historical Association, Cooperstown, New York.

his best. It is a monumental canvas in its way—serene and simple, and in impact not unlike George Caleb Bingham's *Fur Traders Descending the Missouri,* coincidentally painted the same year. Mount's veil of atmosphere and parched landscape are closely observed. The psychological tension within the canvas is managed with quiet power, totally avoiding theatricality. And, while it would have been easy to create a saccharine anecdote around the little boy, his dog, the black woman and the adventure of catching eels, Mount succeeded in fusing these elements into an integrated experience which transcends the trivial. In canvases such as these Mount anticipates Winslow Homer, who had the same gift for transforming the prosaic into something greater.

While Mount occasionally came close to banality, as in *The Sportsman's Last Visit,* and late in his career lapsed into sentimentality, few indeed are the paintings by him which today we would consider potboilers.

The outstanding figure in the group of genre painters who worked in the New York area and formed a satellite galaxy around Mount was Francis William Edmonds (1806-1863). Edmonds was a banker with a passion for painting, which was kindled early and continued until he eventually concentrated on art entirely. He enjoyed a considerable reputation in his day, but his work suffers from a lack of subtlety in his treatment of the story-telling anecdotes. His paintings are sometimes more significant for the light they shed on bygone customs than for their aesthetic qualities.

The study of individual character in faces was not one of Edmonds's strong points. He had a tendency to produce stereotypes, despite the fact that he often used members of his family as models.[7] This is especially true of his heads of young women, which he frequently endowed with expressionless masklike faces, perhaps derived from a Carlo Dolce madonna prototype. Such vapid prettiness, the popular ideal of feminine beauty in the 1840's, as the pin-up girl was in the 1940's, weakens some of his canvases. This flaw, along with the occasional absence of a con-

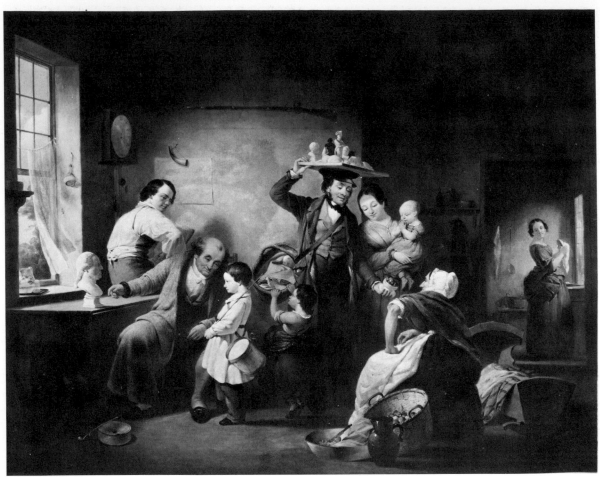

54. Francis William Edmonds, *The Image Peddler*, 1844. The New-York Historical Society, New York.

vincing psychological bond between the figures, tends to undermine his strengths—good draughtsmanship and painstaking attention to the detail of the still-life objects worked into most of his interiors.

The more ambitious of Edmonds's canvases involve ten or more figures, usually in an urban middle-class interior. The success of his efforts to compose so many figures varies considerably. The eleven figures in *The Organ Grinder,* c. 1850 (collection Mr. and Mrs. H. John Heinz III), are arranged so loosely that all unity is lost. *The Image Peddler,* 1844 (Fig. 54), on the other hand, is a well-composed work. Like *The Organ Grinder,* it records a vanished and picturesque side of American life: the itinerant peddler, frequently a recent immigrant, who trudged from town to town and door to door hawking his little store of merchandise or supplying entertainment in the form of a trained monkey. The peddler was a popular figure and a popular subject for genre artists. We have already seen him from the hand of Asher B. Durand, and we shall see him again.

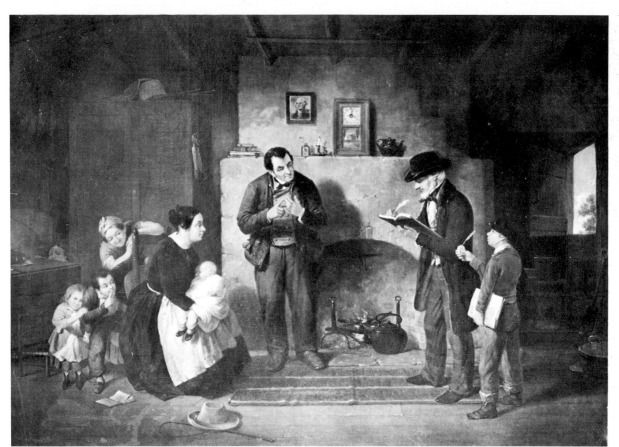

55. Francis William Edmonds, *Taking the Census*, 1854. Private collection.

Since sculpture in stone or bronze was far beyond the means of the average citizen, its place was taken by cheap plaster statuettes cast from molds in quantity and distributed by these itinerant peddlers. Perishable as they were, they satisfied the craving for sculptural adornments for the home. The range of subjects offered was wide, as one can see from the display of this peddler's wares.

While the composition of *Taking the Census*, 1854 (Fig. 55), is less subtle, it is nevertheless effective. All the figures are lined up parallel to the picture plane; the sides of the canvas are left in deep shadow, whereas the two central figures, the head of the house with his red vest, and the aged census taker in his green coat, are strongly illuminated. While the light cannot be accepted as logical, other aspects of the painting show sensitive observation—for example, the small boy who stands holding at the ready an inkwell and spare quill pen for the census taker, and the details of still life in the fireplace and the mantel.

Driving cattle to market over the dusty, unpaved

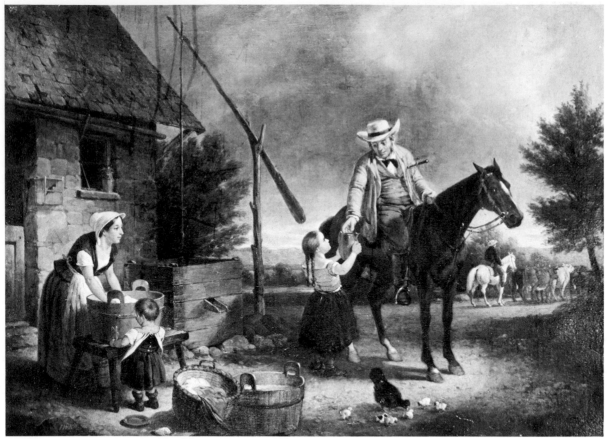

56. Francis William Edmonds, *The Thirsty Drover*, 1856. William Rockhill Nelson Gallery of Art, Kansas City, Missouri.

country roads was common practice in the early nineteenth century. *The Thirsty Drover,* 1856 (Fig. 56), is one of Edmonds's rare out-of-door scenes. He seems to have specialized in urban interiors rather than in figures in a landscape setting. The scene reveals the neighborliness of country people at that time. The drover, parched from hours in the sun, stops at a farm along his route to get a drink of well water.

When he was not faced with the complex problems of a composition involving many figures, Edmonds seems to have been in better control of the results. Aesthetically, some of his canvases having only one or two figures come off far better than his more ambitious efforts. One of these is *All Talk and No Work,* c. 1856 (Fig. 57). In this painting Edmonds resembles Mount in his choice of subject matter (reminiscent of Mount's *Bargaining for a Horse,* 1835, The New-York Historical Society), and also approaches him in the excellence of his characterizations and the acuteness of his observation of psychological relation-

ships. The one false note in this canvas is the picture-within-the-picture, the Gainsborough-like landscape that appears through the barn window.

Edmonds's *Reading the Scriptures,* 1854 (private collection) is another attractive, well-integrated canvas with a rich paint quality. Again it owes a debt to Mount and, through him, to the Dutch Little Masters. There is no anecdotal intent in the single figure of an old woman reading the Bible in an empty room. The painting's charm is based on its simplicity, the strong drawing of the old woman, and the effectively controlled light. Edmonds here uses an old Dutch device he was also fond of—a view through a doorway into another interior space, adding an element of tension or uncertainty by the implication that now-invisible people will soon come in sight through the doorway.

The quality of Edmonds's work varies considerably. At his best he comes close to Mount. One wonders why he was not more consistent. A possible explanation is that he may have been in too great a hurry

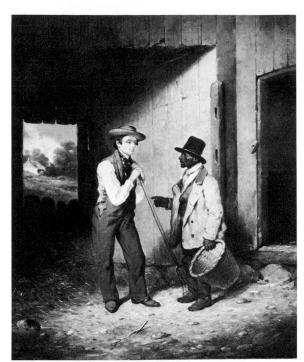

57. Francis William Edmonds, *All Talk and No Work,* c. 1856.
The Brooklyn Museum, Brooklyn, New York.

subject matter. *The Interior of the Second St. Philip's Church, Charleston, South Carolina,* c. 1836, which still belongs to the church, is a rare early depiction of a religious service, and as such is a noteworthy document. Unfortunately both of these paintings are in poor condition.

Another rare glimpse of life in the southern states is the strange, somewhat primitive *Tavern Scene* (collection Mr. and Mrs. William E. Groves). The painting is not dated, but would appear to have been executed about 1840, presumably in or near New Orleans. It is of special interest as one of the few surviving records of lower-class life in ante bellum Louisiana. The scene is not an elegant taproom patronized by wealthy planters, but a saloon of the type which catered to the rough-and-tumble crowd of steamboat men, gamblers and dockhands along the riverfront. The artist tentatively credited with its authorship is C.(?) M. Forteza, about whom nothing seems to be known. A similar subject is represented in a painting attributed to John Wesley Jarvis (1780-1840), *The Pirates Lafitte,* c. 1820 (Louisiana State Museum, New Orleans). The identification of the Lafittes is clearly apocryphal, and this writer is inclined to question the attribution as well. As Harold E. Dickson points out, by the time of Jarvis's visits to New Orleans, Lafitte's base of operation was Texas.[8] The painting, which has slight documentary significance, is in poor condition and is rather crudely painted, so that even if it is by Jarvis it adds nothing to that skilled painter's reputation.

Christian Mayr (c. 1805-1851), a native of Germany, enters the history of American art in 1834, when he first exhibited portraits at the National Academy in New York. He traveled about the country a good deal in the next few years, spending considerable time in the South. In 1838 he was in White Sulphur Springs, West Virginia; in 1839 he was in Boston; in 1840 he was in Charleston, South Carolina; in 1844 he was in New Orleans; in 1845 he returned to New York, where he remained until his death. Although portraits were his livelihood and genre his forte, few of his works can be located today. One example of his skill in composing a non-static group portrait survives in *Officers of the Volunteer Fire Department, Charleston,* 1841 (City Hall, Charleston), which depicts the captains of the various fire companies in full regalia.

Like most Europeans coming to the United States, Mayr must have been fascinated with the black man—a rarity in Europe, especially in the northern countries.[9] Such a fascination might explain his extraordinary choice of subject in *Kitchen Ball at White Sulphur Springs,* 1838 (Fig. 58). An elegant society event would have been acceptable subject matter—indeed, it had been for Henry Sargent—but to commemorate the festivities of servants must have taken remarkable independence of attitude and commercial courage. The painting is, of course, invaluable as a record of ''below-stairs'' life and interior architecture. Perhaps the greatest credit is due Mayr for his honesty and sensitivity in representing

to turn out work. Then too he seems not to have felt deeply the human significance of the subjects he painted, perhaps because he was not himself a participant in the life he portrayed but only an observer of it. Mount was a product of the life he painted, and intended his work to convey convincing psychological relationships. Edmonds, by contrast, gives us the form but not the substance; his subjects' inner life is lacking, which in the end is the greatest difference between him and Mount.

Relatively few artists other than portrait painters worked in the southern states. One of these few was Thomas Middleton (1797-1863), a talented amateur who worked in Charleston, South Carolina. He did an amusing watercolor, *Friend and Amateurs of Musick,* c. 1827 (Gibbes Art Gallery, Carolina Art Association, Charleston), which shows a gathering of twelve gentlemen in an elegant, picture-lined drawing room. Were this his only work, one would dismiss him as one of many gifted amateurs. But another painting has survived that is of great interest because of its

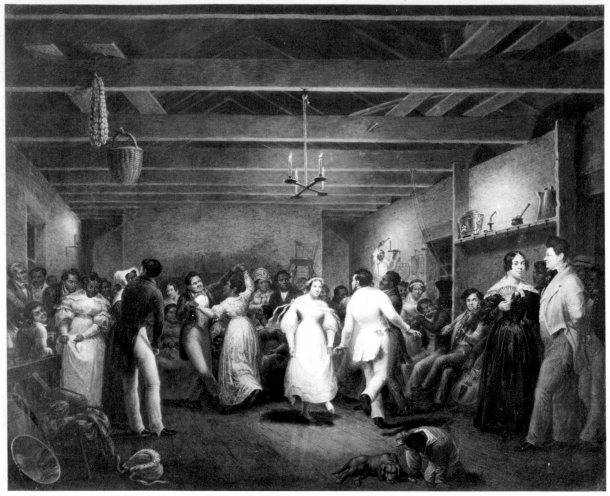

58. Christian Mayr, *Kitchen Ball at White Sulphur Springs,*
1838. North Carolina Museum of Art, Raleigh. (Color plate
IX)

his subjects. How much more popular the painting might have been had it been merely a caricature. One has only to recall Krimmel's or even Mount's early fiddlers to realize that the conventional minstrel-show image of the Negro was already established. Yet Mayr so respected the individuality of his subjects that the figures are certainly portraits—just as the scene is a likeness rather than a comic distortion of what obviously was an important social occasion to the participants.

In Baltimore we find another genre painter who may be considered the peer of William Sidney Mount: the gifted Richard Caton Woodville (1825-1856). During the few productive years before his tragic death at thirty-one from an overdose of morphine, he produced some of the most delightful scenes of American urban life before the Civil War that have come down to us. Unfortunately, there are not many. Although somewhat younger than Mount, Woodville was of the same generation. This, and their similarities in attitude and

in quality of achievement, invites comparison between them.

Unlike Mount, who never studied abroad, Woodville spent six years, 1845-51, in Düsseldorf. At the Academy there, his native sharpness of perception was mellowed and refined by the sophisticated training of the painter Carl Ferdinand Sohn, with whom he worked for five years. This result is especially apparent in his subtle color harmonies and his effective use of modulated light and shadow in an almost Dutch Little Master technique.

While Mount's earthy sense of humor is frequently an element in his painting, Woodville's humor is far less broad, when it is present at all. Woodville also appears to have had a slightly more consistent grasp of the psychological relationships between his actors. Their respective handling of the Negro, who often appears in the compositions of both men, is an example. Woodville never stereotyped the Negro but presented him with dignity and a fine appreciation of

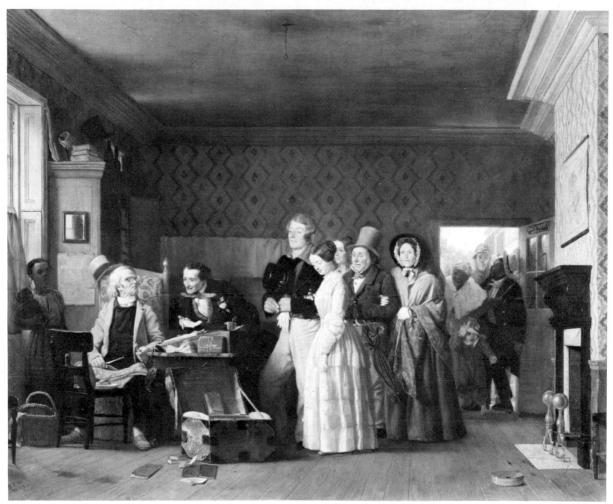

59. Richard Caton Woodville, *The Sailor's Wedding*, 1852. The Walters Art Gallery, Baltimore.

character. Mount leans toward depicting the stereotype of the Happy Negro, the image assiduously promoted by the white man in his blackface minstrel shows.

Woodville's range of subject matter is narrow; all his canvases are essentially interior scenes and all relate to Baltimore. Almost all of his productive career was spent abroad, in Germany, France and England, so it is the more striking that his true genre paintings—as distinct from his historic reconstructions of scenes of earlier periods—are all representations of American life.

His last completed work, *The Sailor's Wedding,* 1852 (Fig. 59), is perhaps his masterpiece. The quality of light is beautifully realized, and the characterization of the twelve figures is sharp and psychologically true to life. The scene is the cluttered room of a Justice of the Peace, whose meal is interrupted by the request that he perform a wedding ceremony. The cast of characters, each a distinct personality and not a

stereotype, includes the persuasive best man, the young sailor, slightly ill at ease but maintaining a manly stance, the bride appropriately shy and possessive, the spinster sister and the parents decked out in their best for the occasion. Interested passersby crowd in at the street door. The painting is a good example of the great finish, the result of his study in Düsseldorf, which is one of the delights of Woodville's work. Painstaking detail is, however, subordinated to the unity of the painting by effective use of subtle color and modulated light and shadow. Woodville's zeal for precision of detail, and his selection of still-life objects appropriate to his subjects, together with the psychologically true-to-life characterization of his figures, assured his popularity. In practice, if not in theory, the American art lover of Woodville's day prized these elements above all others.

Outstanding among the limited number of his works are *Waiting for the Stage,* 1851 (Fig. 60), its wealth of lovingly handled still-life details done with all the skill

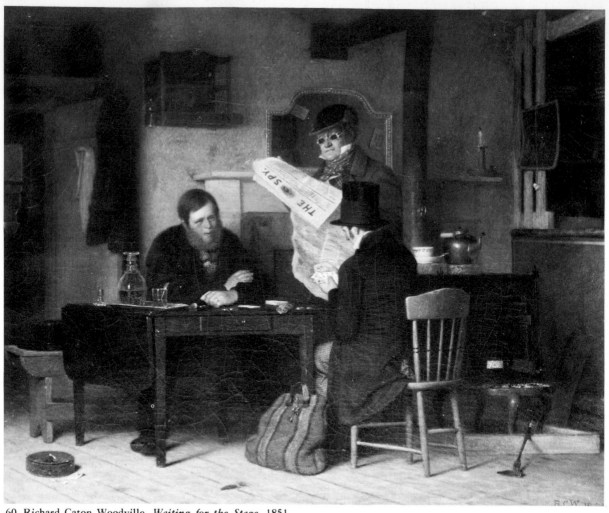

60. Richard Caton Woodville, *Waiting for the Stage*, 1851.
The Corcoran Gallery of Art, Washington, D.C. (Color plate
X)

61. Richard Caton Woodville, *Politics in an Oyster House*,
1848. The Walters Art Gallery, Baltimore.

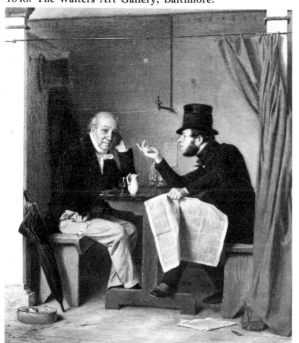

of a Pieter de Hooch, *Politics in an Oyster House*,
1848 (Fig. 61), *Old '76 and Young '48*, 1849 (Fig.
62), and *War News from Mexico*, 1848 (National
Academy of Design, New York), in which the charac-
terization of the central figure is for once discon-
certingly overstated.

The related subject matter of Woodville's *Old '76
and Young '48* and the painting by John L. Magee
(active 1844-1867), *Reading of an Official Dispatch
(Mexican War News)*, c. 1849 (Fig. 63), suggests
comparison of the two interior scenes. In Magee's
painting, the family is learning, from the front page of
an Extra, the news of the death of the husband, father,
son and brother whose portrait as an officer hangs on
the wall behind the group. In Woodville's canvas a
convalescent wounded soldier is recounting his ex-
periences in the Mexican War to a veteran of the
Revolution. How superior is Woodville's technical
achievement and projection of the story to Magee's ill-
proportioned figures, each isolated and fixed in a
theatrical attitude.

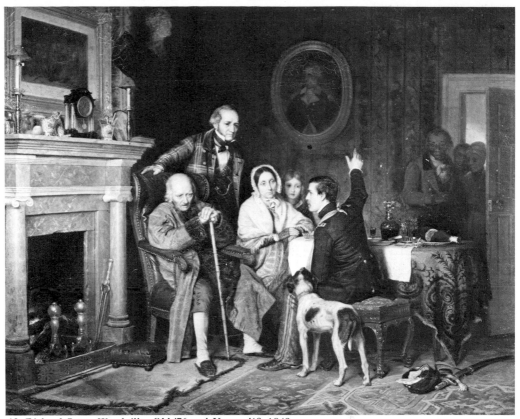

62. Richard Caton Woodville, *Old '76 and Young '48*, 1849.
The Walters Art Gallery, Baltimore.

63. John L. Magee, *Reading of an Official Dispatch (Mexican War News)*, c. 1849. Hirschl and Adler Galleries, New York.

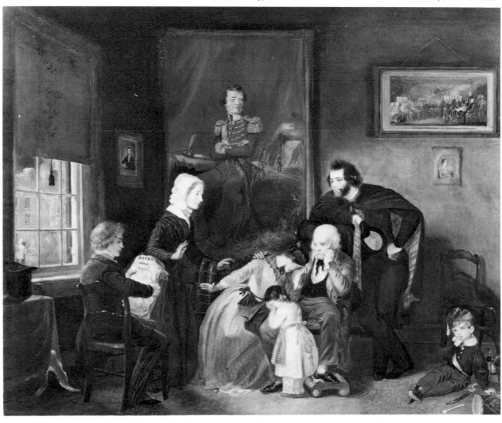

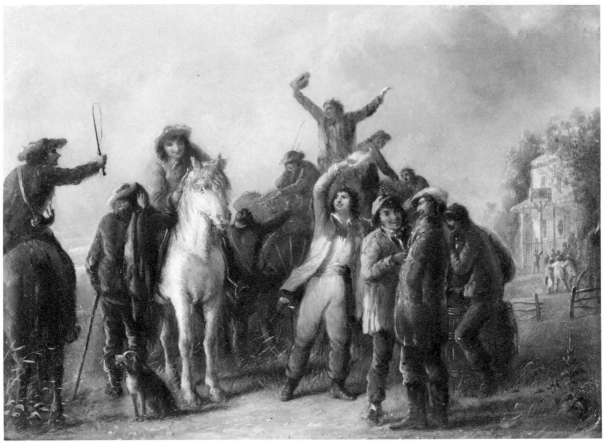

64. Alfred Jacob Miller, *Election Scene, Catonsville, Baltimore County*, c. 1845-61. The Corcoran Gallery of Art, Washington, D.C.

Alfred Jacob Miller (1810-1874), another native Baltimorean, was resident in that city virtually all his life. It was his one notable excursion away from Baltimore, however, which determined the character of his art. In 1837 Miller accompanied one of the earliest private expeditions to the Far West. From 1842, when he was again settled in Baltimore, to the end of his life, Miller devoted himself to western Indian subjects and portraiture.

Documentation of the life of the western Indian fascinated a long line of American and foreign artists, who endured considerable hardship and danger to record it. Their paintings form a large but quite distinct category of American art which might be called "exotic genre." Chiefly because they have already received considerable attention, these eth-

nographic records of Indian life, despite their artistic merit, must be omitted from this survey.

Very few subject paintings of eastern scenes from Miller's brush are recorded, and *Election Scene, Catonsville, Baltimore County*, c. 1845-61 (Fig. 64), appears to be the sole located survivor. It shows his characteristic, rather free impressionistic brushwork and the vitality and joie de vivre that are his hallmarks.[10] The painting summarizes the spirit of the occasion rather than cataloguing the anecdotes and eccentricities associated with one of America's most popular forms of amusement—politics—and is an interesting contrast to George Caleb Bingham's archetypal image of the American political system in action.

Born only five years after William Sidney Mount,

Mount's friend and fellow artist, William Tylee Ranney (1813-1857), was also essentially a painter of genre. Like many of his contemporaries, however, Ranney did not limit himself to one subject area. He painted a few portraits and pure landscapes and essayed historical reconstructions, such as the *First News of the Battle of Lexington,* 1847 (The North Carolina Museum of Art, Raleigh). Yet it is as a genre painter that his abilities were best employed, and it is on his genre paintings that his reputation rests.

Ranney was an established artist as early as 1838, but few of his early paintings, which were primarily portraits, seem to have survived. From 1845, however, he began to paint and exhibit consistently, until he was slowed down late in 1854 by the onset of tuberculosis, which caused his death three years later. The span of his productive career is therefore only from 1845 to 1855.

The son of a Connecticut sea captain, Ranney seems to have inherited from his father a love for the out-of-doors which is reflected in his work. Almost all his genre paintings relate to two main themes: life on the western frontier, and sporting scenes of hunting and fishing in the vicinity of his studio near the Hudson River in West Hoboken, New Jersey.

In 1836 the call of the outdoors, coupled with a yearning for adventure, induced the young Ranney, then only twenty-three, to leave the dull routine of life as an art student in Brooklyn to go to Texas. There he enlisted in the army of the Republic of Texas, which was engaged in its war of liberation from Mexico, and saw service for some eight months. This experience on the Texas frontier was to supply him with a fund of subjects upon which to draw on his return to the Northeast. It is interesting to note that while his experience in the Southwest was military, the paintings which resulted are unrelated to battle or camp life. From their titles *The Wounded Trooper,* c. 1845, and *The Dead Charger,* c. 1846, might be exceptions; the locations of both are unknown.

Approximately nine years elapsed between the sojourn on the Texas frontier and *The Wounded Trooper,* the first painting which appears to have been derived from that experience. It was exhibited at the American Art Union in 1845. Probably Ranney's memory was aided by reference to on-the-spot sketches he made in the West,[11] but while there is mention of sketchbooks among his effects after his death, only a few drawings of western subjects are now known, and most of these appear to have been composition sketches made in the studio in West Hoboken.[12]

Ranney's approach to western genre was different from that of his contemporaries George Catlin, John Mix Stanley, Alfred Jacob Miller, Seth Eastman and Charles Wimar, who also specialized in this area. These artists tended to concentrate on the appearance and activities of Indians, whereas in Ranney's paintings the Indians are an offstage presence, threatening but invisible. Ranney's West is the white man's West. Of his western subjects, *The Retreat* 1850, *The Trappers,* 1851 (both, collection M.

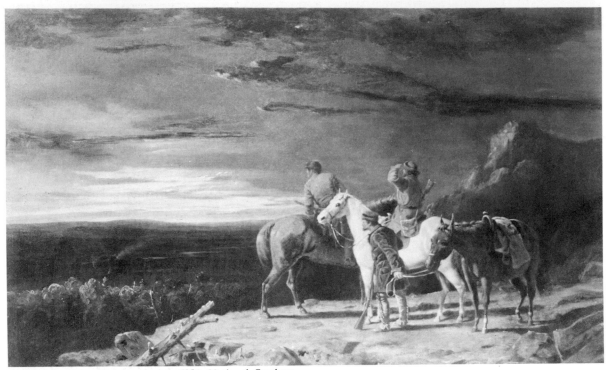

65. William Tylee Ranney, *Scouts*, 1851. National Cowboy
Hall of Fame, Oklahoma City.

Knoedler and Co.), *Scouts*, 1851 (Fig. 65), and its
other version *The Scouting Party*, c. 1851, and
*Advice on the Prairie*, 1853 (both collection Claude J.
Ranney), are typical examples and show him at his full
power as a draughtsman and colorist.

Ranney was an ardent sportsman and thus brought
to his second main area of interest special under-
standing of the landscape, the weather, the ac-
coutrements of the hunter and fisherman and the
psychological reaction of man and beast to the tensions
of these sports. His *Duck Hunters on the Hoboken
Marshes*, 1849 (Fig. 66), captures the intense con-
centration of dog and hunters as they stealthily ap-
proach the raft of ducks. The early morning light is
carefully observed and skillfully rendered, making this
painting one of Ranney's most successful achieve-
ments. *Boys Crabbing*, 1855 (Fig. 67), which has only
recently been located, was also probably painted in
New Jersey. Gay in color and spirit, it shows Ranney
in a slightly different vein, painting not adults engaged
in hunting, or taking part in the westward movement,
but carefree youths enjoying a summer pastime.

Arthur F. Tait, another noted painter of sporting
subjects, was equally faithful in his attention to
detail—a requirement dictated by the taste of art
patrons of the time—but he rarely achieved the sense
of drama which Ranney at his best infused into his
subjects. *Duck Shooting*, 1850 (The Corcoran Gallery
of Art), and *On the Wing*, c. 1850 (The Butler In-
stitute of American Art, Youngstown, Ohio), both
scenes presumably set in the Hackensack Meadows
near Ranney's home in West Hoboken, are other
examples of Ranney's skill in this special type of genre
theme.

Another easterner who capitalized on the dramatic
potential of western genre was Charles Deas (1818-
1867). In 1840 Deas left his native Philadelphia for a
visit to Fort Crawford in Prairie du Chien, Wisconsin;
it was seven years before he returned to the East, to
New York. Deas ranged up and down the Platte,
Missouri and upper Mississippi Rivers absorbing
subject matter for paintings before settling in St.

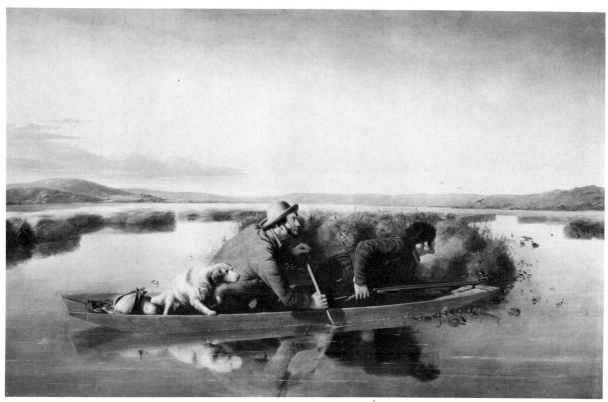

66. William Tylee Ranney, *Duck Hunters on the Hoboken Marshes*, 1849. Museum of Fine Arts, Boston; M. and M. Karolik Collection.

67. William Tylee Ranney, *Boys Crabbing*, 1855. Private collection.

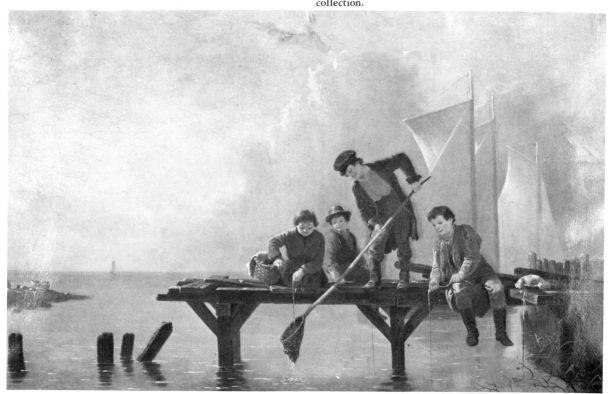

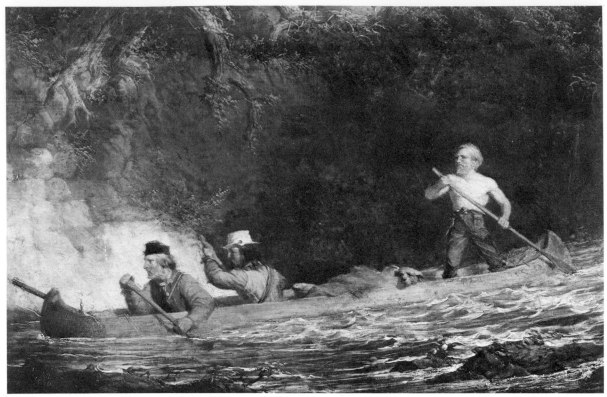

68. Charles Deas, *The Voyageurs*, 1846. Museum of Fine Arts, Boston; M. and M. Karolik Collection.

Louis, then the metropolis of the West—the center of trade, travel and cultured society. The resulting canvases are frontier genre, but genre which has been worked upon by a highly active imagination. All seize on tense moments of physical danger—a truthful reflection of prairie life—but the situations are presented in such melodramatic terms that their emotional power is destroyed.

Deas's career was ended by his mental collapse a few years after he came to New York. Of the handful of his paintings now known, most relate to his sojourn in Missouri, and all of these are characterized by their soap-opera theatricality. *Prairie Fire*, 1847 (The Brooklyn Museum), and *Death Struggle*, 1845 (Shelburne Museum, Shelburne, Vt.), are examples. *The Voyageurs*, 1846 (Fig. 68), is more successful in maintaining a balance between the credibility of the situation and the expression of its dramatic tension.

Deas's earliest surviving genre painting predates his western experience by several years. In subject matter

and restraint of presentation, *The Turkey Shoot*, c. 1836 (Fig. 69), is so markedly different from his western subjects it is difficult to believe it is by the same hand—or rather, the same eye. There is no question of credibility here. This is especially fortunate for the present-day viewer, for the painting has a special interest as record. Competitions in marksmanship were a common form of rural sport at that time when a man's skill with a rifle was a matter of survival, or at least of how well the larder was stocked. Another painting which, from its style, would appear to be a fairly early work done before Deas went West is *Winter Sports*, c. 1840 (collection Lindley Eberstadt). This urban street scene shows two teams of schoolboys having a lively snowball battle while a solitary Negro man huddles against a shed watching the conflict.

George Caleb Bingham (1811-1879) was consciously a social historian. This does not diminish in any way his artistic importance, for one has only to recall the poetic image of his *Fur Traders Descending*

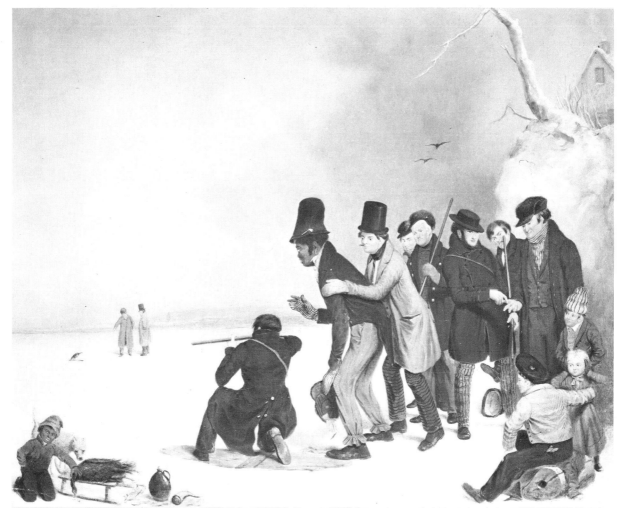

69. Charles Deas, *The Turkey Shoot*, c. 1836. From the Collection of Mr. and Mrs. Paul Mellon.

*the Missouri,* 1845 (The Metropolitan Museum of Art), to be assured of Bingham's impressive accomplishment. The fact was, however, that he set out to paint a series of canvases devoted to "our social and political characteristics." [13] The range of his view was not as all-inclusive as this statement would suggest. In practice Bingham gave attention to just two facets of life in Missouri: the social phenomena of political campaign and popular election, and the life bound up with the great rivers. He shows us nothing of the life of the bankers, merchants and political and cultural leaders in Missouri's thriving towns and cities—the society in which he himself moved.

It is noteworthy that Bingham is our first genre artist to have been raised in the West. The portrait painter Chester Harding is credited with giving him his first interest and instruction in art when he was still in his teens. By 1833 young Bingham was started on his professional career, quite predictably as a painter of portraits. His early paintings show the stock

hardness that characterized semi-trained "provincial portraiture" wherever it was practiced. He came East for the first time in 1837 to study briefly at the Pennsylvania Academy of the Fine Arts in Philadelphia. From 1840 through 1844 he was working in Washington, D.C., but after this lengthy absence returned to Missouri, which remained his base for the rest of his life. There he started the series of genre paintings which were to bring him fame.

E. Maurice Bloch suggests that, in his choice of western subject themes, Bingham was by no means unaware of the demand, especially in the East, for accurate illustrations of the scenes and characters of the Mississippi and Missouri Rivers. [14] Descriptions of them had been written and published by travelers, and thus an appetite had been whetted for visual records to supplement the literary.

In 1845 Bingham submitted two western genre paintings to the American Art Union; both of them were quickly purchased. One of these was *Fur Traders*

*Descending the Missouri,* probably aesthetically his most distinguished work. His career was helped immensely by the successful reception, nationwide, of his early *The Jolly Flatboatmen,* 1846 (Fig. 70), which the American Art Union bought, reproduced by engraving and distributed. With these paintings Bingham was accepted as the unquestioned master of western genre.

Bingham took painstaking care in creating his paintings, not only in the technical sense, but also in working out a conception which would convey the substance and mood of the subject. Like Mount, he was a master craftsman, especially in drawing. This proficiency strongly supported the expressive power of his images. Not until after his 1856-59 stay in Düsseldorf, where his studies led him to embrace the theory and style of its Academy, did his paintings cease to be compelling representations of America's western man.

Bingham generated no school of followers, but he was not the only painter to record the colorful characters and colorful life on the rivers. For example, Henry Lewis (1819-1904) between 1846 and 1848 painted a vast panorama of the Mississippi. He also produced easel paintings of river scenes that are more portraits of the river than genre subjects. Then there was the mysterious William Baldwin, about whom nothing has been recorded, who in 1844 signed and dated the canvas *The Merry Raftsme*n (Fig. 71). This early genre subject, which antedates Bingham's first river scenes, captures the carefree spirit of the river rats and has a genuinely appealing gusto. To compare Baldwin's painting with any one of Bingham's is like comparing the technique of a country fiddler with that of a concert virtuoso.

The consistently high quality of Bingham's genre paintings of life on the great rivers—they virtually disappear from his repertoire after his return from Düsseldorf—makes arbitrary the selection of a small representative group. *Raftsmen Playing Cards,* 1847 (Fig. 72), *The Squatters,* 1850 (Fig. 73), and *Shooting for the Beef,* 1850 (Fig. 74) are typically fine examples of Bingham's best period. In the 1850's he experimented with the problems involved in depicting night scenes, such as *Wood-Boatmen on a River,* 1854 (Museum of Fine Arts, Boston) and *The Belated Wayfarers,* 1852 (Fig. 75), which are an extension of his range but lack the visual appeal of his daytime subjects.

Bingham's series of political subjects, by far his most ambitious works since they involve so many figures, would alone be sufficient to establish him as an American master. *The County Election,* 1851-52 (Fig. 76), *Stump Speaking,* 1854 (Fig. 77), and *The Verdict of the People* (No. 2), 1854-55 (Fig. 78), along with their variants, are unquestionably his major contributions to genre art in this country. That Bingham lavished so much time and effort on these subjects was certainly the result of his personal experience in local politics. He was several times a candidate, served a term in the state legislature and was actively connected with Missouri politics and

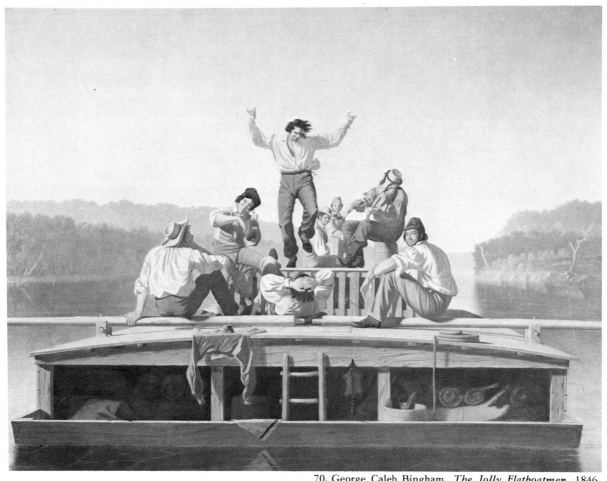

70. George Caleb Bingham, *The Jolly Flatboatmen*, 1846.
Collection Senator Claiborne Pell. (Color plate XI)

politicians throughout his life.

Bingham's habit was to make careful drawings of individual figures, building up a working file of characters from which he cast his compositions. His stock of characters, while precisely delineated, were types and not individuals; it is indicative of Bingham's understanding of and respect for his fellow Missourians that these representative figures were never stereotypes. He was not a subtle man, and his drawing shows it. It is sharp and accurate, leaving no doubt as to the shape or position of a leg or an arm. Each figure was studied in detail and each gesture, each crease and tear in the clothing was recorded. If he drew a face distorted by a hearty laugh, it was with the detachment of a plastic surgeon interested only in the arrangement of muscle and tissue, not in the subject's sense of humor. Bingham's greatest talent may have been that his figures could be set down in a composition with all of this precision of observed detail and yet be subordinate to the total concept of the scene. This skill in formal composition stemmed from his

respect for the traditional devices of European masters, which he absorbed by studying reproductive prints. That his scenes are always convincing vehicles of the spirit of the region and the age is due to his natural affinity for his subjects.

Like Mount, Bingham painted for the many, not the few. On rare occasions he ventured to depict an event of the past, such as *The Emigration of Daniel Boone*, 1851 (Washington University, St. Louis), or an incident of contemporary history, such as *Order No. 11*, c. 1869-70 (State Historical Society of Missouri, Columbia). Normally he avoided the unusual or the ephemeral, concentrating all his efforts on depicting scenes which were duplicated daily by the picturesque river men. In this he was painting the stuff of history. □

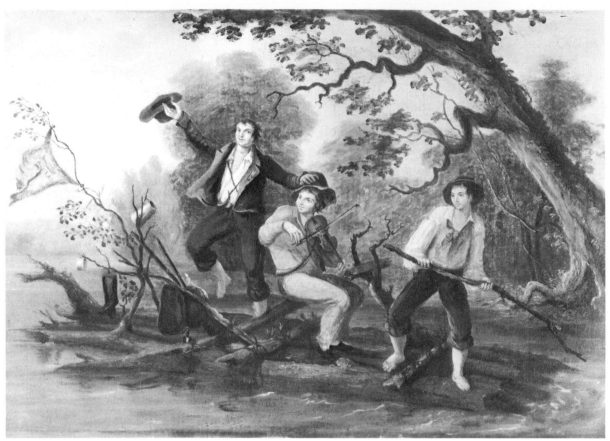

71. William Baldwin, *The Merry Raftsmen,* 1844. City Art
Museum of Saint Louis.

72. George Caleb Bingham, *Raftsmen Playing Cards,* 1847.
City Art Museum of Saint Louis.

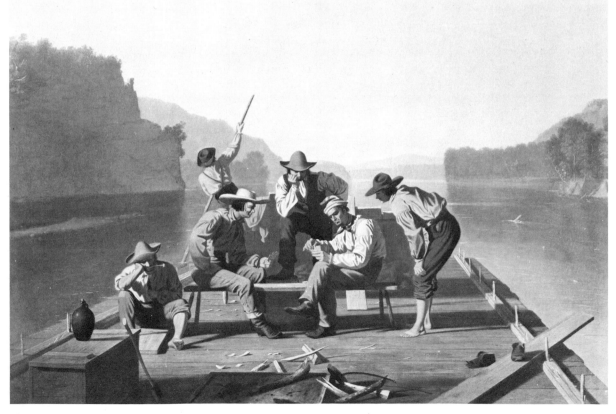

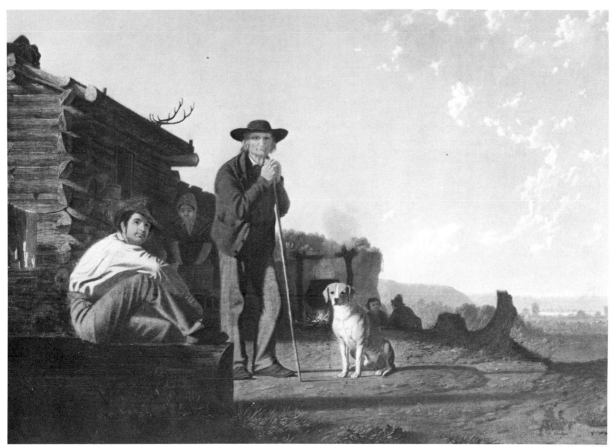

73. George Caleb Bingham, *The Squatters,* 1850. Museum of Fine Arts, Boston; Promised Gift of Henry Lee Shattuck.

74. George Caleb Bingham, *Shooting for the Beef,* 1850. The Brooklyn Museum, Brooklyn, New York.

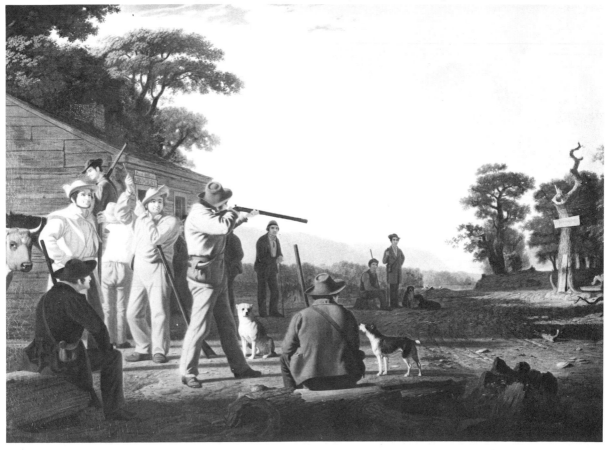

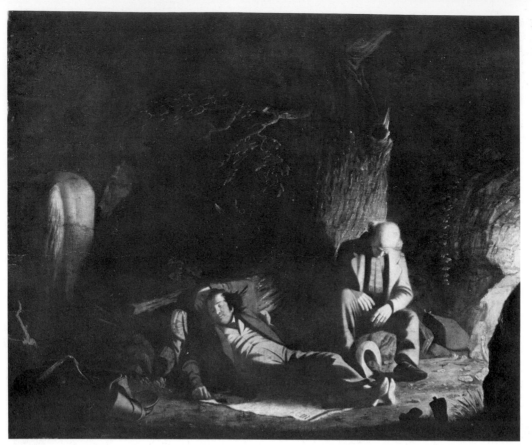

75. George Caleb Bingham, *The Belated Wayfarers*, 1852.
City Art Museum of Saint Louis.

76. George Caleb Bingham, *The County Election*, 1851-52.
Collection The Boatmen's National Bank of St. Louis.

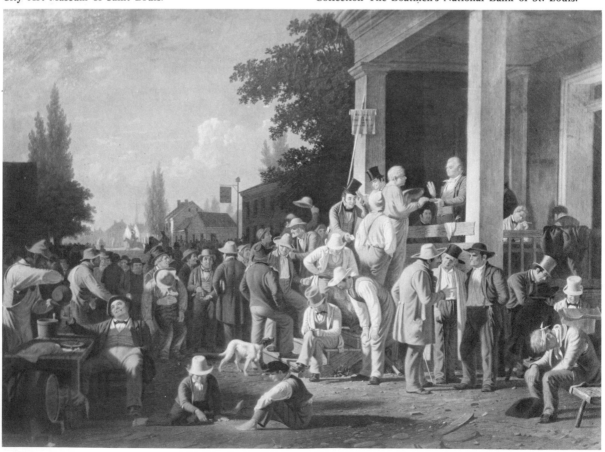

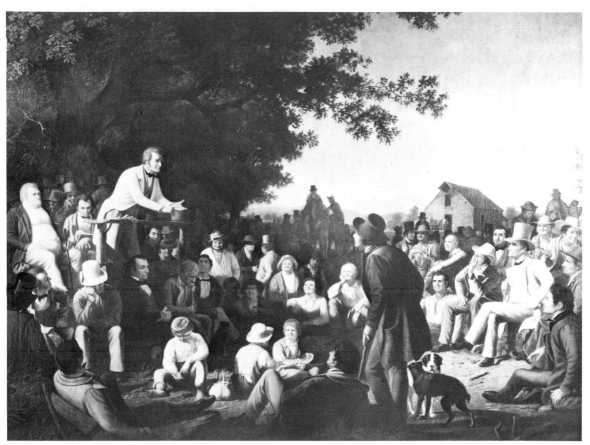

77. George Caleb Bingham, *Stump Speaking*, 1854. Collection The Boatmen's National Bank of St. Louis.

78. George Caleb Bingham, *The Verdict of the People (No. 2)*, after 1855. The R. W. Norton Art Gallery, Shreveport, Louisiana.

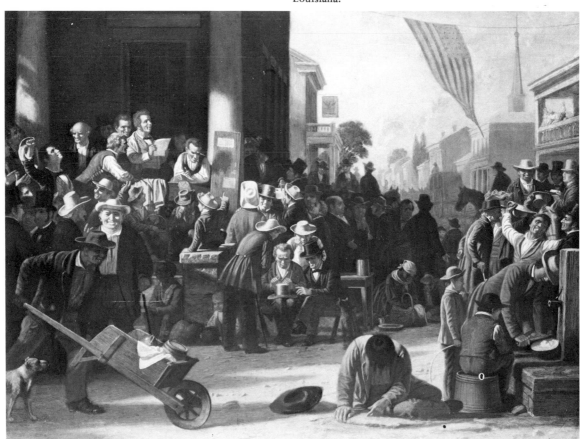

# CHAPTER 4

# Rustic Humor and the Simple Life

This chapter, which chronologically somewhat overlaps the preceding one, is concerned with twenty-nine painters, who for convenience are discussed in three groups. The largest group includes those artists who frequently selected subjects—the simple pleasures and pastimes of rural and urban life situations—which enabled them to poke fun at their fellow citizens. The character of the humor ranges from generalized good nature to the broadly comic, slapstick variety to satire. The second group is made up of painters who had a special interest in sporting subjects, although these themes did not occupy them exclusively. The third group is more diverse but, in general, has in common the desire to record aspects of everyday life with objective clarity. The chapter concludes with the greatest and most individual satirist of this transitional period, David Gilmour Blythe.

A predilection for humorous content is a strain which runs through much of the genre painting produced in the first half of the nineteenth century. It is essentially masculine, and men, almost without

exception, are the butt of the innocent merriment. One rarely encounters a painting in which a woman is made the object of ridicule. American pictorial humor is also remarkably free from the erotic and bawdy, which was prevalent abroad—for example, in the watercolors of the Englishman Thomas Rowlandson, which often exploit and expose intimate feminine anatomy with humorous and erotic intent. In general the humor in American painting of this period is concentrated on the not very subtle level of the practical joke, or the accident which robs the victim of his dignity. Never vicious, it reflects a healthy if unsophisticated attitude, and conforms to the broad pattern of democratic middle-class morality.

Were it not for three atypical paintings by George Henry Durrie (1820-1863), he would have no place in this survey. Durrie, whose fame rests on the Currier & Ives lithographs based on the genre landscapes he produced from about 1850 until his death, worked during this period in New Haven, Connecticut. Almost all of Durrie's somewhat primitive landscapes

are enlivened by small figures hauling wood or grain or engaged in other rural activities, such as making cider or cutting ice—details in what are essentially landscapes. Nevertheless, Durrie's work taken as a whole comes close to providing an encyclopedic coverage of Connecticut farm life in the mid-nineteenth century, and is thus a substantial contribution to an understanding of American rural life.

Durrie's three paintings which contain figures large enough in scale in relation to the whole composition to justify their classification as true genre all show the attenuated influence of William Sidney Mount, especially in their aura of pervasive good humor. This is most obvious in *Holiday in the Country—A Cider Party,* 1853 (Bruce Collection), in which four men, including one Negro, are grouped inside a barn with wide-open doors. Its similarity to *Dancing on the Barn Floor* (Fig. 49) or *The Power of Music,* 1847 (collection The Century Association), makes one suspect that Durrie was familiar with Mount's paintings or the lithographs after them. To a lesser degree, the same is true of *Farmyard in Winter, Selling Corn,* 1857 (Fig. 79), where again figures are grouped around an open barn door.[1]

In *Sledding,* 1851 (Fig. 80), the influence of Mount is less evident. The closest parallels are Mount's two snow scenes of boys tending their rabbit traps, *Catching Rabbits,* 1839 and *The Dead Fall,* 1844 (both, Suffolk Museum and Carriage House). Only in *The Dead Fall,* in which the two lads trudge up a sloping hill toward their sprung trap, is there a similarity in composition. In *Sledding,* the hill slopes in the opposite direction, but it is worth noting that the boy lying on the dead tree trunk in the foreground and the old gnarled tree with its stumps of branches occupy an area similar to that of the masses of trees and bushes in Mount's *The Dead Fall. Sledding* shows Durrie in an entirely new light as a recorder of the pleasures of youth. It is characteristic that he took pains to contrast the slower old-fashioned sled with solid wooden runners with the "modern" version with its light and flexible steel runners. This was typical of the careful attention to detail which makes Durrie's paintings a reliable record of bygone customs and pastimes.

It is apparent that Durrie was not adept at painting figures, which explains why he did not produce more true genre paintings. The figures in these canvases lack volume; despite this technical weakness, the paintings stand as good-natured, modest but authentic and personal depictions of American rural life.

James Goodwyn Clonney (1812-1867) was born in England and began his artistic career in Philadelphia. His genre paintings, however, were all done in New York between the late 1830's and his death in Binghamton. He lived for a short time in the city, but his canvases generally depict incidents of rural life. In spirit and choice of subject matter Clonney seems to follow the lead of William Sidney Mount.[2] He made detailed drawings for all his figures in much the same manner as George Caleb Bingham. While he was capable of an unsentimental realism, more often than not Clonney strained for a chuckle.

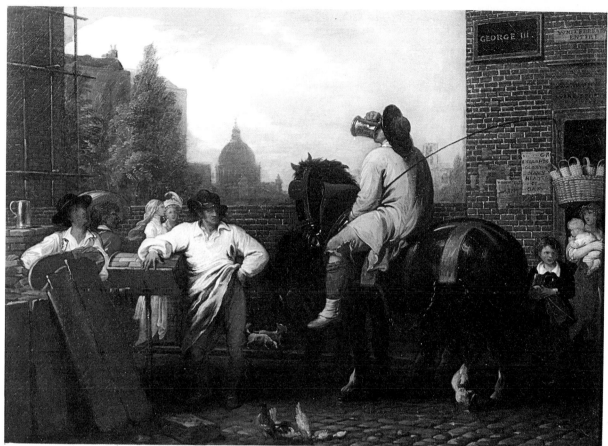

I Benjamin West, *The Old George Inn,* 1796. Hirschl and
Adler Galleries, New York.

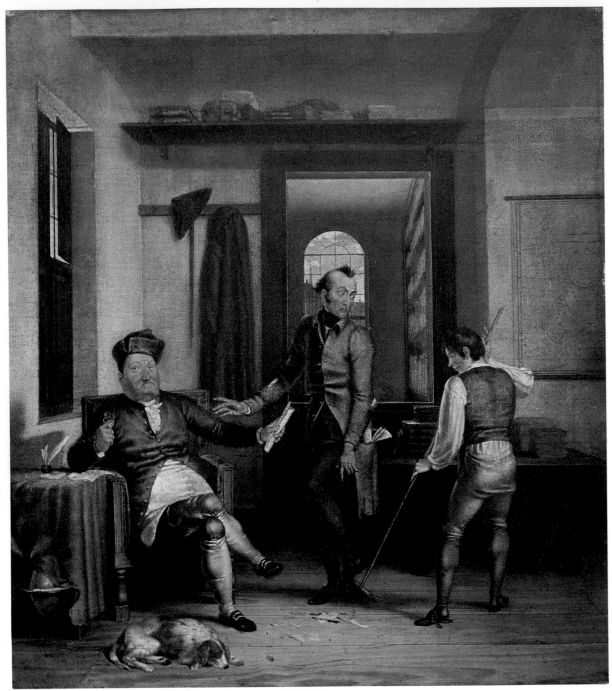

II Washington Allston, *The Poor Author and the Rich Bookseller*, 1811. Museum of Fine Arts, Boston; Bequest of Charles Sprague Sargent.

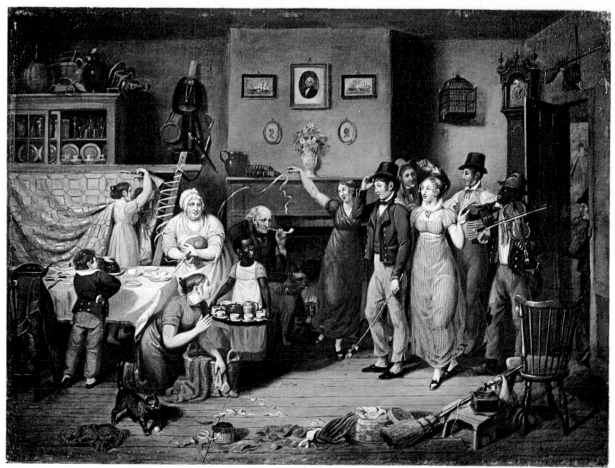

III John Lewis Krimmel, *Quilting Frolic,* 1813. Henry
Francis du Pont Winterthur Museum, Winterthur, Delaware

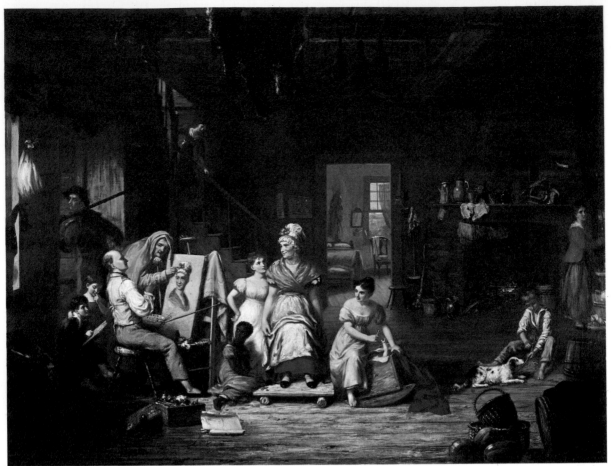

IV Charles Bird King, *The Itinerant Artist,* c. 1813-25. New
York State Historical Association, Cooperstown, New York.

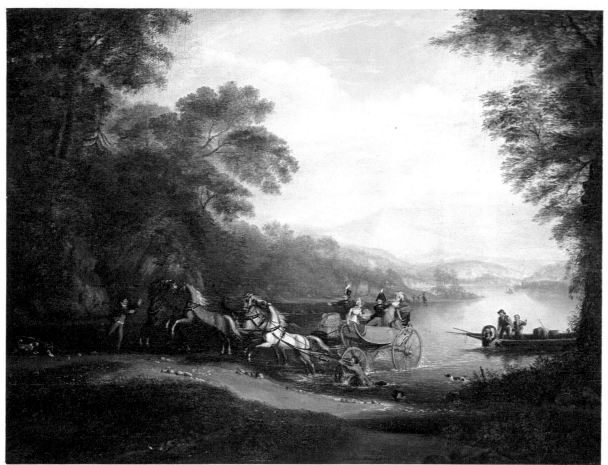

V Alvan Fisher, *Mishap at the Ford,* c. 1818. The Corcoran
Gallery of Art, Washington, D.C.

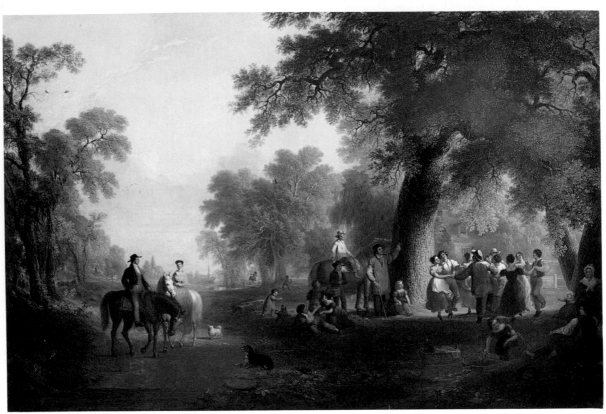

VI Asher Brown Durand, *Dance of the Haymakers*, 1851.
Collection Mr. Webster and Mr. Douglas Collins.

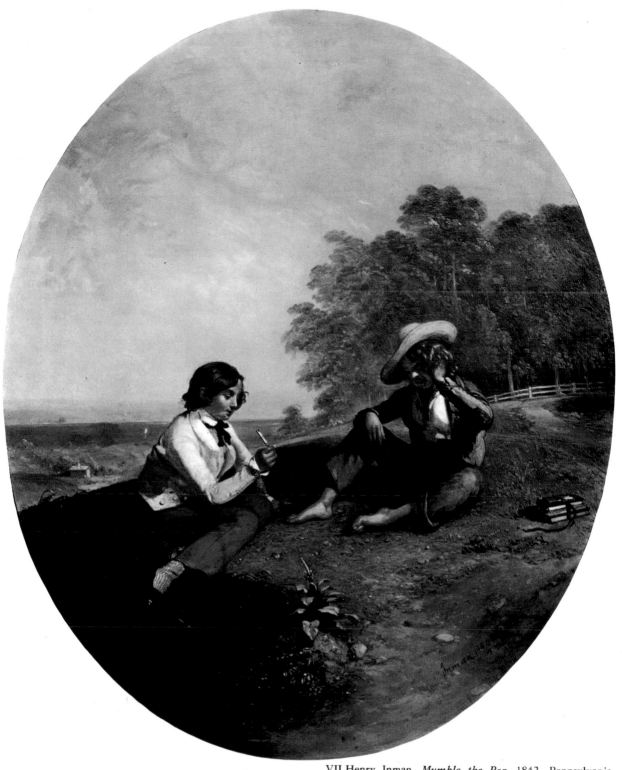

VII Henry Inman, *Mumble the Peg,* 1842. Pennsylvania
Academy of the Fine Arts, Philadelphia.

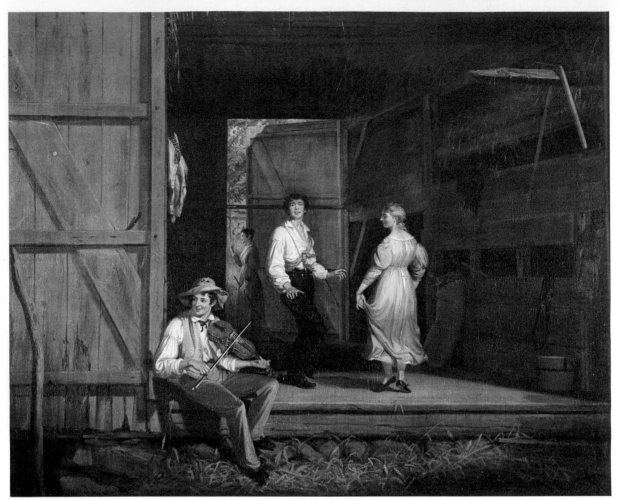

VIII William Sidney Mount, *Dancing on the Barn Floor,*
1831. Suffolk Museum and Carriage House at Stony Brook,
Long Island, New York; Melville Collection.

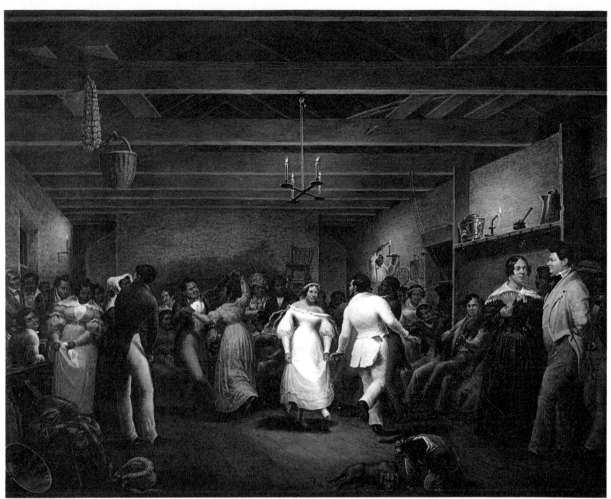

IX Christian Mayr, *Kitchen Ball at White Sulphur Springs,*
1838. North Carolina Museum of Art, Raleigh.

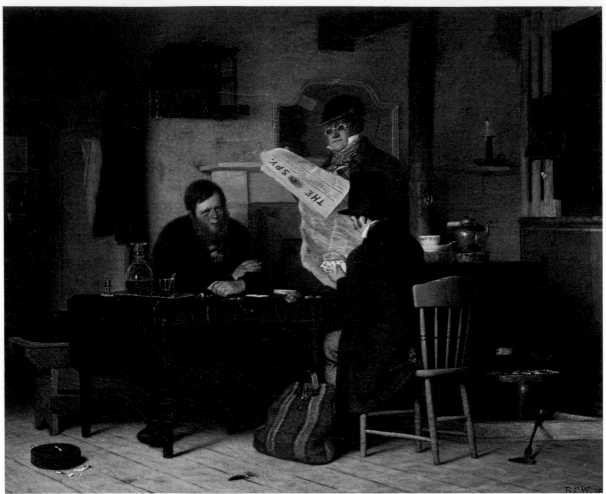

X Richard Caton Woodville, *Waiting for the Stage,* 1851. The
Corcoran Gallery of Art, Washington, D.C.

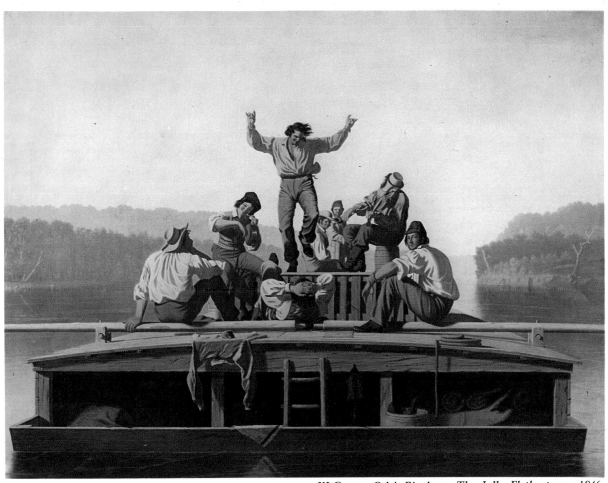

XI George Caleb Bingham, *The Jolly Flatboatmen,* 1846.
Collection Senator Claiborne Pell.

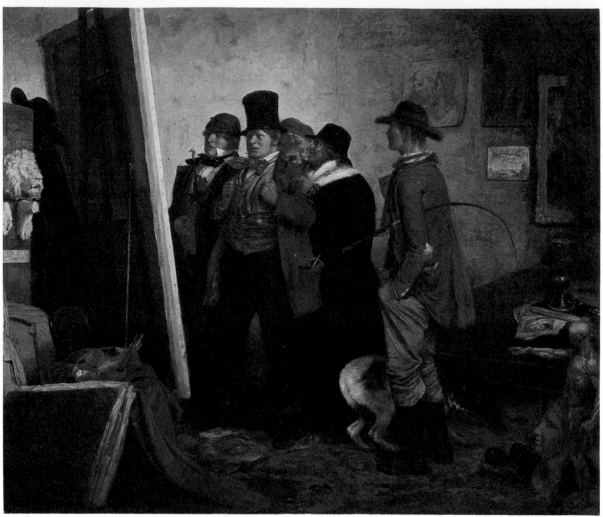

XII Johannes Adam Simon Oertel, *The Country Con-noisseurs,* 1855. Shelburne Museum, Shelburne, Vermont.

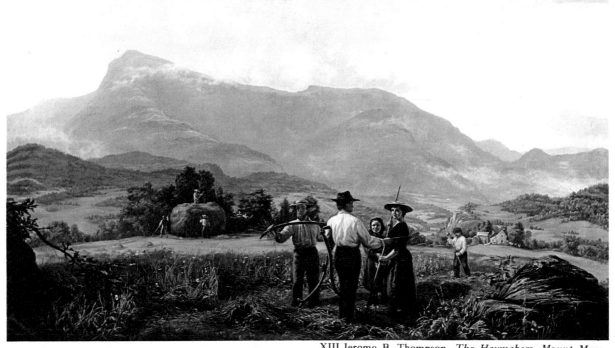

XIII Jerome B. Thompson, *The Haymakers, Mount Mansfield, Vermont*, 1859. Private collection.

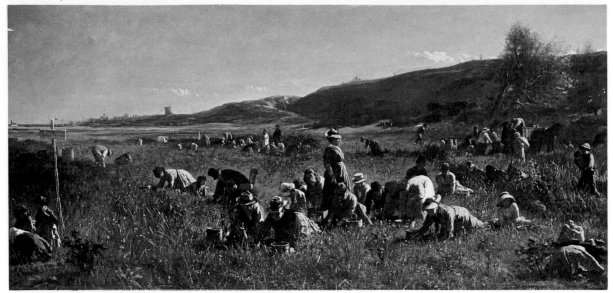

XIV Eastman Johnson, *The Cranberry Harvest, Island of Nantucket,* 1880. Vose Galleries, Boston, and Peter Tillou, Albany.

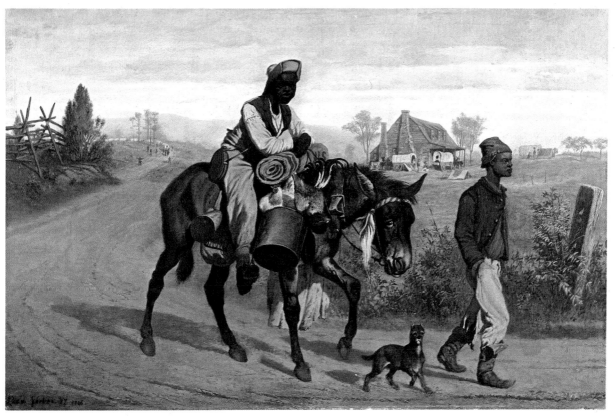

XV Edwin Forbes, *Contrabands,* 1866. Collection Hermann
Warner Williams, Jr.

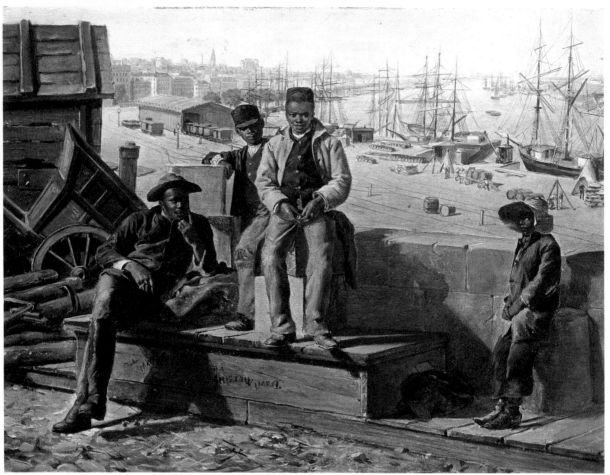

XVI David Norslup *(?)*, *Negro Boys on the Quayside*, c. 1868.
The Corcoran Gallery of Art, Washington, D.C.

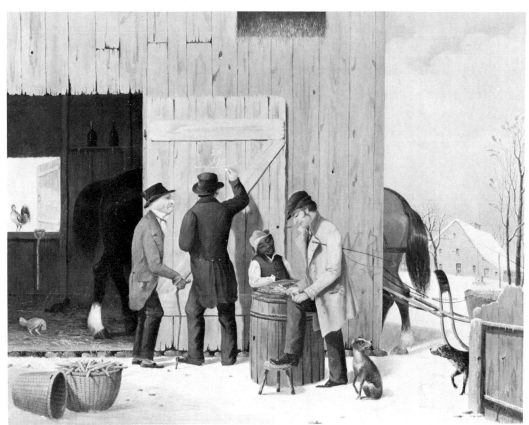

79. George Henry Durrie, *Farmyard in Winter, Selling Corn*, 1857. Hirschl and Adler Galleries, New York.

80. George Henry Durrie, *Sledding*, 1851. From the Collection of Mr. and Mrs. Paul Mellon.

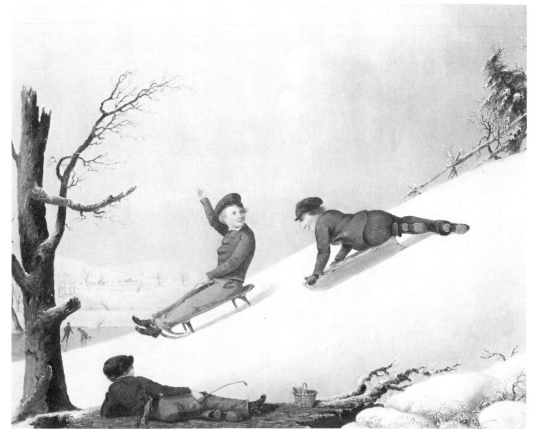

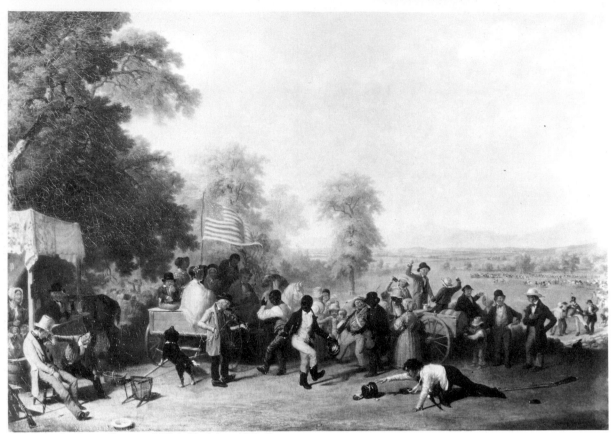

81. James Goodwyn Clonney, *Militia Training*, 1841. Pennsylvania Academy of the Fine Arts, Philadelphia.

*Militia Training*, 1841 (Fig. 81), is, with its numerous figures, one of his most ambitious canvases. It is quite similar in both composition and handling to Sir David Wilkie's *Pitlessie Fair*, 1804 (National Portrait Gallery, Edinburgh). The group of his canvases in the M. and M. Karolik Collection at the Museum of Fine Arts, Boston, each with only a few figures, shows his work at its most typical. These canvases include *The Happy Moment*, 1847, *Waking Up*, 1851 (Fig. 82), and *What a Catch*, 1855, all of which are fishing subjects with a humorous touch. *In the Cornfield*, 1844 (Fig. 83), however, is straight observation without any farcical overtones. In a period when stereotypes were prevalent, it is of special interest that Clonney painted what he saw, even to the ribs of the poor old swaybacked nag being harnessed to

the harrow. Here he also used a low horizon line to silhouette the horse and rider against the clear sky, an effective device which was rarely employed at that time.

Albertus D. O. Browere (1814-1887) was the son of the sculptor John H. I. Browere, who is best remembered for his series of life masks of U.S. Presidents and other prominent Americans. Browere spent most of his life in Catskill, New York, but in the 1850's made two extended trips to California in search of gold.

On the whole Browere was a self-taught painter, who throughout his career helped support himself by carriage and sign painting. For example, he did paintings of fires which show traces of his sign-painting manner. Two examples are in the Museum of

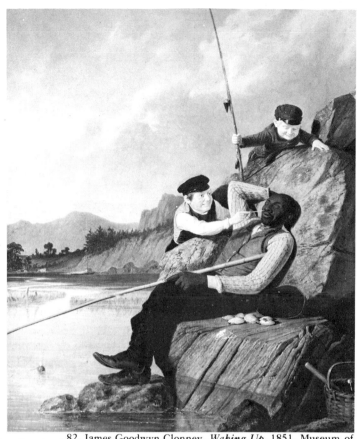

82. James Goodwyn Clonney, *Waking Up,* 1851. Museum of Fine Arts, Boston; M. and M. Karolik Collection.

83. James Goodwyn Clonney, *In the Cornfield,* 1844. Museum of Fine Arts, Boston; M. and M. Karolik Collection.

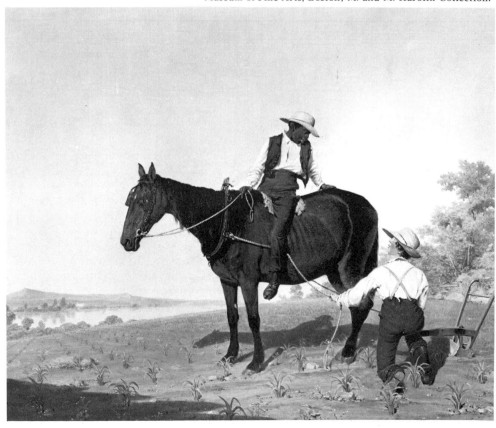

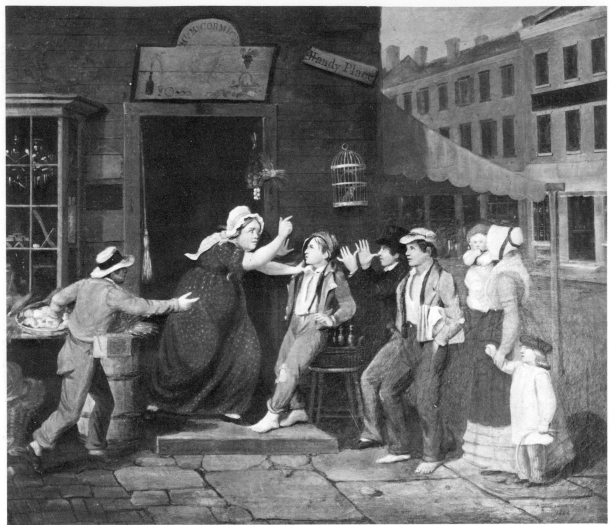

84. Albertus D. O. Browere, *Mrs. McCormick's General Store,* 1844. New York State Historical Association, Cooperstown, New York.

the City of New York. *Mrs. McCormick's General Store,* 1844 (Fig. 84), is his masterpiece. Despite weakness in draughtsmanship and composition, it has a robust quality and provincial flavor which give it a peculiar charm. It also records the appearance of a typical small-town store at mid-century. The gang of boys who have aroused the ire of the proprietress are giving her a hard time and shoplifting while her attention is distracted by the one thumbing his nose. The comic approach Browere used here was characteristic of the period and accorded with the popular taste of the time for obvious buffoonery.

Browere, though he did not strike it rich in the gold fields, capitalized on his travels by painting a number of western landscapes and a few genre subjects of miners. *Gold Mining in California,* 1858 (Fig. 85), is

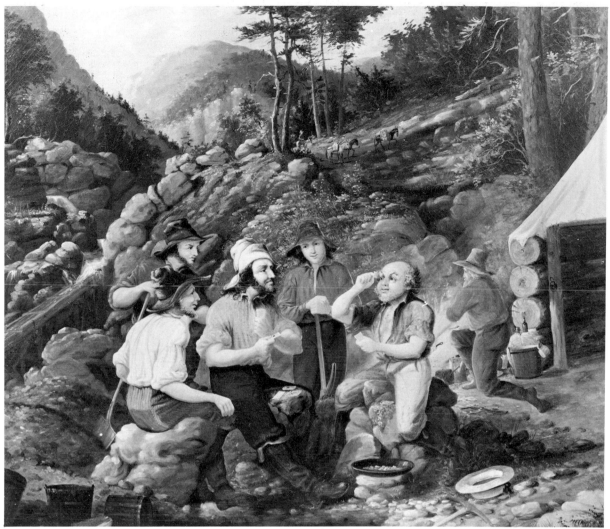

85. Albertus D. O. Browere, *Gold Mining in California,* 1858.
Ira Spanierman Gallery, New York.

characteristic. It is full of pertinent detail: the panning
tin, the picks, spades and buckets, the sluice for
panning the gold and the crude log lean-to in which
the miners camped—and the delightful vignette of the
miner and his pack-train going up a trail in the
background.

David Claypool Johnston (1799-1865), who
worked in Boston, is on occasion linked with David
Gilmour Blythe, who is discussed at the end of this
chapter. Both were satirists it is true, and each
displayed a sense of humor—but there the similarity
ends. Johnston was primarily a draughtsman and
etcher of topical satirical prints. Basically ephemeral,
these have to us largely lost their potency. Perhaps his
best-known work is the watercolor *The Militia
Muster,* c. 1829 (American Antiquarian Society,

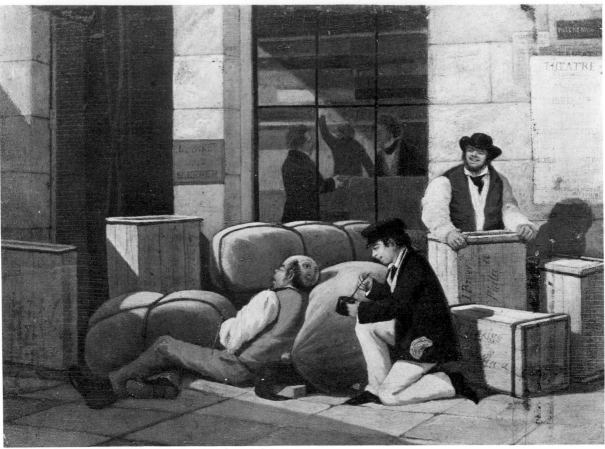

86. David Claypool Johnston, *Wide Awake—Sound Asleep,*
c. 1845. Collection Mr. and Mrs. H. John Heinz III.

87. John Carlin, *After a Long Cruise (Salts Ashore),* 1857.
The Metropolitan Museum of Art, New York; Maria De Witt
Jesup Fund, 1949.

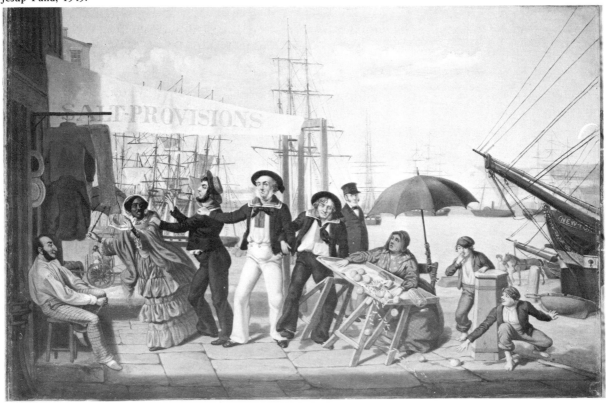

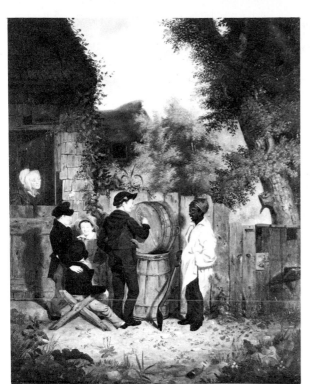

88. Thomas Mickell Burnham, *Taking a Likeness*, c. 1840. Kennedy Galleries, New York.

Worcester, Mass.) which, because of its odd assortment of types and ludicrous apologies for uniforms, still provokes a passing smile. Of his rare oils, only *Wide Awake—Sound Asleep*, c. 1845 (Fig. 86), survives as an important example of his genre painting.

But Johnston, unlike Blythe, does not go beyond superficial realities; there is no deep human response. Often referred to by his contemporaries as "the American Cruikshank," Johnston was content if he evoked a chuckle or a belly laugh.

John Carlin (1813-1891) was a deaf-mute who worked in New York City during his active career. After the advent of photography drastically reduced his income from miniature portrait commissions, he devoted himself largely to genre and landscape painting. While we know the titles of a number of his genre paintings from early exhibition catalogues, few of his works have been located. The only surviving genre painting of importance is *After a Long Cruise (Salts Ashore)*, 1857 (Fig. 87). This canvas has some of the same bawdy humor one finds in Rowlandson's satirical watercolors. It is surprising that the teeming dockside life of our harbors, which seems to offer so many possibilities to an artist, should not have been used more extensively. Few indeed are the scenes which record this vanished and picturesque side of nineteenth-century American life.

Although most of his life was spent in his native Boston, Thomas Mickell Burnham (1818-1866) as a young man passed a few years in Detroit as a sign painter, portraitist and genre artist. It was in this period that he painted his earliest surviving canvas, *First State Election in Michigan*, 1837 (The Detroit Institute of Art). This youthful effort, akin in its obvious satire to the graphic work of David Claypool Johnston, is marked by inconsistencies. Some of the figures are so realistically and tightly painted that they look like miniature portraits (as they may well be); others are loosely painted caricatures. But as a record of frontier life, it has a pungency and liveliness that make up for some of its technical weaknesses. The pigs running loose through the square, the flagpole made from a living tree, the drunkard waving his whiskey bottle—these are all authentic touches.

A similar comic approach, but without satiric overtones, is followed in the far less ambitious but better controlled *Taking a Likeness*, c. 1840 (Fig. 88). Burnham's technique is more delicate than that of most of his contemporaries. In his treatment of the weatherworn shingles and of the foliage he shows almost a miniaturist's approach.

In an age when few American women progressed beyond an amateur status as painters of pretty watercolors of flowers or theorem still-life paintings, Lily Martin Spencer (1822-1902) was a professional. She worked in Ohio and, after 1847, in New York City until her death. At least once, in *The War Spirit at Home, Celebrating the Victory at Vicksburg*, 1866 (The Newark Museum), she produced a truly moving picture. Her accurate observation, together with her

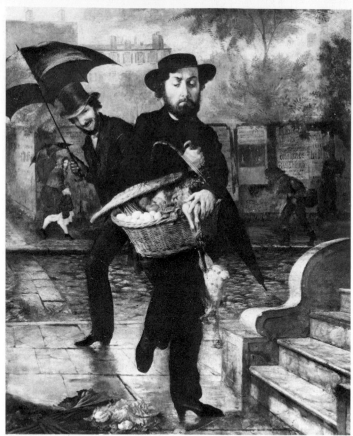

89. Lily Martin Spencer, *The First Marketing*, 1854. Victor
D. Spark, New York.

woman's perceptions, makes this more than a simple
homely scene. The untidy table with stacked dirty
dishes, the careworn face of the elderly woman, the
children, especially the little boy with sagging diapers,
and the mother reading the newspaper while pre-
cariously holding her baby convey an almost pain-
ful summation of smell, confusion and noise, of adult
concern and innocent oblivion. The foreshortened
view of the baby in its mother's lap, the comparative
absence of Victorian sentimentality and fastidious-
ness, are evidence of the artist's ability as a draughts-
man and of her power to transmit essential human
values. Mrs. Spencer did not rise to this level of
performance again, and her other work is generally
uneven in quality.

*The Picnic on the Fourth of July,* c. 1860? (collec-
tion Mr. and Mrs. H. J. Gucker, on loan to The Ohio
Historical Society, Columbus), is an ambitious failure.
It depicts some twenty-five figures, including portraits
of the artist and her husband, gathered on the banks of
a lake. This is a picnic in the grand style, with maid
and butler. The wealth of detail makes it a fascinating
record, if only for its period accessories. It is rather sad
that what might have been a lively essay on an aspect
of middle-class social customs is instead a self-
conscious, theatrical tableau lacking in spontaneity.

Looking at America through its genre paintings
could lead to the conclusion that it never rained. A
rare exception is Lily Spencer's *The First Marketing,*
1854 (Fig. 89). Here again the comic incident is seized
upon—the new husband's clumsiness with a loaded
market basket. The painting demonstrates the artist's
keen perception of human behavior and her skill as a
painter of still life. The woman lifting her skirts and

104

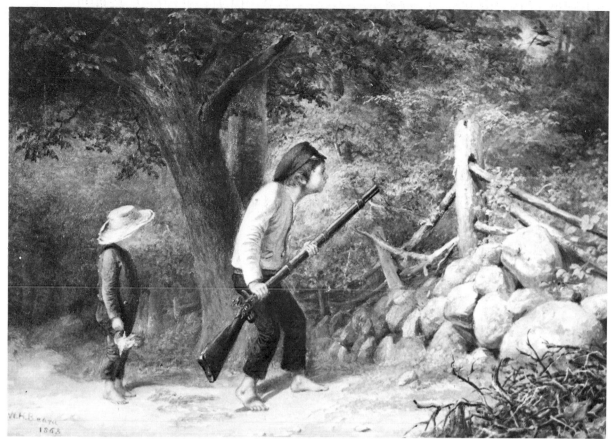

90. William Holbrook Beard, *Boys Hunting*, 1863. The Brooklyn Museum, Brooklyn, New York; James Ricau loan.

petticoats to keep them from the wet sidewalk and the delivery boy hunched over against the rain are true to life. The market basket and its contents of eggs, vegetables and poultry are beautifully painted.

William Holbrook Beard (1824-1900), brother of James Henry Beard, is best known for his allegedly humorous paintings of animals cast in human roles. He insouciantly trod on rather thin ice in his *Jealous Rabbit,* c. 1865? (unlocated), and got away with it, simply because of this substitution of animal for human figures. In this way, he was able to depict marital infidelity without offending the standards of his day. Tuckerman describes the painting in these words: ". . . two rabbits are making love, and a third stands on his hind legs and peers over a cabbage leaf, with an expression of jealous surprise. . . ."[3] Behind this flimsily screened pretense the gentlemen could

guffaw while the ladies pretended that it all passed over their pretty, innocent heads. Allegorical paintings such as these, amusing as they are as documents of Victorian conceits, cannot concern us here.

The comparatively few non-allegorical genre paintings William Beard painted have a similar humorous slant. For example, his *A Lesson for the Lazy,* 1859 (Vassar College Art Gallery, Poughkeepsie, N.Y.), combines a comic with a moralizing message. A fox peers down from a wooded bank at a sleeping hunter and his dog. This painting was given to Vassar by its founder, Matthew Vassar, who may have felt the picture would have a beneficial effect on the study habits of the young ladies.

In *Boys Hunting,* 1863 (Fig. 90), two youngsters, the older carrying an obsolete flintlock musket nearly as tall as he is, are after game birds. Combining a

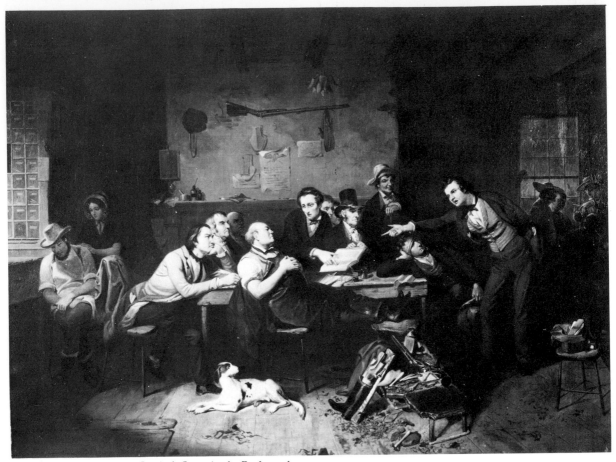

91. Tompkins H. Matteson, *Justice's Court in the Backwoods,*
1852. New York State Historical Association, Cooperstown,
New York.

genuine feeling for nature in the treatment of the
wooded landscape and a sympathetic and basically
true-to-life depiction of the two boys, it is by all odds
Beard's best painting according to present standards.
His accurate observation of the landscape is no ac-
cident, for he painted a few little-known but excellent
pure landscapes.

Tompkins Harrison Matteson (1813-1884) added
nothing but pictures to the story of American paint-
ing. This is not to say that he was an incompetent
painter, or that his canvases do not broaden our vision
of mid-nineteenth-century American life, but only
that he was an able craftsman lacking in imagination.
In his day he was best known for retrospective
historical subjects, dealing, for example, with in-
cidents in the life of George Washington, which met a
contemporary demand, but now appear stilted and
empty. Tuckerman wrote of him that his paintings

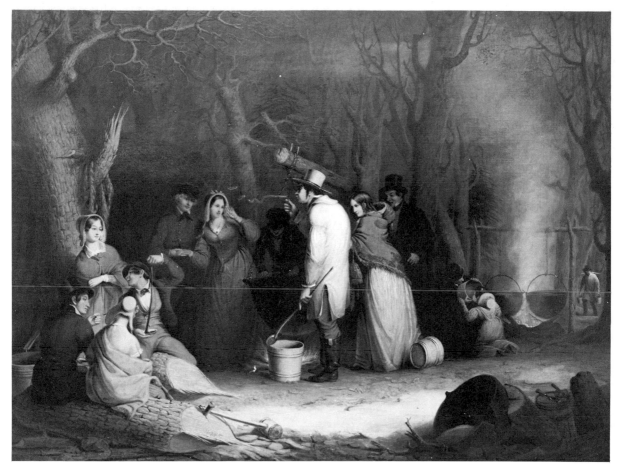

92. Tompkins H. Matteson, *Sugaring Off*, 1845. Museum of Art, Carnegie Institute, Pittsburgh.

''indicate the average taste of the people''; [4] that is still a sound judgment.

Matteson was somewhat younger than Mount, and his genre works, especially his interior scenes, seem to indicate a familiarity with those of his predecessor. For example, in *Now or Never,* 1849 (formerly M. Knoedler and Co.), there are two sources of light and a wealth of still-life objects, characteristics frequently encountered in Mount's work. Further, it has a similar mood of quiet good humor. Matteson's excellent draughtsmanship cannot overcome his weaknesses: compositions lacking in subtlety, a tendency to overly dramatic gestures. One of his more successful paintings is *Justice's Court in the Backwoods,* 1852 (Fig. 91), painted after he had moved from New York City to Sherbourne, New York, in 1851.

Views of the studios of American sculptors are rare, which gives a purely topical interest to his otherwise uninspired *Erastus Dow Palmer in His Albany Studio,* 1852 (Albany Institute of History and Art). The sculptor and his assistants are shown at work, with some ten examples of statuary arranged around the studio. On the other hand, *Sugaring Off,* 1844 (Fig. 92), shows Matteson at his best. Here the atmospheric quality of the light is used with dramatic effect, and the figures are posed with a naturalness he rarely achieved.

A recurring theme in American genre painting is the rural—never urban—courtroom scene. From the 1830's to the close of the Civil War, examples can be found by artists in many sections of the country. Almost always the subject is treated humorously or satirically. None of the principals seems to come off very well. Judge, jury, prosecutor and defense attorney—all are made to appear rather ridiculous; the dignity of the law is conspicuously absent. *Rural Court*

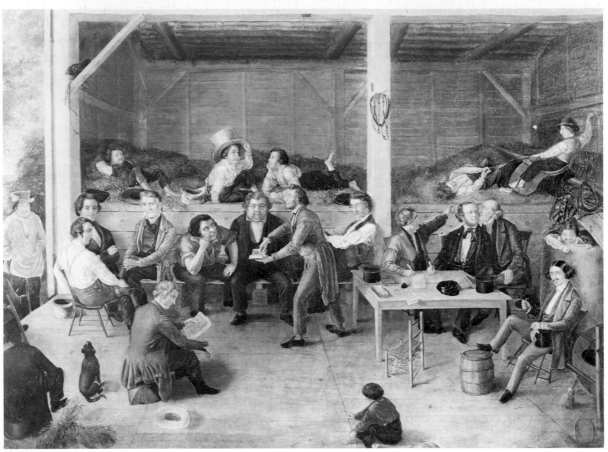

93. A. Wighe, *Rural Court Scene*, 1849. Museum of Art,
Rhode Island School of Design, Providence.

95. Johannes Adam Simon Oertel, *Woodruff Stables, Jerome
Avenue, The Bronx*, 1861. Museum of the City of New York.

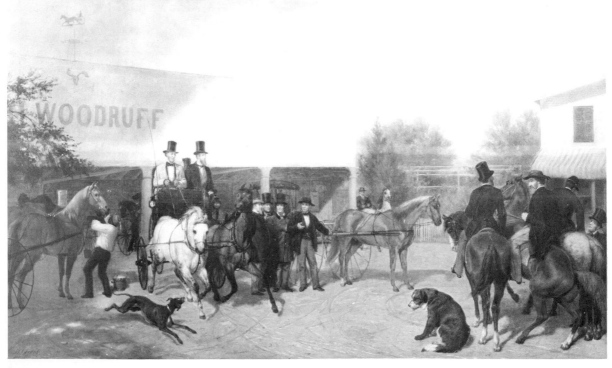

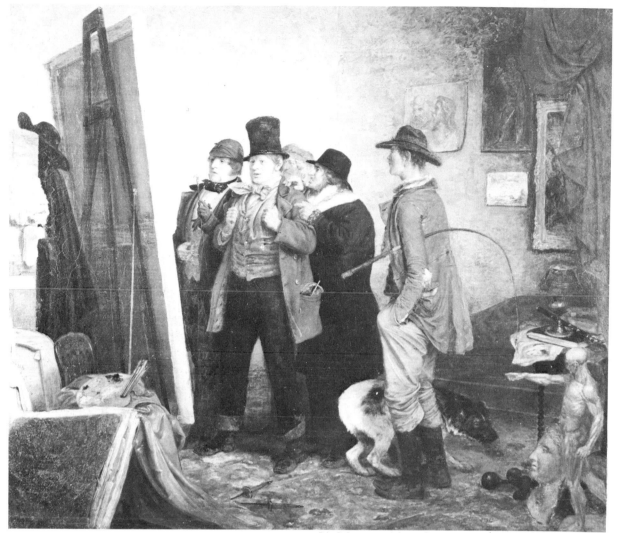

94. Johannes Adam Simon Oertel, *The Country Connoisseurs*, 1855. Shelburne Museum, Shelburne, Vermont. (Color plate XII)

*Scene,* 1849 (Fig. 93), by A. Wighe, may be presumed to show a court in session somewhere in New England. There is no information at present available on either painting or painter beyond the facts that the picture was found in Connecticut and is signed and dated. One is inclined to suspect that Wighe was familiar with Mount's barns. In any event, the painting is a record of rural justice at work in spite of certain difficulties. Clumsy and inept a painter as Wighe was, he had a keen and observant eye and captured a variety of human reactions with good-natured humor. The scene has the ring of truth.

Among the influx of German artist immigrants was Johannes Adam Simon Oertel (1827-1909), who arrived in America in 1848. He became an Episcopal priest in 1871 and followed that calling until he retired in 1895. Thereafter he painted religious subjects. However, during the approximately two decades between 1848 and going into the ministry, he was active as a portrait painter, engraver, teacher and occasional painter of genre scenes.

His *The Country Connoisseurs,* 1855 (Fig. 94), is a variation on a theme used earlier by Dunlap and Mount, an artist's studio where a newly completed work is being scrutinized.[5] Comparison of the three paintings shows a shift in social attitudes. Dunlap's painting is straightforward and dignified—a reflection of the still-aristocratic society of the Federal period; Mount's is full of unrestrained animal enthusiasm, with just a whisper of humor—consistent with the exuberance of the Jacksonian period; Oertel's is more obviously satirical in its implied comment on the man in the street's capacity for art criticism. The representation of the room is full of information about the paraphernalia to be found in an artist's studio: a roll of canvas, various plaster casts, a couple of fencing foils, a flute, a portfolio of drawings as well as a palette and brushes.

Another aspect of Oertel's versatility is shown in *Woodruff Stables, Jerome Avenue, The Bronx,* 1861 (Fig. 95). The painting was lithographed the following year by a carriage manufacturer and looks like what it

109

96. Edward Troye, *Richard Singleton*, c. 1835. From the Collection of Mr. and Mrs. Paul Mellon.

is, a job of commercial illustration.

In the eighteenth and nineteenth centuries there was in Britain a strong school of artists specializing in sporting subjects; no similar school arose in the United States. As we have seen, paintings of such subjects were done by several artists, but there were few before mid-century who specialized in this field. Yet hunting in all its variants, fishing, and horsemanship in its many forms (the steeplechase, flat racing and the peculiarly American sports of trotting and pacing races) were extremely popular in many parts of the country.

In point of fact there is only one true specialist in this area, Edward Troye (1808-1874), and even he had to supplement his income by painting human portraits.[6] He arrived in this country from Geneva, Switzerland, as a young man of twenty and stopped briefly in Philadelphia before going to Charleston, South Carolina. Troye was a prolific painter who specialized in portraying animals, especially thoroughbred horses. These do not concern us here,

but on occasion he varied his formalized side elevations of horses by including grooms, jockeys and trainers in appropriate poses and settings. Most of these works were painted in the heartland of horse-breeding, Kentucky, where he lived from 1835 to 1874. One of the best is *Richard Singleton*, c. 1835 (Fig. 96), a lovingly painted view of a thoroughbred who was seldom defeated in five seasons of racing. Not surprisingly perhaps, the three attendants are painted with far less care than the horse. In *Self Portrait*, 1852 (Yale University Art Gallery) all the components received equal attention, which is understandable since, after all, the central human actor was the artist himself. *Tobacconist*, 1833 (collection Mr. and Mrs. Paul Mellon), shows a famous racehorse standing in the paddock about to be saddled. It is another example of Troye's magnificent gift for painting horses, capturing their individuality and stance and not treating them like taxidermists' models.

Arthur Fitzwilliam Tait (1819-1905) was already over thirty and equipped with some artistic training

97. Arthur Fitzwilliam Tait, *Trappers at Fault, Looking for the Trail*, 1852. The Denver Art Museum, Denver, Colorado.

when he arrived in New York from England in 1850. His paintings of the Adirondacks, where he soon had a summer camp, were popular, and many were lithographed by Currier & Ives. Tait excelled in his specialty, hunting and sporting scenes set in the wilderness of upstate New York. He also occasionally drew upon his imagination and literary sources to depict dramatic encounters between trappers and Indians on the western frontier. These are more believable than, for example, the similar scenes by Deas, who was actually on the spot. Tait, at his best, was a good painter and a good storyteller. He could, however, lapse into the pedestrian, as in *The Latest News,* 1862 (New York Public Library), which contains speaking likenesses of assorted cows, sheep, ponies, fowl and, squeezed into a corner, a couple of specimens of *Homo sapiens* reading a newspaper and providing the basis for the title.

The two outstanding examples of his Wild West paintings are *Trappers at Fault, Looking For the Trail,* 1852 (Fig. 97), and *American Frontier Life,* 1852

111

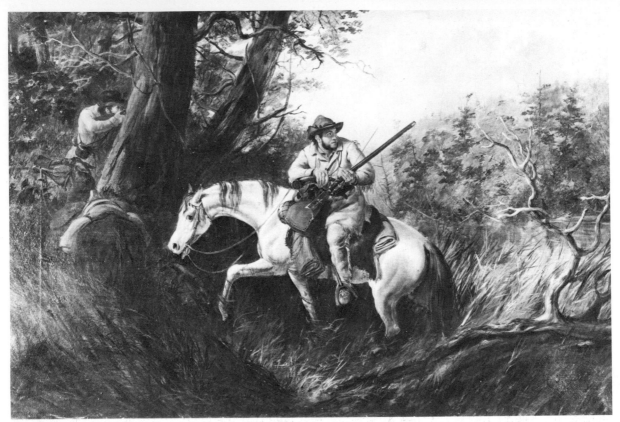

98. Arthur Fitzwilliam Tait, *American Frontier Life*, 1852. Yale University Art Gallery, New Haven, Connecticut; Whitney Collection of Sporting Art.

99. Arthur Fitzwilliam Tait, *Arguing the Point, Settling the* ▶ *Presidency*, 1854. The R. W. Norton Art Gallery, Shreveport, Louisiana.

100. Arthur Fitzwilliam Tait, *A Good Chance*, 1857. Ken- ▶ nedy Galleries, New York.

(Fig. 98). Both convey a sense of mounting tension and excitement. In *Arguing the Point, Settling the Presidency,* 1854 (Fig. 99), Tait forgoes drama for close observation. This was a scene in the Adirondacks, where, both personally and artistically, Tait was thoroughly at home. The crude log cabin and barn, set in a rough clearing cut out of the surrounding forest, can be accepted as a true record of the appearance of such hardscrabble homesteads. The three backwoodsmen are individuals with distinct personalities, and all of them show the shrewd, leathery faces of those who spend most of their days out-of-doors.

Two of the best of the sporting paintings which constitute the bulk of Tait's work are *A Good Chance,* 1857 (Fig. 100), and *A Deer-Hunting Scene,* 1880 (Museum of Fine Arts, Springfield, Mass.). In the former, the dead tree with its peeling bark and the

figures of the two hunters in the canoe are depicted with more sensitivity than we normally expect from this artist.

Tait's reputation as a painter has suffered too much from his well-publicized association with the great print-publishing house of Currier & Ives. He painted for them a large number of works expressly to be reproduced as color lithographs. It is true that often he brought to his art little more than an illustrator's concern with the realities of the scenes before him. But on occasion he coupled his accuracy with a perception that lifted him above the rank of illustrator.

Hugh Newell (1830-1915) came to America from Ireland about 1851 and settled in Baltimore. Most of his active life as a portrait, landscape and genre painter was spent there and in Pittsburgh. He was relatively little known, and his only located genre painting is a charming and restrained sporting picture, *Duck*

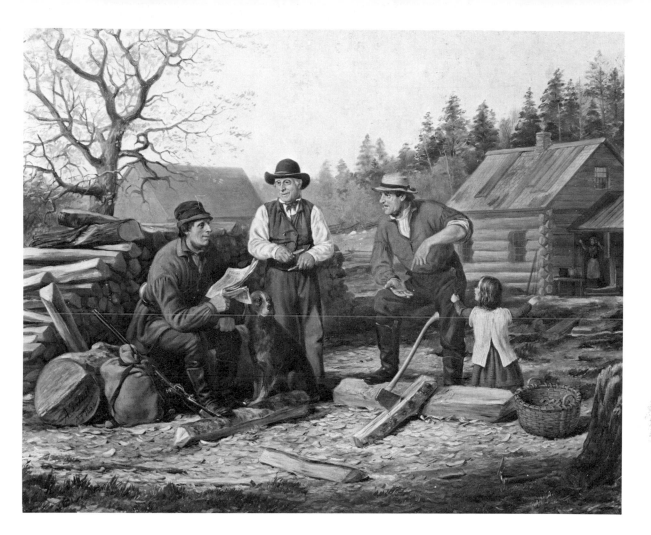

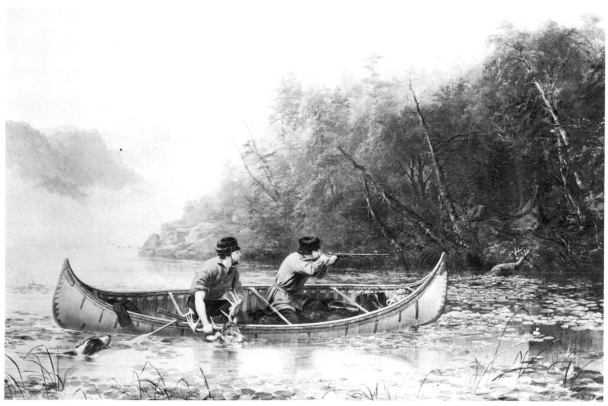

113

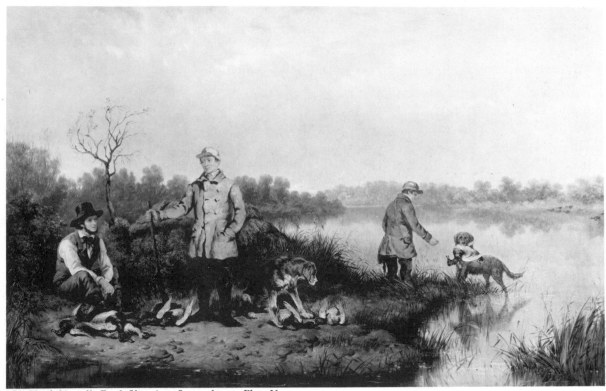

101. Hugh Newell, *Duck Shooting, Susquehanna Flats Near Havre de Grace*, 1856. Victor D. Spark, New York.

102. Junius Brutus Stearns, *Country Landscape with Children Fishing*, 1850. Berry-Hill Galleries, New York.

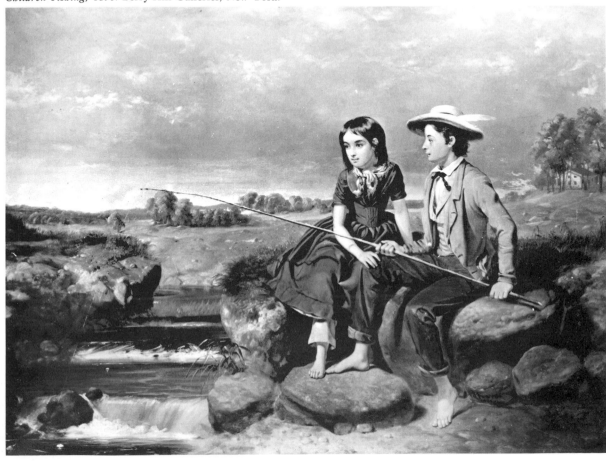

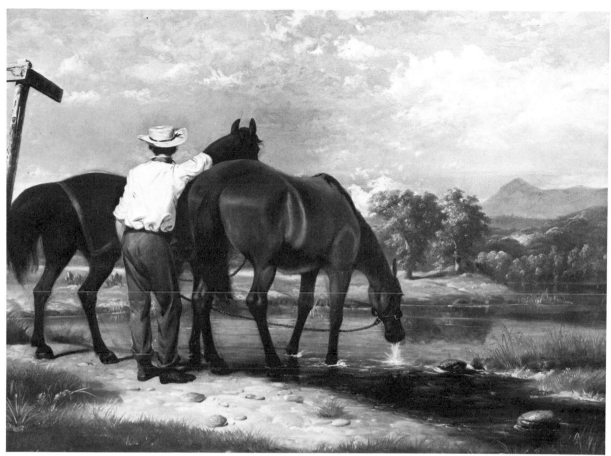

103. Junius Brutus Stearns, *Watering the Horses*, c. 1852.
North Carolina Museum of Art, Raleigh.

*Shooting, Susquehanna Flats near Havre de Grace,* 1856 (Fig. 101). This autumnal landscape with three hunters and their retrievers is low-keyed and un-dramatic and is thus in strong contrast to the tension-charged paintings of the same subject by Ranney and Tait.

Junius Brutus Stearns (1810-1885), who from 1838 worked in New York, was chiefly a painter of portraits and stilted historical reconstructions based on the life of George Washington. However, he did a series of genre paintings featuring men fishing. Generally these are, or give the impression of being, group portraits in an open-air setting.[7] This is cer-tainly true of his *Charles Loring Elliott and His Friends Fishing,* 1857, which was originally in the James C. McGuire Collection, Washington, D.C., and is now in the collection of C. O. von Kienbusch, New York. *Country Landscape with Children Fishing,* 1850 (Fig. 102), is the most attractive of his fishing scenes, but has an artificial look, as if the figures were

painted in the studio and pasted on an existing land-scape background.

A quite different subject by Stearns shows that even a pedestrian painter can occasionally turn out a work that is better than his usual run. *Watering the Horses,* c. 1852 (Fig. 103), is an example of straightforward observation. The farmer boy's relaxed posture and the fact that one sees only his back suggest he is day-dreaming and cast a mood of reverie over what easily could have been a very dull picture of horses' rumps. While the painting has no pretensions to greatness, it shows that when he was content to be simple and direct, Stearns could do a respectable job.

The painters who are discussed in the following pages saw life objectively and painted it in a realistic manner. They continue the enduring strain of forth-right reporting which can be traced through the history of American painting from Copley to the present. Their native and acquired talents vary in kind and quality as does the depth of perception they bring

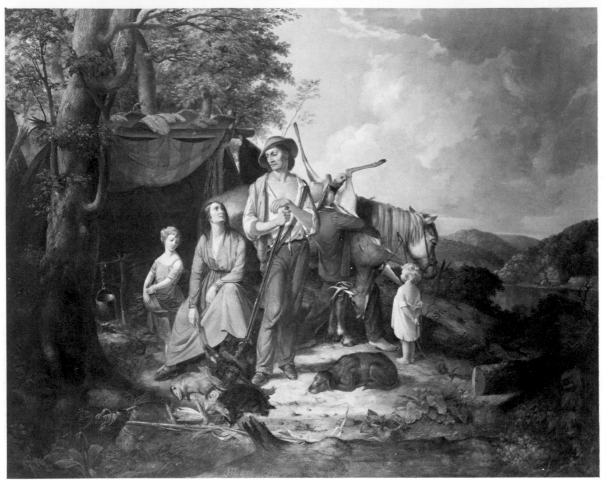

104. James Henry Beard, *Westward Ho*, 1850. Kennedy Galleries, New York.

to their work. Some, like Burr, are rather trite; others, like Le Clear, are startlingly imaginative. All contribute to the overall understanding of the quality of life at mid-century.

For insight into the hardscrabble life of the frontier homesteader in the mountainous areas of Kentucky and adjacent states, then on the borders of our western expansion, one turns to James Henry Beard (1812-1893). In that optimistic age, it was not considered quite the thing to look poverty squarely in the eye. Beard violated this tenet of good taste by painting, between 1845 and 1882, a series of paintings of poor white folk and tenant farmers.

*Westward Ho*, 1850 (Fig. 104), shows a family obviously on its uppers—ill-clothed, suffering from malnutrition if not actually starving, depressed, woebegone, almost without hope. This is quite a contrast to the usual contemporary depiction of poverty, which was limited to the external evidence—

the patched and tattered garments, tousled hair, and the ancillary effects on posture and gesture of a hard and frugal life. Almost without exception, even when they are not overtly sentimental, the conventional interpretations of the poor show stalwart, well-nourished, cheerful men and women, content with their lot and full of hope for a prosperous future. Beard must have known at first hand some of these impoverished small farmers, for he was born on the frontier in Painesville, Ohio, and as a young man had plied the Ohio River as an itinerant portrait painter, traveling between Pittsburgh and New Orleans in the 1820's and 30's. One of his river scenes, *Western Raftsmen*, 1847, is in the collection of The Department of State in Washington.

*Good-bye, Ole Virginia*, 1872 (Fig. 105), is another in this series. In this case, the displaced family is Negro, which in itself makes the painting unusual. Here there is no humor. Beard objectively reports

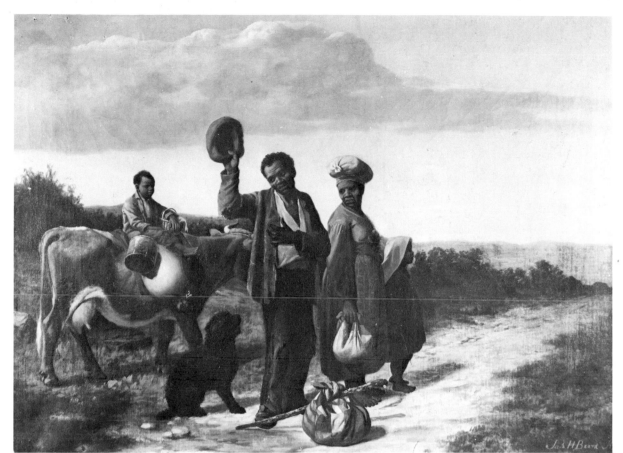

105. James Henry Beard, *Good-bye, Ole Virginia*, 1872. J. N. Bartfield Art Galleries, New York.

what he sees, with no exaggeration, theatricality or sentimentality. The sad family, with its few possessions packed in bundles and driving its prize asset, a cow, trudges along a dirt road toward an unknown destination. Here are all the elements of a real tearjerker, but Beard handles the subject with dignity and sympathy.

This down-to-earth realism, which antedates the similar objective realism of Thomas Eakins and Thomas Anshutz by half a century, was a development of Beard's mature years. As a younger man he, like so many of his generation, including his brother William Holbrook Beard, followed the easier course of appealing to the risibility of his audience. His best-known work, *The Long Bill,* 1840 (The Cincinnati Art Museum), shows an unhappy customer as he receives a long-outstanding account for his purchases in a general store on the advancing frontier. It is typical of the American sense of humor to find comic

the discomfiture of a fellow being. The farcical approach should not, however, distract one from observing the arrangements of the store—its counter and shelves stacked with staples, the barrels, vegetables and turkey—or the old codger warming his hands and feet before the cast-iron stove. Another record of the frontier is his *The Land Speculator,* c. 1845 (collection Dr. Lester E. Bauer), which shows a salesman trying to promote the sale of a parcel of new land to a prospective customer.

Beard was also a prolific portraitist, but his interest for us lies in his genre paintings. Although he did not reach the level of artistic accomplishment that Mount, Bingham and Ranney attained, his insight into contemporary life and his honesty in recording it earn him a respectable place in American art history.

Thomas Hicks (1823-1890) generally is remembered exclusively in terms of his portraits, which are among the best of his generation. Little attention has

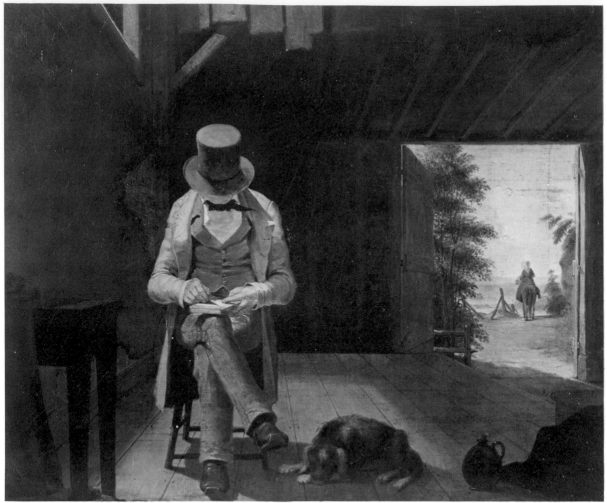

106. Thomas Hicks, *Calculating,* 1844. Museum of Fine Arts, Boston; M. and M. Karolik Collection.

been paid to his rather rare genre paintings. *Calculating,* 1844 (Fig. 106), was painted before he went to Paris, where he completed his formal training under Thomas Couture. A quiet painting, it possesses an individual point of view which Hicks seems to have lost after his study abroad. Certainly *The Musicale, Barber Shop, Trenton Falls, N.Y.,* 1866 (Fig. 107), lacks the spirit which sets *Calculating* apart. It reflects instead a distinctly French influence, which from this point on is to be the rule rather than the exception in American painting. The difference in the two paintings is so marked that one could easily think they were by different hands. *The Musicale* is a rather strange painting for the Reconstruction era and is for that reason all the more interesting. Here we have not only integrated musicians, but also an integrated audience. From all appearances this is not a staged composition developed as propaganda, but a painting derived from an actual incident.

It must be admitted that the painting next discussed is marginal to this study. Although the identities of

the five men portrayed have been lost, the intrinsic evidence of the painting itself clearly suggests that they were known individuals and were painted as such and not as types. Notwithstanding this compelling reason for its exclusion, the painting is so unusual in its subject matter that the temptation to include it proved irresistible. *Four Wine Tasters in a Cellar,* c. 1850 (Fig. 108), by an unidentified painter, is a rare depiction of an American wine cellar. The painting presumably shows a cave where wines imported from Madeira and France were stored pending their sale. The cellarer with lighted candle is in attendance on the four presumed owners, but the general illumination is provided by a gas jet over the arched doorway. From the expressions on the faces, wine tasting is an extremely serious occupation, or perhaps they have just sampled a cask that has turned to vinegar. Unfortunately, we shall never know the answer.

The Philadelphian Thomas Birch (1779-1851), like Durrie, painted landscapes which contain elements of genre. As a young man he worked with his father,

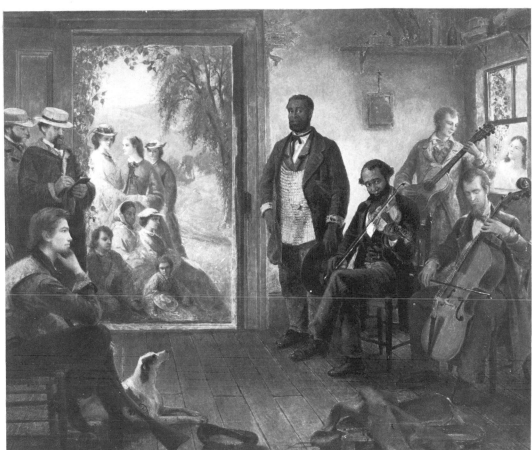

107. Thomas Hicks, *The Musicale, Barber Shop, Trenton Falls, N.Y.*, 1866. North Carolina Museum of Art, Raleigh.

108. Unidentified artist, *Four Wine Tasters in a Cellar*, c. 1850. Museum of Fine Arts, Boston; M. and M. Karolik Collection.

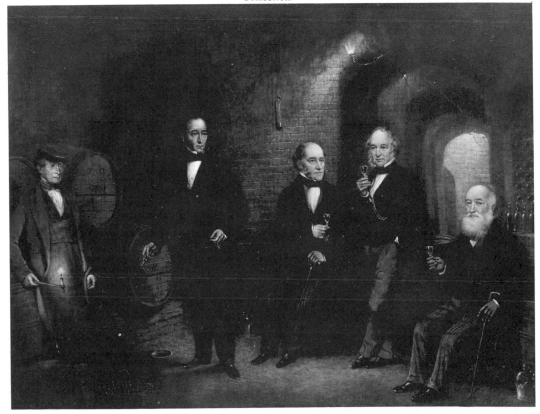

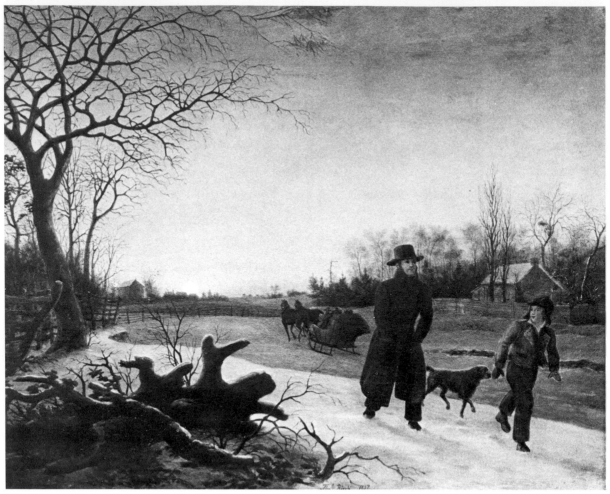

109. Thomas Birch, *Winter*, 1838. The Reading Public Museum and Art Gallery, Reading, Pennsylvania.

William Russell Birch, in producing a series of engraved views of Philadelphia, but he is best known for his marine paintings.

With Alvan Fisher and Durrie, Birch was one of the first Americans to specialize in painting winter landscapes. Like Durrie he rarely placed figures prominently in the foreground, using them instead only to provide a human element in his landscapes. However, as is often the case, there is an exception to this generalization. In *Winter,* 1838 (Fig. 109), the focus of attention is on a father, son and dog walking by the side of a road. The snowy landscape contributes in about the same degree as the figures to the effective impression the painting conveys: the sunset light on the snow, the silhouetted branches of the trees against the lighter sky, sharpen the sense of penetrating chill as the figures head toward the cozy hearth that awaits their arrival.

Jerome B. Thompson (1814-1886) during much of his active career lived on Long Island, New York. In his earlier days, it would appear, he was exclusively a

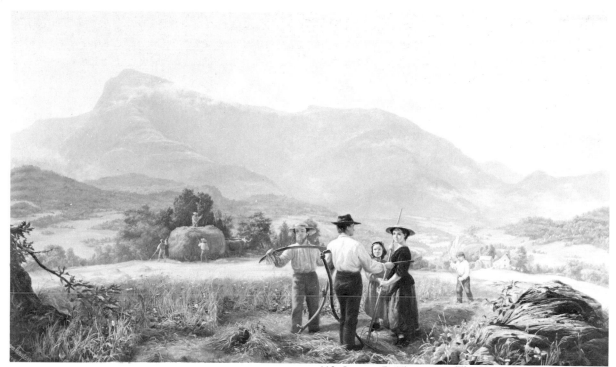

110. Jerome B. Thompson, *The Haymakers, Mount Mansfield, Vermont*, 1859. Private collection. (Color plate XIII)

portrait painter. He exhibited at the National Academy of Design from 1835 on, but it was not until 1850 that his first genre picture was shown. He stopped exhibiting at the Academy after 1860, but showed at the Boston Athenaeum until 1865. Thompson developed an artistic format for his genre paintings that was distinctly his own. Perhaps his idea developed from seeing such paintings as Durand's *Dance of the Haymakers*, but in any event between 1850 and 1860 Thompson painted a series of canvases which most successfully integrate genre and landscape. With great skill the figures are made to appear completely at home in the landscape, which is not merely a backdrop for the figures but has a life of its own.

The painting which best exemplifies this is *The Haymakers, Mount Mansfield, Vermont*, 1859 (Fig. 110). In the foreground, the focus of attention is the farmer and his family working in the hot morning sun. Then the eye is inevitably drawn to the broad expanse of the valley with its rising mists, and finally to the

121

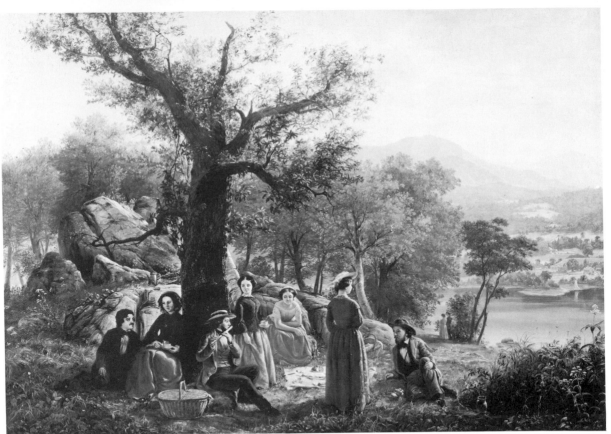

111. Jerome B. Thompson, *The "Pick Nick" near Mount Mansfield,* c. 1850. M. H. De Young Memorial Museum, San Francisco.

112. Jerome B. Thompson, *Apple Gatherers,* 1856. The Brooklyn Museum, Brooklyn, New York.

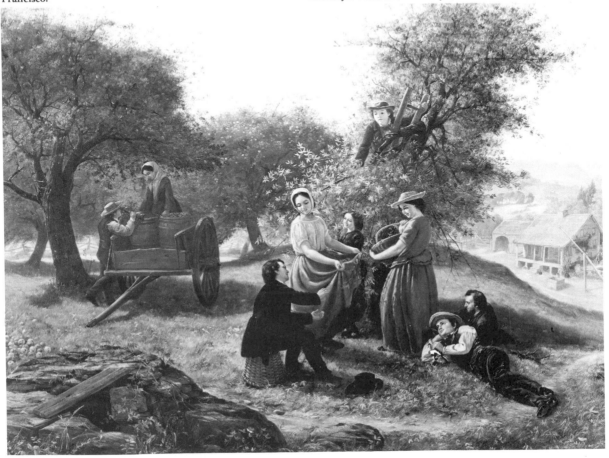

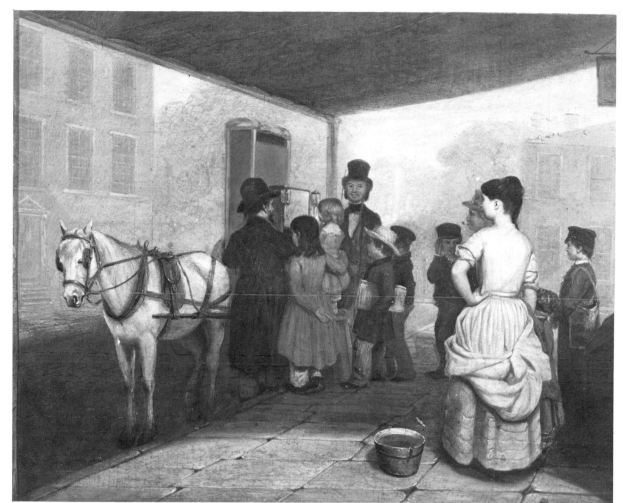

113. Jerome B. Thompson, *The Peep Show*, 1851. Museum of Fine Arts, Boston; M. and M. Karolik Collection.

distant mountains beyond. The quiet of the impressive, luminous landscape is an effective foil for the toiling figures. It is a scene of peace, which, despite its commonplace subject, possesses a strange dignity.

The earliest located pictures in this series are *The "Pick Nick" near Mount Mansfield,* c. 1850 (Fig. 111), with its vista of Lake Champlain, rolling hills and distant Adirondack mountains and picnickers quietly listening to the tune played by the flutist, and *Pic Nick, Camden, Maine,* c. 1850 (Museum of Fine Arts, Boston), which is a more robust variant on the ever-popular theme of out-of-door social gatherings. Here the participants are indulging in various innocent pranks.

*Apple Gatherers,* 1856 (Fig. 112) has much of the same charm as *The Haymakers,* but the setting is not as impressive, since the landscape prospect is limited to a vista on the extreme right. The last of the series, *Old Oaken Bucket,* 1860 (collection Hirschl and Adler Galleries), lacks the vitality of Thompson's

earlier canvases, but on a less ambitious level is a sincere evocation of rustic life before the Civil War.

Thompson's painting of city life, *The Peep Show,* 1851 (Fig. 113), is not as well painted, but has considerable interest as a representation of a vanished bit of Americana, the traveling peep show.

William James Stillman (1828-1901) was a man with interests as diverse as his natural talents: artist, diplomat, newspaperman, author and art critic. He studied landscape painting with Frederic E. Church in the late 1840's, but after 1860 apparently ceased to paint to any extent. Stillman founded *The Crayon,* the first American art magazine, in 1855. Before that he had taken part in Kossuth's rebellion in Hungary. He was American consul at Rome and later at Crete. He settled in England, but spent much time in Rome as a special correspondent for the London *Times.* He died in Surrey, England.

Very few of his paintings have been located. One of these rare canvases, *The Philosophers' Camp in the*

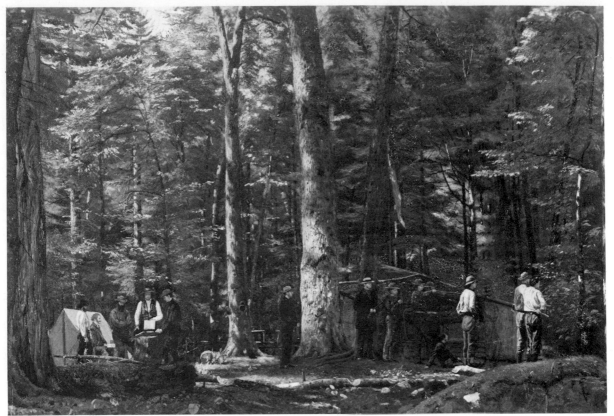

114. William James Stillman, *The Philosophers' Camp in the Adirondacks*, 1858. Concord Free Public Library, Concord, Massachusetts.

*Adirondacks*, 1858 (Fig. 114), shows a group of savants encamped in the depths of a virgin forest at Follansbee Pond, near Saranac, New York.[8] All the individuals shown can be identified, and they are very impressive personages, including Ralph Waldo Emerson, James Russell Lowell, Louis Agassiz and the artist.[9] What excites us today about the painting is not the celebrity of the individuals it portrays, but the curious way in which it seems to forecast the objective realism of Thomas Eakins, not only in the handling of the light and shadows, but even in technique. For its period it is a very modern canvas.

Frank Blackwell Mayer (1827-1899) worked primarily in the Baltimore-Annapolis area. He did a few rather inept ethnological paintings based on a trip to Minnesota in 1851, but most of his work was in the nature of historical reconstructions. He also painted many portraits, at least one pleasant landscape, *Francis Street, Annapolis,* 1876 (The Metropolitan Museum of Art), and two genre paintings which have survived. *Leisure and Labor,* 1858 (Fig. 115), was

painted before he went to study in Paris with Marc Gleyre and Gustave Brion.[10] It is by far his most successful canvas, carrying on the genre tradition of Mount and Bingham with facility and charm. The village smith is hard at work shoeing a horse, while an elegantly dressed young man observes. There are no overtones of social comment; the painting remains a pleasant but unpointed commentary on a commonplace event.

In one of his paintings Mayer chose to do an unusual subject, the interior of a chart room at sea. *Ship's Cabin,* 1890 (The Maryland Historical Society, Baltimore), is unpretentious, but for the social historian it is a rare document. Paintings showing close-up views of life at sea are extremely scarce.

Only one painting by the younger brother of the painter Robert W. Weir, Charles E. Weir (c. 1823-1845), has come to light. This, *The Wood Sawyer,* 1842 (Fig. 116), shows the single figure of a Negro sawing wood into fireplace lengths in what appears to

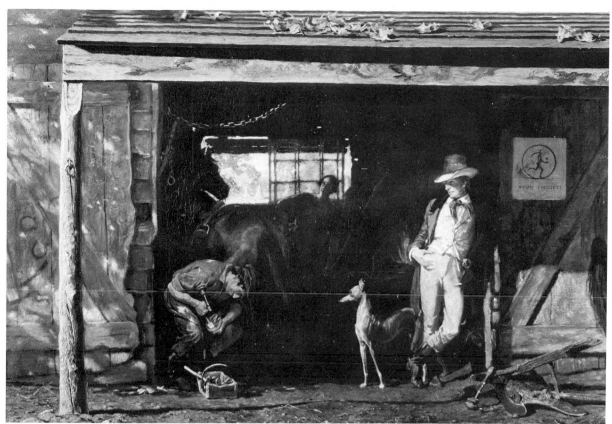

115. Frank Blackwell Mayer, *Leisure and Labor,* 1858. The Corcoran Gallery ot Art, Washington, D.C.

116. Charles E. Weir, *The Wood Sawyer,* 1842. Collection Jay P. Altmayer.

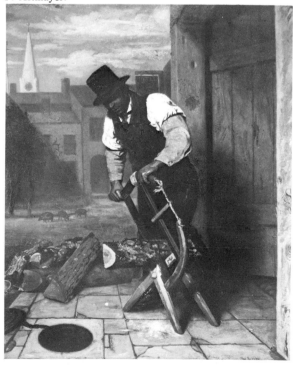

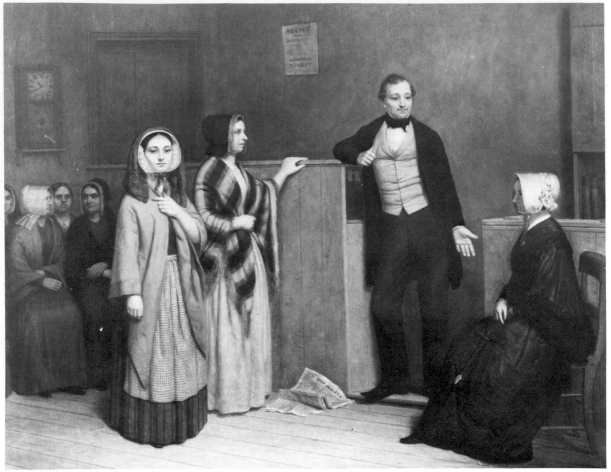

117. William Henry Burr, *Intelligence Office,* 1840. The
New-York Historical Society, New York.

be a mews in lower Manhattan. New York was then
still sufficiently countrified that the three pigs rooting
around under the trees were a familiar part of the city-
scape. Weir, in this youthful but thoroughly pro-
fessional work, shows himself to have been a
talented draughtsman. In the four years he exhibited at
the National Academy of Design, he showed almost as
many genre subjects as he did portraits, and some,
such as the unlocated *Compositor Setting Type,*
1844, are unusual in subject matter. It is unfortunate
that his promising career was cut short by an untimely
death.

Another figure who remains obscure, owing to the
paucity of his located work, is William Henry Burr
(active 1840-1859). Burr lived and worked in New
York, and the only canvases by him that are known to
the writer are his *Intelligence Office,* 1840 (Fig. 117),
and the more colorful *The Scissors Grinder,* 1856
(Fig. 118). The former painting is another of the many
works which are of greater interest for subject than for
artistic qualities. The terminology of the title is ar-

chaic today; what is shown in the painting we now call
an employment agency. From the conveniently
provided sign and the persons shown, we know this
one specialized in placing female domestics. The
subject of the painting is apparently unique in its
period, and consequently, as a document of social
history, it takes on special significance.

It is strange that there are so few surviving pictorial
records which relate, even indirectly, to the im-
migrants who arrived on almost every ship from
Europe. The earliest painting so far located which
shows the debarkation of a cargo of immigrants is *The
Battery, New York,* 1855 (Fig. 119), by Samuel Bell
Waugh (1814-1885). Waugh was noted for his
panoramas, and this painting was done on that scale.
The ship that is tied up at the dock disgorging hordes
of new arrivals seems to have come from Ireland,
judging from the appearance of those already ashore.
In the background lies the Chinese junk which created
such a stir when she arrived in 1847 and which
Waugh included in his composition despite the fact

126

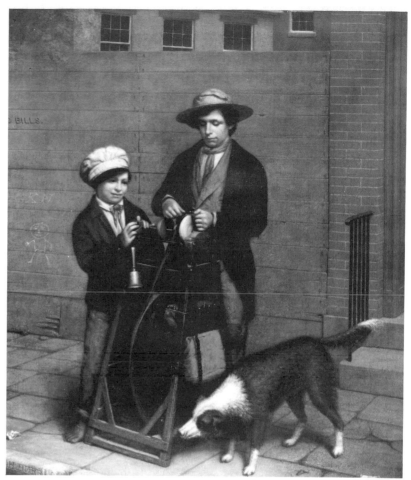

118. William Henry Burr, *The Scissors Grinder*, 1856.
Collection Mrs. Norman B. Woolworth.

119. Samuel Bell Waugh, *The Battery, New York*, 1855.
Museum of the City of New York.

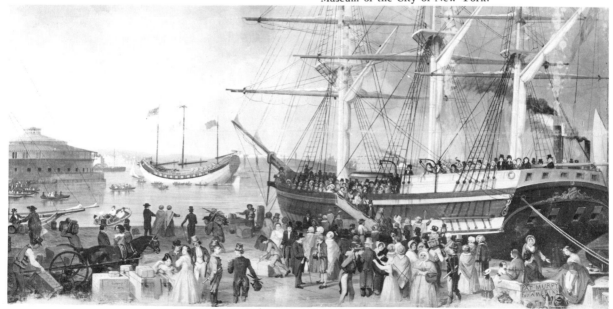

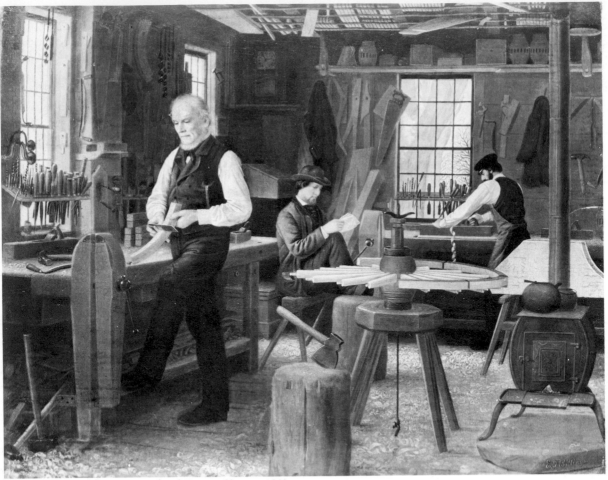

120. Edwin T. Billings, *Ira Billings' Wagon Shop,* c. 1860.
Collection E. F. Fischer.

that she was no longer in New York harbor at the time
he painted this picture.

Edwin Tryon Billings (1824-1893) was primarily a
portrait painter. He is believed to have been a native of
Massachusetts. In 1857 he was in Alabama, but by
1858 was back in Massachusetts. He eventually
moved to Boston, where he remained to the end of his
life. About the year 1865 he became a recluse.[11]

*Ira Billings's Wagon Shop,* c. 1860 (Fig. 120),
smacks of the Yankee. Here is direct observation in
pure form; the record of the scene is uncomplicated by
any obeisance to the canons of the grand style. That
Billings was a gifted observer is attested by the bleak
vista of wintry trees through the back window, the
stance of the carpenter using his plane, the long curl of
shaving and especially the delicate modulation of light

on the various surfaces.

Again, as is true of so many other artists, how sad it
is that this minor masterpiece is apparently Billings's
sole claim to immortality.

Thomas Le Clear (1818-1882), whose mature work
is somewhat akin to that of William Page in its softly
focused impressionistic technique, is a painter who
clearly deserves greater recognition.[12] He studied
with Henry Inman in New York between 1839 and
1846, and Inman's influence can be detected in the
work of Le Clear's youthful years. From 1847 to
1863, when he left for New York, he worked in
Buffalo, and, while portraits provided his main in-
come, according to surviving exhibition records he
also produced a considerable number of genre paint-
ings. One of these, *The Reprimand,* now lost, was

128

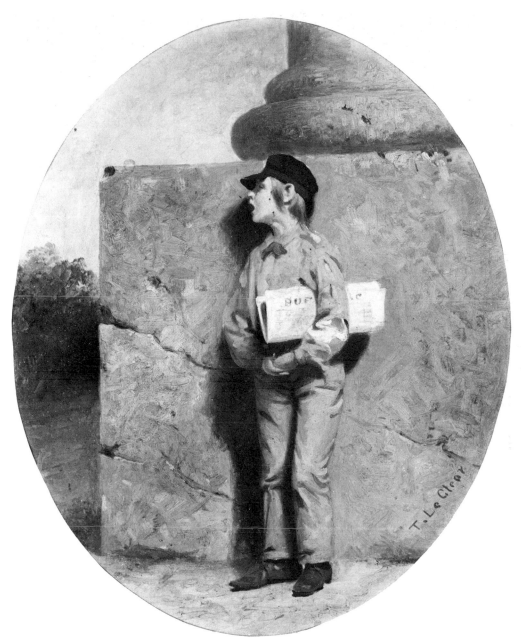

121. Thomas Le Clear, *The Little Buffalo Newsboy,* c. 1845.
Collection David S. Jackson.

purchased in 1846 by the American Art Union.
Unfortunately, few of his genre subjects can now be
located. After 1863 he devoted himself exclusively to
portraiture.

Le Clear's genre pictures were largely street scenes
peopled by youngsters selling newspapers, playing
musical instruments and aping their elders. *Two
Children,* c. 1863 (National Academy of Design, New
York), a painting of a boy and girl reading, reflects
Inman's influence. But it lacks Inman's facility and
charm and is a dull picture that does not show Le Clear
at his best. While again not a major effort, *The Little
Buffalo Newsboy,* c. 1845 (Fig. 121), is a charming
and sensitively painted study. [13] It is far superior to his
teacher's similar canvas, *The Newsboy,* 1841
(Addison Gallery of American Art).

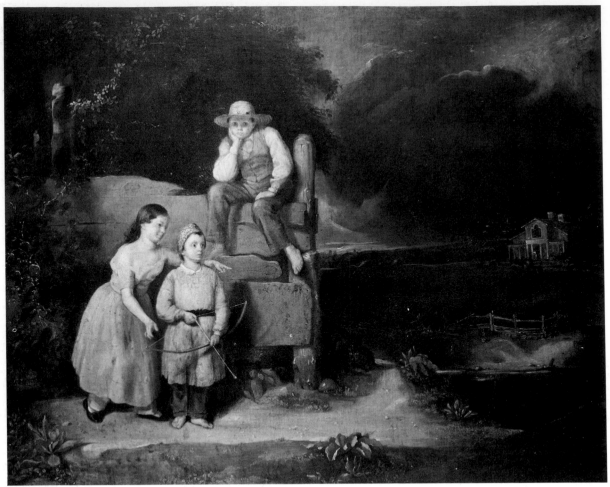

122. Thomas Le Clear, *The Young Hunter*, c. 1840. Private collection.

An undated work which stylistically would appear to come from early in Le Clear's career (the late 1830's or early 1840's) is *The Young Hunter* (Fig. 122). The canvas shows a small boy with a child's bow and arrow; his attention is being directed by a young girl to a target outside the painting. Sitting on a fence above the pair is an older boy who stares enigmatically directly at the viewer. The anecdote is far from clearly stated, with the viewer left in doubt as to what is going on. The asymmetrical composition may not be completely satisfactory, but it is strongly individualistic. This painting shows Le Clear to be one of the best colorists of his period, capable of a paint quality equal to Woodville's.

In contrast to this early work, Le Clear's *Buffalo Newsboy,* 1853 (Fig. 123), is simple and direct. It presents a single figure and captivates the viewer into sympathetic rapport with the young newsboy eating an apple.

The only other genre painting by Le Clear of which this writer is aware is technically a commissioned portrait; however, it goes considerably beyond the limitations that implies. This recently rediscovered painting, *Two Children in the Studio,* c. 1865 (collection Mrs. Frank St. John Sidway), has a distinctly surrealistic quality, although that term was unknown to Le Clear. [14] The two children stand stiffly in front of a photographer's backdrop in a cluttered studio. On the extreme right a photographer bends over his camera adjusting the lens. Off center, on the left, a hound peers expectantly around a partially open door. The contrast between the dark studio, painted in realistic detail, the equally alive photographer and hound, and the two small children frozen in a stiff pose before the large, luminous landscape backdrop, creates an eerie atmosphere reminiscent of the imagery of a dream.

The circumstances under which the painting was commissioned and executed might explain much of its unusual character. According to family tradition, this portrait was ordered by the children's older brother, Franklin Sidway. The little girl, Parnell, died at the

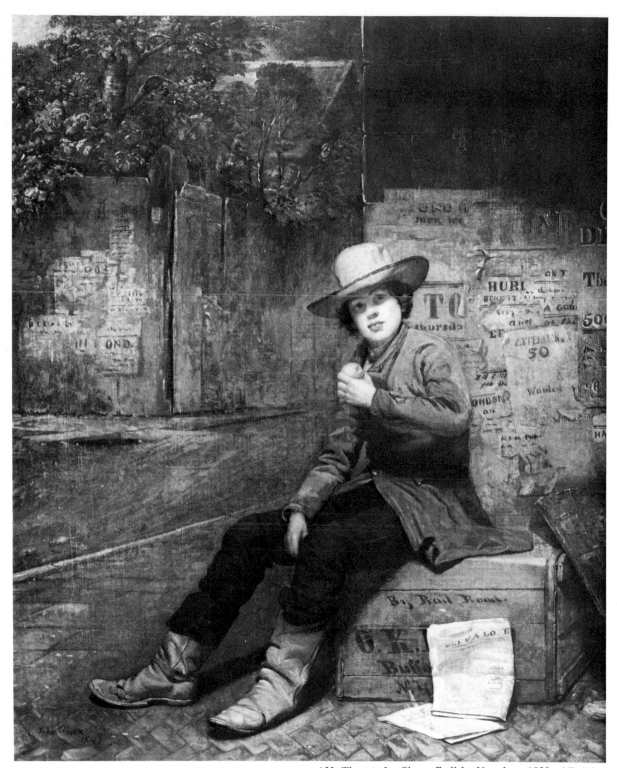

123. Thomas Le Clear, *Buffalo Newsboy*, 1853. Albright-Knox Art Gallery, Buffalo, New York.

age of twelve in 1849; the boy, James, died in a fire in 1865. Beaumont Newhall states that the camera shown, a wet collodion type, could not have been made before 1860. He suggests that Le Clear painted the two children from an existing daguerreotype, which from the pose and costume seems very plausible. The painting is difficult to date accurately. If it was completed in Buffalo before Le Clear left for New York, 1863 would be the latest date possible. It would be more logical to assume, however, that the portrait was ordered after the tragic death of James in 1865. It would then have been most apt to occur to a surviving member of a family to record the likenesses of his deceased brother and sister, which would mean that the painting was executed in New York about 1865 as a memorial commission.

Primarily a historical, religious and portrait painter, Thomas Prichard Rossiter (1818-1871) left one located genre painting that justifies his inclusion. This painting, *Rural Post Office,* 1857 (Fig. 124). was probably painted in New York State, possibly in the vicinity of Cold Spring on the Hudson, where in 1860 Rossiter built a house in which he resided until his death. The painting does not make a unified, clear-cut impression on the viewer, probably because Rossiter has incorporated enough pictorial material for several canvases. There are passages of good painting, as in the figure of the man with the straw hat reading a letter on the porch steps, but the handling of perspective and of anatomical proportion, especially in the delineation of the small girls, is woefully inept.

George Henry Yewell (1830-1923) was a student at the National Academy in New York from 1851 until 1856, when he went abroad to study with Thomas Couture in Paris. He did not return to America permanently until 1878. Only one early painting by Yewell of a genre subject has been located, *The Bootblack,* 1852 (Fig. 125), This strange canvas, perhaps a little awkward in some respects, shows the impress of a strong individuality and a freshness and candor that make it unusual for its day. Against the backdrop of New York's Tombs prison, built in Neo-Egyptian style, the young bootblack sits, grave and composed. Buttoned up against the chill, the lad neither asks for nor expects sympathy. He may not be happy with his lot, but he is taking it in stride. What a contrast he is to the slick, well-scrubbed bootblacks produced in never-ending succession by J. G. Brown in his later years.

The major genre satirist of the nineteenth century in the United States was David Gilmour Blythe (1815-1865). Born in Ohio at the time when that state was still on the frontier, Blythe was largely self-taught. His approach to painting was strongly individualistic, further tempered by the vicissitudes of his life. His happy marriage was terminated after only a year by the death of his bride. Thereafter grief, self-pity, bitterness and alcoholism colored his work.

Beneath the surface buffoonery of some of his canvases there is a keen perception of human foibles, caught with an appreciative and often genial gusto. Blythe's best-known works show aspects of urban life

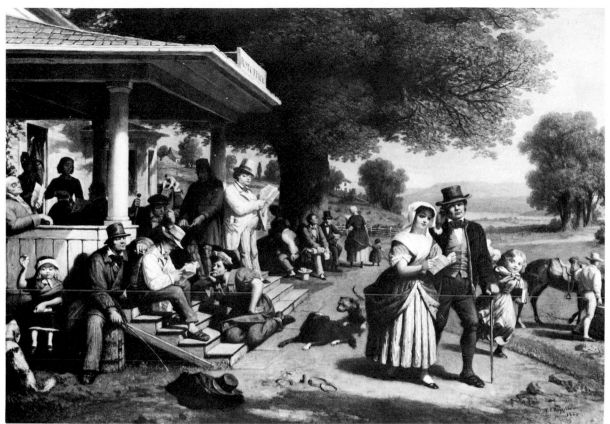

125. Thomas Prichard Rossiter, *Rural Post Office,* 1857. International Business Machines Corporation, Armonk, New York.

124. George Henry Yewell, *The Bootblack,* 1852. The New-York Historical Society, New York.

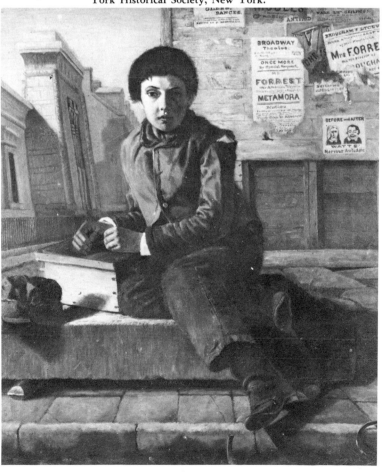

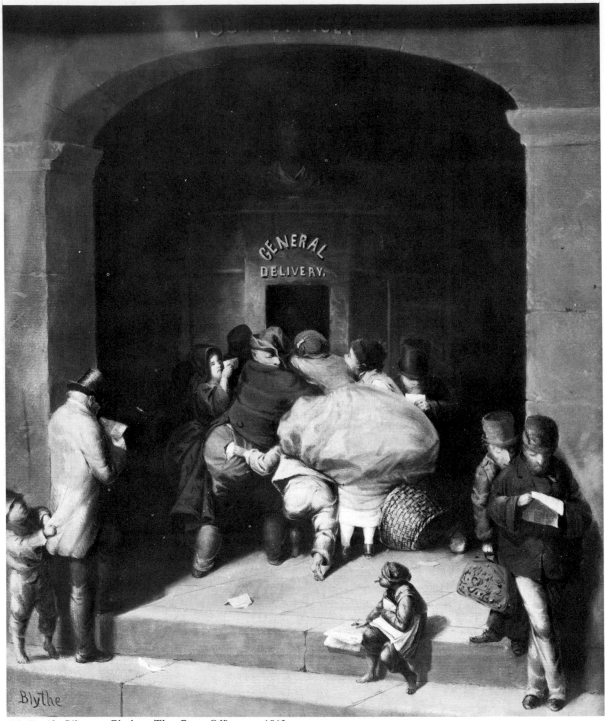

126. David Gilmour Blythe, *The Post Office,* c. 1863.
Museum of Art, Carnegie Institute, Pittsburgh.

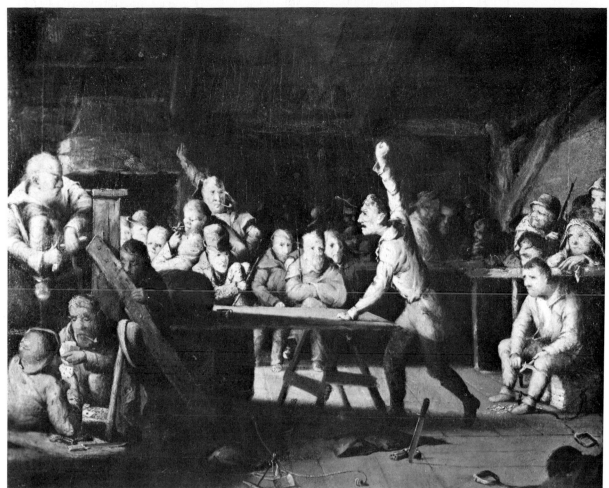

127. David Gilmour Blythe, *Trial Scene*, c. 1860. The Memorial Art Gallery of the University of Rochester, Rochester, New York.

in which he wags a derisive finger at the venality, absurdity and frailty of society. He brings out as did no other American painter of the nineteenth century the pathos of the common people.

Blythe's period of greatest productivity is the decade between 1856 and 1865, although he produced a considerable volume of primitive portraits early in his career. The work of his mature years is almost equally divided between urban genre scenes of Pittsburgh and his deeply felt compositions related to life during the Civil War.

Among the former are some of his finest paintings, such as *Pittsburgh Horse Market,* c. 1860 (collection Mrs. R. Lucien Patton), *The Post Office,* c. 1863 (Fig. 126), and *Trial Scene,* c. 1860 (Fig. 127). They display no discernible development in style or technique and are all painted in the same restricted, muted palette, because Blythe generally speaking seems only occasionally to have been interested in color. He made full use in his drawing, however, of artistic distortion for dramatic effect—and did it at a time when such

license was not conceded the artist. *The Shoremen,* c. 1860? (Fig. 128), is Daumier-like in its impact and shows Blythe's sensitive yet powerful mastery of figure drawing. The freedom of the brushwork and the rich effect, unusual for Blythe, of the muted but glowing colors make this small canvas a little gem of delight. *The Hideout,* c. 1855 (Fig. 129), is a satirical comment on underworld characters, which no other American painter of Blythe's period attempted to depict.

Blythe is at his best in compositions with two or more figures. A fair number of his paintings with a single figure appear to have been dashed off in a hurry as pot-boilers, or perhaps, in the case of Blythe, it would be more accurate to say whiskey snorts.[15] One which does not seem to have been painted in this manner is *Conscience Stricken,* c. 1860 (Fig. 130), which shows a gravedigger standing beside a tombstone, overcome by unhappy recollections.

A strange exception to Blythe's usual city subjects is *Corn Husking,* c. 1860 (The Metropolitan Museum

135

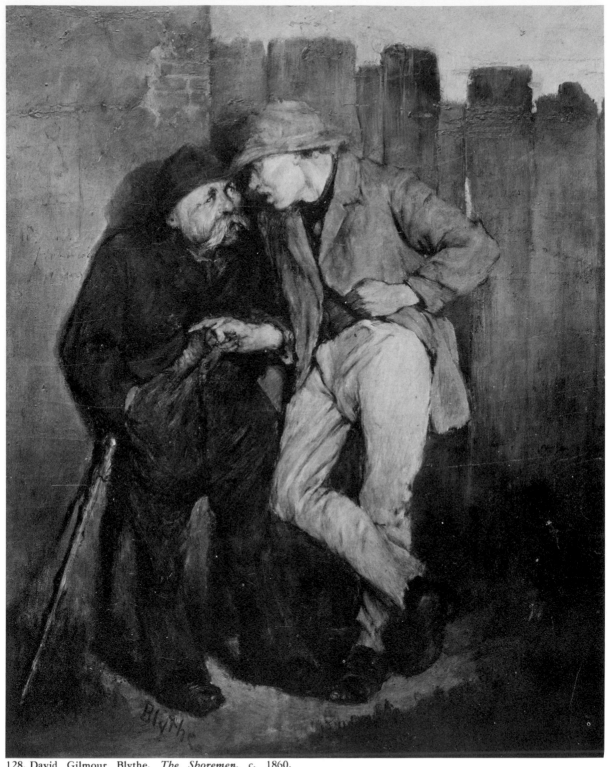

128. David Gilmour Blythe, *The Shoremen*, c. 1860.
Collection William H. Vodrey.

130. David Gilmour Blythe, *Conscience Stricken*, c. 1860. ▶
Philadelphia Museum of Art; W. P. Wilstach Collection.

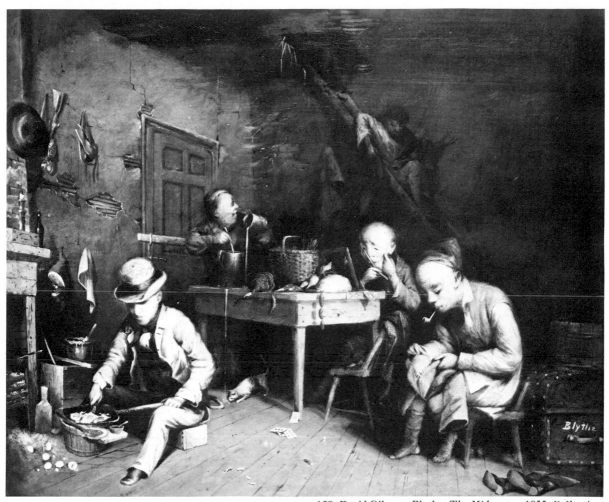

129. David Gilmour Blythe, *The Hideout,* c. 1855. Collection
Joseph Kelly Vodrey.

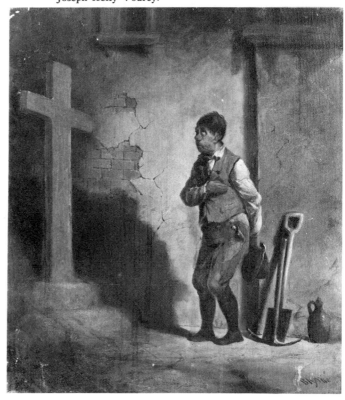

131. David Gilmour Blythe, *Libby Prison*, 1863. Museum of
Fine Arts, Boston; M. and M. Karolik Collection.

of Art), a moody nocturnal landscape with, in the
foreground, a group of seven figures husking corn in
the moonlight.

Equally impressive is the group of paintings, only
some of them satirical, of incidents in the Civil War,
which elicited a strong emotional response from the
artist. His *General Abner Doubleday Watching His
Troops Cross the Potomac,* c. 1863 (National Baseball
Hall of Fame and Museum, Cooperstown, N.Y.) is a
major work, although it hardly qualifies as genre. Its

freshness and the gaiety of its color and spirit contrast
with *Libby Prison,* 1863 (Fig. 131), which, despite
the fact that Blythe had not visited the Confederate
prison in Richmond, captures the oppressive quality of
its fetid, cramped conditions. *Battle of Gettysburg,*
1863-65 (Museum of Fine Arts, Boston), focuses on
teams of horses rearing back in fright from an ex-
ploding shell, and in it Blythe paints with a passion
and technical force in sharp contrast to his usual
manner. A more typical Blythe Civil War theme is

*The Story of the Battle*, c. 1865 (collection Duquesne Club, Pittsburgh), which shows four people on a back porch. Two women and an old man are listening intently to a soldier who has lost a hand and a leg tell the story of his experience. Blythe presents his story simply and effectively, making full use of the quiet, homey setting to emphasize the horror of the war.

A genre painter by temperament, Blythe's indifference to financial reward from his art freed him to paint without considering public response and criticism. His point of view is refreshingly at variance with those of most of his contemporaries. For the most part, they were motivated by the desire to exhibit, to have their works reproduced as prints and to sell. They frequently made compromises in choice of subject matter, technique and message to achieve these ends.

Blythe's surviving work is uneven in quality, but when he was at his best, he was without peer. He did not carry finish to anything remotely approximating the degree attained by the popular artists working in the Düsseldorf tradition. He was more concerned with the effects of light and shade and atmosphere, and he never felt obliged to force himself. His chief interest was in people, and he depicts them honestly, without sentimentality, idealism or romanticism. His scrutiny cuts through the polite clichés of the period and affords us a glimpse into the past through his highly sensitive perceptions. Blythe had an understanding of what is common to all people, and that is why he is a greater artist than most of his American contemporaries.

It is appropriate to close the chapter with Blythe, for he was the last important figure before the great change in taste that came over American painting after the Civil War. To be sure he was a complete individualist and his work does not fit the pattern followed by his contemporaries. Blythe had in his interpretive views of our society the disconcerting habit of criticizing existing conditions. In this he differed from the artists touched on in this chapter who preceded him. They were apparently oblivious to social problems—and did not share the cynicism of vision with which Blythe scrutinized his fellows. On the contrary, they exhibited a thoughtless optimism. Their work by and large has a quality of innocence, one might say a provincial simplicity, or in some cases a stark clarity. And while Blythe was a maverick among them, they nevertheless all shared a forthright and self-confident attitude.

The war changed all this. The accepted belief in the perfection of American life was shaken. The old, placid ways were disrupted. A new international role of uncertain direction, for which we were scarcely prepared, was suddenly thrust upon us. The artist was swept along in the fast current of change. The earlier native clarity of style was losing its adherents and patrons. The country was seized by a yearning for sophistication, which encouraged many artists to study abroad and to bring back not just a broader appreciation and acquired technical skills but the surface styles and attitudes of the continental art centers with which we were henceforth to compete.

□

# CHAPTER 5

# The Winds of Change

The third quarter of the nineteenth century saw the conflict between the northern and southern states come to bloody confrontation and final resolution. It also witnessed changes in the nation's social and economic structure. The rise of large-scale industry organized on modern mass production principles took place in this period. Agriculture similarly made increasing use of machines, replacing manual labor. Methods of transportation and communication were improved as a result of technological advances. New schools and colleges were founded and older institutions expanded. The tide of immigration continued to pour its multitudes from abroad onto the vast continent.

By 1865, the country had affirmed its unity and ostensibly solved its major problems. Yet some basic problems still existed and new ones were appearing. The question of slavery was formally settled, the assimilation of the Negro was not. Slums grew as the cities grew and began to disturb the public consciousness. Large-scale industry brought into focus the distinctions between capital and labor and sharpened their antagonism as they struggled to cope with the problems of recessions, unemployment, strikes and dangerous and unhealthy working conditions. Corruption in political office became more prevalent. The gap between poor and rich became, at its extremes, vast, whereas in simpler republican days the range had been small. There was still an identifiable frontier, but now it was far to the West; the chance for a better life was no longer just over the next mountain range. Some of the buoyant optimism and self-satisfaction went out of American life and out of American art as well.

Painters were swept along with the tide of an expanding economy. There were patrons now. No longer did the affluent citizen have to face the censure of his peers for collecting art, considered not long before a luxury injurious to a pure republican state. It was an age of conspicuous consumption, and many a newly-rich magnate had private galleries which rivaled the palazzos of Rome in ostentation. Sadly, it was not the

American artist who benefited most from the increased cultural acquisitiveness.

It was an age of outward gentility. As a general rule the artist respected the bounds of good taste and respectability, as limited by the Victorian ethic, in his choice of subject. Thus scenes touching on the life of the poor laborer, or the child who lived on city streets, were rarely honest representations which would point to the need for social reform. The Victorian taste for elegance and sentimentality could not help but inhibit depiction of the sordid, oppressed side of American society. It is indicative of the temper of the time that in the main the inheritors of the clear-cut vision of the earlier years of the century were painters of rural subjects. The new urban life styles came under the brush of artists whose tastes and training led them to romanticize their subjects.

The great tide of immigration from Europe brought in not only the Irish peasant after the potato famine, but also a great many intellectuals, artists and skilled workers from Germany who had become disenchanted with conditions in Europe. These and other arrivals from Middle Europe, Scandinavia, Italy and elsewhere, bringing their own cultural patterns, changed the essentially Anglo-Saxon character of the country to that of a cosmopolitan, indeed, a temporarily polyglot nation. The old unity was gradually eroded and was replaced by new standards which evolved to meet new social and economic conditions.

Sometime after the Civil War interest slackened in American scenes by American artists. This trend, encouraged by such experienced art dealers as Goupil's in New York, succeeded in bringing about a complete change of taste. The vogue for European art, which lasted through the balance of the nineteenth century and well into the twentieth, steadily gathered momentum. The few American museums in existence during this period did virtually nothing to encourage American art, but blithely collected Barbizon paintings and old masters, giving an occasional memorial exhibition to some safely dead, uncontroversial member of the National Academy. This change in taste was a reflection of the weakening of our earlier nationalistic self-confidence. The war, with its human and material destruction, immigration, industrialization and urbanization, all on a huge scale, brought to the fore problems that had not been faced, and raised some that had not existed. Increasingly we turned to the more experienced and sophisticated Old World for cultural guidance. Europe seemed to have the answers to the new needs and aspirations.

Eastman Johnson (1824-1906), despite his acknowledged place as one of the outstanding painters of the nineteenth century, surprisingly has never been the subject of a major book.[1] Johnson lived a long and productive life, dividing his time between portraits and genre. Unlike his contemporary, Winslow Homer (1836-1910), who concentrated on genre throughout his career, Johnson abandoned this area of subject matter in the early 1880's, turning almost exclusively to portraiture which, because he was greatly in demand, was vastly more lucrative.

As a young man, Johnson followed the traditional path of the nineteenth-century American painter. After early training at home in Augusta, Maine, he traveled to Düsseldorf in 1848, then in 1851 to The Hague, where he spent several years, and finally, in 1855, to Paris. This formal artistic training is reflected in the eclecticism of his work, which shows borrowings from all the centers where he studied and from the old masters, especially Rembrandt.

Johnson moved around the country more than many of his contemporaries. After his return from Paris in 1855, he went in 1856 and again in 1857 to the western frontier. His work there was restricted to depicting the indigenous inhabitants, the Chippewa Indians living in Superior, Wisconsin. Another group of paintings limited to a single subject, the maple-sugar camps of Fryeburg, Maine, were done between 1865 and 1875. However, according to John I. H. Baur, Johnson painted other aspects of Maine farm life in the Kennebunkport area between approximately 1873 and 1879.2 He also explored pictorially the island of Nantucket, where he summered for many years from the early 1870's onward. Numerous canvases record the salty islanders at home and at work in the fields and cranberry bogs. This itinerary does not take into account trips of shorter duration, to the Catskills and to Murray Bay, Quebec—excursions made in the late 1860's—or those to the battlefields in Virginia, Maryland and Pennsylvania early in the Civil War.

However, Johnson's main center of activity was New York, where he first established a studio in 1859-60. From the time of his marriage on June 29th, 1869, to the end of his life, he made his home at 65 West Sixty-fifth Street. There he developed and completed canvases which originated on his trips around the country. There he also painted the domestic life of New York's bourgeoisie.

Like Mount's *The Rustic Dance* and Bingham's *The Jolly Flatboatmen,* Johnson's first major genre painting, *Negro Life in the South,* 1859 (The New-York Historical Society), which he did while visiting his family, which had moved to Washington, D.C., won the artist immediate national recognition. The painting, later called *Old Kentucky Home,* was actually painted in Georgetown, the old city which modern Washington has engulfed. In it Johnson demonstrated he was not by nature a reformer. He records the dilapidated Negro quarters, the shabbily clad Negroes and the well-maintained adjacent mansion, but he accepts the situation as he finds it. The scene is permeated with a spirit of youthful optimism, and displeased neither the abolitionists nor the slaveholders. Johnson did a number of related canvases, some of which may have been painted as preliminary studies, while others, such as the small, unpretentious *Chimney Corner,* 1863 (Munson-Williams-Proctor Institute, Utica), are later offshoots of its success.

To the dismay of scholars, Johnson did not follow a normal sequential pattern of development in technique or style; for no apparent reason, he fluctuated between

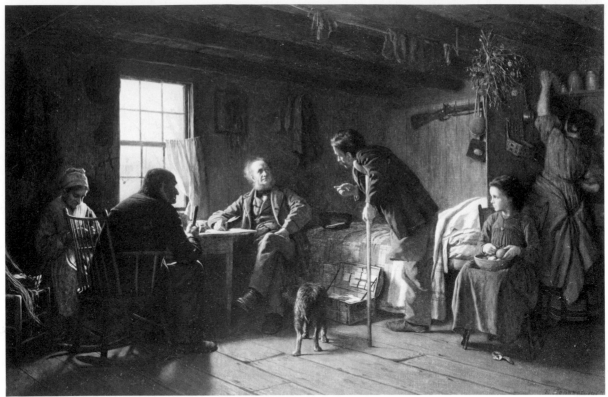

132. Eastman Johnson, *The Pension Agent,* 1867. California
Palace of the Legion of Honor, San Francisco.

two distinctly different manners. One, which he used
throughout his career, was precise and detailed, and
produced the finish which was so much admired by
mid-century Americans. *The Pension Agent,* 1867
(Fig. 132), exemplifies this aspect of his style. As his
career progressed, Johnson sometimes used his al-
ternate approach, a very free and loose handling of
medium and deliberate obscuration of detail. An
outstanding example of this broadly brushed technique
is *In the Fields,* 1871-79 (Fig. 133).

That Johnson produced works in both these dis-
parate manners concurrently, apparently choosing
between them on no basis other than passing in-
clination, makes it very difficult to reconstruct an
order in his production—especially as he left many
canvases undated. Sometimes it is equally difficult to
establish a precise subject locale, even in the case of
dated paintings, because of Johnson's habit of
mobility. A case in point is the attractive *Fiddling His
Way,* 1866 (Fig. 134), which for all its homely detail
of furniture and equipment cannot with assurance be

associated with a specific region.

The Civil War does not appear to have had much
effect on Johnson either personally or aesthetically. He
may have witnessed more actual fighting than
Homer—he was present at the Second Battle of Bull
Run, at Antietam and at Gettysburg and possibly at
other engagements—but he produced relatively few
canvases on subjects related to the war.

*A Ride for Liberty, The Fugitive Slaves,* 1862-63
(The Brooklyn Museum), however, represents an
incident he witnessed near Centerville, Virginia,
during the Second Battle of Bull Run, which did
arouse an emotional response. The simplicity of its
statement, coupled with the sense of urgency and
desperation of the three fleeing slaves mounted on the
clumsy cart horse, conveys a genuinely felt dramatic
message. This is rare in Johnson's work; he tended to
concentrate on the commonplace incidents of everyday
life.

One other painting related to combat shows an
incident he observed during the bloody Battle of

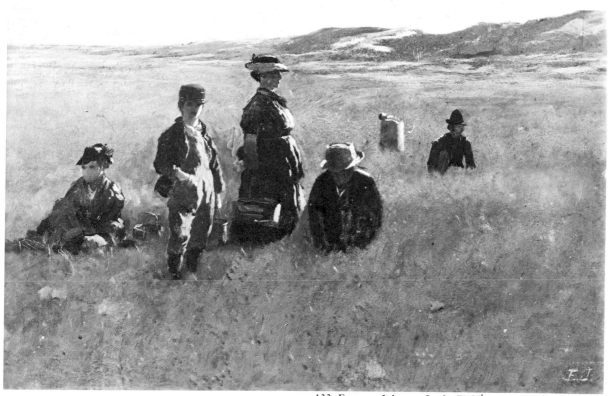

133. Eastman Johnson, *In the Fields*, c. 1871-79. The Detroit Institute of Arts; Gift of Dexter M. Ferry, Jr.

134. Eastman Johnson, *Fiddling His Way,* 1866. Coe Kerr Gallery, New York.

Antietam. This, *The Wounded Drummer Boy*, 1871 (final version, The Union League Club, New York), unlike *The Fugitive Slaves*, is conceived as a typical salon picture. Despite the effort he put into the painting over a period of roughly six years, Johnson must have been disappointed in the result. He fails to capture his emotional reaction upon witnessing the heroic incident, and achieves only a labored, academic and overstated machine piece.

*News from the Front*, 1861 (collection Edward Eberstadt & Sons, New York), *Writing to Father*, 1863, *The Letter Home*, 1867 (both, Museum of Fine Arts, Boston), and *The Pension Agent*, 1867 (Fig. 132), are typical of his other Civil War scenes. While they avoid excessive sentimentality and are technically well executed, their photographic literalness makes them a little dull. Intelligent and gifted as Johnson was in his ability to select and compose commonplace incidents, he lacked the intuitive skill to convey with freshness the universality implicit in his subjects. It is the absence of this quality which touches his youthful paintings with tediousness—and is the chief difference between his works and Homer's early paintings.

It is characteristic of Johnson to experiment with variations on a theme over a period of some years. Probably he did more canvases of the maple-sugar camp than of any other subject. Inspired by childhood memories of the maple-sugar camps in Fryeburg, near Augusta, Maine, he revisited the area after the war and became almost obsessed with the idea of painting his masterpiece on this theme. Like Allston's *Belshazzar's Feast*, 1817-43 (The Detroit Institute of Arts), the masterpiece was never completed, but many canvases, including some of Johnson's best paintings, explore its pictorial possibilities. They can be divided into two groups: studies for the projected overall composition, and studies for its component parts, both in numerous versions. Some of these studies are finished paintings, others are what Johnson's contemporaries would have considered unfinished oil sketches, but which we now treat as works of art in their own right. *A Sly Drink at the Camp*, c. 1861-67 (The Art Institute of Chicago), *The Shelter*, c. 1870 (The Corcoran Gallery of Art), and *Card Playing at Fryeburg, Maine*, c. 1871 (Fig. 135), are among the forty or more "finished studies" of self-contained incidents, some of which were to have been incorporated in the complex final scheme.[3] Among the many compositional studies, one of the best is *The Maple Sugar Camp—Turning Off*, 1875 (Fig. 136).

The flavor of New York during the 1870's and 1880's, when brownstone houses lined the streets, is captured by Johnson in a series of interiors. These are painted in a subdued, muted palette which accurately reflects the mood and appearance of these genteel residences and the dim light which filtered through their narrow windows. *Not at Home*, c. 1870-80 (The Brooklyn Museum), is the outstanding example of this group. By its unconventional composition and the understatement of the anecdote, it avoids being simply

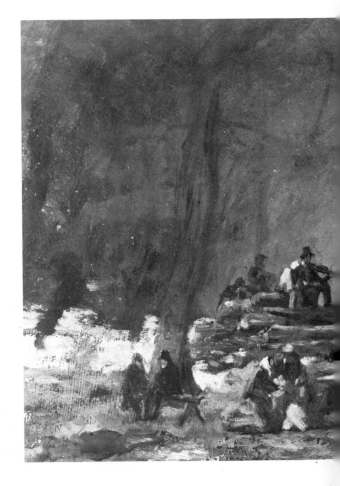

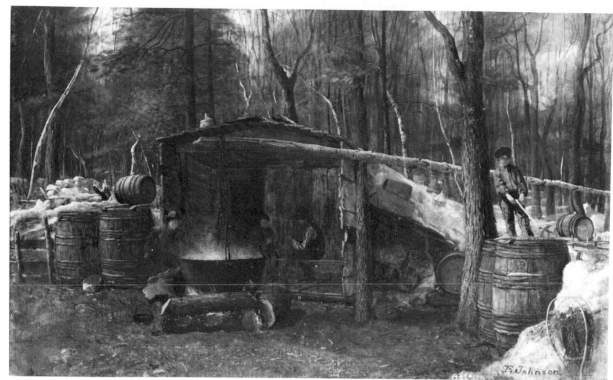

135. Eastman Johnson, *Card Playing at Fryeburg, Maine,*
c. 1871. Collection Dr. and Mrs. Irving Levitt.

136. Eastman Johnson, *The Maple Sugar Camp - Turning Off,*
1875. Collection Mrs. Norman B. Woolworth.

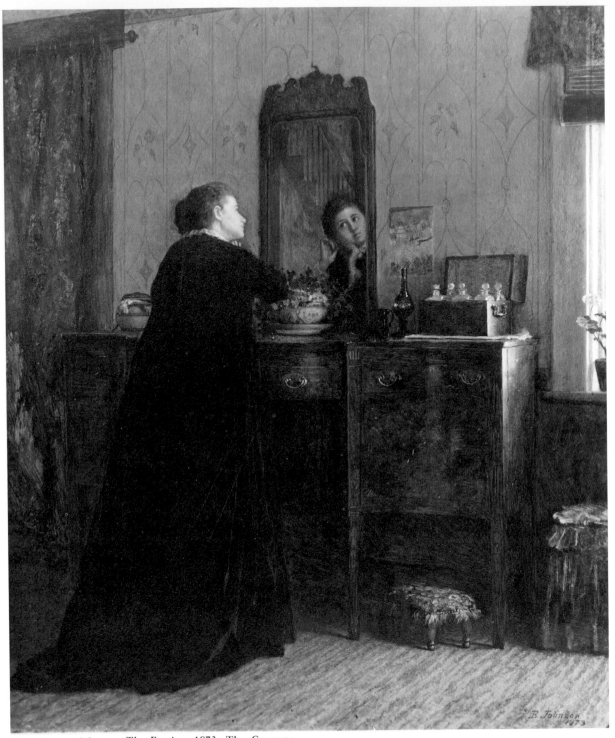

137. Eastman Johnson, *The Earring,* 1873. The Corcoran
Gallery of Art, Washington, D.C.

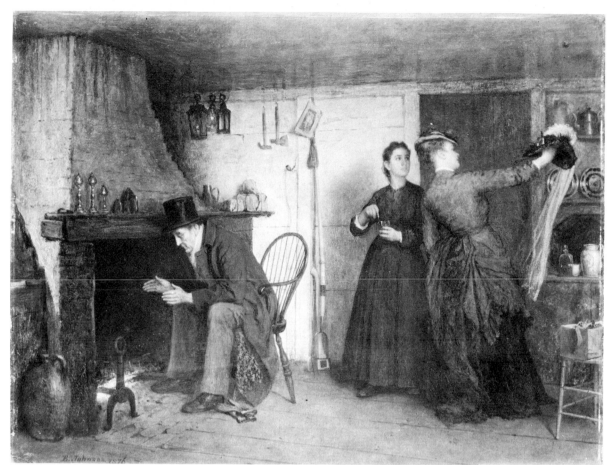

138. Eastman Johnson, *The New Bonnet,* 1876. The Metropolitan Museum of Art, New York; Bequest of Collis P. Huntington, 1925.

a social commentary of ephemeral value. The story is a simple one: a young matron quietly slipping upstairs to avoid an unwelcome caller. A less well-known but characteristic member of this group is *The Earring,* 1873 (Fig. 137). It is distinguished by the jewel-like quality of the still-life details, which glow in the dusky light.

The scenes Johnson did in Nantucket between the early 1870's and 1880's, such as *The New Bonnet,* 1876 (Fig. 138), show him at the peak of his powers. This is no doubt partly due to the fact that he found the temperament and characteristics of the islanders akin to those of the reticent, independent and individualistic Maine people among whom he had grown up in Augusta. The Nantucket scenes are divided into interior subjects, usually painted in his carefully finished technique, and views of the cranberry bogs, done in a freer, more impressionistic style of great power and beauty.

While they lack the ''importance'' traditionally reserved for paintings with more figures, some of the smaller Nantucket paintings are little gems. *Embers,* c. 1880, but possibly not finished until 1899 (collection Mrs. Herbert S. Darlington), and *Nantucket Sea Captain,* 1873 (collection Hirschl and Adler Galleries), show Johnson's adherence to observation, his skill in handling light, his delight in depicting incidental still-life objects, bringing out their differing textures, and his mastery in integrating the whole into a cohesive unit with a rich and glowing palette. *The Nantucket School of Philosophy,* 1887 (The Walters Art Gallery, Baltimore), one of the interior subjects, was his last genre painting and the summation of the series.

In his Nantucket out-of-door subjects, Johnson forecast the direction American painting was to take in the last decades of the nineteenth century. Such paintings as *In the Fields,* c. 1871-79 (Fig. 133), bring his luminism to its peak. A scene in the cranberry bogs, it concentrates not on the action of the figures, but on the flood of light over the totality of the land and people. *The Cranberry Harvest, Island of*

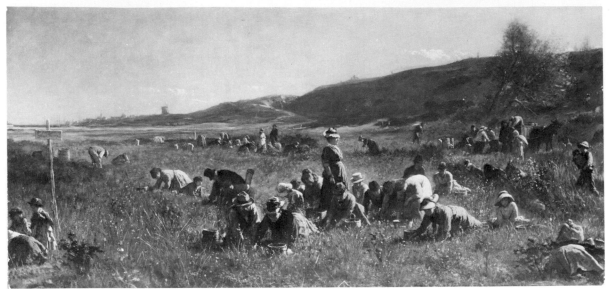

139. Eastman Johnson, *The Cranberry Harvest, Island of Nantucket,* 1880. Vose Galleries, Boston, and Peter Tillou, Albany. (Color plate XIV)

*Nantucket,* 1880 (Fig. 139), brings together both of Johnson's somewhat conflicting objectives: his consuming passion for the diffused effects of atmospheric light, and his interest in a sharply focused depiction of individuals in action. Johnson here succeeds in welding them into a unified whole and, in so doing, creates what is certainly one of his finest works.

Edwin Forbes (1839-1895) was probably the best known and most talented of the combat artists who reported the Civil War, making on-the-spot drawings which were subsequently engraved on wood for the illustrated magazines. Although he is famous as a draughtsman and illustrator, it is not generally known that he was also a painter.[4] He began to study painting in 1857 and after 1859 was a student of Arthur F. Tait. Like his master, he began as an animal painter,

but later extended his field to include genre and landscape. In 1865 when Forbes returned to New York he exhibited *Lull in the Fight,* c. 1865, a painting recording an incident in the Battle of the Wilderness, at the National Academy of Design. Its present location is unknown, but an unfinished and undated oil study exists in the writer's collection.

*Contrabands,* 1866 (Fig. 140), is a fine example of straightforward reportage—a trustworthy document—well painted but without the spark of genius. Only in the handling of the landscape background, which goes beyond the factual, is there an indication of sensitivity. However, it is the most important of Forbes's genre paintings of the war so far located.

Like Winslow Homer, Forbes did three or four small paintings of Union soldiers in camp. Pictorially they are much less interesting than Homer's series for

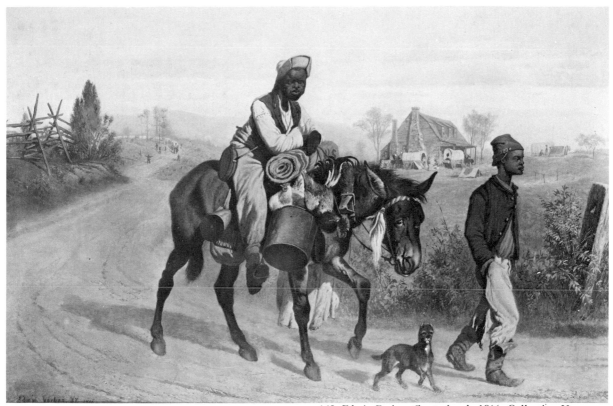

140. Edwin Forbes, *Contrabands*, 1866. Collection Hermann
Warner Williams, Jr. (Color plate XV)

141. Edwin Forbes, *Drummer Boy Cooling His Coffee,*
c. 1867. Amherst, College, Amherst, Massachusetts.

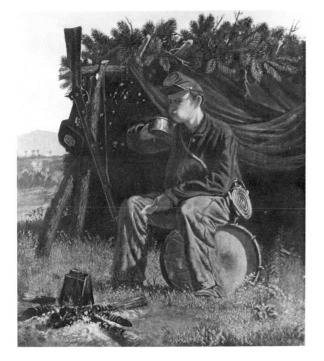

they show only a single figure, whereas Homer's
usually involved several figures and included broader
views of camp life in the background, adding con-
siderably to their effectiveness. Typical of Forbes's
series are *Mess Boy Sleeping,* 1862 (The Wadsworth
Atheneum, Hartford, Conn.) and *Drummer Boy
Cooling His Coffee,* c. 1867 (Fig. 141). It is en-
lightening to compare the work of these two young
men working at the same time in the same medium on
the same subject matter. Forbes comes off a poor
second to Homer, who was the better colorist, the
better draughtsman and the more creative artist.
While it is possible that Forbes painted other subjects,
all the located genre paintings by him relate to the war.

The change in American taste away from the earlier
robust approach to reality toward a more sophisticated
continental style, which began to show itself about the

151

time of the Civil War, is well illustrated by G. Grato's *The Departure*, 1864 (Fig. 142). Nothing is known about this painter's life nor has any other canvas by him come to light, but the painting speaks for itself. Obviously the artist was trained abroad, probably in Paris, where he absorbed the techniques and point of view of painters like Couture. The scene of a preponderantly female crowd bidding Godspeed to a troop train on its way south is a vivid reminder of the drain on manpower which, as the war progressed, left almost no able-bodied men in the towns and farms of either North or South.

It is quite possible that E. D. Hawthorne was commissioned to paint his *Interior of George Hayward's Porter House*, 1863 (Fig. 143). It is conceivable that, like Oertel's *Woodruff Stables, Jerome Avenue, The Bronx* (Fig. 95), it was to have been lithographed as a promotion piece to publicize the popular saloon. This flourishing establishment catered to well-to-do male New Yorkers and for its regular patrons served much the same purpose as a men's club. The saloon is elegantly appointed. The proprietor must have been a patron of the arts, for the walls are liberally lined with Hudson River School landscapes and what appears to be a portrait of Washington. The painting is full of other fascinating details. Note the shoeshine boy and the little match girl plying their trades. Among the four officers bellying up to the long bar is one wearing the French-inspired uniform of one of the fashionable Zouave regiments, possibly Duryea's. Even he is outclassed by the gentleman in full Scottish regimentals, a member of the 79th New York Volunteers, the only unit to take the field in complete Highland uniform.

As to Hawthorne himself, we are up against a total mystery. His biography is a blank, even to what the initials E. D. stand for. This is the only painting by him so far located. Yet such is the obvious competence of the work that it stands to reason it was not the artist's first effort at oil painting.

It is hard to justify the inclusion of Albert Bierstadt (1830-1902) in the context of this study. His principal contributions to American art are unquestionably the vast landscapes of the West which made him the most sought after and highest priced artist of his day in America. When figures are present in his landscapes, they are usually small in scale and unessential to the overall concept. There are, however, among his prolific output two canvases in which the figures, although small in scale in comparison with the landscape, are nevertheless the dominant feature of the composition. One is the well-known and inaccurately titled *Guerrilla Scene, Civil War,* which is better identified as *Attack on a Union Picket Post,* 1862 (Fig. 144). The other is *The Ambush,* 1870-75 (Museum of Fine Arts, Boston). This fine, moody landscape was based on Bierstadt's experience as a member of General Frederick West Lander's expedition to the Wind River country of Wyoming in the 1850's. An Indian attack on a covered wagon is being fought off by soldiers partially hidden in the bushes to the side of the road.

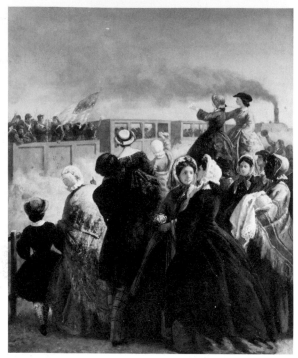

142. G. Grato, *The Departure*, 1864. Collection N. S. Meyer, Inc., New York.

143. E. D. Hawthorne, *Interior of George Hayward's Porter* ▶ *House*, 1863. The New-York Historical Society, New York.

144. Albert Bierstadt, *Attack on a Union Picket Post,* 1862. ▶ The Century Association, New York.

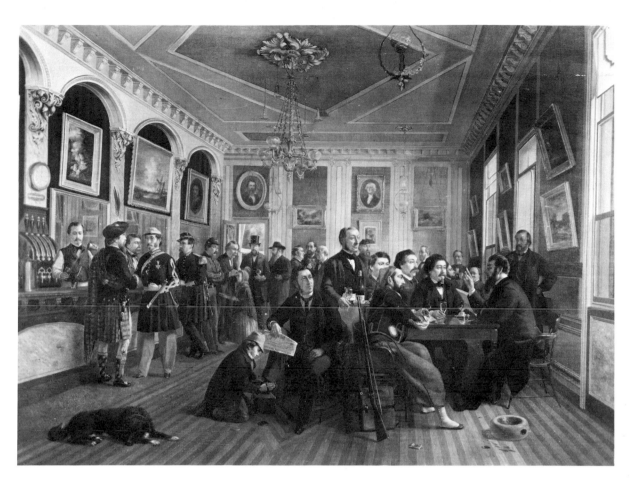

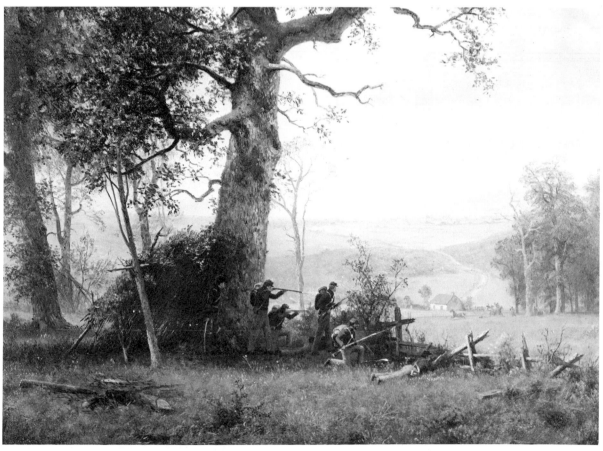

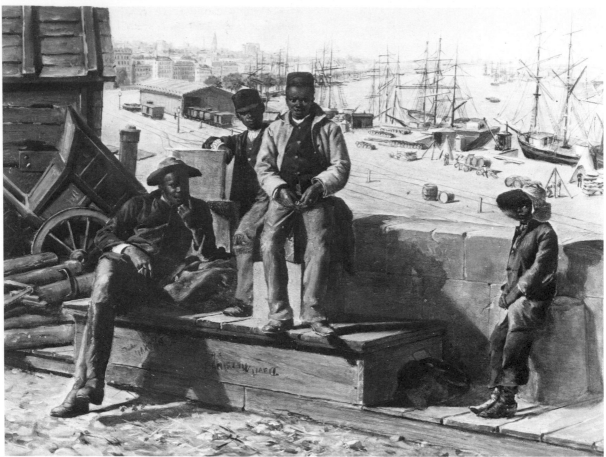

145. David Norslup *(?)*, *Negro Boys on the Quayside,* c. 1868.
The Corcoran Gallery of Art, Washington, D.C. (Color plate
XVI)

146. John Whetten Ehninger, *October,* 1867. Kenneth M.
Newman, The Old Print Shop Inc., New York.

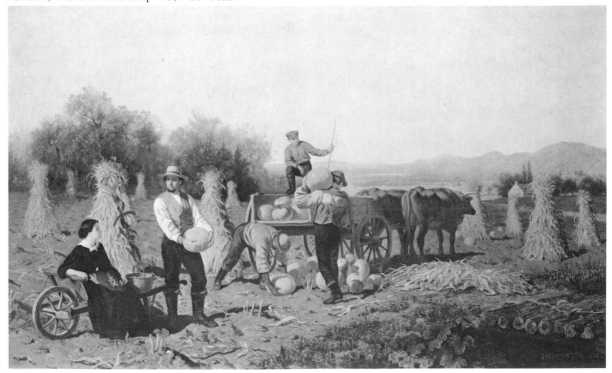

Both these canvases are frankly marginal as genre, and their inclusion in this study can be defended only by the assertion that for Bierstadt's contemporaries what was happening was part of everyday existence, although at our distance in time many would probably call the subjects historical.

*Negro Boys on the Quayside,* c. 1868 (Fig. 145), is a problem picture. The best reading that can be made of the signature is David Norslup; no artist of that name is recorded. Despite the considerable effort that has been expended in attempts to identify the location and assign a date to the work, both remain unestablished. The youths are wearing what appear to be discarded blue Union Army blouses with the brass buttons still in place. This fact would indicate a date during the Civil War or shortly thereafter. None of the other details in the painting, such as the shipping, railroad boxcars or gaslights, provides data which bear definitively on the question of date. The unresolved questions are all the more frustrating because the painting itself is extraordinary. The hard, enamel-like paint surface and miniaturist finish are unlike the work of any other nineteenth-century American painter. A strange, cold light permeates the scene. The subject, too, is puzzling, for as has been mentioned, it was unfashionable to paint laborers, especially Negro laborers; the Civil War made no appreciable difference in this attitude. Yet here are four bedraggled young blacks presented just as they were without condescension or apology. As a social record it is unique at this period of our history. Its artistic merits are considerable, forecasting the work of Eakins and Anshutz in its unblinking objectivity of statement. The artist shows his mastery by massing the figures in the foreground while keeping the distant prospect of the quays and the city in harmonious relationship—leading the viewer's eye gradually from the foreground through the minutely painted middle distance to the horizon.

The painter John Whetten Ehninger (1827-1889) passed some six years, from 1847 to 1853, studying painting in France, Germany and Italy. On his return he worked in New York and later in Saratoga Springs. His work is competent but lacking in spark, and his leaning on European masters is quite obvious. This is especially visible in *Yankee Peddler,* 1853 (The Newark Museum), which was executed in Paris. Although the subject is American, some of the details of costume and architecture indicate that when Ehninger's memory failed he turned to local French sources for models.

Because of its simplicity and lack of pretension, as well as for its recollection of crisp fall days at the close of the harvest season, *October,* 1867 (Fig. 146), shows Ehninger to much better advantage. It is a pleasing visual reminder of farm life of the past century, a time when the farmer actually worked his farm himself aided by his sons and a couple of hired men, when motive power by oxen was sure, if slow, and there was time for him to stop for a leisurely chat with his wife while gathering a load of bright orange pumpkins.

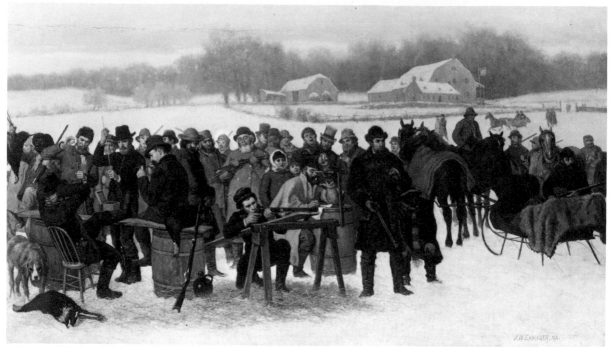

147. John Whetten Ehninger, *Turkey Shoot,* 1879. Museum of Fine Arts, Boston; M. and M. Karolik Collection.

Ehninger's *Turkey Shoot,* 1879 (Fig. 147), a tour de force with its two score figures, falls of its own weight. The friezelike composition lacks the dramatic center of interest that is needed in order to subordinate the sea of faces to one focal point. Nonetheless as a record of a once-popular country pastime, it is convincing and full of carefully observed detail. Unlike Deas's *Turkey Shoot* (Fig. 69) in which the sportsmen are shooting from a standing position at a tethered turkey, here there is an abstract test of marksmanship using a bench rest to support the rifle, and, instead of a live bird, a paper target. The prize turkey lies on the snow ready to be taken home by the winner. The two paintings are capsule demonstrations of the propensity of Americans to transform a simple pastime into a highly developed sport with elaborate rules and more and more specialized equipment, such as the spotter telescope used to record the score for each round fired—the same sort of evolution which has in our time turned college football into big business.

One of the many painters who remain little known

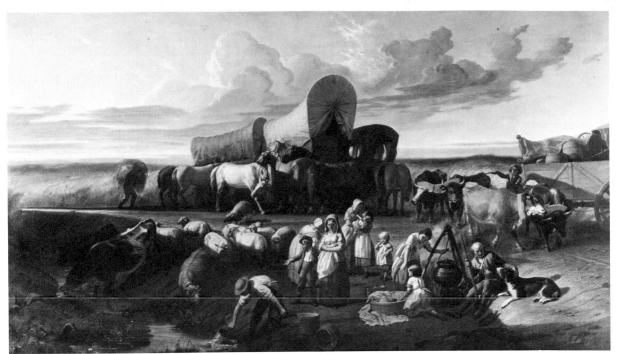

148. Benjamin Franklin Reinhart, *The Emigrant Train Bedding Down for the Night*, 1867. The Corcoran Gallery of Art, Washington, D.C.

because few of their works are in public collections is Benjamin Franklin Reinhart (1829-1885). His career started on his return to this country in 1853 from study in Düsseldorf, Paris and Rome. He made a number of painting trips into the Midwest and South from his studio in New York until, in 1861, he went to England, where he had success primarily as a portrait painter for the next seven years. In 1868 he returned to New York, where he spent his remaining days. *The Emigrant Train Bedding Down for the Night* (Fig. 148) is dated 1867 and so presumably must have been painted in England from sketches and the recollections of his midwestern trips. It is apparently Reinhart's only painting of a genre subject in a public collection. By the time it was painted, the first tides of the western movement, which Ranney had put on canvas, were past and were being followed by waves of land-hungry emigrants eager to settle on the free public lands which in Ranney's day had been the frontier.

One of the few painters who worked in the South

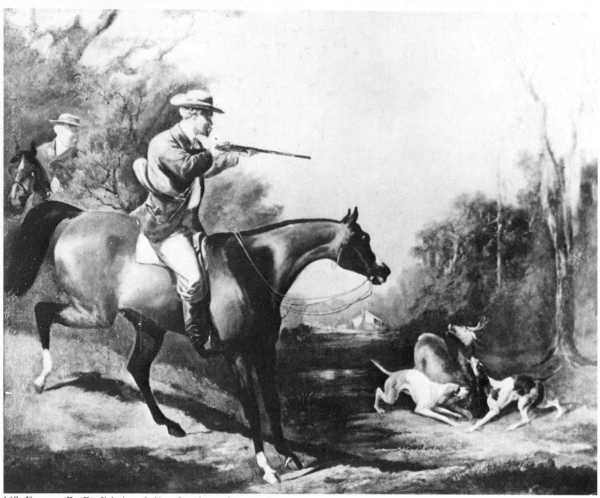

149. Everett B. D. Fabrino Julio, *Southern Swamp Deer Hunt,* c. 1873. Collection Jay P. Altmayer.

during the Reconstruction era was Everett B. D. Fabrino Julio (1843-1879).[5] This talented and little-known landscape and genre painter was born on the island of St. Helena, but was brought up in Boston. As a young man of twenty-one he went to St. Louis, where he earned his living as an artist. In 1871 he moved to New Orleans. He went abroad about 1874 and studied with Léon Bonnat in Paris for nearly two years before returning to this country. He died in Kingston, Georgia.

His *Southern Swamp Deer Hunt,* c. 1873 (Fig. 149), shows a landscape typical of Northern Louisiana or Mississippi, including in the distance a Negro shanty with characteristic outside chimney and covered porch. Before it was acquired by Mr. Jay P. Altmayer, the painting belonged to Francis Tobin, New Orleans proprietor of the White River Line, which operated a fleet of steamboats on the Mississippi. These circumstances indicate that it was painted in that section of the South rather than in Georgia, where Julio died. Hunting deer on horseback

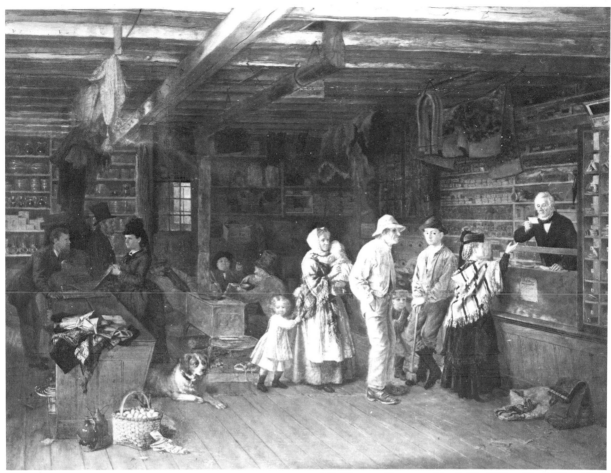

150. Thomas Waterman Wood, *The Village Post Office*, 1873. New York State Historical Association, Cooperstown, New York.

with hounds was not a common American practice; the usual way was to go on foot into the forest, without dogs. This painting is therefore probably unique as a record of an extremely rare form of stag hunting in the Deep South.

Thomas Waterman Wood (1823-1903), after he settled in New York in 1867, was primarily a genre painter. He was less addicted to the sentimentality of the age than many of his contemporaries. In *The Return of the Flags 1865,* 1869 (collection United States Military Academy), a sentimental subject if ever there was one, the emotional quality seems to be felt but kept in dignified restraint. His style, both here and generally, tends to be hard and lacking in subtlety.

His real gift for careful observation is brought out in what is probably his best-known painting, *The Village Post Office,* 1873 (Fig. 150). As the railroad gradually displaced the stagecoach, the taverns which had serviced the stages for generations also gradually became obsolete. In their place the general store, often with an adjunct post office, became the gathering place

159

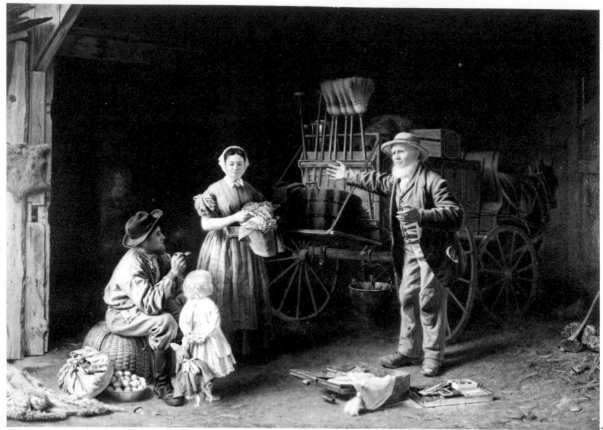

151. Thomas Waterman Wood, *The Yankee Peddler*, 1872.
Collection Mrs. Norman B. Woolworth.

of the citizenry in small towns throughout the country. Wood's store, with its stock of articles in common use in home and farm, is typical. The mail is being distributed on one side, while on the other a well-set-up woman is making a purchase, and around the cast-iron stove the village elders are conversing. On the floor is a basket of eggs which have been bartered for some manufactured goods, and the mailbags are ready to be taken to the depot. The details of the still life are well painted, and the baker's dozen of village types is faithfully observed and well integrated into the composition as a whole.

Wood's *The Yankee Peddler,* 1872 (Fig. 151), is a late example of this perennially popular American subject. Here is Wood at his least wooden. It has a directness of observation and an absence of affectation rare at this period.

The theme of cider making and drinking is one that recurs frequently in American genre painting. It

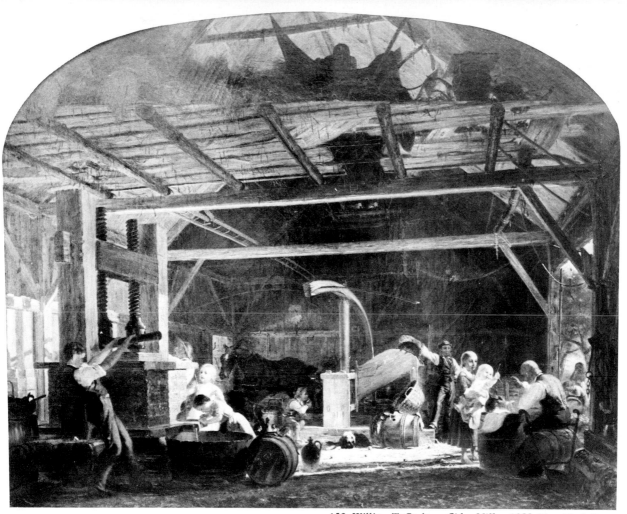

152. William T. Carlton, *Cider Mill*, c. 1855. New York State Historical Association, Cooperstown, New York.

captured the interest of Mount, Durrie and a minor painter who worked somewhat later, William Tolman Carlton (1816-1888), a portrait and genre painter who was active in the Boston area from 1836 to 1855. His *Cider Mill,* c. 1855 (Fig. 152), shows the interior of a barn where cider is being made. The artist is as much concerned with the pattern of light and shadow in the dark interior of the barn, formed by the sunlight streaming in through the open door, as he is with depicting the home industry.

Seymour Joseph Guy (1824-1910), after studying in London as a young man, emigrated to America in 1854. He settled in New York and there enjoyed a successful career as a portrait and genre painter.

His particular dish of tea was women—especially pretty young girls—and children. He gave his canvases a smooth, glossy surface, and his rich colors were blended and fused, eliminating modeling by sharply defined shadows and lights. *Making a Train,*

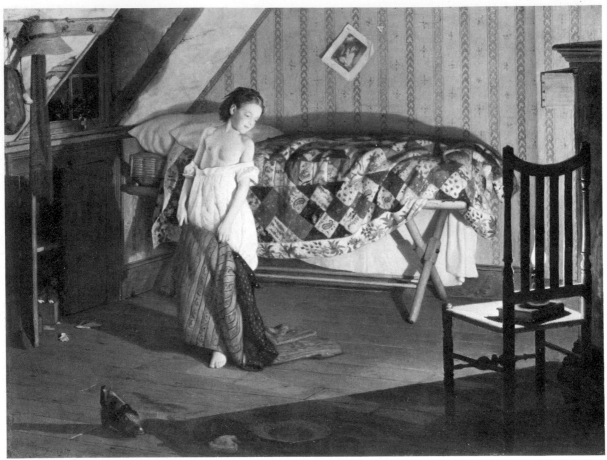

153. Seymour Joseph Guy, *Making a Train*, 1867.
Philadelphia Museum of Art; George W. Elkins Collection.

1867 (Fig. 153), exploits the sensuality of the partially
draped young girl and succeeds in striking a more
voluptuous note than anything done by Guy's con-
temporaries. For sheer technical virtuosity in the
handling of textures and light, it is a remarkable
performance. If it were not dated 1867, one could be
pardoned for thinking it was done a half century later,
so well would it fit the artistic climate of the period of
Edmund C. Tarbell and William M. Paxton.

Another portrait and genre painter of secondary
importance in the period is George Henry Story
(1835-1923). Although he was born in Connecticut,
most of Story's active years were spent in New York
City. Like many of his contemporaries, he was
competent but uninspired, and his work is almost
indistinguishable stylistically from that of other
painters of the time. Perhaps his best canvas is a prod-
uct of his mid-thirties. *Twenty Thousand Majority,* c.
1870 (George Walter Vincent Smith Art Museum,
Springfield, Mass.), although lacking the academic
draughtsmanship Story later acquired, still has a

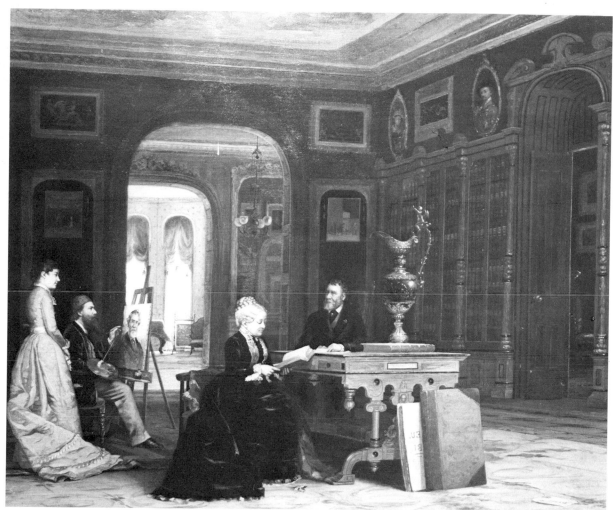

154. George Henry Story, *Library at "Winyah Park" with Portraits*, 1880. The Carolina Art Association, Gibbes Art Gallery, Charleston, South Carolina.

certain zest missing in his later works. The choice of subject is an interesting reprise of the days of Mount, Bingham and Woodville. It depicts a group of men in a general store reading the election returns, with enthusiasm displayed on all faces except that of the top-hatted gentleman sitting glumly on the right. In the background a lad has climbed up to retrieve an old roped snare drum slung from the rafters, in anticipation of a torchlight victory parade.

The conversation piece, *Library at "Winyah Park" with Portraits,* 1880 (Fig. 154), shows Story to better advantage. While technically it is a group portrait, the presence of the artist painting the likeness of bewhiskered Colonel Richard Lathers adds a strong genre touch. Story here shows considerable dexterity in his handling of light and shade, and incidentally gives us a record of the decor of a wealthy New York household.

Charles Caleb Ward's (c.1831-1896) thinly painted scenes of daily life have a distinctive style and personal vision which set them apart from the academic techniques and hackneyed subject matter of many of his

155. Charles Caleb Ward, *The Circus Is Coming*, 1871. The
Metropolitan Museum of Art, New York; Bequest of Susan
Vanderpoel Clark, 1967.

157. William Hahn, *Union Square*, 1878. Hudson River ▶
Museum, Yonkers, New York.

contemporaries. Ward, technically a Canadian paint-
er, was born in St. John, New Brunswick, studied
painting in England with William Henry Hunt
and worked both in New York and in New Bruns-
wick.[6] His American scenes are far scarcer than his
hunting scenes set in the Canadian woods. *The Circus
Is Coming,* 1871 (Fig. 155), employs an unusual
perspective and has a snapshot quality in the poses of
the figures which is atypical of its period. The stark-
ness of the weatherbeaten wooden buildings and the
moodiness of the light foreshadow the magic realists'
concern for textures and light. *Force and Skill,* 1869
(Fig. 156), shows a simple scene of two small country
boys sharpening a scythe before an open barn door.
Ward lifts this ever-popular genre subject from routine
by the depth of his identification with the subject. The
two boys are really putting their backs into the chore,
and, so penetrating is Ward's observation, the viewer
cannot but be conscious of their effort.

Certainly one of the best painters associated with the
West, specifically California, was William Hahn
(1829-1887), a native of Germany. Hahn received his
first training in Dresden and later studied in
Düsseldorf and Paris. Sometime in the early 1860's he
arrived in this country, settling temporarily in New
York. His New York subjects are rare. Indeed it
appears that *Union Square,* 1878 (Fig. 157), must
have been completed in California, possibly from
sketches made before he left for the West. This lively
city scene with its horsecar and newspaper delivery
cart, surrounded by a crowd of newsboys getting the
late edition, is a charming nostalgic view of urban life
as it existed after the Civil War.

Most of Hahn's work was done in California, where
he arrived in 1867. Establishing himself in San
Francisco, he did not limit his work to that city but
made sketching trips to Southern California, Yosemite
and Northern California. He was by no means ex-
clusively a painter of genre subjects, but also did
portraits, landscapes and still life. Nevertheless it is his

156. Charles Caleb Ward, *Force and Skill,* 1869. Collection
Henry M. Fuller.

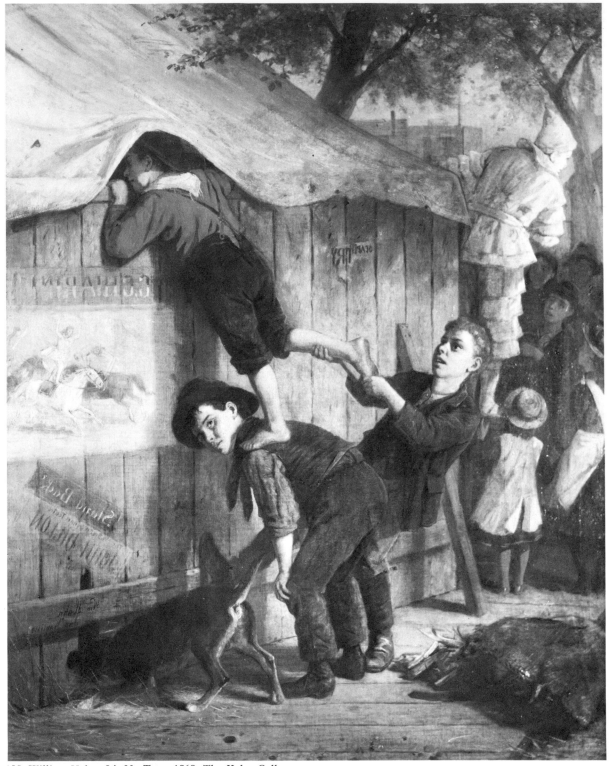

158. William Hahn, *It's My Turn,* 1868. The Kahn Collection; The Oakland Museum, Oakland, California.

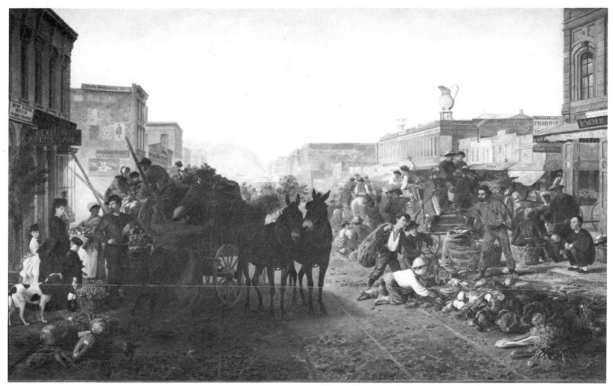

159. William Hahn, *Market Scene, Sansome Street, San Francisco*, 1872. E. B. Crocker Art Gallery, Sacramento, California.

genre paintings which account for his importance today.

*It's My Turn* (Fig. 158) was painted in 1868, one year after Hahn arrived in San Francisco, and shows a tent of Chiarini's Royal Italian Circus with three boys and a dog trying to get a free look at the mysterious goings-on behind the barriers of wood and canvas. Despite the popularity and the proliferation of traveling circuses during the nineteenth century, they were seldom the subject of paintings.

Hahn's style did not change very much over the years; he continued to follow the stolid German academic manner he had absorbed as a young student. *Playing School*, 1880-81 (The Oakland Museum), for example, painted twelve years after *It's My Turn*, continues that painting's style and essential subject theme—childhood as seen by adults. Very *gemütlich*, it shows five children playing school on the back porch of a frame house. Despite the sentimentality of the subject, it does not come off badly, and the play of light and shadows is handled with taste and skill.

Far more interesting than the intimate genre scenes just mentioned are Hahn's original and ambitious city scenes. *Sacramento Railroad Station*, 1867 (M. H. De Young Memorial Museum, San Francisco), not only is well painted, but is a fascinating record of place and period, full of carefully observed detail. An early locomotive belching smoke, the crude wooden depot, the stylish carriage meeting a wealthy family, the ragged porters and the general bustle and confusion of scores of people going about their respective tasks give us an amazingly complete visual record of the California capital. Equally absorbing as a document of social history is *Market Scene, Sansome Street, San Francisco*, 1872 (Fig. 159). The crowds, confusion and mixture of people of all social levels are descriptive of the effect of the rapid expansion of the West after the war. San Francisco, which started to expand with the Gold Rush, shared the frantic character of all boom towns, and such was the appearance and feel of all the new metropolises which sprang into existence almost overnight as the frontier was pushed to the Pacific.

Hahn also did a remarkable painting, *Yosemite Valley*, 1874 (California Historical Society). The valley was part of Yellowstone National Park, which had been created in 1872. A party of tourists, some of the first of the millions who have come to wonder at the spectacular beauty, are scattered over the top of a promontory gazing at the view.

Another German-born painter, Charles Christian Nahl (1818-1878), worked mostly in the San Francisco area. His scenes of frontier life in California are among the rare early records of that part of the West. *Sunday Morning in the Mines,* c. 1851 (E. B. Crocker Art Gallery, Sacramento, Calif.), an ancestor of Hollywood westerns, is filled—excessively filled—with typical western exuberance. A companion salon picture, *The Indian Camp,* 1874 (E. B. Crocker Art Gallery), is another tour de force. It shows a buxom, semi-nude Indian girl with a baby and a handsome brave and his horse around a campfire. No sense of actuality is conveyed. The concept is that of a Wild West Show poster. Of all his large salon paintings, *The Fandango,* 1873 (Fig. 160), is the best. Although it could be a scene from an operetta, so theatrical are the costumes, poses and exaggerated gestures of the carefully typed participants, it nevertheless has a gay and carefree spirit which partly makes up for its artificiality. In contrast, *Crossing the Plains,* c. 1856 (Stanford University Museum, Palo Alto, Calif.), is quieter and more realistic, resembling the work of William Ranney in composition and subject.

James Walker (1818-1889) was primarily a painter of battle scenes and as such merits little space here. He maintained his studio in New York during most of his active career, but also worked in Washington, D.C. After the Civil War he went to California, where he died in Watsonville.[7] The quality of his earlier Mexican War battle scenes, done during the war or slightly later, is generally better than that of his subsequent work, which becomes coarse. During his sojourn in California, living on his brother's ranch, he did a number of paintings of life on the cattle ranches, which record the Spanish colonial character of the state. *Roping the Bear,* c. 1876-77 (California Historical Society), for example, shows six rancheros, togged out in typical Mexican style, lassoing a bear. Pictorially, two paintings of cattle drives in the same collection are more satisfactory. *Cattle Drive No. 1,* c. 1877 (Fig. 161), has a certain posterlike impact in the surging mass of long-horned cattle charging the viewer. Here Walker uses a compositional device similar to the one he used earlier in what is perhaps his best-known Civil War painting, *Review of the Grand Army of the Potomac,* 1865 (collection Mr. and Mrs. Will Hippen, Jr.), which depends for its effect on the seemingly endless mass of marching soldiers.

The five painters next discussed were all associated with Philadelphia. The first, William E. Winner (c. 1815-1883), a genre painter active at mid-century, had two strings to his bow: humor and blatant sentimentality. In either vein, few of his works offer an unbiased view of everyday life.

The two related canvases *Crazy Nora,* c. 1855, and

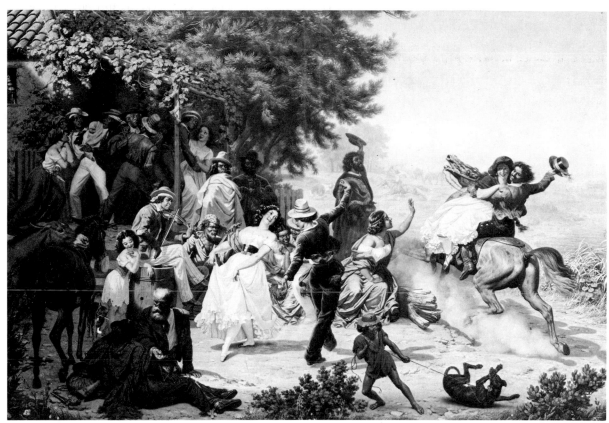

160. Charles Christian Nahl, *The Fandango*, 1873. E. B. Crocker Art Gallery, Sacramento, California.

161. James Walker, *Cattle Drive No. 1*, c. 1877. California Historical Society, San Francisco.

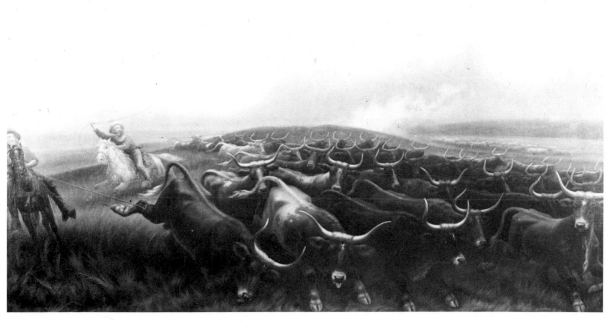

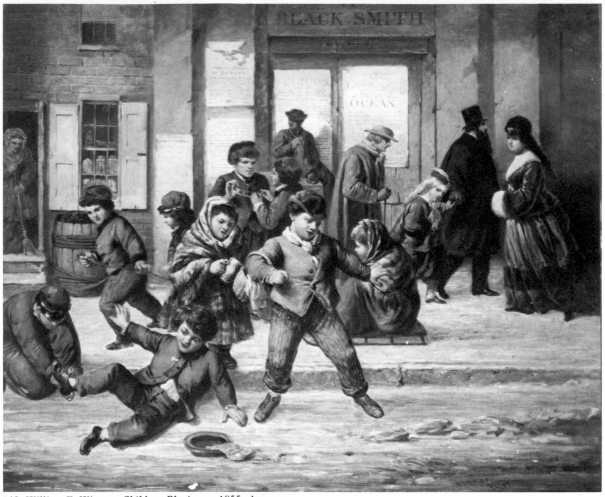

162. William E. Winner, *Children Playing,* c. 1855. Atwater
Kent Museum, Philadelphia.

*The Pie Man,* 1856 (both, Historical Society of
Pennsylvania), each of which has as its central figure a
local character familiar to all Philadelphians of that
day, are somewhat atypical. The central figures are
identifiable portraits, although not commissioned
ones. Both Nora and the Pie Man were simple-minded
individuals who were permitted by the authorities to
roam the city streets as was then the practice through-
out the country. Winner's aim in painting these pic-
tures presumably was to create a modified version
of "The Cries of London," tailored to local cir-
cumstances. In *Crazy Nora,* he brings out the flavor of
city life by the inclusion of an omnibus rattling over
the cobblestones and ladies strolling along the opposite
sidewalk. He does the same, with an added humorous
touch, in *The Pie Man,* by including the excitement
of a tumultuous parade complete with banners, brass
band and a mounted dignitary having trouble con-
trolling his horse.

Also with humorous overtones, Winner painted a
number of genre scenes of urchins frolicking in the

163. William E. Winner, *Domestic Felicity*, c. 1845. Philadelphia Museum of Art; W. P. Wilstach Collection.

city streets. *Children Playing,* c. 1855 (Fig. 162), is typical. While this painting has a trace of sentimentality, it is mild compared with the sentimentality of his canvases singing the praises of domestic bliss. *Garden Scene Near Philadelphia,* c. 1840 (Wadsworth Atheneum), is a perfect—if that is the word—example of Victorian treacle. The happy parents peek at their five offspring through a bower of flowers. Their bouncing children, all adorable and all spick-and-span, are merrily playing under the fond eye of a Nanny, who holds the youngest in her arms. All is perfect: weather, garden, lawns and dispositions. Another example, *Domestic Felicity,* c. 1845 (Fig. 163), varies the theme by putting the proud parents in the spotlight, and a more romantic pair it would be hard to imagine. The soulful-looking husband reads from a large book while his young wife gazes into space. Their two innocents play with flowers, while a poetic landscape spreads to the distant horizon.

George H. Comegys (c. 1816-after 1852) studied under John Neagle in the 1830's. He died in The

171

164. George H. Comegys, *The Little Plunderers*, c. 1845.
Pennsylvania Academy of the Fine Arts, Philadelphia.

Pennsylvania Hospital for the Insane in Philadelphia. Few of his genre works have come to light, and those that have possess a rugged strength but little of the good humor and polish that made the work of his contemporaries Mount and Woodville so popular. A canvas worthy of mention, *Two Tars in a Grog Shop,* 1839 (collection Victor D. Spark, New York), shows two sailors, one of whom has on his hat ribbon the legend "Constitution," drinking in a low tavern. The painting is dark and the draughtsmanship of the figures is somewhat crude, although the details of still life on the cupboard are well painted.

Comegys' masterpiece appears to be *The Little Plunderers,* c. 1845 (Fig. 164). It clearly shows his debt to his teacher Neagle in the broadly brushed handling of the figures. There is nevertheless something gross about Comegys' work. His faces are usually a bit too large for the bodies, and the expressions tend toward caricature rather than sharply defined characterization. The eyes, for example, are exaggeratedly large and give a glassy stare that is

disconcerting. Still, his work avoids sentimentality and is refreshing in its vigor and boldness of statement.

Christian Schussele (1824-1879) received his artistic training abroad. He left his native Alsace in 1848 and settled in Philadelphia. One of the many genre painters who flourished here in the third quarter of the century, he has the misfortune of being rather dull. This is largely because he was lacking in sensitivity as a painter, and his strong vein of sentimentality only made this deficiency more obvious. *Skating at Kelly's Dam, Germantown,* 1856 (Historical Society of Pennsylvania), was painted in collaboration with Paul Weber (1823-1916), a landscape painter who arrived in Philadelphia from Germany in the same year as Schussele. The landscape is the work of Weber and the figures of children skating were done by Schussele. It is a pleasant, if superficial, canvas which extols the simple pleasures of childhood.

Much more typical is *A Family Group,* 1855 (collection Victor D. Spark), which is very Germanic

165. Christian Schussele, *Contrast,* 1852. Carlen Galleries, Philadelphia.

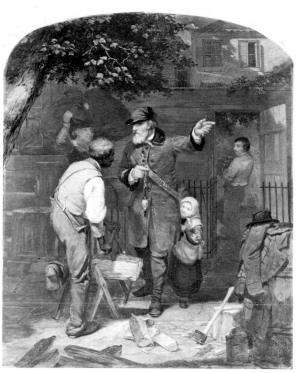

166. Charles F. Blauvelt, *The German Immigrant Inquiring His Way,* 1855. North Carolina Museum of Art, Raleigh.

in feeling and technique despite its American setting. The painting could as well represent a couple of German burghers sitting in their garden. The heavy sentimentality, characteristic of Schussele's work, impairs its present-day appeal.

What must be the epitome of Victorian sentimentality was reached by Schussele in *Contrast,* 1852 (Fig. 165). A variant on the popular mid-century theme of contrasting rich and poor, it pushes its message to the extreme. In the hands of a Daumier the subject would have carried powerful conviction and aroused a sense of outrage in the viewer. But Daumiers are rare. It is obvious here that Schussele was not filled with a burning sense of social injustice. His concern is with the "pathetic"—so much so that he unintentionally verges on satire. Not an observation based directly on nature, it reflects a literary point of view. The aged beggar, with sockless feet, unshorn white locks fringing his bare bald head and an expression of noble resignation on his careworn face, and his granddaughter, a real beauty with the swooning

expression characteristic of seventeenth-century female saints in ecstasy, are contrasted with the fashionably clad matron and child just descended from their coach, who enter a pillared mansion.

One of the more prolific genre painters of the period was Charles F. Blauvelt (1824-1900), who worked in New York, Philadelphia and Annapolis. For the most part he painted simple compositions involving one or two figures, often including children. A number of these small oils are in Baltimore's Walters Art Gallery. Blauvelt had a special interest in immigrants, judging from the frequency with which, in the 1840's and 50's, he exhibited paintings with titles referring to this subject.

One of his most important works dealing with this theme is *The German Immigrant Inquiring His Way,* 1855 (Fig. 166). Well painted, and with no more than a whisper of sentiment, it depicts a minor incident, experienced no doubt by countless foreigners as they moved about the country searching for their new homes.

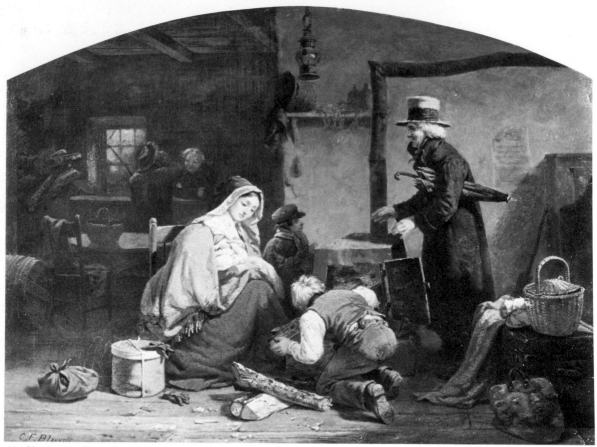

167. Charles F. Blauvelt, *Waiting for the Train*, c. 1860.
Maxwell Galleries, San Francisco.

*Waiting for the Train,* c. 1860 (Fig. 167), is not as obviously related to the immigrant theme. [8] The group of passengers, surrounded by their possessions, who warm themselves around a cast-iron stove may include an immigrant family. Again we have a theme which recurs quite regularly in American art—and life: waiting for the stagecoach, steamer, train or plane. Blauvelt was a good colorist and draughtsman, but occasionally, as here, succumbed to a weakness of his time by depicting young women as pretty stereotypes. The young mother in the painting has the same classic beauty that Hiram Powers duplicated *ad nauseam* in marble.

On a par with Blauvelt is George Cochran Lambdin (1830-1896), who worked largely in Philadelphia. In general his work is more sentimental than Blauvelt's. Occasionally he was capable of surpassing the dullness of his average product in such a work as *The Pruner,* 1868 (Fig. 168). Free of sentimentality, it is strangely moving in its simplicity and lack of pretension. Lambdin's handling of atmosphere and light here shows unusual sensitivity for him; there is an affinity to Millet in the monumentality of the figures. No other painting by Lambdin comes close to *The Pruner* in quality, and it confirms the old saw that even a mediocre painter has the capability of producing at least one minor masterpiece.

Characteristic of his heavy-handed sentimentality is *Consecration,* 1861 (Berry-Hill Galleries, New York), painted at the start of the Civil War and probably reflecting fairly accurately the romantic view of the war which existed for the first few months. The painting shows a young woman kissing the blade of a young captain's sword while he presses the rose she has given him to his lips. Such mawkish and overt emotion is almost incomprehensible now, but such scenes were no doubt actually enacted in 1861.

William Morris Hunt (1824-1879) was more important as an influential teacher and arbiter of taste than as an artist. He was an enthusiastic disciple of Millet, with whom he had worked at Barbizon. When he returned to Boston in 1862, he brought back a

174

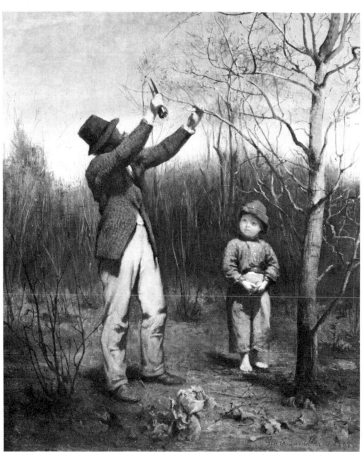

168. George Cochran Lambdin, *The Pruner,* 1868. Museum of Fine Arts, Boston; M. and M. Karolik Collection.

169. William Morris Hunt, *Playing Field Hospital,* 1865. Collection William N. Bourne.

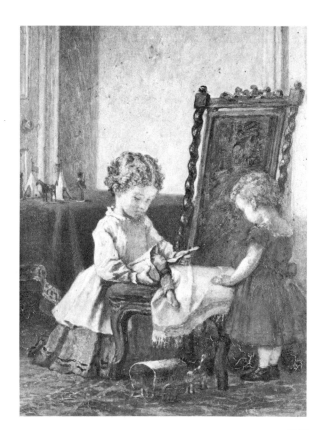

French point of view and manner of painting. His two best-known genre works, although American in subject matter, are entirely French in feeling. *The Ball Players,* c. 1874 (The Detroit Institute of Arts), which shows three men playing one o' cat, blends the figures into the landscape. Likewise, it takes quite an effort to realize that the idealized boys skinny-dipping in the Charles River in *The Bathers,* 1878 (Worcester Art Museum), were painted in prosaic Boston. Both paintings have an un-American detachment from the practical and factual. Instead they mirror the poetic type of figure painting which Millet had introduced in France. While the two paintings mentioned above are the works of Hunt most frequently reproduced, *Playing Field Hospital,* 1865 (Fig. 169), shows a less poetic, more sentimental and more characteristically American Victorian approach, although it, too, is thoroughly French in handling.

James H. Cafferty (1819-1869) was born in Albany. He went to New York and made that city his home from the early 1840's until his death. While he

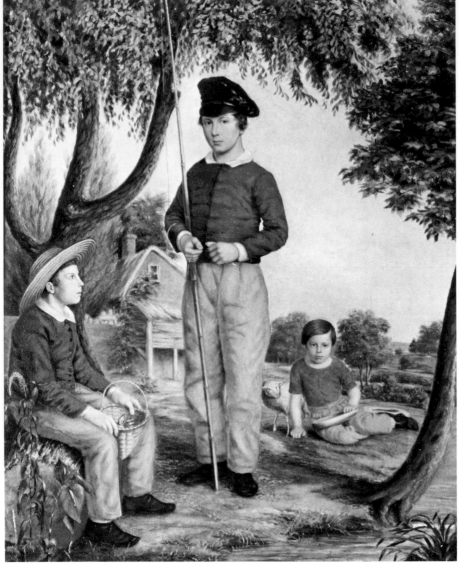

170. James H. Cafferty, *Boys Fishing,* c. 1840. M. Knoedler and Co., New York.

painted portraits, as did nearly every other American artist of the nineteenth century, his interest lies in his genre subjects, although he did far fewer genre paintings than he did portraits.

His style underwent considerable change between the 1840's and the 1860's. About 1840, when he painted *Boys Fishing,* (Fig. 170), he used a rather dry, tight manner reminiscent of Clonney. He treated his subject objectively, with neither a humorous nor a sentimental veneer. A typical canvas of about 1860, such as *The Encounter* (Fig. 171), shows a marked change not only in technique, which is in a lusher, more painterly French manner, but in attitude as well. Going with the tide of fashion, Cafferty became sentimental. His theme, the poor beggar woman and the little rich girl, was ideally suited to appeal to the sensibilities of a "lady bountiful"—one who could be sympathetic to the plight of the poor while remaining complacent about her own comfortable circumstances.

Another minor painter of the third quarter of the century was Henry Bebie (c.1824-1888), who was

176

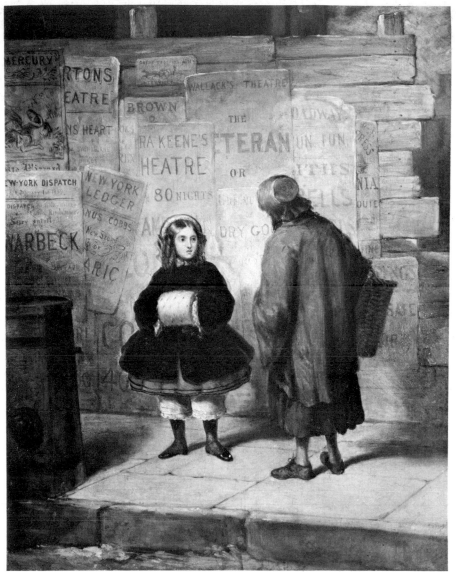

171. James H. Cafferty, *The Encounter*, c. 1860. M. Knoedler and Co., New York.

born in Switzerland and came to Richmond, Virginia, around 1842. He appears to have settled in Baltimore about 1846, probably remaining there until his death. His special forte was interiors with figures—in this case the elegant bordellos of Baltimore and their female attractions. Nothing in Bebie's painting would raise an eyebrow today, for his well-endowed *filles de joie,* even when in dishabille, are models of refinement and careful grooming who would be equally at home in the pages of *Godey's Lady's Book.* Indeed, his women are so generalized, they convey no sense of animation and are thus not at all provocative.

Bebie was the first and, it would appear, the only American painter before the end of the nineteenth century to paint the lush bordellos which could be found in all cities of any size. That the paintings are of brothels is not immediately evident, for at first glance one of Bebie's "conversation pieces" might be a group of young ladies in a finishing school. On studying several of these canvases, however, one is struck by the fact that all of the girls are not fully

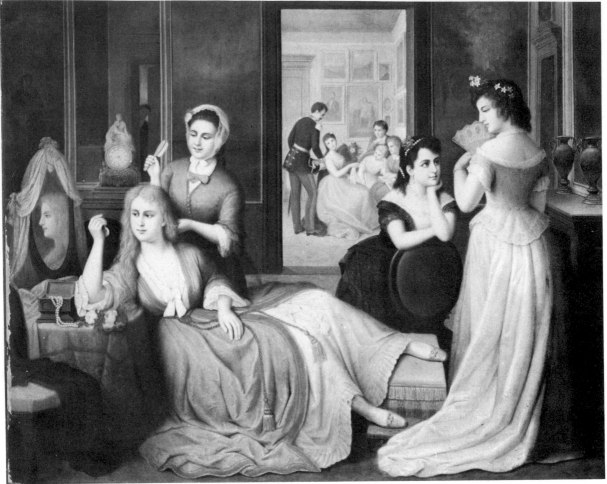

172. Henry Bebie, *Conversation*, c. 1875. The Peale Museum, Baltimore.

dressed. that their décolletages are less than modest, that they are all of approximately the same age, and that the mirrors, clocks and vases scattered about are embellished with *amorini* and nude or semi-draped figures.

Any lingering doubts are dissipated by close examination of *Conversation*, c. 1875 (Fig. 172). In the foreground is a young woman in a dressing gown whose hair is being brushed by a maid while she reclines on the chaise longue. Through a wide-open door there is a vista of the adjoining room, where four girls are entertaining a solitary army officer, resplendent in full-dress uniform and carrying the new-style German pickelhaube helmet, which the U.S. Army adopted in 1872. It is hard to imagine any other circumstance which would account for these deviations from Victorian social norms.

While *Conversation* is Bebie's most elaborate composition, his other known variants on this theme are similar in most respects. *The Toilette,* c. 1870 (collection Victor D. Spark), shows two women in an elegantly appointed bedroom; *Conversation Piece: Young Ladies in an Interior,* c. 1870 (Baltimore Museum of Art), shows six elegantly dressed women with flowers or jewels in their hair conversing in a drawing room while two others peek through a parted portière.

Prostitution was a fact of nineteenth-century life, but its existence was rarely acknowledged by polite society. Certainly paintings of this subject would hardly have been considered fit for private collections—let alone have been publicly exhibited. Hence it is hard to understand why Bebie should have painted this taboo subject, unless it was for a limited audience. Perhaps they were commissioned group portraits, since he had a certain local popularity as a portrait painter, but it is unlikely that we shall ever learn the true story.

It is unfortunate for John George Brown (1831-1913) that he became the victim of his own popularity, productivity and what, in retrospect, appears to have been misdirected specialization. To

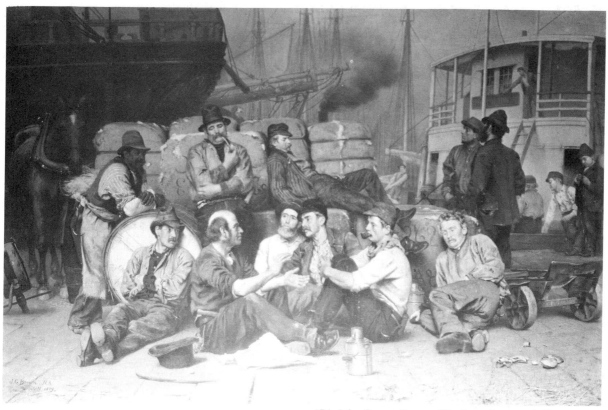

174. John George Brown, *The Longshoremen's Noon*, 1879. The Corcoran Gallery of Art, Washington, D.C.

173. John George Brown, *Tuckered Out - The Shoeshine Boy*, c. 1890. Museum of Fine Arts, Boston; Bequest of Maxim Karolik.

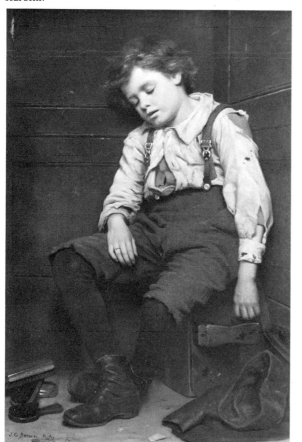

this day he is usually dismissed as a minor painter who specialized in sentimentalized bootblacks, such as *Tuckered Out—The Shoeshine Boy*, c. 1890 (Fig. 173). He was not the only American painter to hit on a formula which, when it proved successful, he ran into the ground, but he is a glaring example of an artist who became caught in a rut of his own making.

One cannot make out a case that, had things been different, he might now be ranked with Homer and Eakins, for it appears that he was a talented craftsman of limited intellectual capacity. Nonetheless, on occasion he was capable of solid straightforward realistic painting. *The Blacksmith*, c. 1900 (North Carolina Museum of Art, Raleigh), is such a work. Unpretentious and direct, it avoids the contrived effect that weakens some of his more ambitious efforts, including what is perhaps his best work, *The Longshoremen's Noon*, 1879 (Fig. 174). This impressive painting is well composed and, despite its rich detail, has unity. The color is good, the atmospheric light is capably handled, and as usual Brown is a master of

179

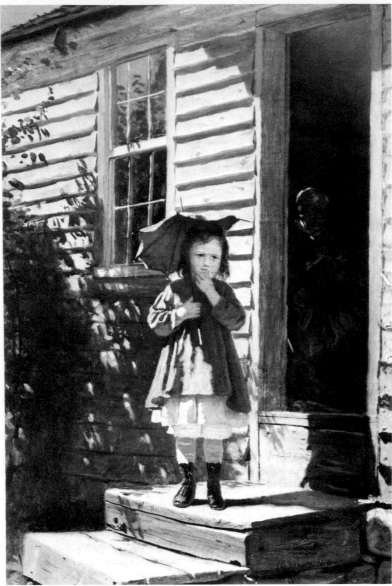

175. John George Brown, *The Broken Parasol*, c. 1865. Collection Mrs. Norman B. Woolworth.

drawing. However, the dockside workers are too obviously types selected by central casting: the Irishman, Swede, Negro, German and Yankee. The costuming is appropriate, but the make-up artist was not on the job; a cleaner, better-groomed and closer-shaved group of men would be hard to find. For all its inconsistencies of observation, this painting remains one of Brown's most successful large works.

Although less of an all-out effort, *A Sure Shot,* c. 1875 (The Brooklyn Museum), is relatively free from the studio look which often weakens Brown's statement. His characteristic sentimentality, which was strong in the street urchin series, appears in *The Music Lesson,* 1870 (Metropolitan Museum of Art), but the period flavor is so concentrated that the sentimentality almost passes unnoticed. It is rather sad that a man who at one time could almost equal Homer in his direct observation and painterly ability to catch the effect of brilliant sunlight, as in *The Broken Parasol,*

c. 1865 (Fig. 175), should have allowed himself to go up a dead-end street.

But how many of our painters have approached the sustained genius of Homer? Winslow Homer (1836-1910) is the outstanding genre painter in the history of American art. The bulk of his work is concerned with incidents of the everyday life of the farmer, the hunter, the fisherman, the woodsman, and indeed many other facets of American life.

Because Homer's career covers a considerable time span—1862 to 1909—it seems desirable to divide the discussion of his paintings into two parts: his earlier work in this chapter, his work after 1882 in Chapter VI. His great watercolors are omitted here for technical reason only; their consideration would not alter in any substantive way the view of the broad development of his work.

As is well known, after a brief but useful apprenticeship with the lithographer John H. Bufford in

Boston, Homer moved to New York and became, at the age of twenty-three, a free-lance artist-illustrator, working chiefly for *Harper's Weekly,* the best-known illustrated journal then published in the United States.

He displayed, even at that youthful age, the independence characteristic of the Yankee. No one could dictate to him; he was determined to chart his own course. And so he did, throughout his long and productive career.

It was for *Harper's* that he went South to record his impressions of the Civil War; they appeared in the form of woodcuts in that publication. In 1862 he painted his first oil based on these experiences. For Homer the war was not a succession of skirmishes or battles or hand-to-hand combat between individuals. Nor was it the martial splendor of grand parades or regimental reviews with colors flying and bands playing. As he presented it in his paintings, war was made up of little things. Homer saw war from the enlisted man's viewpoint: the early beating of drums for reveille, company punishment, the paying of one's last respects to a fallen comrade buried in a lonely grave far from home. War was the way one passed the long, tedious hours when there was nothing to do but wait: one carved with penknife a pipe from a briar root, or pitched quoits, or just lounged outside one's tent if the weather was good, or sought to supplement the rations of hard tack and salt horse with a nice fresh goose. Occasionally there was fighting, but this too, for Homer, was an individual, not a mass, experience. He painted a sharpshooter drawing a bead on some unlucky, far distant "greyback," and a soldier who, from sheer boredom, left the safety of an earthwork to shout defiance from its parapet. His one painting of combat, *Skirmish in The Wilderness,* 1864 (New Britain Museum of American Art), is reminiscent of Bierstadt's *Attack on a Union Picket Post,* 1862 (Fig. 144), in the small scale of the figures in relation to the landscape and in the feeling of tension it evokes.

The paintings which Homer produced during and shortly after the Civil War are unquestionably the best of the many paintings the war inspired. They show that Homer, in his late twenties, knew by instinct how to extract the human meaning from the holocaust. His contemporary, Eastman Johnson, in *The Wounded Drummer Boy,* c. 1866 (collection Mrs. McCook Knox), beats the drum of patriotism or, in *The Pension Agent,* 1867 (Fig. 132), strives for the pathetic, but Homer is not interested in such effects. His simplicity and solidity make a more telling statement than the studied, over-elaborated and over-finished efforts of his contemporaries.

*Prisoners from the Front,* 1866 (Metropolitan Museum of Art), is the masterpiece of this series. This famous work made Homer's reputation when it was shown at the National Academy of Design in 1866, and its merits were reaffirmed in 1867 by French and English critics when the painting traveled to the Paris Exposition.

In general, Homer's palette in these early oils was restricted and sober, but in *Pitching Quoits,* c. 1865 (Fogg Art Museum, Harvard University), and *The*

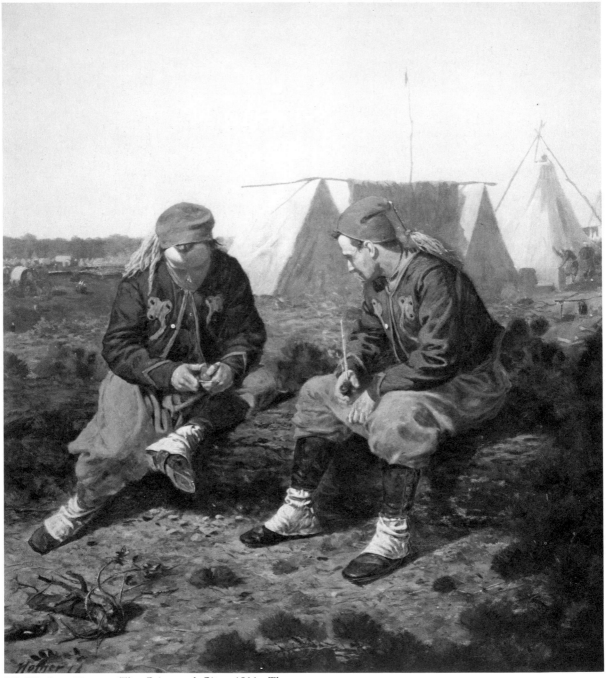

176. Winslow Homer, *The Briarwood Pipe*, 1864. The
Cleveland Museum of Art; Mr. and Mrs. William H. Marlatt
Fund.

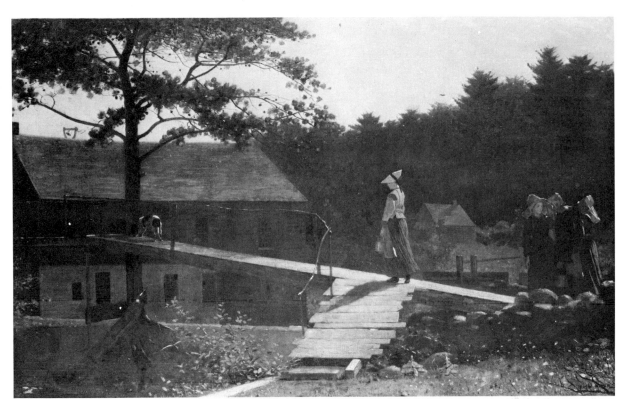

177. Winslow Homer, *The Morning Bell*, c. 1866. Yale University Art Gallery, New Haven, Connecticut; Bequest of Stephen Carlton Clark.

*Briarwood Pipe,* 1864 (Fig. 176), the poppy-red of the baggy Zouave trousers gave him a chance to experiment with color. Even in these early works he shows the interest in light which was a major lifelong preoccupation. More importantly, these works show his already deep and abiding concern for humankind and his ability to abstract beauty from commonplace activities.

Some of Homer's best work was produced in the late 1860's and 1870's. Ten months in France in 1867 had little apparent effect on his work, although he thoroughly enjoyed his sojourn in Paris. He looked at the advanced contemporary art on view, especially that of Manet, who was then very controversial, and at Japanese Ukiyoe prints, but remained his own man. On his return he continued, with steadily improving mastery, to paint subjects which were not greatly different from his war scenes. He depicted the everyday life of the countryside, not in the prosaic or sentimental manner usual with his contemporaries in the genre field, but with an eye to the odd angle (like

Andrew Wyeth today) and a keen perception of the inner life of the subject. There were already indications of that pictorial monumentality which is the glory of his mature work. *The Morning Bell,* c. 1866 (Fig. 177), and *Breezing Up,* 1876 (National Gallery of Art, Washington, D.C.), show the beginnings of this development.

At this time Homer was still somewhat the free-lance artist on a spree—painting whatever appealed to him—not yet having truly found himself. Like a small boy in a candy store, he sampled this sweet and that without any apparent consistency of direction. For example, it was in this period that he did a number of paintings relating to the one-room schoolhouse: *Snap the Whip,* 1872 (Butler Institute of American Art, Youngstown, Ohio), *The Country School,* 1871 (City Art Museum of St. Louis), and *School Time,* 1874 (collection Mr. and Mrs. Paul Mellon), which are refreshing in their naturalism and total lack of sentimentality. These were interspersed with such varied subjects as the bathing women in *High Tide,* 1870

183

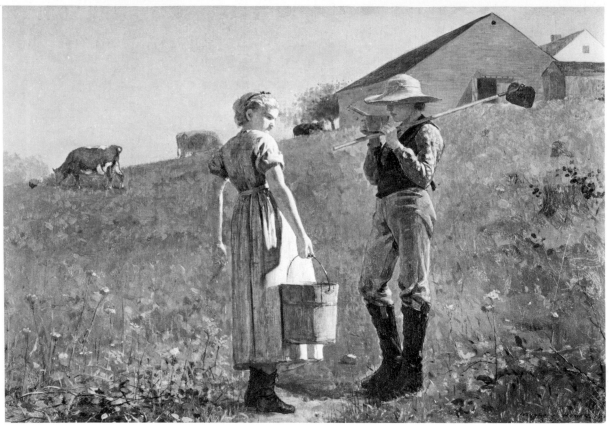

178. Winslow Homer, *Gloucester Farm,* 1874. Philadelphia
Museum of Art; Purchased: John H. McFadden, Jr., Fund.

(Metropolitan Museum of Art), and numerous
paintings of life on the farm, such as *Gloucester Farm,*
1874 (Fig. 178).

Of special interest today are the canvases which
resulted from a trip to Virginia in 1875. Apparently
Homer's first acquaintance with the American Negro
in large numbers occurred during the war years. He
painted them in a number of his Civil War scenes,
such as *Army Teamsters,* 1866 (Colby College Art
Museum, Waterville, Maine), and *Army Boots,*
1865 (collection Victor Spark). He observed them as
he did everything else that captured his interest—
objectively, but with warm understanding. It is in-
dicative of Homer's genius that even in this early
phase of his career he avoided the error, as many of his
contemporaries did not, of depicting Negroes as comic
black-faced minstrels, or Uncle Toms. They were to
him just fellow human beings, each with his own
idiosyncratic posture and gesture. The two statuesque
girls of *The Cotton Pickers,* 1876 (Fig. 179), are
painted as convincingly as his Gloucester, Mass-

184

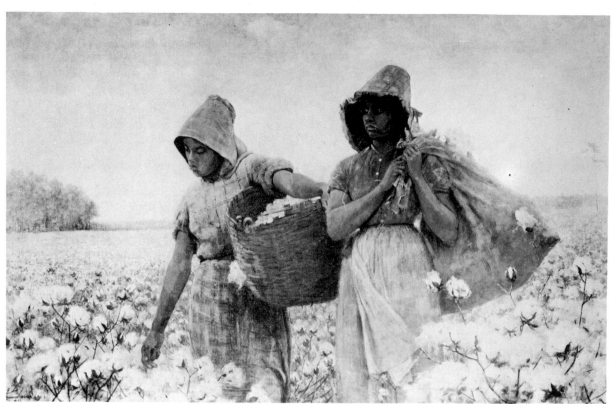

179. Winslow Homer, *The Cotton Pickers*, 1876. Private collection.

achusetts, farmhands. In another canvas, *The Carnival*, c. 1877 (Metropolitan Museum of Art), the same authenticity is present, but the color and the strong sunlight create a more cheerful atmosphere.

In 1878 Homer decided to go abroad again, but not to Paris this time. Instead he went directly to England and shortly settled in Tynemouth on the North Sea. It was during his two years in Tynemouth that Homer formulated the direction his future course would take and mastered the subtleties of his craft. The random carefree days were past. On his return to America he settled in Prout's Neck, Maine, and launched upon the series of masterworks that proclaim his stature. His admiration for the quiet courage of the simple English fisher folk in their daily struggle against the North Sea was transferred to the fishermen of the New England coast and supplied the unified theme he had been seeking. □

# CHAPTER

# Crest of a Wave

The final quarter of the nineteenth century saw no sudden shift in the direction taken by American genre painters. Except for two men, Homer and Eakins, who brought genre to a crest, it was a period of gradual change. Europe continued to be the dominant source to which our painters turned for precedent and example. It became apparent, however, that academism no longer offered a completely satisfying standard, especially for younger men just starting their careers. Yet the tradition of the highly finished story-telling salon painting retained its hold on the conservative element of society. Impressionism, which had flourished for some time in France and had its American disciples, was slow to cross the Atlantic. The movement did not gain full momentum in America until nearly 1900. With it came an entirely new attitude toward subject matter. To the true impressionist, what mattered was light and color; it made little difference whether the objects painted were haystacks or figures playing croquet. Thus impressionist genre paintings, substituting as they do one value for another, have, in general, limited topical content.

By now, genre subject matter had long been a staple of the artistic repertoire. The period of exploration and innovation in choice and treatment of subject was past. Whereas at mid-century the subjects presented by genre painters had a substantial relationship to the realities of everyday American life, by the late years of the nineteenth century most genre themes and their manner of presentation had become artistic conventions. Also, for both better and worse, the American artist and his patron were at last sophisticated men of the world. Both took themselves rather seriously. The inclination to poke fun at native idiosyncrasies was gone. Reporting the minutiae of places and events was no longer sufficient artistic accomplishment in itself; more complex and urbane interpretations were wanted.

The conventions of genre were perfectly adaptable to the expression of the Victorian ethic. The popularity of paintings which presented accepted char-

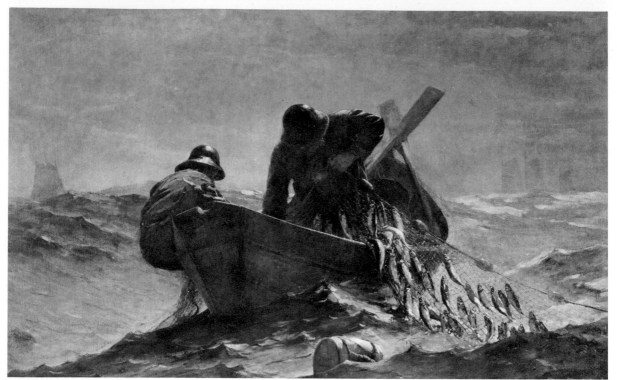

180. Winslow Homer, *The Herring Net*, 1885. The Art Institute of Chicago.

acters and situations in the sentimental haze of Victorian romance was assured, and so increasing attenuation of reality was encouraged. Practitioners of this mode of genre proliferated. Technical excellence in execution was common; imaginative, sensitive portrayal of the American scene was not. Homer and Eakins had the capacity to overcome the inherent shortcoming of genre art, its mundane topicality, and to make pictures of aspects of contemporary life which summed up the elemental human condition. Between the extremes of mediocrity and greatness were painters whose independent vision and honest response to the realities of the times kept alive the forthrightness of statement peculiar to American painting in general and to the genre tradition in particular.

This closing chapter of our theme and of the century is concerned with the development of genre painting at the hands of the two giants of American art and genre, the minority of other gifted chroniclers, and a sampling of those artists who might be called genre

mannerists. It was at once the best of times and the worst of times.

In the preceding chapter, Winslow Homer's years up to his return from England were summarized. The account continues with his career after 1883, when he settled at Prout's Neck, Maine. Except for trips to Canada and the Adirondacks in summer and to Florida and the West Indies in winter, he lived there for the remainder of his life.

After his return from Tynemouth, his work takes on a greater mastery and monumentality. The range of subject matter becomes more concentrated. The broad theme, new to Homer, that in general engrosses him from now on is man and nature, more specifically, man and the sea. He at last found, in the eternal struggle of man to survive in the face of the wind-driven seas, a subject worthy of his mature powers and satisfying to his artistic aspirations. Within this theme he could depict man's physical stamina and indomitable spirit in daily risking his life against the

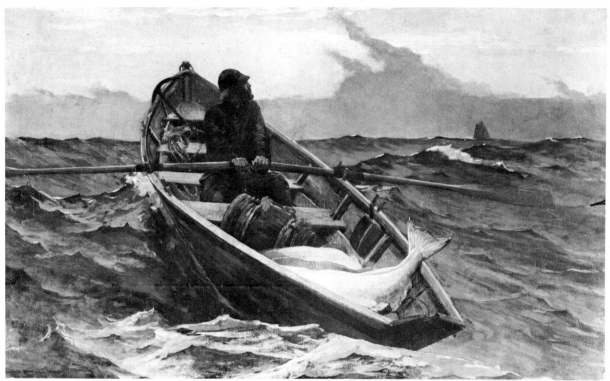

181. Winslow Homer, *The Fog Warning*, 1885. Museum of Fine Arts, Boston; Otis Norcross Fund.

elemental, unpredictable forces of nature. The theme had unity, but it also provided almost limitless variations which he could shape to his purpose.

In this period, through a succession of masterpieces, Homer captured the feel and look of the New England fisheries, which had ever been at the very core of the region's existence and survival. The life he painted had not changed materially since Colonial times. Men still went to sea under sail and fished in solitude from small dories on the heaving seas as they had in earlier days. But no American before Homer recognized the epic poetry in the subject—perhaps to earlier Yankees the smell of drying fish had imposed an impenetrable curtain of distaste.

Of the many paintings Homer did at this time, one masterpiece is certainly *The Herring Net,* 1885 (Fig. 180). The design is of classic simplicity. Although monumental, it is not stark and is made more effective by contrasts of intense and subdued tones. The silver scales of the herring catch the light, the red seine-float

provides a counterpoint to the soft, delicate tones of the sky, and the whole captures with authority the mood of fog at sea at sunset.

Perhaps even more impressive because of a sense of tension absent in *The Herring Net* is *The Fog Warning,* 1885 (Fig. 181). This ambitious canvas, the final resolution of a concept on which Homer worked for some time, is another masterly painting. Its mood is set by its cold light and somber color. The vastness of the sea is made menacingly apparent by the parallel horizontal lines of the ominous fog bank and the horizon line of the sea. Hull down on the extreme right is the schooner from which the lone fisherman has ventured forth. Will the schooner tack into the fog bank and be lost to sight? Is the fisherman's course correctly calculated to intercept hers? One cannot fail to be caught up in the drama and to appreciate the awful, somber beauty of the threatening sea.

These are but two of the many paintings Homer completed in the 1880's and 1890's depicting the life

189

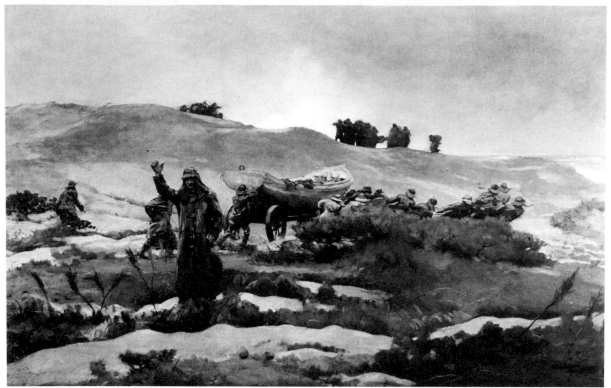

182. Winslow Homer, *The Wreck*, 1896. Museum of Art, Carnegie Institute, Pittsburgh.

of fishermen at sea; in quality and strength they are unequalled.

The culmination of Homer's paintings of man and the sea is *The Wreck*, 1896 (Fig. 182), a painting that slowly evolved from his experiences in Tynemouth, where he first became excited by the pictorial possibilities of rescue from the sea. Over the years he experimented with many variations on the theme, ranging from actual shipwrecks to rescues by breeches buoy and the saving of swimmers caught in the undertow. *The Wreck* is the stronger for its simplicity and for the fact that the whole anecdote is not spelled out in the painting. The ship in distress is hidden by the dunes. One sees only the rescue attempt, the tense spectators on the crest of the dune watching the operation of the breeches buoy, the toiling men of the life-saving crew taking a surf boat to a point where it can be launched. The scene is dominated by the single figure of the crew chief, his arm upraised. It is a powerful and dramatic work, painted with a somber

palette which heightens the sense of stress and urgency.

Homer's other great painting of disaster at sea, *The Gulf Stream*, 1899 (Metropolitan Museum of Art), again leaves much to the imagination of the viewer. In its brilliant color, it is at the other end of the spectrum from *The Wreck*, but it too conveys the message of man's courage in the face of forces he must confront but cannot dominate.

Homer's second source of subject matter for his oils in this period derived from his love of the outdoor life in the mountains and along mountain streams. His vacations, if one may call his summer trips to the Adirondacks and Canada that, resulted in a wealth of the greatest watercolors done in this country in the century. The subjects of the watercolors are varied— the logger on the river drives, the deer hunter, the fisherman, the canoeist and the woodsman. As was Homer's wont, when he was especially pleased with the realization of a watercolor, he further developed

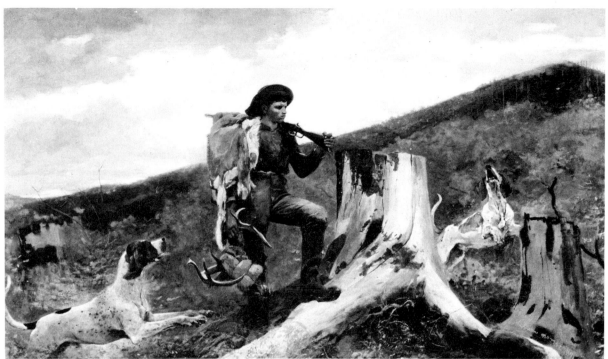

183. Winslow Homer, *Huntsman and Dogs*, 1891. Philadelphia Museum of Art; William L. Elkins Collection.

and refined the concept as an oil. His *Huntsman and Dogs,* 1891 (Fig. 183), and *Hound and Hunter,* 1892 (National Gallery of Art, Washington, D.C.) are two of his characteristic, superb canvases of Adirondack guides, a hardy breed of men, equally as knowledgeable in their sphere as the sturdy fishermen of Maine. With a sure hand and practiced eye Homer caught the spirit and the appearance of these descendants of the rangers who roamed the forests in Colonial days.

Born in San Francisco at the time Homer was painting his first oils of the Civil War, Henry Alexander (1860-1895), one of the first native-born California painters, began his short career in the late seventies. Little is known about his life other than that he received some art training at home, and later studied in Munich for seven years with Loefftz and Lindenschmidt. He must have shown unusual talent, for at nineteen he exhibited a painting in Munich. Sometime before 1886 he returned from Germany and es-

tablished a studio in New York, where he died at the age of thirty-five. His having a New York studio is hard to reconcile with the fact that all his known paintings are of San Francisco subjects.

This strange young man, gifted with unusual sharpness of vision, painted aspects of San Francisco life which appealed to his unconventional interests—for example, the alien life of the city's exotic Chinatown. Of greater significance to us are the interiors of dimly lighted offices, laboratories and shops which are his unique contribution to our record of the American scene. Alexander's art rises above the level of reportage because of the quiet, pensive mood he captured and his skill in the handling of light effects. This is apparent especially in the way he delighted in picturing light passing through glass vials and flasks filled with brilliantly hued chemicals, as in *The Laboratory of Thomas Price,* c. 1887 (Metropolitan Museum of Art). In *Neglected Business,* c. 1890 (M. H. De Young Memorial Museum), two elderly men,

191

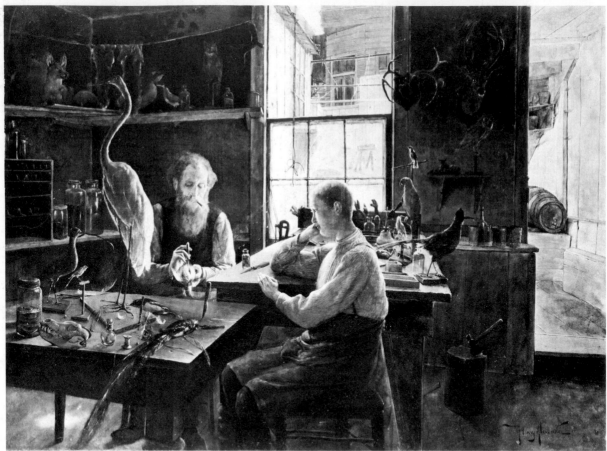

184. Henry Alexander, *The First Lesson,* c. 1890. California
Palace of the Legion of Honor, San Francisco.

wrapped in concentration over a game of chess, sit in a
darkened office interior with a vista, through a long
window, of the brightly sunlit facade of the building
across the street. The light coming through the
window is used with great subtlety to pick out and
dramatize the still-life objects on the desk-top—
packages of letters, a glass inkwell, pencils and other
oddments scattered about. Similarly his *The First
Lesson,* c. 1890 (Fig. 184), shows the taxidermist
William Nolte instructing his young apprentice,
William J. Hackmier, in Nolte's studio at 110 Golden
Gate Avenue, San Francisco. Again the interior is
dark, but a window gives a glimpse of a sun-drenched
courtyard and provides the source of indirect light
which illuminates the stuffed birds, bottles of chem-
icals and apparatus arranged on the table and shelves.
Paintings which convey such highly personal reactions
to mundane subjects are rare. While Alexander's
importance is modest, his independence of spirit and of
vision makes him one of the most interesting artists of
the late nineteenth century.

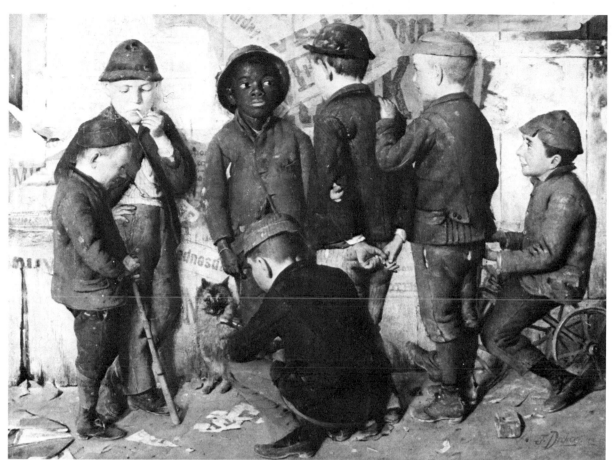

185. Joseph Decker, *Our Gang*, 1886. Collection Mr. and Mrs. H. John Heinz III.

Little is now known about the life of Joseph Decker (1853-1924) beyond the simple facts that he was born in Württemberg, Germany, and worked in Brooklyn, New York. His highly personal style had no contemporary counterpart and is strangely germane to American taste today. Few works from his brush, other than several magnificently painted still lifes of apples, have been found with which to document the range of his work. During the period 1877 to 1884, he exhibited four paintings in the Brooklyn Art Association's exhibitions: *First Fall of Snow, A Wreck at Rockaway, The Sleeping Beauty* and *Fruit.* However, only one important figurative painting, *Our Gang,* 1886 (Fig. 185), has come to light. This unconventional canvas shows seven gnomelike urchins who are probably up to no good, although exactly what they are doing is unspecified. Its surrealistic quality gives it a feeling of timelessness, which is one of the reasons it appeals so strongly to us today. A sense of tension—of some impending but uncertain turn of events—provides a unity of mood

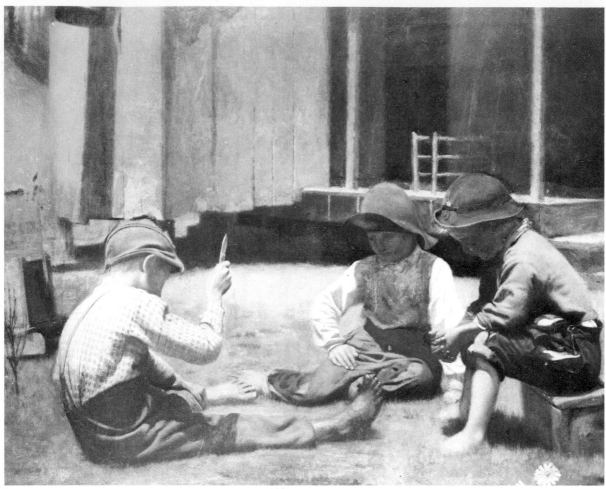

186. James Longacre Wood, *Mumble the Peg,* 1892. Collection Dr. and Mrs. Sherman E. Lee.

which is increased by the enigmatic relationships of the unnatural figures to one another. It is to be hoped that other examples of the work of this painter will be located, for until then no comprehensive analysis of his work can be made.

Among the delights of exploring neglected fields is the discovery of quasi-forgotten artists of merit. Dr. Sherman E. Lee called the author's attention to an example by such a painter in his collection. It is *Mumble the Peg,* 1892 (Fig. 186), by James Longacre Wood (1867-1938). We earlier encountered another representation of this perennially popular pastime in the work of Henry Inman (Fig. 43). Wood's delight-fully idiosyncratic painting is free from stale academic formulas and has a freshness and personality of its own. Little is known about Wood other than that he was a pupil of Thomas Eakins, who painted a portrait of Wood's father which is now in the Detroit Institute of Arts.[1] The dilute influence of Eakins can be detected more in the attitude of the artist toward his subject than in the application of paint. The natural-

ness of the poses of the three boys, the seriousness with which they concentrate on the business at hand, and the abstract handling of the background make it a fresh and absorbing painting—an appreciation it may well not have been accorded at the time it was painted.

The work of George Newell Bowers (1849-1909) is little known outside Springfield, Massachusetts, where he lived. As a young man he worked as a druggist's clerk, but by 1878 he had made the transition to artist. Between 1874 and 1879 he managed to study at the Art Students League as well as in Paris with Bonnat and Ferrier.[2] The nature of his work in the decade following this period of study is unknown, but in 1889 he painted three genre paint-ings which bear the impress of his individual manner. After 1890, when he returned from a further period of study in New York, he made a marked shift in tech-nique and subject matter and turned his talents to landscapes which possess a certain lyric quality. Of the three genre paintings that have come to light, *Meditation,* 1889 (Fig. 187), best shows the special

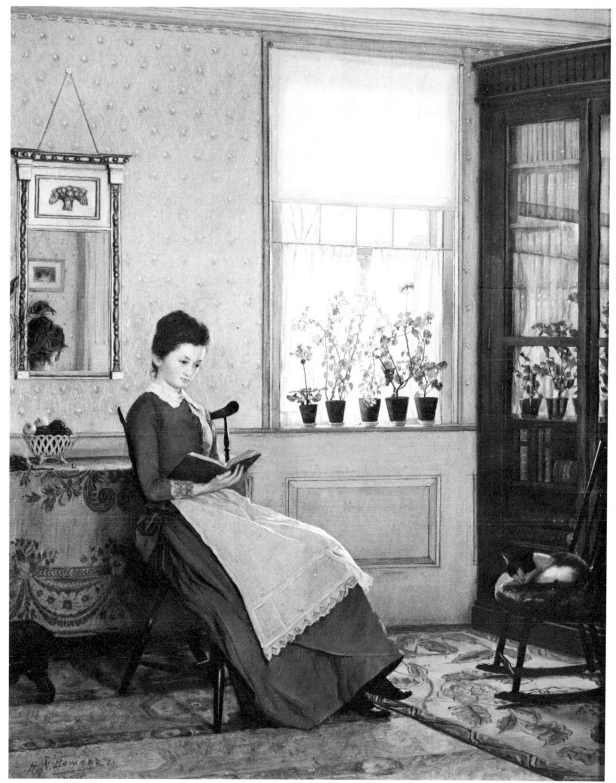

187. George Newell Bowers, *Meditation,* 1889. Museum of
Fine Arts, Springfield, Massachusetts.

quality of Bowers's work. Notwithstanding his meticulous detail and high finish, he succeeded in creating a unity of mood—one of quiet resignation and peace. One can almost hear the regular ticking of a clock—surely the only sound breaking the hush that rests like an invisible cloud over the typical New England room. The relaxed, understated charm he conveys is accompanied by subtlety in controlling the effects of direct and indirect sunlight as it permeates the room. His other two known genre canvases, *The Newsboy,* 1889 (Museum of Fine Arts, Springfield), and *Nantucket Journal,* 1889 (Old Print Shop, New York), are similar in their restraint and lack of self-consciousness.

The simplistic quality of Bowers's painting makes it akin to the work of another Massachusetts artist, Edwin Romanzo Elmer (1850-1923).[3] Elmer's *Lady of Baptist Corner, Ashfield, Massachusetts,* c. 1892 (Fig. 188), has an interest in light and a mood of tranquillity and quiet similar to those in Bowers's paintings. The young woman, actually Elmer's wife, is engaged in making whipsnaps for the tops of buggy whips. By doing such piecework at home, farm women of this period earned a little personal pocket money, which otherwise rarely came their way. The machine on which Mrs. Elmer is working was invented by her husband, who had a typically Yankee mechanical bent as well as an aesthetic one. It was not his only invention, for he also devised a machine for shingling houses and a mechanical butter churn. Aside from a brief period of study at the School of the National Academy of Design in 1889, Elmer spent his entire life in Ashfield. His unusually imaginative work ranges from landscape to still life to genre. As Alfred Frankenstein has written, all of Elmer's work has an "eerily obsessive ultra-photographic attention to detail."[4] His well-known *Mourning Picture,* c. 1899 (Smith College Museum of Art, Northampton, Mass.), especially, has this brooding quality which gives him a special place in late nineteenth-century painting.

Samuel S. Carr (active 1838-1894) is a painter about whom nothing is known beyond his name and the facts that he was born in England and lived in Newark, New Jersey, and Brooklyn, New York. He exhibited at the Brooklyn Art Association between 1871 and 1891, when he ceased to submit works. A number of his paintings survive—all of genre subjects. Four examples are known to the writer. *Winter Landscape,* 1886 (New Britain Museum of American Art), is a pleasantly innocuous scene of children skating, handled with the technical competence of a well-trained professional. This can be contrasted with *Beach Scene,* c. 1879 (Fig. 189), in which the style is more interesting, but less consistent and less professional.[5] This canvas, with its purely accidental surrealist overtones, includes a peep show and a tintype photographer making portraits of the holiday crowd. Carr's *The Vegetable Vendor,* c. 1885 (collection Kennedy Galleries, New York), is another example of the painter's interest in portraying the unglamorous aspects of American middle-class life.

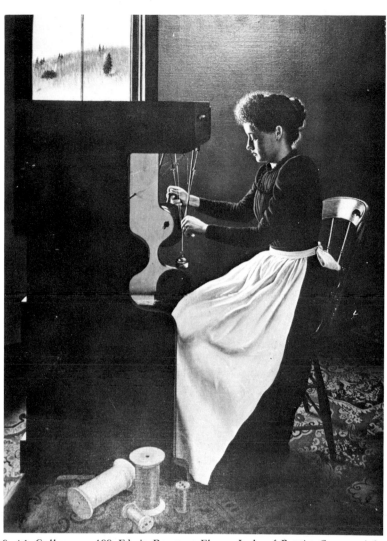

189. Samuel S. Carr, *Beach Scene*, c. 1879. Smith College Museum of Art, Northampton, Massachusetts.

188. Edwin Romanzo Elmer, *Lady of Baptist Corner, Ashfield, Massachusetts*, 1892. Collection E. Porter Dickinson.

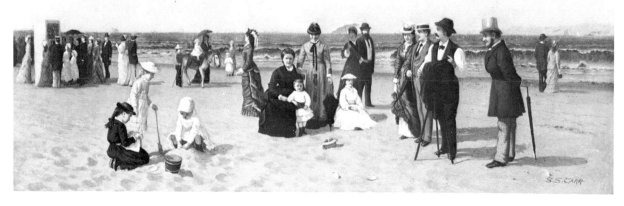

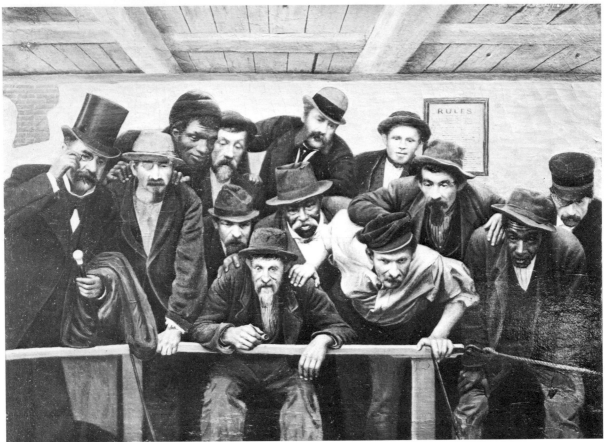

190. Horace Bonham, *Nearing the Issue at the Cockpit,* 1870.
The Corcoran Gallery of Art, Washington, D.C.

For all Carr's seemingly prosaic rendering, he succeeds in putting on canvas a believable sense of life. His views are not glossy Franco-American pastiches artificial in pose, composition and subject, but faithful mirrors reflecting the images seen with his clear and unsophisticated eye.

Horace Bonham (1835-1892) was a painter of modest capabilities who also studied under Bonnat. His principal claim to fame is the canvas *Nearing the Issue at the Cockpit,* 1870 (Fig. 190). Bonham succeeds in conveying a sense of tension and excitement by the simple expedient of eliminating the embattled cocks from view and concentrating our attention on the expressions of the mixed bag of spectators who watch the fight-to-the-death. The sport of cockfighting, popular abroad, was illegal in many sections of this country, and these events were often

198

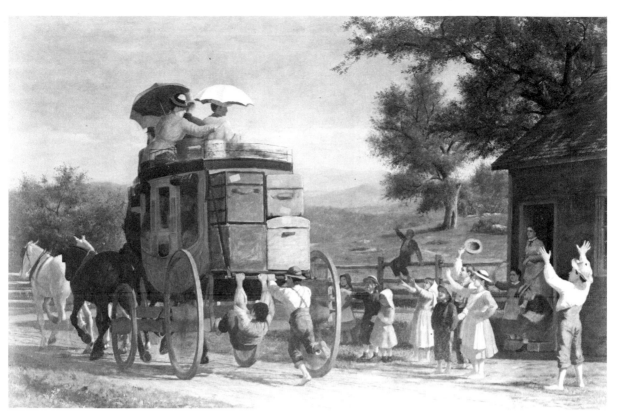

191. Enoch Wood Perry, *Pemigewasset Coach,* c. 1895. Shelburne Museum, Shelburne, Vermont.

staged surreptitiously. This painting by Bonham is exceptional both in recording an obscure American pastime and in its superiority to the routine level of most of Bonham's genre paintings.

Enoch Wood Perry (1831-1915) is another neglected painter of this period.[6] Like many another American artist, he studied abroad. He went in 1852 to Leutze at Düsseldorf for two and a half years, then to Paris for a year with Couture. In 1858, six years after his departure, he returned to this country, where with characteristic American restlessness he worked briefly in Philadelphia, New Orleans, California, the Sandwich Islands and Salt Lake City until, in 1866, he established himself permanently in New York.

While Perry was primarily a genre painter, and a prolific one, he was also a portraitist and painted an amusingly varied lot of individuals, ranging from Jefferson Davis and John Slidell to Kings Kamehameha IV and V, Brigham Young and U. S. Grant.

During his lifetime Perry's genre paintings found their way into the collections of some of the wealthiest patrons of the day—Leland Stanford and Collis P. Huntington, for example—but he has received scant critical attention in recent years. Three remarkably differing examples, covering roughly a forty-year span, show his diversity as a genre painter.

The earliest of these, *How the Battle Was Won,* 1862 (The Newark Museum), was painted in New Orleans. Its somewhat awkward composition is compensated for by its being one of the few surviving canvases to show an incident in the Civil War behind Confederate lines. *Pemigewasset Coach,* c. 1895 (Fig. 191), is both characteristic of works in his later style and more ambitious and successful than most of them.

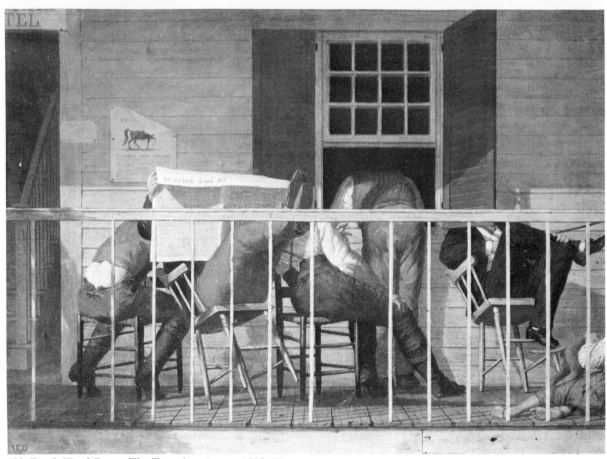

192. Enoch Wood Perry, *The True American,* c. 1875. The
Metropolitan Museum of Art, New York; Arthur H. Hearn
Fund, 1955.

193. William Aiken Walker, *Plantation Scene,* 1881.
Collection Jay P. Altmayer.

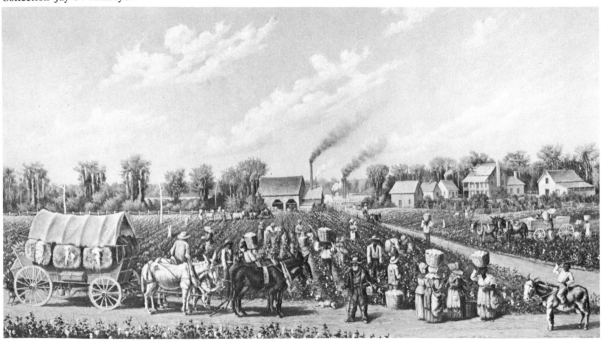

Loaded with passengers and trunks, a four-horse coach is passing a country school at recess time—giving some of the braver youngsters a chance to hook a dusty ride on the luggage rack. The painting captures the spirit and atmosphere of a sunny early summer day in the country without exploiting the quaintness of the scene. The third painting is markedly different—a sort of painted pun which at one time was entitled *The Vanishing American* and is now called *The True American,* c. 1875 (Fig. 192). This amusing canvas, reminiscent of the work of David Claypool Johnston, shows six figures on the porch of a country hotel (another is climbing the stairs on the left). By a variety of devices the artist renders them all headless, hence the title, which is also the name of the newspaper in the painting. Even the head of the horse on the broadside posted on the wall is concealed by a corner of the poster. The lighthearted, fun-loving spirit which called this work into being is a refreshing contrast to the prosaic and uninspired generality of contemporary painting of anecdote.

Close to the hearts of present-day collectors in the South is the painter William Aiken Walker (c. 1838-1921). Among the reasons for Walker's present popularity is that his work is still readily available, for by all accounts he was a fast and prolific painter who finished a painting a day. Perhaps more compelling is the fact that his simply conceived and simply executed paintings are so unmistakably of the Deep South. Walker was born in Charleston, South Carolina, and apparently spent his entire life in the South, working in Louisiana, Georgia and Florida as well as in the Carolinas. In the mid-1880's Currier & Ives published two large folio lithographs, *The Levee New Orleans* and *A Cotton Plantation on the Mississippi,* after his paintings. Walker's range seems restricted to four basic themes: the Negro shack on a country road with figures lounging around the yard, genre landscapes of cotton-picking in the huge fields, small paintings of Negro laborers shown full length and Mississippi River steamboats unloading bales of cotton at New Orleans. *The Levee at New Orleans,* 1885 (collection Hirschl and Adler Galleries) is a typical example: baled cotton is stacked in the foreground, and in the distance horse-drawn drays are lined up before the smoke-belching steamboats docked thickly along the levee.[7] A fine example of Walker's cotton-plantation series is *Plantation Scene,* 1881 (Fig. 193). With its numerous small figures of Negro field-hands picking cotton, distant gin and steamboat, and plantation house and outbuildings, this canvas is a richly detailed factual record of an aspect of American life which has disappeared, except in musical form.

The son of the artist Henry Inman, John O'Brien Inman (1828-1896) followed, somewhat falteringly, in his father's footsteps as a portrait and genre painter. It would be doing him less than justice, however, not to call attention to two very different products of his easel, each of which stands as an individual statement. *Moonlight Skating, Central Park, The Terrace and Lake,* c. 1878 (Museum of the City of New York), is filled with dozens of figures sporting around the lake in

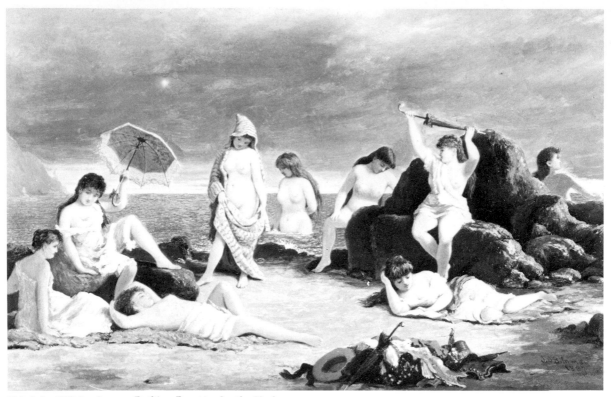

194. John O'Brien Inman, *Bathing Beauties by the Hudson*, 1887. Kennedy Galleries, New York.

the light of the moon. Nocturnal landscapes are uncommon in American painting, but in the second half of the nineteenth century there seems to have been a minor vogue for such scenes. Johann Mongles Culverhouse (active c. 1849-1891), for example, was another New York painter who liked to paint nocturnal scenes combining landscapes and figures. Ten years later, Inman painted *Bathing Beauties by the Hudson,* 1887 (Fig. 194), which in its day must have been considered titillating, if not actually racy, for it shows nine women in varying stages of undress.[8] It is yet another example of a painting which does not fit any precise category. It is not a textbook example of genre, nor is it figure painting because the contemporary costume gives it a genre flavor. It is impossible to believe that at that date a group of ladies would have been found disporting themselves nude on the banks of a much-traveled river. One may suspect that the scene, if it is not satirical, was a matter of wishful thinking on Inman's part. On the other hand, all young female New Yorkers were not ladies, so

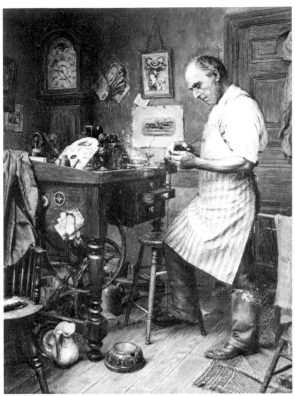

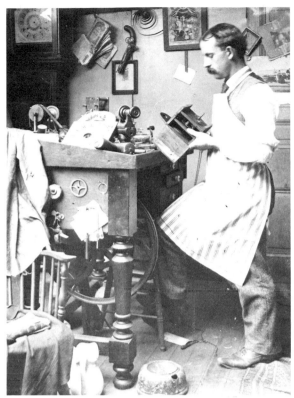

195. Jefferson David Chalfant, *The Clockmaker*, c. 1898. Collection Amanda K. Berls.

196. Jefferson David Chalfant, study photograph for *The Clockmaker.* Courtesy of Mrs. J. D. Chalfant through Coe Kerr Gallery, New York.

perhaps one should defer final judgment.

Jefferson David Chalfant (1856-1931) began his career as a cabinetmaker in Wilmington, Delaware, but later switched to painting. His paintings fall into three periods: his silvery still lifes done in the 1880's, his genre paintings of the 1890's and his portraits after 1900. His work reflects a good cabinetmaker's attention to detail and craftsmanship. It is precise, consistent and controlled. Most of his paintings are small in size and rarely include more than a few figures, often skilled craftsmen or young Negro children. They are sensitive, painted in a restricted, almost monochrome, warm palette with the painstaking detail of a miniaturist. Chalfant was among those American painters who, like Homer, Eakins and others, made extensive use of photography as an aid to his painting. This is shown by a comparison of his *The Clockmaker,* c. 1898 (Fig. 195), with the photograph (Fig. 196) that he himself made as a study for the painting.[9] While the alteration in the craftsman's age and small changes in detail are apparent, the com-

position is the same, as is the pose of the figure. It requires no persuasion to accept Chalfant's paintings' reliability as to detail, but they are far more than records. The integrity of the artist is implicit in them, and the quality of his vision is so distinctly personal, so sensitive, so simple yet so strong, that his paintings merit our respect for their aesthetic qualities also.

One would not expect to find an example of genre painting in the trompe l'oeil still-life tradition of Harnett and Peto. Nevertheless this unlikely mélange did occur in at least one isolated instance. Victor Dubreuil (active 1888-1900), accomplished this neat trick in *Don't Make a Move,* c. 1900 (Fig. 197). Nothing is known of Dubreuil's life except that he worked in New York for a little over a decade. In this entertaining picture, the viewer is the victim of a stick-up by a villainous, unkempt bandit who thrusts his six-shooter through the grillwork of a cashier's booth while his confederate, an old crone, helps herself to the loose U.S. treasury notes in the cash drawer. From his few other known canvases, it seems Dubreuil's specialty was trompe l'oeil rendering of money—the kind of sublimated exercise of the counterfeiter's art now forbidden by law. The situation he has created here to support a money-portrait leaves us a unique memento of late-nineteenth-century America. The painting may be taken quite seriously, probably not as genre of the "slice of life" category, but as genre of the slice of popular imagination. The late nineteenth century was the era when easterners devoured the dime-novel adventures of outlaws, commonly of a grotesquely evil type conjured out of the remote West. Dubreuil's painting might be taken as a cultural ancestor of early feature movies like "The Great Train Robbery."

This painting illustrates a point made in the introduction, that art terminology has distinct limitations. No matter how carefully they are defined, terms such as landscape, seascape, figure, marine, still life, genre or history painting are only relatively sacrosanct. The artist, traditionally impatient with any shackles on his freedom of expression, pays not the slightest heed to the implied limitations of such terms whenever it suits his fancy to experiment and improvise.

In recent years scant attention has been devoted to the remarkable work of Charles F. Ulrich (1858-1908), probably because so few of his paintings have found their way into public collections in this country. He is an artist who deserves wider appreciation and study. As a young man Ulrich studied in Munich. He then worked in New York for a period, but much of his later professional life was passed abroad in Italy and Germany. His best-known painting is *In the Land of Promise—Castle Garden,* 1884 (Fig. 198). Ulrich was not one of the fashionable genre painters who chose "safe" subjects like the social activities of the upper middle class. To the contrary, he appears intentionally to have searched out offbeat subjects that showed a side of life which other more conventional and less imaginative painters avoided. *In the Land of Promise* is a case in point.

Castle Garden was no garden; it was the great

197. Victor Dubreuil, *Don't Make a Move,* c. 1900. The New England Merchants National Bank, Boston.

198. Charles F. Ulrich, *In the Land of Promise—Castle Garden,* 1884. The Corcoran Gallery of Art, Washington, D.C.

199. William Merritt Chase, *The Open Air Breakfast,* c. 1888.
The Toledo Museum of Art, Toledo, Ohio; Gift of Florence
Scott Libbey, 1953.

immigration center in New York's Battery Park.
Despite the fact that it lay at their doorstep, few New
Yorkers ever set foot there. Between 1855 and 1890,
eight million immigrants passed through its portals. In
contrast to his important contemporary, William
Merritt Chase (1849-1916), whose elegant subjects,
such as *The Open Air Breakfast,* c. 1888 (Fig. 199),
depicted the world Americans preferred to acknowl-
edge, Ulrich painted unprepossessing actuality.

The influence of the training Ulrich received in
Munich is apparent in *The Glass Blowers,* c. 1890
(Museo de Ponce, Puerto Rico), which has a rich,
dark tonality. Ulrich here chose to paint another
aspect of working-class life—the sweatshop with rows
of workers crowded around a workbench.

*The Village Print Shop,* c. 1885 (Fig. 200), is a
strong canvas with rich paint quality and asymmetrical
composition. Again Ulrich shows a working-class
subject. In composition and mood, especially in its

effective handling of light, the painting forecasts the
style and format of Andrew Wyeth. The interior of the
job printer's shop is bathed in a diffused light which
picks out highlights on the surfaces of the furnishings
in a lively yet subtle way. The apparently casual
placing of the figures is the more effective because of
the naturalness it lends the scene. But the quality
which makes this a minor masterpiece is the beautiful
handling of light, especially on the head of the boy
drinking coffee.

Edward Lamson Henry's (1841-1919) earliest
professional works were done during the Civil War.
Such works as *The Old Westover Mansion,* 1869
(The Corcoran Gallery of Art), combine topographical
landscape with genre. In this painting, with the fine
detail of a miniaturist Henry depicts the damaged
mansion and the Union troops who have occupied it.
His passion for microscopic detail appears also in *City
Point, Virginia, Headquarters of General Grant,*

200. Charles F. Ulrich, *The Village Print Shop*, c. 1885.
Collection Mrs. Norman B. Woolworth.

1865-73 (Addison Gallery of American Art, Phillips Academy, Andover, Mass.), where Grant is portrayed sitting by his tent, recognizable even though he is only a fraction of an inch in height.

Henry was a prolific painter who single-mindedly concentrated on genre scenes. New York was his headquarters during most of his productive years, and it was there that he produced the more than twelve hundred works catalogued by Elizabeth McCausland.[10] His paintings, it must be observed, do not show the impress of a strong artistic personality or a highly individual style. Instead they have an earnest, pedantic, emotionless factuality. He lacked the painterly qualities one might expect him to have acquired during his sojourn in Paris, where he worked under Courbet, among others. His paint surfaces tend to be dry, and there is little richness in his use of color.

During his life Henry enjoyed considerable popularity on account of his scenes of the Colonial and Federal periods, which were well researched but, like most reconstructions, somehow miss the spirit of the earlier periods and consequently lack real conviction. Henry's interest in historical reconstructions was part of a larger movement, joined by novelists, architects, furniture manufacturers and others, which was based on nostalgia for the youthful years of the century—an American variant of ancestor worship. During the quarter-century following the centennial celebration of 1876, inexact reproductions of eighteenth-century furniture flooded the market, and architects designed pseudo-Colonial and Federal houses to satisfy their patrons' desires for ancient and respectable roots. This adulation of the American past even took the form of costuming elite quasi-military units in uniforms patterned on those worn during the Revolution. Henry's visions of the past were appropriate complements to the reproduction furniture in the "period" houses.

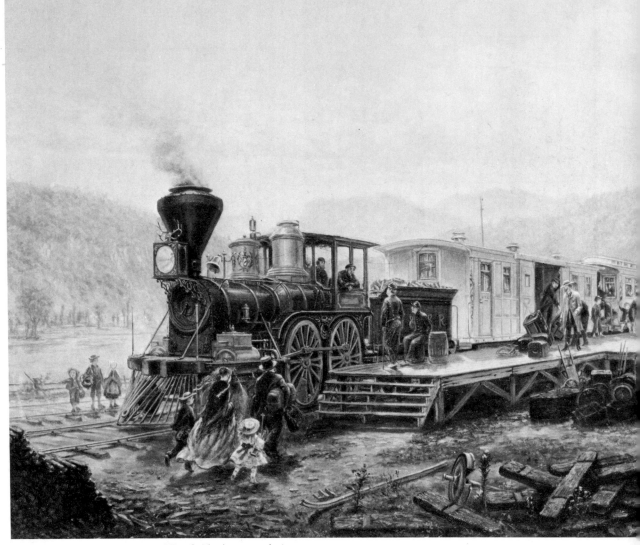

201. Edward Lamson Henry, *The 9:45 Accommodation, Stratford, Connecticut*, 1867. The Metropolitan Museum of Art, New York; Bequest of Moses Tanenbaum, 1939.

But Henry also maintained a steady interest in the country activities of his own day. Occasionally, as in his *The 9:45 Accommodation, Stratford, Connecticut*, 1867 (Fig. 201), which is perhaps his masterpiece, he achieves a spontaneity that is almost gay. In more typical works, such as *Country Breakfast*, 1884 (New Britain Museum of American Art), while we can admire the draughtsmanship and the completely and accurately documented representation, there is no sense of excitement. Here is descriptive prose with no trace of poetry. Henry's *Kept In*, 1888 (Fig. 202), shows his skill at recording the details which make his paintings of contemporary subjects such valuable social documents, but here he also achieves a strong mood—an embellishment which his detached antiquarian's mind rarely permitted.

Working in a style and palette very close to that of Henry was James Wells Champney (1843-1903), one of the few American illustrators or painters actually to have served as a soldier in the Civil War. Before he enlisted in the 45th Massachusetts Volunteers,

Champney had had some training in art and had been an employee of the engravers Bricker & Russell in Boston. In 1867 he studied with Edouard Frère, joining the hordes of American art students who congregated in Paris after the war.

As a painter Champney was primarily interested in genre; employing a formula of his master, Frère, he often took the contrast of youth and old age as his theme. A characteristic example, probably painted in Deerfield, Massachusetts, where he had a summer home, is *Boon Companions*, 1879 (Smith College Museum of Art, Northampton, Mass.). Champney, like Chalfant, sometimes used photographs, which he took himself, as aids in painting; several surviving photographs demonstrate his reliance on them for composition and background detail.[11] His paintings are gentle and unexciting; they tend to be diffuse in composition and empty of either intellectual or aesthetic content.

John Ferguson Weir (1841-1926) was the son of the painter Robert Walter Weir (1803-1889), who

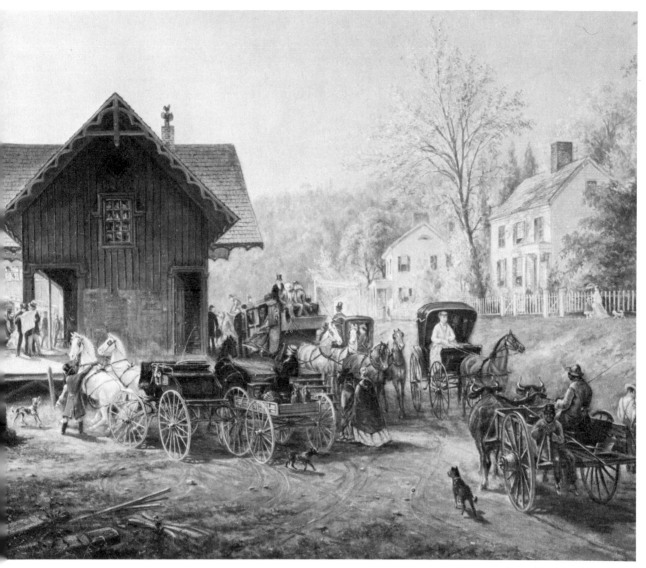

202. Edward Lamson Henry, *Kept In*, 1888. New York State
Historical Association, Cooperstown, New York.

painted some literary and historical genre subjects that do not concern us here. J. F. Weir was, half a century after Bass Otis, the next American artist to see grandeur and beauty in industry. He painted two remarkable pictures on this theme, which were, strangely enough considering their unorthodox subjects, hailed as major accomplishments by his contemporaries. These, *The Gun Foundry,* 1866 (Putnam County Historical Society, Cold Spring, New York), and *Forging the Shaft,* 1877 (Fig. 203), show man pitted against the machine in much the same way Homer shows man struggling against nature. Weir's paintings have something of the impressiveness of Piranesi's *Prisons.* The cavernous space, the lurid light emanating from the red-hot forging, the figures struggling to control the massive bulk of the shaft, make a powerful statement. No other artist attempted to paint the dramatic potential of giant industry until well into the twentieth century, when the machine was again recognized as a major force in contemporary life by such artists as Diego Rivera.

With Weir we conclude the roster of the artists who maintained allegiance to the older tradition of forthright statement, and turn our attention to the more sophisticated talents of the genre mannerists. This group is large, so large that only a sampling is here attempted, partially for the reason that these painters offer little diversity of skill, temperament or content and in large doses become repetitious.

Henry Bacon (1839-1912), American by birth, was an expatriate who lived mainly in London and in Paris, where, as a young man, he had studied painting. Like his contemporary, Champney, he was an infantryman during the Civil War and, while serving with the 13th Massachusetts Volunteers, was wounded in action. Shortly thereafter, in 1864, he went abroad. Because of his protracted foreign residence, most of his paintings are of European or Egyptian subjects. However, the paintings of shipboard scenes for which he was especially noted have interest today.

*Sailing Out of New York,* 1891 (collection Ira Spanierman), epitomizes Bacon's slick, meticulous technique and high finish, culmination of the academic salon painting which was being replaced by the second generation of American impressionism and the boldly brushed realism of Henri, Chase and Duveneck. It shows a well-corseted, somewhat teary beauty, sitting alone on a life raft on the boat deck and gazing soulfully at the receding shoreline and the Statue of Liberty, which had been unveiled five years before. The presentation is frankly sentimental, but somehow the painting is so much of its time that it has a certain curious validity.

Bacon's *On Shipboard,* 1877 (Fig. 204) strikes a gayer note. The scene depicts a passenger liner on the Atlantic crossing. While clouds of inky-black soft-coal smoke drift off to port, two ladies are playing a furious game of quoits, and other passengers read or pass the time in conversation. The figures are impeccably drawn, yet they do not have a life of their own. Nor does the ship vibrate with the pulsing of its engines or

203. John Ferguson Weir, *Forging the Shaft,* 1877. The ▶ Metropolitan Museum of Art, New York; Gift of Lyman G. Bloomingdale, 1901.

204. Henry Bacon, *On Shipboard,* 1877. Museum of Fine ▶ Arts, Boston; Gift of Mrs. Edward Livingston Davis.

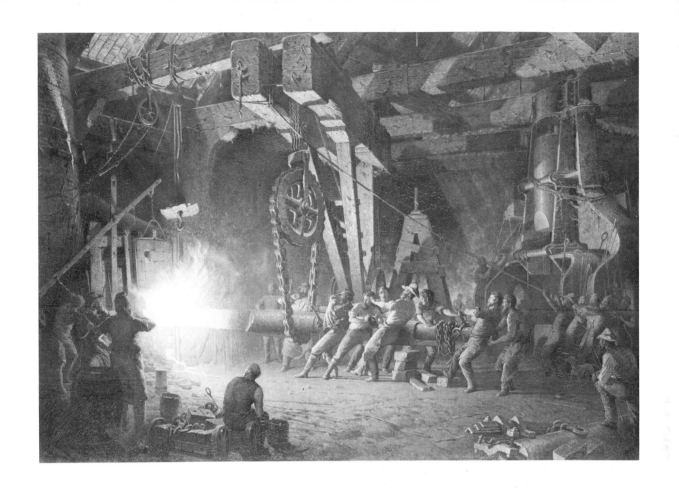

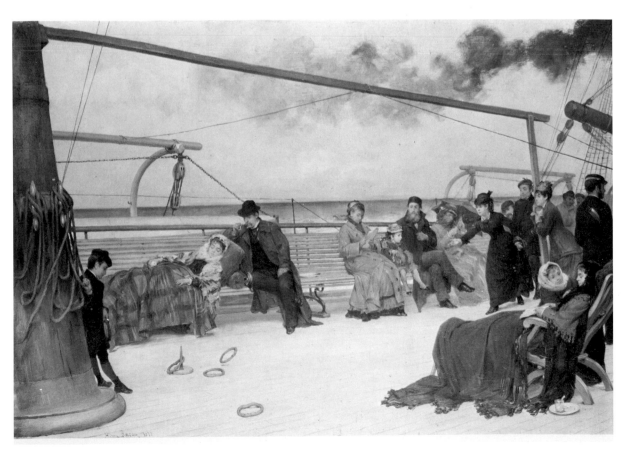

the movement of the sea. It is a beautiful daydream, a vision which existed only in the painter's imagination.

Bacon lived on the surface of life. His work, for all its cleverness, grace and virtuosity, now strikes us as delightful, but dated, illustration, although this judgment may change with time. In any event, without his paintings we would know far less about the flavor of society life in the Mauve Decade.

Julius L. Stewart (1855-1919) is similar in several ways to Henry Bacon. Both are extreme examples of the late-nineteenth-century tendency of American art and artists to turn to Europe, especially France, as the world's cultural center. Like Bacon, Stewart was born in this country but spent most of his life abroad, where he worked and exhibited and where he died. He was a genre painter who appears to have restricted himself to recording the life of international high society in the gilded age which lasted from the 1880's to the beginning of World War I. The titles of some of his unlocated paintings indicate the range of his interests: *Court in Cairo*, 1883, *Five O'Clock Tea*, 1884, *Hunt Ball*, 1885, *Full Speed*, 1886. As an example of this American expatriate's work, *The Yacht Namouna in Venetian Waters*, 1890 (Fig. 205), is characteristic. While this yacht is cruising the Adriatic, it could as easily be in New England waters, where similar floating palaces steamed through the sunny seas in July and August, putting in at the fashionable resorts of Newport and Bar Harbor. Superficial and without a trace of philosophical content, this painting mirrors to perfection an aspect of the life of the truly idle rich. The only evidence of the large crew needed to stoke the steam boilers, prepare meals in the hot galley and attend to the owners' every whim is the solitary immaculate sailor on lookout in the bow.

Louis Charles Moeller (1855-1930) studied his craft in Munich in the 1880's and then returned to the United States, where he flourished as a genre painter. His works are generally low in key; his figures almost disappear in the dimly lighted brownish interiors which they inhabit. *Disagreement*, c. 1890 (The Corcoran Gallery of Art), is typical. While today's taste finds the situations he elected to paint so contrived and obvious that they are boring, no one can deny that he was a skilled draughtsman and a well-schooled painter. So long as Moeller worked in his straightforward realistic manner he can be taken seriously, but on occasion he allowed himself to be carried away by his own virtuosity. When this happened and all stops were pulled, the result, while perhaps breathtaking, is also incredibly tasteless. He achieves such a pinnacle of the ridiculous in *The Antique Store*, c. 1895 (Fig. 206). The veritable maelstrom of sensuous textures—bronze, leather, velvet, ceramics, feathers—all meticulously rendered in the highest degree of finish to which the human eye and hand can aspire—serves to reinforce our judgment of the painting as vulgar in its parts and in the whole. As a document of social history, however, it clearly reveals the pretensions and the conspicuous consumption which characterized the petty world of the social climber at the end of the century.

205. Julius L. Stewart, *The Yacht Namouna in Venetian Waters*, 1890. Wadsworth Atheneum, Hartford, Connecticut; Ella Gallup Sumner and Mary Catlin Sumner Collection.

206. Louis Charles Moeller, *The Antique Store*, c. 1895. Ira Spanierman Gallery, New York.

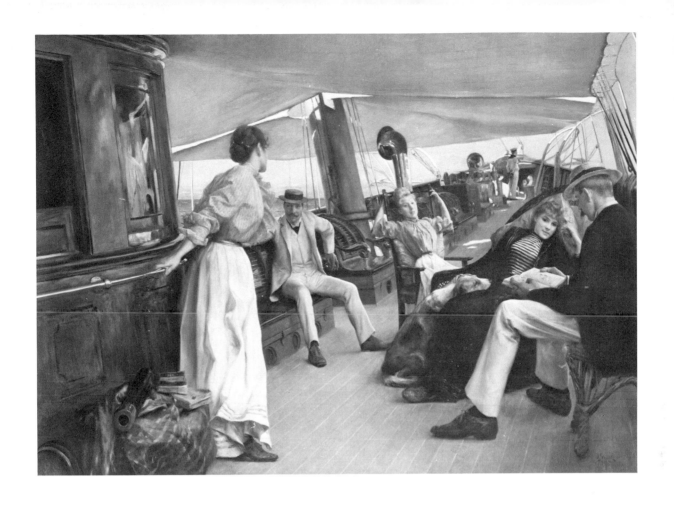

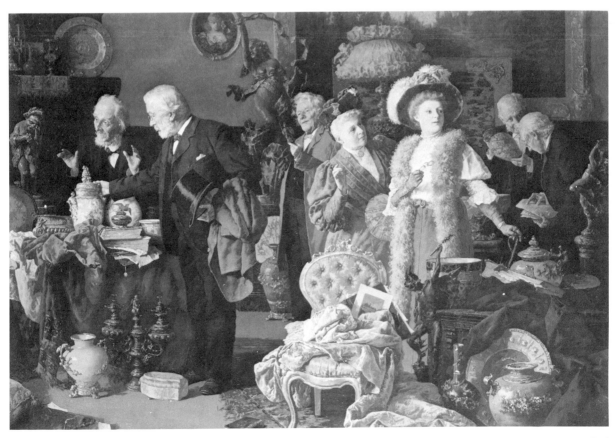

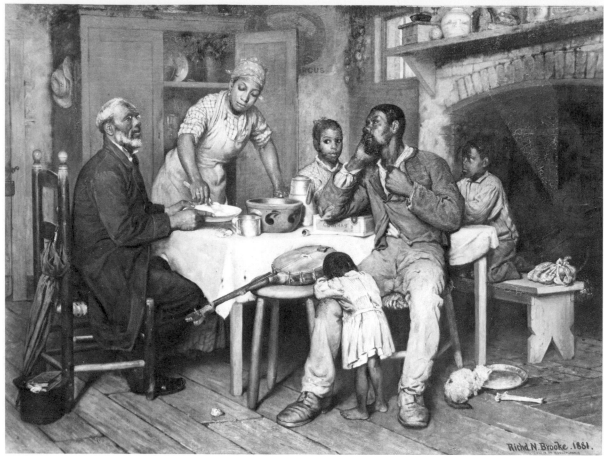

207. Richard Norris Brooke, *A Pastoral Visit,* 1881. The Corcoran Gallery of Art, Washington, D.C.

Among the many American painters who were profoundly, and adversely, influenced by the French academicians with whom they studied was Richard Norris Brooke (1847-1920). His principal teacher was Bonnat, for whom he had great esteem. On his return to this country, Brooke concentrated for a while on paintings of Negro life in the vicinity of Warrenton, Virginia, where he was born and which he regarded as his home. Later he became primarily a landscape and portrait painter. *A Pastoral Visit,* 1881 (Fig. 207), despite the American subject matter, shows the indelible influence of his master. If French peasant faces were substituted and a few props, such as the banjo, were eliminated, the painting could be retitled *Lunch in a Breton Cottage.* Brooke realized that he was out of step with his time in painting Negro subjects, but did so with affectionate understanding. As a consequence, his paintings are trustworthy records of the perhaps not uncomfortable, but invariably rundown conditions in which the Negroes of Virginia lived immediately after the war.

Possessing a background similar to Brooke's, John Adams Elder (1833-1895), although primarily a portrait painter, deserves brief mention here. A native of Washington, he was raised in Fredericksburg, Virginia, studied in Düsseldorf with Emanuel Leutze and later worked in Paris. While he is best known for his portraits of the famous Confederate generals Lee and Jackson, c. 1880 (both, The Corcoran Gallery of Art), he did an occasional genre painting. Like Brooke he was brought up in close contact with the Negro in Virginia, and he shared Brooke's sympathetic knowledge of their way of life. His *A Virginny Breakdown,* c. 1870? (collection Kennedy Galleries), shows the interior of a log cabin, with six members of a Negro family watching a boy dancing. The style, an all-pervasive European academism, leaves no latitude for individual expression. The figures are well observed, though the overall effect is a touch too saccharine.

When one thinks of Thomas Hovenden (1840-1895) one immediately recalls his *Breaking Home Ties,* 1890 (Philadelphia Museum of Art), one of the

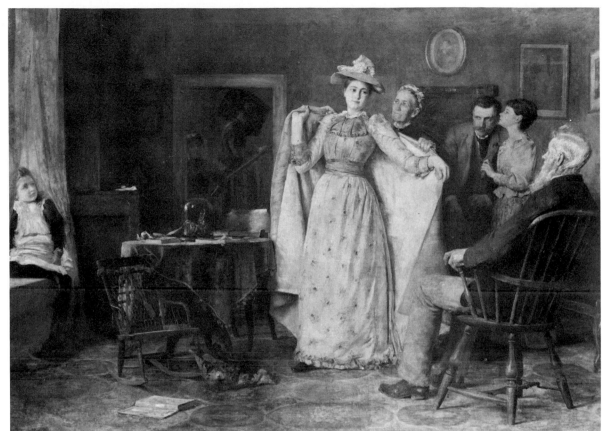

208. Thomas Hovenden, *Bringing Home the Bride*, 1893. Kennedy Galleries, New York.

star attractions in the 1893 World's Columbian Exposition in Chicago. Hovenden is as well known for this one canvas as Emanuel Leutze is for *Washington Crossing the Delaware,* 1851 (Metropolitan Museum of Art). Each work fired the popular imagination as have few other American paintings. Large sepia reproductions of *Breaking Home Ties* hung in many an American parlor for years, although most of them have by now found their way into thrift shops and oblivion. The painting itself does not deserve the same fate, and one must guard against dismissing it as a trite period piece simply because it is so familiar as to be a cliché. Actually it is far less contrived than Leutze's great machine and depicts, without sentimentality, an experience common at the time. This was the period when small ancestral farms, long the mainstay of the typical American family, were becoming less and less productive—or, rather, marginal and unable to compete. Many young men, forced off the land, flocked to the teeming cities in the East or went west toward new opportunities on the rapidly vanishing

frontier. This was Hovenden's theme and the reason for the painting's popularity.

Hovenden, born in Ireland, studied in Paris with Cabanel for six years. The experience seems to have made him a member of the academic establishment, although toward the end of his life, cut short when he was killed in a vain attempt to rescue a child from the path of a locomotive, he turned out some gay, high-keyed impressionist landscapes which are almost unknown today. The paintings with which we are here concerned are very much in the French academic tradition. He painted the everyday life of the solid middle class, who lived in plain but substantial homes furnished with an accumulation of objects which over the years had come into the family's possession. One of the best of these, *Bringing Home the Bride,* 1893 (Fig. 208), which is similar in format to *Breaking Home Ties,* has his typical rich, if subdued, color.

Hovenden seems to have developed more or less fixed formulas for his paintings. The most common of these is the interior scene with two figures. *The Old*

215

*Version*, 1881 (private collection), for example, shows a middle-aged couple in their Victorian parlor reading aloud from the Bible—a popular theme in the second half of the nineteenth century. Another painted the same year, *Sunday Morning* (Fig. 209), shows two elderly Negroes. It is richly painted, and the depiction of the Negroes preserves their individual personalities.

Hovenden was an admired and respected teacher (Robert Henri was one of his students), but he was not one of the major figures of the period. Nevertheless, he can be counted on for solid serious work and a production that maintains a consistent level.

Among the almost forgotten painters of the later nineteenth century is Lemuel Everett Wilmarth (1835-1918). He exhibited paintings of genre subjects, which became his specialty, as early as 1866 and continued until his health began to fail in 1892. His work is characterized by accurate draughtsmanship and well-designed composition. Few of his works can be found in public collections and from old exhibition catalogues we have only a tantalizingly suggestive list of titles—*Another Candidate for Adoption, The Pick of the Orchard, Ingratitude. The Sailor's Return*, 1884 (collection Victor D. Spark), is typical of the sentimentality that runs through much of his work. On the other hand, *An Incident on the Morning of the Target Excursion*, 1878 (Fig. 210), represents a practical joke—both then and now a characteristic form of American humor. The painting is also of considerable interest as perhaps the only surviving representation of a German-American *Schützenverein*. These shooting clubs existed in many parts of the country where there were large German communities; they combined an interest in marksmanship with the chance to dress up in fancy uniforms, march in parades and consume a prodigious amount of lager beer. This painting shows Wilmarth's skill in rendering still-life objects and, indeed, in handling a complicated composition with painterly ability.

At this point we leave the genre mannerists to introduce two transitional painters who in temperament and in the content of their work must be considered precursors of developments which came to full flower only in the next century. These men, Maurer and Anshutz, are, to be sure, dwarfed by Eakins, but they exhibit a similar approach to life.

The German-born Louis Maurer (1832-1932) emigrated to this country in 1851 and established himself in New York. He had great commercial success as a lithographer, working for Currier & Ives for eight years, then for Major & Knapp and finally establishing his own firm, which he headed from 1872 until he retired in 1884. His pre-Civil War lithographs of the *Life of a Fireman* are his best-known works. His son was the well-known artist Alfred H. Maurer (1868-1932) who, embittered by his father's arrogance and domineering traits, committed suicide.

Louis Maurer, although known primarily as a lithographer, was also a painter, and devoted himself to painting after his retirement at the age of fifty-two.

210. Lemuel Everett Wilmarth, *An Incident on the Morning of the Target Excursion*, 1878. Private collection.

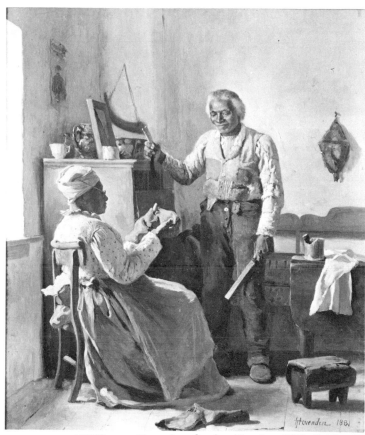

209. Thomas Hovenden, *Sunday Morning,* 1881. California
Palace of the Legion of Honor, San Francisco.

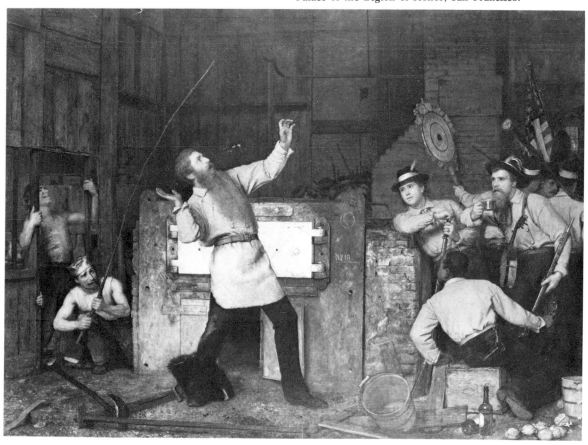

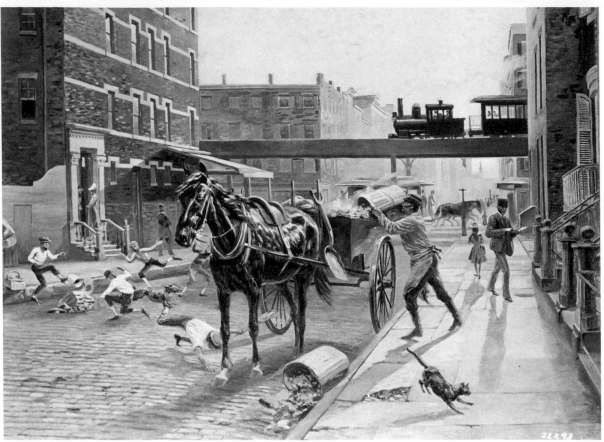

211. Louis Maurer, *Forty-Third Street West of Ninth Avenue*, 1883. Present location unknown.

*Forty-third Street West of Ninth Avenue,* 1883 (Fig. 211), justifies his inclusion here. Some quarter-century before the advent of the Ash Can School of Henri, Sloan and Glackens, it anticipates their revolt against the politeness of American academic painting. Here, in even harsher realism than one finds in any of the street scenes of John Sloan, is a view of an unfashionable section of New York, with its garbage cans, stray cat, "el" and, by implication, the smells, dirt and noise of the teeming city.

Thomas Eakins's disciple Thomas Anshutz (1851-1912) was a most interesting artist who has been late in receiving his meed of recognition. Anshutz was born in Kentucky. At the age of twenty-two he came to New York, where he studied at the School of the National Academy of Design. Two years later, he went to Philadelphia to enroll at the Pennsylvania

Academy of the Fine Arts where Eakins was teaching and where Anshutz himself later became a member of the faculty. He was a renowned and respected teacher, whose pupils included such men as Henri, Luks, Sloan and Glackens.

His *The Cabbage Patch,* 1879 (Fig. 212), is far in advance of its day in understanding and sympathetic, yet almost clinical, depiction of the Negro. There is no attempt to gloss over poverty's deadening effect on the spirit and the hard, grinding labor that goes into eking out a marginal living from the soil. There is a portrait-like quality to the figure of the woman whose dogged labor we witness. In an age when laborers were shown as stalwart and contented with their lot, the depiction, as here, of a person clearly depressed in mind and spirit was rare. Anshutz seems to have found satisfaction in scenes of labor and industry, for his other

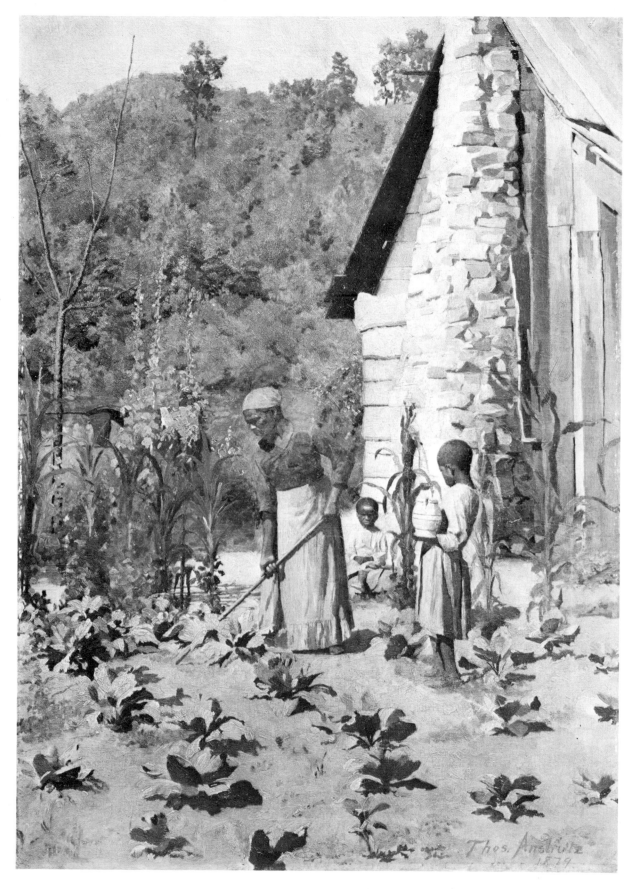

212. Thomas P. Anshutz, *The Cabbage Patch,* 1879. The Metropolitan Museum of Art, New York; Morris K. Jesup Fund, 1940.

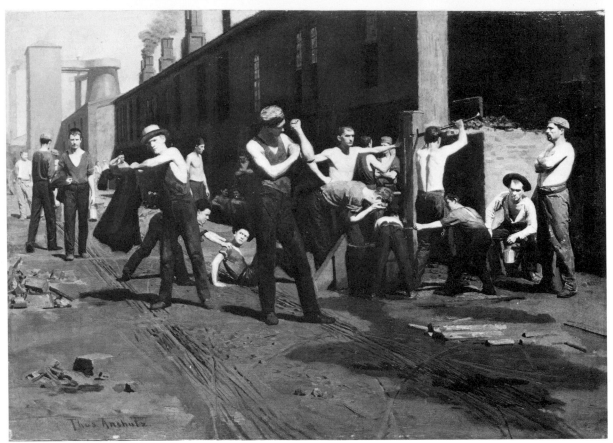

213. Thomas P. Anshutz, *The Steelworkers: Noontime*, 1883.
Collection Dr. and Mrs. Irving F. Burton.

famous canvas, *The Steelworkers: Noontime,* 1883
(Fig. 213), is another strong rendering of believable
reality. Anshutz's genre works were largely con-
centrated in his early years; later in life he turned his
attention more to landscape and portraits. He was an
important transitional figure between the nineteenth
and twentieth centuries; the significance of his
originality of vision is at last being recognized.

This chapter began with the last two decades of the
work of the great realist painter Winslow Homer. It
closes with another great painter, Thomas Eakins
(1844-1916). There are parallels between the two, the
most obvious being that to each his art was an all-
consuming passion. Homer survived a long period of
neglect to reap the satisfaction of wide recognition.
Eakins on the other hand experienced repeated rebuffs
and ended his career in discouragement and obscurity.

Both Homer and Eakins were concerned with man.
Homer's interest was in man's deep satisfactions in
the face of the forces of nature, especially in situations

which draw on his inner reservoirs of spiritual courage
and fortitude. Eakins concentrated on man's phys-
iology and character. Like Homer, Eakins studied
in France, but was more attracted to and influenced by
Old Masters such as Rubens, Rembrandt and Veláz-
quez than by his French contemporaries.

Eakins is as closely tied to Philadelphia as Homer in
the later part of his life was to Prout's Neck. Eakins
rarely traveled, and his genre works are largely re-
stricted to the activities taking place in the environs of
Philadelphia. The few paintings he did in the West,
such as *Cowboys in the Badlands,* 1888 (collection
Mrs. Francis P. Garvan), and *Home Ranch,* 1890
(Philadelphia Museum of Art), the result of a trip to
the Dakotas in the summer of 1887, are exceptions.

There were as many differences between the two
men as there were similarities. Perhaps the most
obvious was Eakins's scientific turn of mind, shown in
his studies of human and animal locomotion through
photography (he invented a special camera, a fore-

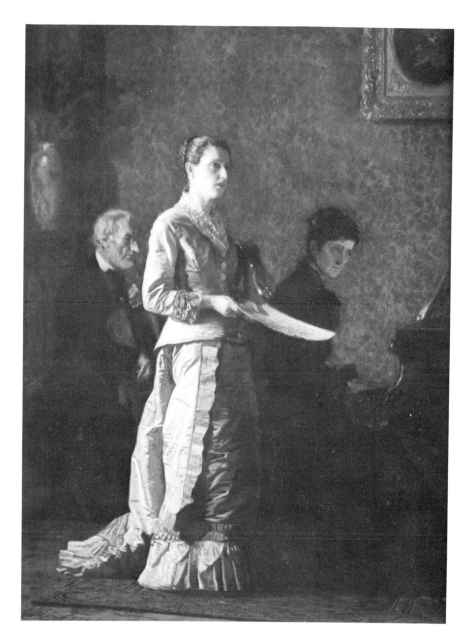

214. Thomas Eakins, *The Pathetic Song,* 1881. The Corcoran Gallery of Art, Washington, D.C.

runner of the motion-picture camera), his passion for perspective, and his interest in the scientific study of anatomy.

Eakins's work shows a concern for detail and finish which Homer did not share, and, in general, Eakins's canvases are smaller and more intimate in scale. Homer habitually used his friends in and around Prout's Neck as models for his Adirondack guides and fishermen, but even when they are identifiable, they are somehow types, not individuals. Eakins also used his friends and family as models, but never failed to retain their character as individuals. Such painfully exact, penetrating likenesses are central to his great *The Pathetic Song,* 1881 (Fig. 214), a painting which erases any boundary between group portrait and genre. (The singer is Margaret A. Harrison; the pianist Susan H. Macdowell, later Mrs. Eakins; and the cellist Mr. Stolte, a member of the Philadelphia Philharmonic Orchestra.) Here Eakins's mastery of psychological characterization, the great strength of

221

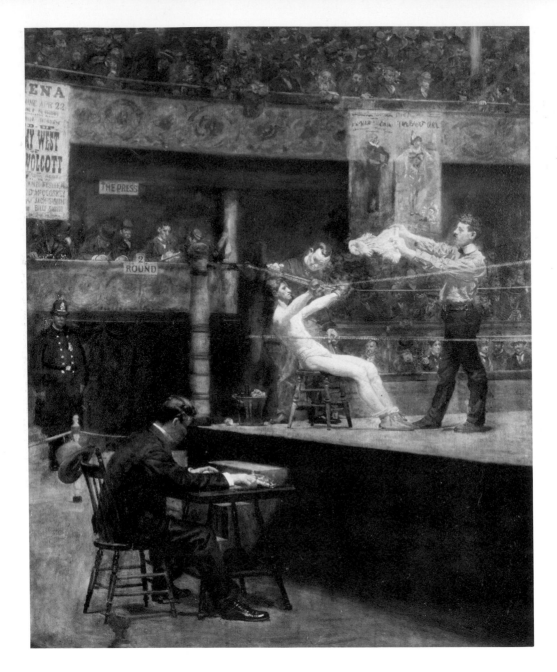

215. Thomas Eakins, *Between Rounds,* 1899. Philadelphia Museum of Art; Given by Mrs. Thomas Eakins and Miss Mary A. Williams.

his formal portraits, is shown at its best. His artistry weds the two disparate elements, genre and portraiture, into an impressive unity.

Eakins's genre works cover a considerable range of subjects. Numerous paintings testify to his interest in wrestling and boxing. For example, his diploma painting, *The Wrestler,* 1899, given by him to the National Academy of Design, shows two red-faced, sweating, semi-nude figures struggling on the mat. The concentration on the floor level action is so intense that only the legs of two spectators and, beyond them, a man exercising on a rowing machine, are included in the scene. More characteristic of Eakins's representations of these sports are *Taking the Count,* 1898 (Yale University Art Gallery), *Salutat,* 1898 (Addison Gallery of American Art, Phillips Academy), and *Between Rounds,* 1899 (Fig. 215), which captures the atmosphere of the packed hall with

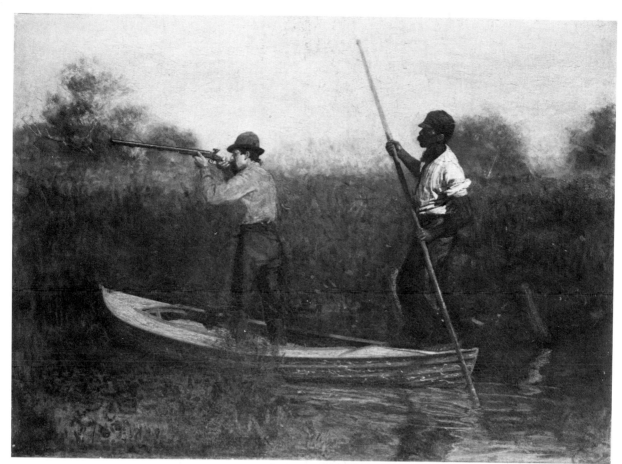

216. Thomas Eakins, *Will Schuster and Blackman Going Shooting*, 1876. Yale University Art Gallery, New Haven, Connecticut; Bequest of Stephen Carlton Clark.

a realism that enables one almost to smell the liniment and resin. There is no romance in these paintings of the ring. The lean fighter waiting for the bell to start Round 3 in *Between Rounds* is utterly prosaic. He is a veteran who has adapted to his calling, as any well-schooled professional would have. Eakins does not treat him as a hero with well-proportioned rosy body, but shows him as he was, unprepossessingly natural in his semi-nakedness. The detached, impersonal rendering of the scene, the absence of posturing and heroics, are the painting's strengths.

Hunting marsh birds was another subject which appealed to Eakins. One of his great paintings on this theme, *Will Schuster and Blackman Going Shooting,* 1876 (Fig. 216), is an early work. Eakins's treatment of the landscape background, subordinating it to the figures, yet using it to contribute to the mood of quiet, restrained calm, is especially fine. Each figure lives the role it plays: the Negro, rendered with Eakins's characteristic objectivity, handles the pole with assurance and grace; Will Schuster, braced for the discharge of his shotgun, is ready to squeeze off a shot. The monumental quality of this small canvas is impressive. Here a recurring thread of continuity in American life asserts itself—Eakins's canvas echoes the same general motif which, in 1849, had engaged Ranney's attention in *Duck Hunters on the Hoboken Marshes* (Fig. 66). There are distinct differences in attitude. The personalities of Eakins's hunters are more perceptively drawn than Ranney's. This is true also of Eakins's hunting scenes as compared with Homer's: Homer's emphasize the rugged qualities of man and nature, whereas those of Eakins are more intimate and gentler in mood.

Another subject Eakins uses repeatedly is the oarsmen of the Schuylkill, the river which winds

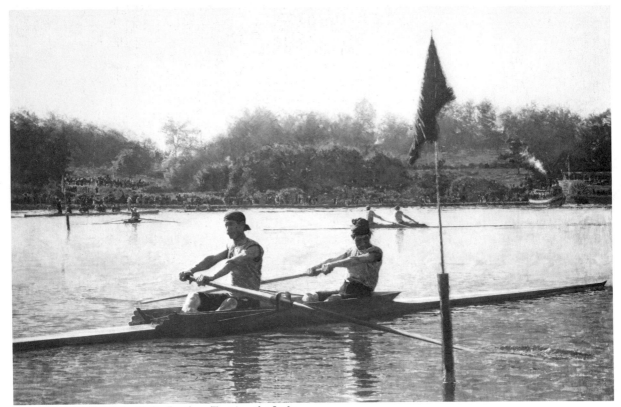

217. Thomas Eakins, *The Biglin Brothers Turning the Stake*, 1873. The Cleveland Museum of Art; Hinman P. Hurlbut Collection.

through his native Philadelphia. One of the most attractive of these paintings is *The Biglin Brothers Turning the Stake*, 1873 (Fig. 217). Somehow it sums up the futility of man's ambition to win glory in physical competition and at the same time it acclaims the dedication of the competitor. It is a lonely picture, despite the distant crowds of spectators. This painting and *Max Schmitt in a Single Scull*, 1871 (Metropolitan Museum of Art), *The Pair-Oared Shell*, 1872 (Philadelphia Museum of Art), *Oarsmen on the Schuylkill*, 1873 (The Brooklyn Museum) and *The Biglin Brothers Racing*, c. 1873 (National Gallery of Art), which complete the series, are among the most sensuous works Eakins produced. The combination of sunlight and shadow, movement of the sparkling river waters, touches of brilliant color, as in the bandannas worn by the scullers, brilliant greens of the trees and blue skies, provided lush fare in which the artist must have delighted.

Eakins was also fascinated by the movement of horses in action and with the aid of photography made studies to determine their natural movement. In *The Fairman Rogers Four-in-Hand*, 1879 (Fig. 218) which was commissioned by Fairman Rogers, author of *Manual of Coaching*, Eakins depicted the elegant turnout and its fashionable passengers in a manner which pleased his patron. The painting stands as one of his masterpieces, jewel-like in color and full of life and movement. Rarely did Eakins draw on the life of the leisure class for subject matter, yet he approached a scene such as this one with complete editorial detachment, just as he approached less elegant aspects of Philadelphia life.

*Shad Fishing at Gloucester on the Delaware*, 1880 (Fig. 219) and *Mending the Net*, 1881 (Philadelphia Museum of Art), are primarily landscapes with figures and communicate a mood of meditation and a sense of detachment from reality. The figures appear to be oblivious of each other—each works in quiet solitude in the midst of the others. In the comparative unimportance of the figures these works are akin to Eakins's paintings of sailing, another subject which

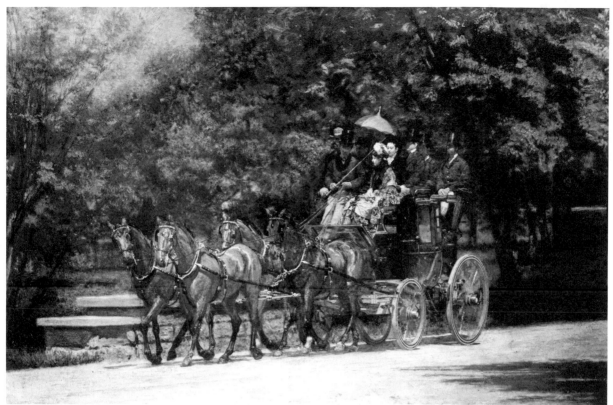

218. Thomas Eakins, *The Fairman Rogers Four-in-Hand,*
1879. Philadelphia Museum of Art; Given by William
Alexander Dick.

219. Thomas Eakins, *Shad Fishing at Gloucester on the
Delaware,* 1881. Philadelphia Museum of Art; Given by Mrs.
Thomas Eakins and Miss Mary A. Williams.

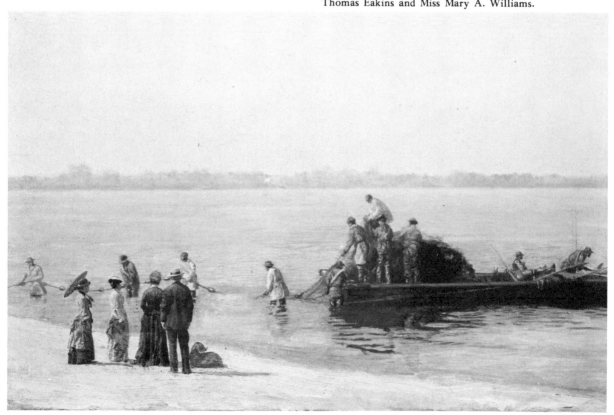

excited his scientific curiosity.

Eakins's masterpiece, one of the truly great paintings of American art, is *The Gross Clinic,* 1875 (Jefferson Medical College, Philadelphia). It is hard to believe that this remarkable work, so well known and so much admired today, was not recognized for its quality when it was painted. Eakins did not have the good fortune that came to Mount, Bingham and Johnson when they submitted their first genre efforts to public view. In fact, *The Gross Clinic* was refused by the jury of the American painting section of Philadelphia's prestigious Centennial Exhibition. Into this one monumental canvas Eakins, then a young man, had put his heart and soul, all his knowledge and skill and all the energy of his youthful enthusiasm. Conceived on a grand scale, the painting was a gesture of homage to the world of medical science, of which Philadelphia was then one of the great centers. Its composition, its lighting, the detail and explicit characterizations are handled with a mastery which produced a unity of effect that cannot be faulted. It was a strong statement.

Its rejection by his peers was a blow of the severest sort—from which Eakins never fully recovered. When it was shown in the medical section of the Exhibition, it was greeted by the press and public with horror and expressions of outrage. The painting was labeled ''a degradation of art.'' The simple fact is that Eakins was decades ahead of his audience, who were totally unprepared for this assault on their sensibilities. These blows did not cause Eakins to change his principles, but he was, in all probability, deflected from the inspired course he would have taken had the painting met with the acclaim he had anticipated.

This survey ends with the close of the nineteenth century, but the years after 1900 saw continued development of genre painting in America. At the conclusion of the Spanish-American War, the United States was a world power with overseas possessions and responsibilities. The timidity which had fostered our excessive reliance on the Old World in the period following the Civil War was replaced by a new spirit of self-confidence, analogous to the nationalistic pride which prevailed in the early years of the nineteenth century.

New strength and a more vigorous and independent attitude affected the course of American art. The discontent of the younger painters with the art establishment gradually gained momentum and support. Revolt was in the air. The Ash Can School came into its short reign as a leading force, with the genre paintings of its members, especially those by John Sloan, showing a fresh approach. No longer was ancedote the key element, no longer were highly finished details important. The change is in the overall meaning of the painting, not its detailed content. Hotter colors, looser brushwork replaced the photographic realism of an archetypal genre painter such as E. L. Henry.

Slightly later than the Ash Can painters, a group sometimes referred to as total painters developed another more refined and polite brand of genre

painting, but they too put little importance on narrative. Their prime concern was the rendering of the quality of light. Among the leaders of this movement were Edmund Tarbell, Thomas Dewing and Joseph R. DeCamp.

Still later, in the 1930's, the American Scene painters held the spotlight. Social protest was their key concern. Genre as a vehicle of serious political concepts was new to American art and was a direct result of the great depression. Thomas Hart Benton, Grant Wood, John Steuart Curry and William Gropper were the important exponents of this movement, which was to be continued by such painters as Ben Shahn and Jack Levine.

So the steady concern of American artists with their surroundings continues to the present. Even during the two decades just past, which have seen the most startling changes in art forms since Neolithic times, this interest has never been long submerged. The violent changes in media and content which have taken place may sometimes mean an effort is required to re-interpret genre in twentieth-century terms, but the paintings of such artists as Andy Warhol, Robert Rauschenberg and Larry Rivers, for example, are nevertheless based on a concern for contemporary daily American life, seen afresh. The heritage of the realistic American genre tradition is to be found in the paintings of Edward Hopper and Andrew Wyeth and in the three-dimensional works of Edward Kienholz and George Segal. ☐

# BIBLIOGRAPHY

The purpose of this bibliography is to indicate books, periodical articles and museum and exhibition catalogues which the author has found useful or which add to the information he has given. Many of these publications have excellent bibliographies which will lead the serious student further.

As they reflect quite a different point of view from those of recent date, the older surveys of American painting are grouped in a separate section. The late nineteenth- and early twentieth-century surveys often place emphasis on artists who are almost forgotten today. Flexner's *Light of Distant Skies* (1954) and *That Wilder Image* (1962) include many of these painters who are less known today and also provide useful bibliographical references.

The New-York Historical Society's *Dictionary of Artists in America, 1564-1860* (1957), by Groce and Wallace, is indispensable for short biographies of and references to almost all artists who were working before or by 1860. This bibliography does not repeat all the data cited there and, since that work was published fifteen years ago, adds books and articles which have appeared subsequently. Some of these periodical articles were located by means of *The Art Index* (New York: H. W. Wilson Co., VI- , 1929- ). Thieme-Becker, *Allgemeines Lexikon der Bildenden Künstler,* Leipzig, Seemann, 1908-1950, 37 v.), Bénézit, *Dictionnaire Critique et Documentaire des Peintres, Sculpteurs, Dessinateurs, et Graveurs* (Paris, Grund, 1948-1955, 8 v.) and Champlin and Perkins, *Cyclopedia of Painters and Paintings* (New York, Scribner's, 1885, 4 v.) are useful supplements to Groce and Wallace.

A section of the bibliography is devoted to the alphabetical listing of individual artists mentioned in the text. In the cases of painters whose work has been extensively studied, only one or two monographs or recent exhibition catalogues are cited, since definitive bibliographies are provided in the standard texts. In the case of an artist who has not been the subject of a major monograph, however, an effort has been made to list the most informative periodical article or exhibition catalogue. Some artists are listed only in biographical dictionaries or accorded a scant few words in one of the general surveys.

Alice F. Williams

1834 Dunlap, William. *History of the Rise and Progress of the Arts of Design in the United States.* 2 v. New York: George P. Scott & Co., 1834.

  1. New ed. by Alexander Wyckoff incorporating notes compiled by Bayley and Goodspeed in 1918 and with corrections and additional biographical material. New York: Benjamin Blom, 1965.

  2. Reprint of the 1834 ed. with introduction by James Thomas Flexner, ed. by Rita Weiss. 2 vols. in 3. New York: Dover, 1969. Illustrations throughout the text and an index have been added.

1864 Jarves, James Jackson. *The Art-Idea: Sculpture, Painting and Architecture in America.* Boston: Houghton Mifflin, 1864.

  1. New ed. with introduction and notes by Benjamin Rowland, Jr. Cambridge: Harvard University, Belknap Press, 1960.

1867 Tuckerman, Henry T. *Book of the Artists: American Artist Life.* New York: G. P. Putnam's Sons, 1867.

——Neal, John. *Observations on American Art: Selections from the Writings of John Neal (1793-1876).* Edited by Harold Edward Dickson. State College, Pa.: Pennsylvania State College, 1943.

1880 Benjamin, Samuel Greene Wheeler. *Art in America: A Critical and Historical Sketch.* New York: Harper and Brothers, 1880.

1881 Sheldon, G. W. *American Painters.* enl. ed. New York: D. Appleton, 1881.

1902 Hartmann, Sadakichi. *A History of American Art.* Rev. ed. 2 v. Boston: L. C. Page, 1902.

1905 Isham, Samuel. *The History of American Painting.* New York: The Macmillan Company, 1905.

  1. New ed. with supplementary chapters by Royal Cortissoz, 1933.

1907 Caffin, Charles H. *The Story of American Painting: The Evolution of Painting in America from Colonial Times to the Present.* New York: Frederick A. Stokes, 1907.

1917 Bryant, Lorinda Munson. *American Pictures and Their Painters.* New York: John Lane, 1917.

Barker, Virgil. *American Painting: History and Interpretation.* New York: The Macmillan Company, 1950.

Baur, John I. H. *American Painting in the Nineteenth Century: Main Trends and Movements.* New York: Frederick A. Praeger, 1953.

——"Unknown American Painters of the 19th Century." *College Art Journal* 6 (Summer 1947): 277-82.

Burroughs, Alan. *Limners and Likenesses: Three Centuries of American Painting.* Cambridge: Harvard University Press, 1936.

Corcoran Gallery of Art, *Bulletin.* "Five American Genre Painters." 13 (October 1963): 1-23.

Dickson, Harold E. *Arts of the Young Republic: The Age of William Dunlap.* Chapel Hill: University of North Carolina Press, 1968.

Dorra, Henri. *The American Muse.* Foreword by Hermann Warner Williams, Jr. New York: The Viking Press, 1961.

Eliot, Alexander. *Three Hundred Years of American Painting.* Introduction by John Walker. New York: Time Inc., 1957.

Flexner, James Thomas. *American Painting: First Flowers of Our Wilderness.* Boston: Houghton Mifflin, 1947.

——*American Painting: The Light of Distant Skies 1760-1835.* New York: Harcourt Brace, 1954.

——*Nineteenth Century American Painting.* New York: G. P. Putnam's Sons, 1970.

——*That Wilder Image: The Painting of America's Native School from Thomas Cole to Winslow Homer.* Boston: Little, Brown, 1962.

Gowans, Alan. *The Restless Art: A History of Painters and Painting, 1760-1960.* Philadelphia: J. B. Lippincott Co., 1966.

Groce, George C. and Wallace, David H. *The New-York Historical Society's Dictionary of Artists in America 1564-1860.* New Haven: Yale University Press, 1957.

Harris, Neil. *The Artist in American Society: The Formative Years, 1790-1860.* New York: George Braziller, 1966.

Haverstock, Mary Sayre. "The Tenth Street Studio." *Art in America* 54 (September-October 1966): 49-57.

Larkin, Oliver W. *Art and Life in America.* Rev. and enl. ed. New York: Holt, Rinehart and Winston, 1960.

Lipman, Jean (Herzberg). *American Primitive Painting.* New York: Oxford University Press, 1942.

McCoubrey, John W. *American Tradition in Painting.* New York: George Braziller, 1963.

McCracken, Harold. *Portrait of the Old West.* With a biographical check list of western artists. Foreword by R. W. G. Vail. New York: McGraw-Hill Inc., 1952.

Marshall, Lillian B. *Patrons and Patriotism: The Encouragement of the Fine Arts in the United States, 1790-1860.* Chicago: University of

Chicago Press, 1966.

Novak, Barbara. *American Painting of the Nineteenth Century: Realism, Idealism, and the American Experience.* New York: Frederick A. Praeger, 1969.

Peters, Harry T. *America on Stone, the other printmakers to the American people: A chronicle of American lithography other than that of Currier & Ives, from its beginning shortly before 1820, to the years when the commercial single-stone hand-colored lithograph disappeared from the American scene.* New York: Doubleday, Doran, 1931.

———*Currier & Ives: Printmakers to the American People.* Garden City, New York: Doubleday, Doran, 1942.

Pinckney, Pauline A. *Painting in Texas, The Nineteenth Century.* Introduction by Jerry Bywaters. Austin: published for the Amon Carter Museum of Western Art, Fort Worth, by The University of Texas Press, 1967.

Rathbone, Perry T., ed. *Westward the Way: The Character and Development of the Louisiana Territory as Seen by Artists and Writers of the Nineteenth Century.* St. Louis: City Art Museum, 1954.

Richardson, Edgar P. *American Romantic Painting.* New York: E. Weyhe, 1944.

———*Painting in America: From 1502 to the Present.* New York: Thomas Y. Crowell Co., 1965.

Rutledge, Anna Wells. *Artists in the Life of Charleston, Through Colony and State from Restoration to Reconstruction.* Philadelphia: American Philosophical Society, 1949.

Sadik, Marvin. "The Negro in American Art." *Art in America* 52 (June 1964): 74-83.

Sears, Clara Endicott. *Highlights Among the Hudson River Artists.* Boston: Houghton Mifflin, 1947.

Sitwell, Sacheverell. *Narrative Pictures: A Survey of English Genre and Its Painters.* With notes on the illustrations by Michael Sevier. London: B. T. Batsford, 1969. First printing, 1936.

Taft, Robert. *Artists and Illustrators of the Old West 1850-1900.* New York: Charles Scribner's Sons, 1953.

Van Nostrand, Jeanne and Coulter, Edith M. *California Pictorial: A History in Contemporary Pictures, 1786 to 1859.* With descriptive notes on pictures and artists. Berkeley and Los Angeles: University of California Press, 1948.

Weisendanger, Martin and Margaret. *Louisiana Painters and Paintings: A catalogue of the collection of W. E. Groves.* New Orleans: W. E. Groves Gallery, 1971.

Williams, Hermann Warner, Jr. *The Civil War: The Artists' Record.* Boston: Beacon Press, 1961.

Wunderlich, Rudolf. "Artists of the Civil War." *Kennedy Quarterly* 2, pt. 1 (May 1961): 37-88.

———"Thomas Hovenden and the American Genre Painters." *Kennedy Quarterly* 3 (April 1962): 1-48.

Cowdrey, Mary Bartlett. *American Academy of Fine Arts and American Art Union, 1816-1852.* 2 v. New York: The New-York Historical Society, 1953.

———*National Academy of Design Exhibition Record, 1826-1860.* 2 v. New York: The New-York Historical Society, 1943.

Marlor, Clark S. *A History of the Brooklyn Art Association with an Index of Exhibitions.* New York: James F. Carr, 1970.

Rutledge, Anna Wells. *Cumulative Record of Exhibition Catalogues: The Pennsylvania Academy of the Fine Arts, 1807-1870; The Society of Artists, 1800-1814; The Artists' Fund Society, 1835-1845.* Philadelphia: American Philosophical Society, 1955.

Swan, Mabel Munson. *The Athenaeum Gallery, 1827-1873: The Boston Athenaeum as an Early Patron of Art.* Boston: Boston Athenaeum, 1940.

Baltimore. The Walters Art Gallery. *Catalogue of the American Works of Art,* by Edward S. King and Marvin C. Ross, 1956.

Boston. Museum of Fine Arts. *American Paintings in the Museum of Fine Arts, Boston.* 2 v. 1969. V. I Text: Barbara Neville Parker and Arianwen Howard. V. II Plates. Introduction: Perry Townsend Rathbone.

Boston. Museum of Fine Arts. *M. and M. Karolik Collection of American Paintings,* 1815 to 1865. Cambridge: Harvard University Press, 1949. Introduction by John I. H. Baur; W. G. Constable, editor.

New Britain, Connecticut. New Britain Museum of American Art. *Oil Paintings, Water Colors, Lithographs, Etchings,* n.d.

New York. Metropolitan Museum of Art. *American Paintings: A Catalogue of the Collection of the Metropolitan Museum of Art.* V. 1. Painters born by 1815, compiled by Albert Ten Eyck Gardner and Stuart P. Feld, 1965.

New York. National Academy of Design. *Catalogue of the Permanent Collection, 1826-1910.* 1911.

Newark, New Jersey. Newark Museum. *A Museum in Action: Catalogue of an Exhibition of American Paintings and Sculpture from the Museum's Collections.* Introduction by Holger Cahill. 1944.

Raleigh. North Carolina Museum of Art. *Catalogue of Paintings.* 2d ed. V. 1. American Paintings to 1900. 1966. Introductions by Justus Bier and William R. Valentiner.

Saratoga Springs, New York. National Museum of Racing. *Catalogue.* V. 1. *Equine Portraits, Sculptures and Histories.* 1962. Compiled by Joseph C. O'Dea.

Shelburne, Vermont. Shelburne Museum. *Inaugural Selection of Eighteenth and Nineteenth Century American Art at Shelburne Museum.* Compiled by Lilian Baker Carlisle. Foreword by H. R. Bradley Smith. 1960. (Museum Pamphlet Series, no. 5.) Supplement, 1962.

Washington, D.C. Corcoran Gallery of Art. *A Catalogue of the Collection of American Paintings in the Corcoran Gallery of Art.* 2 v. V. 1 Painters born before 1850, compiled by Dorothy W. Phillips and edited by Hermann Warner Williams, Jr., 1966. V. 2 Painters born after 1850, compiled by Dorothy W. Phillips, scheduled for publication 1972.

Washington, D.C. National Gallery of Art. *American Paintings and Sculpture: An Illustrated Catalogue.* 1970. Preface and catalogue by William P. Campbell.

EXHIBITION CATALOGUES

Baltimore. Baltimore Museum of Art. *Two Hundred and Fifty Years of Painting in Maryland.* May 11-June 17, 1945. Introduction by J. Hall Pleasants.

Bloomington, Indiana. Indiana University, Museum of Art. *The American Scene, 1820-1900.* An exhibition of landscape and outdoor genre held in honor of the Sesquicentennial of Indiana University. Organized by Louis Hawes. Jan 18-Feb. 28, 1970.

Boston. Museum of Fine Arts. *Sport in American Art.* Oct. 10-Dec. 10, 1944. Introduction by George H. Edgell.

Brooklyn, New York. The Brooklyn Museum. *The Nude in American Painting.* 1961.

——*Triumph of Realism: An Exhibition of European and American Realist Paintings, 1850-1910.* Oct. 3-Nov. 19, 1967. Preface by Thomas S. Buechner; introduction by Axel von Saldern.

Brunswick, Maine. Bowdoin College. Museum of Art. *The Portrayal of the Negro in American Painting.* 1964.

Cambridge. Harvard University, William Hayes Fogg Art Museum. *Art in New England: New England Genre.* May 15-Sept. 1, 1939.

Chicago. Art Institute of Chicago. *From Colony to Nation: An Exhibition of American Painting, Silver and Architecture from 1650 to the War of 1812.* Apr. 21-June 19, 1949.

Greensburg, Pennsylvania. Westmoreland County Museum of Art. *Two Hundred and Fifty Years of Art in Pennsylvania.* Compiled and edited by Paul A. Chew. 1959.

Middlebury, Vermont. Middlebury College. *Art out of the Attic: An Exhibition of 19th Century American Paintings from Vermont Homes.* 1970.

New Haven. Yale University Art Gallery. *American Art from Alumni Collections.* Apr. 25-June 16, 1968. Foreword by Andrew Carnduff Ritchie; introduction by Jules D. Prown.

New York. Bernard Danenberg Galleries. *Our American Heritage. A loan exhibition of important paintings for the benefit of the building fund of the New Britain Museum of American Art.* Sept. 18-Oct. 12, 1968.

New York. Coe Kerr Gallery. *The American Painting Collection of Mrs. Norman B. Woolworth.* Nov. 10-29, 1970.

New York. Hirschl and Adler Galleries. *The American Scene: A Survey of the Life and Landscape of the 19th Century.* Oct. 29-Nov. 22, 1969. Introduction by Stuart P. Feld; text by Cecily Langdale.

New York. Metropolitan Museum of Art. *Life in America.* A special loan exhibition of paintings held during the period of the New York World's Fair. Apr. 24-Oct. 29, 1939. Introduction by Harry B. Wehle.

——*American Paintings and Historical Prints from the Middendorf Collection.* Oct. 4-Nov. 26, 1967. Foreword by Stuart P. Feld.

——*19th Century America, Paintings and Sculpture.* An exhibition in celebration of the

hundredth anniversary of the Metropolitan Museum of Art. Apr. 6-Sept. 7, 1970. Introduction by John K. Howat and John Wilmerding; text by John K. Howat, Natalie Spassky and others.

New York. Whitney Museum of American Art. *American Genre: The Social Scene in Paintings and Prints.* Mar. 26-Apr. 29, 1935. Introduction by Lloyd Goodrich.

New York State Council on the Arts. *Art in New York State: The River, Places and People.* An exhibition organized by the New York State Council on the Arts for the New York State Pavilion at the New York World's Fair, 1964. Buffalo. Fine Arts Academy. Albright-Knox Art Gallery, 1964.

Newark, New Jersey. Newark Museum. *Early New Jersey Artists, 18th and 19th Centuries.* Mar. 7-May 19, 1957.

————*Of Other Days: Scenes of Everyday Life.* June 6-Nov. 17, 1957.

Oakland, California. Oakland Art Museum. *Early Paintings of California in the Robert B. Honeyman Jr. Collection.* 1956. Edited by Paul Mills, with a foreword by Joseph R. Knowland.

Pittsburgh, Carnegie Institute. Department of Fine Arts. *An Exhibition of American Genre Paintings.* Feb. 13-Mar. 26, 1936. Introduction by Homer Saint-Gaudens.

————*Pictures of Everyday Life: Genre paintings in Europe, 1500-1900.* Oct. 14-Dec. 12, 1954. Introduction by Gordon Bailey Washburn.

————*Survey of American Painting.* Oct. 24-Dec. 15, 1940. Introduction by Homer Saint-Gaudens.

Portland, Maine. Portland Museum of Art. *A Century of Portland Painters, 1820-1920.* July 8-Sept. 30, 1970.

Richmond, Virginia. Virginia Museum of Fine Arts. *An Exhibition of Nineteenth Century Virginia Genre.* Jan. 17-Feb. 13, 1946.

St. Louis, Missouri. City Art Museum of St. Louis. *Mississippi Panorama, Being an Exhibition of the Life and Landscape of the Father of the Waters.* 1949. Preface by Perry T. Rathbone; introduction by Charles Van Ravenswaay.

University Park, Pennsylvania. Pennsylvania State University. *Pennsylvania Painters, Centennial Exhibition.* Oct. 7-Nov. 6, 1955. Text by Harold E. Dickson.

Utica, New York. Munson-Williams-Proctor Institute. *Art Across America.* Oct. 15-Dec. 31, 1960. Introduction by Richard B. K. McLanathan.

Washington, D.C. Corcoran Gallery of Art. *American Processional, 1492-1900.* A special exhibition held at the Corcoran Gallery of Art. July 8-Dec. 17, 1950. Washington, D.C., National Capital Sesquicentennial Commission, 1950. Introduction by Hermann Warner Williams, Jr.; text by Elizabeth McCausland.

————*American Painters of the South.* Apr. 23-June 5, 1960. Foreword by Hermann Warner Williams, Jr., and Henri Dorra.

WASHINGTON ALLSTON: Richardson, Edgar Preston. *Washington Allston: A Study of the Romantic Artist in America.* Chicago: University of Chicago Press, 1948.

THOMAS ANSHUTZ: Katz, Leslie. ''The Breakthrough of Anshutz.'' *Arts Magazine* 37 (March 1963): 26-29.

HENRY BACON: Washington, D.C. Smithsonian Institution. National Museum. *Catalogue of a Memorial Exhibition of Water Colors of Egypt, Greece, France, Italy and England by Henry Bacon (1839-1912)*, Mar. 14-Apr. 30, 1931.

JAMES HENRY BEARD: Smith, S. Winfred. ''James Henry Beard.'' Columbus, Ohio State Museum, *Museum Echoes* 27 (April 1954): 27-29.

HENRY BEBIE: Baltimore. Maryland Historical Society. *Henry Bebie (Hans Heinrich Bebie) ·1800?-1888, Portrait and Genre Painter of Baltimore*; exhibition, May-June, 1956.

ALBERT BIERSTADT: Hendricks, Gordon. ''The First Three Western Journeys of Albert Bierstadt.'' *Art Bulletin* 46 (September, 1964): 333-65.

GEORGE CALEB BINGHAM: Bloch, E. Maurice. *George Caleb Bingham.* 2 v. Berkeley and Los Angeles: University of California Press, 1967.

McDermott, John Francis. *George Caleb Bingham, River Portraitist.* Norman: University of Oklahoma Press, 1959.

THOMAS BIRCH: Philadelphia. Maritime Museum. *Thomas Birch, 1778-1851, Painting and Drawings*; exhibition, March 16-May 1, 1966.

DAVID GILMOUR BLYTHE: Miller, Dorothy. *The Life and Work of David G. Blythe.* Pittsburgh: University of Pittsburgh Press, 1950.

Columbus, Ohio. Gallery of Fine Arts. *Works by David Blythe, 1815-1865*; exhibition, Mar. 8-31, 1968.

GEORGE NEWELL BOWERS: ''New Light on Bowers.'' Springfield, Massachusetts. Museum of Fine Arts, *Bulletin,* 13 (April and May 1947): n.p.

Robinson, Frederick B. ''George Newell Bowers.'' *Art in America* 36 (July 1948): 141-47.

ALBERTUS DEL ORIENT BROWERE: Smith, Mabel P. and MacFarlane, Janet R. ''Unpublished Paintings by Albertus del Orient Browere.'' *Art in America* 46 (Fall 1958): 68-71.

JOHN G. BROWN: Benjamin, S. G. W. ''A Painter of the Streets.'' *Magazine of Art* 5 (1882): 265-70.

OTIS ABEL BULLARD: Parker, Barbara N. ''The Dickinson Portraits.'' *Harvard Library Bulletin* 6 (Winter 1952): 133-37.

JEFFERSON DAVID CHALFANT: Wilmington, Delaware. Society of Fine Arts. *Jefferson D. Chalfant, 1856-1931*; exhibition, Jan. 8-Feb. 1, 1959.

JAMES WELLS CHAMPNEY: Deerfield, Massachusetts. Deerfield Academy. *James Wells*

*Champney 1847-1903*; exhibition, 1965.

JOHN GADSBY CHAPMAN: Washington, D.C. National Gallery of Art. *John Gadsby Chapman, Painter and Illustrator*; exhibition, Dec. 16, 1962-Jan. 13, 1963. Introduction by William P. Campbell.

CONRAD WISE CHAPMAN: Richmond, Virginia. Valentine Museum. *Conrad Wise Chapman, 1842-1910: an Exhibition of His Works*, 1962.

WILLIAM MERRITT CHASE: Roof, Katharine M. *The Life and Art of William Merritt Chase.* New York: Charles Scribner's Sons, 1917.

Santa Barbara. University of California. The Art Gallery. *The First West Coast Retrospective Exhibition of Paintings by William Merritt Chase (1849-1916).* 1964-1965.

THOMAS COLE: Noble, Louis Legrand. *The Life and Works of Thomas Cole.* Edited by Elliot S. Vesell. Cambridge: Harvard University Press, Belknap Press, 1964.

Rochester, New York. University of Rochester. Memorial Art Gallery. *Thomas Cole*; exhibition, Feb. 14-Mar. 23, 1969. Introduction and catalogue: Howard S. Merritt.

Hartford, Connecticut. Wadsworth Atheneum. *Thomas Cole, One Hundred Years Later*; exhibition Nov. 12, 1948-Jan. 2, 1949. Introduction and catalogue: Esther I. Seaver.

GEORGE H. COMEGYS: ''A Philadelphia Genre Painter.'' Harry Shaw Newman Gallery, *Panorama* 1 (June-July, 1946): 107.

JOHN SINGLETON COPLEY: Flexner, James Thomas. *The Double Adventure of John Singleton Copley: First Major Painter of the New World.* Boston: Little, Brown, 1969.

Prown, Jules David. *John Singleton Copley.* 2 v. Cambridge: Harvard University Press, 1966.

JASPER F. CROPSEY: College Park, Maryland. University of Maryland Art Gallery. *Jasper F. Cropsey, 1823-1900: A Retrospective View of America's Painter of Autumn;* an exhibition of oil paintings, along with selected works by Thomas Cole, David Johnson, and George Inness, Feb. 2-Mar. 3, 1968. Text and catalogue: Peter Bermingham. Preface: George Levitine. Foreword: William H. Gerdts.

CHARLES DEAS: McDermott, John Francis. ''Charles Deas: Painter of the Frontier.'' *Art Quarterly* 13 (Autumn 1950): 293-311.

VICTOR DUBREUIL: Frankenstein, Alfred. *After the Hunt: William Harnett and Other American Still Life Painters, 1870-1900.* Rev. ed., Berkeley and Los Angeles: University of California Press, 1969.

WILLIAM DUNLAP: Coad, Oral Sumner. *William Dunlap: A Study of His Life and Works and of His Place in Contemporary Culture.* New York: Russell and Russell, 1962. Originally published 1917.

Dunlap, William. *Diary of William Dunlap, 1766-1839: The Memoirs of a Dramatist, Theatrical Manager, Painter, Critic Novelist, and Historian.*

New York: The New-York Historical Society, 1931.

ASHER B. DURAND: Durand, John. *The Life and Times of A. B. Durand.* New York: Charles Scribner's Sons, 1894.

Huntington, Daniel. *Asher B. Durand: A Memorial Address.* New York: The Century Association, 1887.

Lawall, David Barnard. *Asher Brown Durand: His Art and Art History in Relation to His Times.* 4 v. Ann Arbor, Michigan: University Microfilms, Inc., 1966.

GEORGE HENRY DURRIE: Durrie, Mary Clarissa. ''George Henry Durrie: Artist.'' *Antiques* 24 (July 1933): 13-15.

Hartford, Connecticut. Wadsworth Atheneum. *George Henry Durrie, 1820-1863, Connecticut Painter of American Life*; exhibition, Mar. 12-Apr. 13, 1947. Text: Mary Bartlett Cowdrey.

THOMAS EAKINS: Goodrich, Lloyd. *Thomas Eakins: His Life and Work.* New York: Whitney Museum of American Art, 1933.

New York. Whitney Museum of American Art. *Thomas Eakins.* Retrospective exhibition by Lloyd Goodrich. Sept. 22-Nov. 21, 1970.

Porter, Fairfield. *Thomas Eakins.* New York: George Braziller, 1959.

Schendler, Sylvan. *Eakins.* Boston: Little, Brown, 1967.

RALPH EARL: Goodrich, Laurence B. *Ralph Earl, Recorder for an Era.* Albany: State University of New York Press, 1967.

SETH EASTMAN: McDermott, John Francis. *Seth Eastman, Pictorial Historian of the Indian.* Norman: University of Oklahoma Press, 1961.

FRANCIS WILLIAM EDMONDS: Mann, Maybelle. ''Francis William Edmonds: Mammon and Art.'' *American Art Journal* 2 (Fall 1970): 92-106.

JOHN ADAMS ELDER: Richmond. Virginia Museum of Fine Arts. *A Retrospective Exhibition of the works of John Adams Elder, 1833-1895.* Jan. 11-Feb. 5, 1947. Introduction: Edward Morris Davis III.

EDWIN ROMANZO ELMER: Elmer, Maud Valona. ''Edwin Romanzo Elmer as I Knew Him.'' *Massachusetts Review* (Autumn-Winter 1964-65): n.p.

Frankenstein, Alfred. ''Edwin Romanzo Elmer.'' *Magazine of Art* 45 (October 1952): 270-72.

Northampton, Massachusetts. Smith College. Museum of Art. *Edwin Romanzo Elmer, 1850-1923*; exhibition, Oct. 1-24, 1952. Catalogue: Mary Bartlett Cowdrey.

ALVAN FISHER: Vose, Robert C., Jr. ''Alvan Fisher, 1792-1863, American Pioneer in Landscape and Genre.'' The Connecticut Historical Society. *Bulletin* 27 (October 1962): 97-129.

JOHN GREENWOOD: Burroughs, Alan. *John Greenwood in America, 1745-1752.* A monograph with notes and a check list. Andover, Massachusetts: Addison Gallery of American

Art, 1943.

GEORGE HARVEY: Parker, Barbara N. "George Harvey and His Atmospheric Landscapes." Boston, Museum of Fine Arts. *Bulletin* 41 (February 1943): 7-9.

Shelley, Donald A. "George Harvey and His Atmospheric Landscapes of North America," The New-York Historical Society. *Quarterly* 32 (April 1948): 104-13.

——"George Harvey, English Painter of Atmospheric Landscapes in America." *American Collector*. V. 17 (April, 1948): 10-13.

EDWARD LAMSON HENRY: McCausland, Elizabeth. "The Life and Work of Edward Lamson Henry, N.A., 1841-1919." New York State Museum. *Bulletin* no. 339 (September 1945): 3-381.

WINSLOW HOMER: Beam, Philip C. *Winslow Homer at Prout's Neck.* Boston: Little, Brown, 1966.

Gardner, Albert Ten Eyck. *Winslow Homer, American Artist: His World and His Work.* New York: Clarkson N. Potter, Inc., 1961.

Goodrich, Lloyd. *Winslow Homer.* New York: published for the Whitney Museum of American Art by The Macmillan Company, 1944.

THOMAS HOVENDEN: Wunderlich, Rudolf. "Thomas Hovenden." *Kennedy Quarterly* 3 (April 1962): 3-11.

WILLIAM MORRIS HUNT: Angell, Henry C. *Records of William M. Hunt.* Boston: James R. Osgood and Co., 1881.

Knowlton, Helen M. *Art Life of William Morris Hunt.* Boston: Little, Brown, 1900.

Shannon, Martha A. S. *Boston Days of William Morris Hunt.* Boston: Marshall Jones Company, 1923.

HENRY INMAN: Bolton, Theodore. "Henry Inman, An Account of His Life and Work." *Art Quarterly* 3 (Autumn 1940): 353-75. Catalogue of the artist's work, 401-48.

Gerdts, William H. "Inman and Irving, Derivations from Sleepy Hollow," *Antiques* 74 (November 1958): 420-23.

JOHN WESLEY JARVIS: Dickson, Harold E. *John Wesley Jarvis, American Painter.* New York: The New-York Historical Society, 1949.

EASTMAN JOHNSON: Ames, Kenneth. "Eastman Johnson, The Failure of a Successful Artist." *Art Journal* 29 (Winter 1969-70): 174-83.

Brooklyn, New York. Brooklyn Museum. *Eastman Johnson, An American Genre Painter, 1824-1909;* exhibition, 1940. Text: John I. H. Baur.

New York, Whitney Museum of American Art. *Eastman Johnson;* exhibition March 28-May 14, 1972. Text: Patricia Hills.

Walton, William. "Eastman Johnson, Painter." *Scribner's* 40 (September 1906): 263-74.

DAVID CLAYPOOL JOHNSTON: Brigham, Clarence Saunders. "David Claypoole Johnston, the American Cruikshank." American Antiquarian Society, *Proceedings* 50 (1941): 98-110.

Worcester. Worcester Art Museum. *David Claypool Johnston; American Graphic Humorist, 1798-1865;* exhibition, March 1970. Text: Malcolm Johnson.

JOHN LEWIS KRIMMEL: Jackson, Joseph. "Krimmel, the American Hogarth." *International Studio* 93 (June 1929): 33-36ff.

THOMAS LE CLEAR: Viele, Chase. "Four Artists of Mid-Nineteenth Century Buffalo." *New York History* 43 (January 1962): 49-78.

HENRY LEWIS: McDermott, John Francis. *The Lost Panoramas of the Mississippi.* Chicago: University of Chicago Press, 1958.

LOUIS MAURER: McCausland, Elizabeth. *A. H. Maurer.* New York: published for The Walker Art Center, Minneapolis, by A. A. Wyn, 1951.

FRANCIS BLACKWELL MAYER: Mayer, Francis Blackwell. *With Pen and Pencil on the Frontier in 1851: The Diary and Sketches of Frank Blackwell Mayer.* Edited by Bertha L. Heilbron. St. Paul: Minnesota Historical Society, 1932.

Mayer, Francis Blackwell. *Drawings and Paintings.* Photographed by E. Balch. Baltimore: n.p., 1872.

ALFRED JACOB MILLER: De Voto, Bernard. *Across the Wide Missouri.* Illustrated with paintings by Alfred Jacob Miller, Charles Bodner and George Catlin. Boston: Houghton Mifflin, 1947.

Ross, Marvin C. *The West of Alfred Jacob Miller; from the Notes and Water Colors in the Walters Art Gallery and an Account of the Artist.* Rev. and enl. ed. Norman: University of Oklahoma Press, 1968.

CHARLES LOUIS MOELLER: Gerdts, William H. "People and Places of New Jersey." Newark Museum. *The Museum* n.s. 15 (Spring-Summer 1963): 34.

SAMUEL F. B. MORSE: Larkin, Oliver W. *Samuel F. B. Morse and American Democratic Art.* Boston: Little, Brown, 1954.

Mabee, Carleton. *The American Leonardo: A Life of Samuel F. B. Morse.* New York: Knopf, 1943.

Morse, Samuel Finley Breese. *Samuel F. B. Morse, His Letters and Journals.* Edited by his son Edward Lind Morse. 2 v. Boston: Houghton Mifflin, 1914.

WILLIAM SIDNEY MOUNT: Cowdrey, Mary Bartlett and Williams, Hermann Warner, Jr. *William Sidney Mount 1807-1868, An American Painter,* published for the Metropolitan Museum of Art by Columbia University Press, 1944.

Frankenstein, Alfred. "William Sidney Mount and the Act of Painting." *American Art Journal* 1 (Spring 1969): 34-42.

——*Painter of Rural America: William Sidney Mount, 1807-1868.* An exhibition circulated by the International Exhibitions Foundation. Stony Brook, New York: Suffolk Museum, 1968. Introduction: Jane des Grange.

Keyes, Donald D. "The Sources of William Sidney

Mount's Earliest Genre Paintings." *Art Quarterly* 32 (Autumn 1969): 258-68.

CARL NAHL: Gudde, Erwin Gustav. "Carl Nahl, California's Pioneer of Painting." *American-German Review* 7 (October 1940): 18-20.

JOHANNES ADAM SIMON OERTEL: Oertel, J. F. *A Vision Realized, A Life Story of Rev. J. A. Oertel*, D.D. Milwaukee: The Young Churchman Company, 1917.

BASS OTIS: Hendricks, Gordon. "A Wish to Please and a Willingness to Be Pleased." *American Art Journal* 2 (Spring 1970): 16-29.

WILLIAM PAGE: Taylor, Joshua Charles. *William Page: The American Titian.* Chicago: University of Chicago Press, 1957.

JEREMIAH PAUL: Dickson, Harold E. "A Note on Jeremiah Paul, American Artist." *Antiques* 51 (June 1947): 392-93.

CHARLES WILLSON PEALE: Richardson, Edgar P. "Charles Willson Peale's Engravings in the Year of the National Crisis 1787." *Winterthur Portfolio One*, 1964.

Sellers, Charles Coleman. *Charles Willson Peale.* 2 v. Philadelphia: American Philosophical Society. 1947.

———*Charles Willson Peale and the "Mammoth Picture."* Baltimore: Peale Museum, 1951.

———*Charles Willson Peale.* New York: Charles Scribner's Sons, 1969.

———"Charles Willson Peale with Patron and Populace, A Supplement to *Portraits and Miniatures by Charles Willson Peale* with a Survey of His Work in Other Genres." American Philosophical Society, *Transactions* 59 (May 1969): 3-146.

JOHN RITTO PENNIMAN: Swan, Mabel M. "John Ritto Penniman," *Antiques* 39 (May 1941): 246-48.

ENOCH WOOD PERRY: Cowdrey, Mary Bartlett. "The Discovery of Enoch Wood Perry," *The Old Print Shop Portfolio* 4 (April 1945): 172-81.

MATTHEW PRATT: Flexner, James Thomas. "The American School in London." Metropolitan Museum of Art. *Bulletin* 7 (October 1948): 64-72.

Sawitzky, William. *Matthew Pratt, 1734-1805, A Study of His Work,* New York: The New-York Historical Society, 1942.

WILLIAM TYLEE RANNEY: Washington, D.C. Corcoran Gallery of Art. *William Ranney, Painter of the Early West,* by Francis Grubar; exhibition, Oct. 4-Nov. 11, 1962. Foreword by Hermann Warner Williams, Jr.

JOHN ROGERS: Wallace, David H. *John Rogers, The People's Sculptor.* Middletown, Connecticut: Wesleyan University Press, 1967.

HENRY SARGENT: Addison, Julia De Wolf. "Henry Sargent: A Boston Painter." *Art in America* 17 (October 1929): 279-84.

LILY MARTIN SPENCER: Cowdrey, Mary Bartlett. "Lilly Martin Spencer, 1822-1902, Painter of the American Sentimental Scene." *American*

*Collector* 13 (August 1944): 6-7.

JUNIUS BRUTUS STEARNS: Rogers, Millard F., Jr. "Fishing Subjects by Junius Brutus Stearns." *Antiques* 97 (August 1970): 246-50.

THOMAS SULLY: Biddle, Edward and Fielding, Mantle. *The Life and Works of Thomas Sully (1783-1872).* Philadelphia: Wickersham Press, 1921.

WILLIAM JAMES STILLMAN: Stillman, William James. *Autobiography of a Journalist.* 2 v. Boston: Houghton Mifflin, 1901.

ARTHUR F. TAIT: Keyes, Homer Eaton. "A. F. Tait in Painting and Lithography." *Antiques* 24 (July 1933): 24-25.

EDWARD TROYE: Coleman, J. Winston. *Edward Troye, Animal and Portrait Painter.* Lexington, Kentucky: Winburn Press, 1958.

JAMES WALKER: McNaughton, Marian R. "James Walker—Combat Artist of Two American Wars." *Military Collector and Historian* 9 (Summer 1957): 31-35.

Perry, Milton F. "Four Walker Paintings." *Military Collector and Historian* 9 (Winter 1957): 109.

WILLIAM AIKEN WALKER: Mastai, M. L. D'Otrange. "The World of William Aiken Walker." *Apollo* 74 (June 1961): 213-15.

CHARLES CALEB WARD: Green, Samuel M. "Charles Caleb Ward; the Painter of 'The Circus Is Coming'." *Art Quarterly* 14 (Autumn 1951): 231-51.

JOHN FERGUSON WEIR: Weir, John Ferguson. *The Recollections of John Ferguson Weir; Director of the Yale School of Fine Arts, 1869-1913.* Edited by Theodore Sizer. Reprinted with additions from the New-York Historical Society *Quarterly* of April, July and October, 1957. New York and New Haven: The New-York Historical Society and the Associates in Fine Arts at Yale University, 1957.

BENJAMIN WEST: Evans, Grose. *Benjamin West and the Taste of His Times.* Carbondale: Southern Illinois Press, 1959.

THOMAS WATERMAN WOOD. MacAgy, Jermayne. "Three Paintings by Thomas Waterman Wood (1823-1903)." San Francisco, California Palace of the Legion of Honor. *Bulletin* 2 (May 1944): 10-15.

JOHN A. WOODSIDE: Jackson, Joseph. "John A. Woodside, Philadelphia's Glorified Sign-painter." *Pennsylvania Magazine of History and Biography* 52 (January 1933): 58-65.

RICHARD CATON WOODVILLE: Washington, D.C. Corcoran Gallery of Art. *Richard Caton Woodville, An Early American Genre Painter;* exhibition, Apr. 21-June 11, 1967. Foreword: Hermann Warner Williams, Jr. Essay: Francis S. Grubar.

# NOTES

## PREFACE

1. *Art out of the Attic, An Exhibition of 19th Century American Paintings from Vermont Homes,* (exhibition catalogue) Middlebury College (Middlebury, Vermont, 1970), (published by Vermont Council on the Arts, Inc., Montpelier, Vermont) 48 pp., ill.
2. Quidor did paint one atypical work, *The Young Artist,* 1828 (The Newark Museum), which, if it is not an idealized self-portrait, as has been suggested, could be considered genre. However, it is so early a work and so unlike his mature paintings that it does not seem to merit more than this passing mention.
3. David A. Wallace, *John Rogers, The People's Sculptor* (Wesleyan University Press, Middletown, Conn., 1967) contains a definitive essay on the sculptor and a catalogue of his work.
4. Charles C. Sellers, *Charles Willson Peale* (New York, Charles Scribner's Sons, 1969) p. 95.
5. *The School for Scandal* was revived at the Park Theatre in New York in three different years: 1798, 1800 and 1802, cf. George C. D. Odell, *Annals of the New York Stage* (New York, Columbia University Press, 1927) Vol. 2 *passim.* According to the Curator of the Theatre Collection, Harvard College Library, the painting was probably done between 1800 and 1810, although it is undated.
6. There is also a large watercolor drawing by John Searle, *Interior of the Park Theatre, New York, November, 1822,* in The New-York Historical Society, which shows not only the stage and the actors but also the audience in boxes and pit.

## INTRODUCTION

1. *New England Genre* (exhibition catalogue), Fogg Art Museum, Harvard University (Cambridge, Mass., 1939), p. 5.
   The reader interested in a fuller discussion of the nature of genre and its development in Europe should consult the admirable essay by Gordon Bailey Washburn in *Pictures of Everyday Life: Genre Painting in Europe, 1500-1900* (exhibition catalogue), Department of Fine Arts, Carnegie Institute (Pittsburgh, Oct. 14-Dec. 12, 1954) n.p.

## CHAPTER 1

1. Alan Burroughs, *John Greenwood in America,*

*1745-1752* (Andover, Mass., Addison Gallery of American Art, 1943) p. 47.
2. This is not to imply that British painters were not equally engaged in enlarging the scope of their work in portraiture, for examples abound by Reynolds, Gainsborough, Zoffany and others.
3. Two other landscape-cum-genre paintings by West in American collections are *Paddington Passage,* 1801 (Detroit Institute of Arts), and *Woodcutters in Windsor Great Park,* 1795 (Indianapolis Museum of Art).
4. Edgar P. Richardson, "Charles Willson Peale's Engravings in the Year of the National Crisis 1787," *Winterthur Portfolio One,* 1964, p. 179.
5. Updike Underhill, on a visit to Mrs. Diaway's mansion in Boston sometime between 1769 and 1775, records his experience with a once common but rarely preserved item of fashionable household decoration, and a curious byproduct of the instinct for genre: "As I ascended the vast staircase, the walls of which were covered with smoak dried pictures, and arrived at the first landing place I met a man drooping under a weight of years with a stripped cotton cap on his head and a pipe stuck into a side apperture in his frieze breeches. I stopped for him to pass down but he not moving I surveyed him more narrowly than the light admitted through the high curtained windows had first permitted and soon discovered it to be one of those ornamental figures once so common in houses fashionably furnished, painted on canvas attached to a board which humored the shape. On the next landing was an old woman of the same family with a birch broom in her hand apparently sweeping the stairs." From: "The Bay Boy," Chapter X, contained in: Marius B. Péladeau, ed., *The Prose of Royall Tyler* (Rutland and Montpelier, Charles E. Tuttle and Vermont Historical Society, 1972) pp. 119 ff.
6. Samuel Lovett Waldo (1783-1861), a highly successful portrait painter of New York, was apparently one of those who practiced the trade of sign painter to tide him over lean early years: "Waldo was then a student, beginning to practice portraiture, and eking out a scanty purse by painting signs for hatters, butchers and tapsters. Some of those pictures of beaver hats with their beautiful gloss, or ribs of beef and fat chickens, or foaming mugs of ale in the hands of jolly topers, which were swinging in the wind in our boyish days were the handicraft of Waldo, as he himself told the writer; and in after days, as he glanced at them, cracked and sobered by sun and rain, he was mortified, he said, to think that he had improved so little in the lapse of years." Daniel Huntington, *Asher B. Durand: A Memorial Address* (New York, printed for the Century Association, 1887) pp. 10-11.
7. Quoted by James Thomas Flexner, *American Painting: First Flowers of Our Wilderness* (Boston, Houghton Mifflin Co., 1947) p. 172.

## CHAPTER 2

1. This belief did not deter such individuals as Pavel Petrovich Svin'in (1788-1839), the wealthy and well-read Russian diplomat who visited this country about 1811 and made a fascinating record in watercolor drawings of those of our social customs as especially caught his eye. But Svin'in was a foreign visitor, and his paintings had no influence on our native artists.
2. Peale's letter to West, dated December 16, 1807, is given in its entirety in Charles Coleman Sellers,

*Charles Willson Peale and the "Mammoth Picture"* (Baltimore, Peale Museum, 1951) p. 3.

3. The only earlier portraits which rival Peale's in their lively interpretation of subject are Copley's *Boy with a Squirrel*, 1765 (private collection), and *Paul Revere* (Fig. 3). Copley later retreated from these early demonstrations of individualism and instead aimed at and achieved perfect compliance with English eighteenth-century tradition.

4. *American Paintings in the Museum of Fine Arts, Boston* (Boston, Museum of Fine Arts, 1969) Vol. I, p. 12.

5. While an undergraduate at Harvard, Allston made a series of genre drawings, *The Buck's Progress* (collection Mrs. Frank M. Clark), undoubtedly inspired by Hogarth's example. His youthful interest in genre subjects was for their humorous potentialities. The mature Allston, who aspired to be the greatest painter in the country, must have concluded that such subjects were inconsistent with his high purpose, for he never returned to true genre.

6. Archives, Department of Paintings, Museum of Fine Arts, Boston.

7. Edgar Preston Richardson, *Washington Allston: A Study of the Romantic Artist in America* (Chicago, The University of Chicago Press, 1948) p. 93.

8. *Ibid.*, pp. 93-94.

9. Other lost paintings by Krimmel, known only in the form of prints, include typical examples of his interiors: *The Return from a Boarding School, Return from Market* and *Dance in a Country Tavern*.

10. Krimmel was undoubtedly influenced by the example of Sir David Wilkie, then much admired in England, whose works were well known in America through engravings. Krimmel produced at least two copies after Wilkie, *Blind Fiddler* and *Cut Finger*, apparently in the nature of study exercises. His first exhibited painting—unfortunately now lost—was *Pepper Pot, A Scene in the Philadelphia Market*, a purely American—indeed a purely Philadelphian—subject.

11. Archives, Department of Prints and Drawings, The Art Institute of Chicago.

12. Margaret Hall, *The Aristocratic Journey, Being the Outspoken Letters of Mrs. Basil Hall Written During a Fourteen Months' Sojourn in America, 1827-28*, Una Pope-Hennessy, ed. (New York and London, G. P. Putnam's Sons, 1931), p. 89.

13. Robert C. Vose, Jr., "Alvan Fisher, 1792-1863; American Pioneer in Landscape and Genre," *Connecticut Historical Society Bulletin*, Vol. 27 (October, 1962) p. 101.

14. Penniman did a set of four hunting scenes, *Pheasant Shooting, Duck Shooting, Woodcock Shooting* and *Snipe Shooting. Duck Shooting*, now in the collection of the New England Historic Genealogical Society, was based on an English aquatint published by F. P. Cook in 1791. Letter, Edgar Packard Dean, Director, New England Historic Genealogical Society, to the writer.

15. Mabel M. Swan, "John Ritto Penniman," *Antiques*, Vol. 39 (May, 1941) pp. 246-48.

16. William Dunlap, *The History of the Rise and Progress of the Arts of Design in the United States* (New York, George P. Scott & Co., 1834) Vol. 2, p. 264.

17. The theme of an accident at a river crossing is the subject of both these paintings. They relate, in some manner which needs to be investigated, to a painting, so far unattributed, in the collection of the Wadsworth Atheneum. This painting, seemingly inaccurately titled *English Landscape*, is closely related in subject and detail to *Mishap at the Ford*. Robert Vose has told the writer that in his opinion the Atheneum's painting is by Fisher. The lost painting *Overthrow of the Landau*, by Penniman, which was offered for sale in the *Columbian Centinel*, Boston, May 2, 1827, should also be considered in this connection.

18. Duplication of subject also occurred because the patron frequently stipulated in some detail the subject he wished to commission. William Sidney Mount's manuscript notes contain numerous references to clients' requests that the paintings they ordered echo some known composition.

19. Dunlap, *op. cit.*, p. 265.

CHAPTER 3

1. His innovative approach to painting was recognized and admired by his contemporaries: "Durand had been a pioneer in engraving; he was now a pioneer in another very important branch of study, viz., that of painting carefully finished studies directly from nature out-of-doors. Before his day our landscape painters had usually made only pencil drawings or, at most, slight water-color memoranda of the scenes they intended to paint, aiding the memory by writing on the drawings hints of the color and effect. Cole, to be sure, lived at Catskill, in full view of magnificent scenery, and was endowed with a wonderful memory, so that he gave an astonishing look of exact truth to many of his pictures of American scenery, but he rarely, if at all, up to that period, painted his studies in the open air.
"Durand went directly to the fountain-head, and began the practice of faithful transcripts of 'bits' for use in his studio, and the indefatigable patience and the sustained ardor with which he painted these studies not only told on his elaborate works, but proved a contagious influence, since followed by most of our artists, to the inestimable advantage of the great landscape school of our country." Daniel Huntington, *Asher B. Durand: A Memorial Address* (New York, printed for the Century Association, 1887), pp. 28-9.

2. Dr. David B. Lawall, of the University of Virginia, who is preparing a catalogue of the work of Asher B. Durand, has kindly called to my attention the presence in the collection of the New-York Historical Society of four painted door panels which Luman Reed commissioned to decorate his private art gallery in New York. The subjects of the panels are: *Boy Chasing a Pig, School Let Out, Blind Man's Buff* and *Boys Playing Marbles*. Durand was working on these panels in February, 1836. Two other subjects for this project: a woman churning in a shed with a child on the floor, and farmers eating dinner under a tree, are mentioned in correspondence between Reed and Thomas Cole. If they were actually executed, they have not, so far, been located.

3. The question of the possible existence of a late replica dated 1872 remains to be resolved.

4. James Thomas Flexner, *That Wilder Image* (Boston, Little, Brown and Company, 1962) p. 207.

5. Alfred Frankenstein, *Painter of Rural America: William Sidney Mount* (Washington, D.C., International Exhibitions Foundation, 1969), p. 14, cites two earlier paintings, now lost: *A Girl at the Spring Reading a Love Letter*, 1828 (?), and *Girl with a Pitcher Standing at a Well*, 1829.

6. Donald D. Keyes, "The Sources of William Sidney Mount's Earliest Genre Paintings," *Art Quarterly*, Vol. 32 (Autumn, 1969) pp. 258-68.

7. According to Maybelle Mann, the fortunate owner of Edmonds' manuscript autobiography, Edmonds, like Mount, frequently used members of his family as models for his paintings. Maybelle

Mann, "Francis William Edmonds: Mammon and Art," *The American Art Journal,* Vol. 2 (Fall, 1970) p. 99.

8. Harold E. Dickson, *John Wesley Jarvis, American Painter* (New York, The New-York Historical Society, 1949) pp. 232-33.

9. The Swiss painter Frank Buchser, who visited this country at the close of the Civil War, is an example of the European for whom the dark skin and the warm personality of the American Negro held great fascination. Buchser painted a number of genre scenes while he lived in Charlottesville, Virginia, all of which are concerned with aspects of Negro life. Indeed Buchser, a dashing and fearless character with a stormy and romantic temperament, established a liaison with a beautiful mulatto woman, which caused a great stir in Washington. His two most important genre canvases are *The Ballad of Mary Blane,* a title derived from a contemporary song (Museum der Stadt, Solothurn), and *The Volunteer's Return,* 1867 (Kunstmuseum, Basel).

10. Mary H. Forbes, "Election Scene, Catonsville, Baltimore County," *The Corcoran Gallery of Art Bulletin,* Vol. 13 (October, 1963) pp. 15-17.
The Walters Art Gallery owns a considerable number of watercolor genre scenes of Baltimore by Miller.

11. The Corcoran Gallery of Art's drawing entitled *Dragoon with His Charger* may well be a study for *The Wounded Trooper* since the soldier is leaning on his horse for support.

12. Ranney's studio, apparently of his own design, was interesting. Unusual for the period, it was glassed in and two stories high. Nearby was a stable for the artist's horses, which he used as models as well as for riding. Henry T. Tuckerman was so impressed that he described the studio in some detail: ". . . so constructed as to receive animals, guns, pistols, and cutlasses hung on the walls; and these, with curious saddles and primitive riding gear, might lead a visitor to imagine he had entered a pioneer's cabin or border chieftain's hut; such an idea would, however, have been at once dispelled by a glance at the many sketches and studies which proclaimed that an artist, and not a bushranger, had here found a home." Henry T. Tuckerman, *Book of the Artists* (New York, G. P. Putnam's Sons, 1867) pp. 431-32.

13. Virgil Barker, *American Painting* (New York, The Macmillan Company, 1950) p. 470.

14. E. Maurice Bloch, *George Caleb Bingham: The Evolution of an Artist* (Berkeley, University of California Press, 1967) p. 79.

## CHAPTER 4

1. This is a later variant of a painting dated 1852 in the collection of Peter H. B. Frelinghuysen, Jr.

2. In at least one instance Clonney seems to have borrowed an idea directly from Mount. In his *Farmer's Nooning,* 1836 (Suffolk Museum and Carriage House), Mount has as the central incident a farm lad tickling the nose of a sleeping Negro. The painting was engraved by Alfred Jones and published by the Apollo Association in 1843. Clonney uses the same situation as his theme in *Waking Up,* 1851 (Fig. 82), and it seems unlikely that it is a coincidence.

3. Henry T. Tuckerman, *Book of the Artists* (New York, G. P. Putnam's Sons, 1867) p. 498.

4. Tuckerman, *op. cit.,* p. 434.

5. Dunlap's painting is Fig. 7, page 27. Mount's painting of an exhilarated painter showing his newly finished canvas to a friend is entitled *The Painter's Triumph,* 1838 (Pennsylvania Academy of The Fine Arts).

6. There were, of course, a number of other painters who depicted the horse. In general the American-born painters of racehorses and trotters who worked in the second half of the nineteenth century were largely untrained, and their work has a primitive quality which puts it outside the scope of his survey. The better painters were European. For example, there was the itinerant German-born August Wenderoth (1825-after 1863), who worked in Brooklyn, San Francisco and Philadelphia in the 1850's and 1860's. He turned out fashionable works, such as *Hiram and Roanoke*, 1850 (collection Mrs. John Rutherford), which includes the likenesses of Hiram and the liveried groom in cashmere waistcoat, tall silk hat and slate-grey coat, and the even more elegant *Sleighing Scene*, 1850 (collection Mrs John Rutherford), which portrays five members of the Sidney Mason and Theodorus B. Meyers families driving behind a pair of white horses bred for Queen Victoria. Then there was Henri Delattre (1810/2-1876) a Frenchman who painted *Zachary Taylor and Mac*, c. 1850 (collection Harry T. Peters, Jr.), while on an extended visit to the United States between 1850 and 1855. He is also represented in Mr. and Mrs. Paul Mellon's collection by two paintings: *Portrait of the Artist Driving a Pair of Horses,* 1852, and *Trotter and Driver on Union Raceway, Goshen, New York*, undated. Both Wenderoth and Delattre were essentially visitors who retained their continental styles and attitudes.

7. Millard F. Rogers, Jr., "Fishing Subjects by Junius Brutus Stearns," *Antiques,* Vol. 97 (February, 1970) pp. 246 ff.

8. Another landscape-cum-genre painting by Stillman, *Confederate Soldiers Camping,* which was exhibited in 1946 at the Virginia Museum of Fine Arts, Richmond, is now in the collection of O. Roy Chalk, Washington, D.C. While the soldiers in the painting wear grey uniforms, a color popularly associated with the Confederacy, no other detail supports the identification of the subject. Since Union regiments, such as the 7th New York, also took the field in grey uniforms early in the war, it is more likely, since Stillman was a northerner, that the troops shown here were Federal.

9. William James Stillman, *The Autobiography of a Journalist,* (Boston, Houghton Mifflin Co., 1901) Vol. 1, pp. 280-81, describes the painting as follows:
"I painted a study of the camp and its inhabitants, with the intention of making from it, at a future time, a picture which should commemorate the meeting – but owing to changes in my plans, it remained a study, and was purchased by Judge Hoar. . . . In my study the painting is divided in the habit of morning occupations: Lowell, Hoar, Binney and myself engaged in firing at the target; Agassiz and Wyman dissecting a trout on a tree-stump, while Holmes and Dr. Howe watch the operation; but Emerson, recognizing himself as neither a marksman nor a scientist, choosing a position between the two groups, pilgrim staff in hand, watches the marksmen, with a slight preference as between the two groups. My own figure I painted from a photograph, the company insisting in my putting myself in; but it was ill done, for I could never paint from a photograph."

10. The handsome canvas *The Tinker,* 1868, in the collection of Mrs. Norman B. Woolworth, was painted while Mayer was living in France. In com-

position and color it is superior to the few paintings of American subjects by him which have so far been found. William H. Gerdts, *The American Painting Collection of Mrs. Norman B. Woolworth* (exhibition catalogue), Coe Kerr Gallery, Inc. (New York, 1970) p. 45, illus.

11. Charles K. Bolton's MS. in the Boston Athenaeum, kindly quoted by David McKibbin in a letter to the writer, gives Billings's name as Edwin Tryon Billings and confirms his death in Dorchester, Massachusetts, on 19 October 1893. It also identifies what is almost certainly this painting as "... father, Ira in his waggon shop, Deerfield ..."

12. The writer is much indebted to Chase Viele, who graciously and generously supplied a fund of data on Le Clear, the results of many years of painstaking research. His essay, "Four Artists of Mid-Nineteenth Century Buffalo," *New York History,* Vol. 43 (January, 1962) pp. 49-78, is the fullest account of this artist's career in print.

13. This painting may be the lost *Newsboy's Lament* exhibited at the National Academy of Design in 1845; the style and shape of the boy's cap are appropriate to that date.

14. The owner of the painting has refused to permit its reproduction in this work. It is illustrated in Viele, *op. cit.,* p. 71.

15. Leon Arkus, Director of the Museum of Art, Carnegie Institute, Pittsburgh, has indicated to me orally that many paintings bearing Blythe signatures may be by another hand entirely. He finds tremendous divergences in style, and believes some of these paintings may have been by Trevor McClurg, who worked in Blythe's studio. Arkus says that some paintings are obvious forgeries and some of them were painted by unidentifiable contemporary Pittsburgh artists with the subsequent addition of the "Blythe" signature.

## CHAPTER 5

1. The exhibition catalogue by John I. H. Baur, *An American Genre Painter Eastman Johnson 1824-1906,* The Brooklyn Museum, 1940, 82 pp., illus., although thirty years have passed since its publication, remains the basic reference work on Johnson. Patricia Hills, who is currently working on a doctoral thesis on Johnson, has generously given the benefit of her opinion as to the dates of certain pictures and supplied the date of Johnson's marriage. Mrs. Hills's catalogue for the Johnson exhibition, Whitney Museum, 1972, contains much new material.

2. Baur, *op. cit.,* p. 22.

3. William Walton, "Eastman Johnson, Painter," *Scribner's,* Vol. 40 (September, 1906) p. 268.

4. An artist-reporter on the Confederate side was Conrad Wise Chapman (1842-1910), who is noted for his series of handsome oil sketches of the defenses of Charleston, South Carolina. These paintings are more landscape than genre; only in *Picket Post: Self-Portrait,* 1863 (The Valentine Museum, Richmond, Va.), did Chapman produce what could be considered a genre subject. He portrays himself as a ragged private in the 59th Virginia Infantry sitting on a red clay bank at Diascund Bridge, Virginia, holding his musket, bayonet fixed. In the heavily wooded background is a crude log lean-to where other off-duty members of the picket guard are lounging. A most attractive painting, it is also a skillfully painted objective record of the war. *Conrad Wise Chapman 1842-1910, An Exhibition of His Works,* Valentine Museum, Richmond, Virginia, 1962, no. 18, illus. (color) frontispiece.

5. *Mississippi Panorama* (exhibition catalogue), City Art Museum of St. Louis, 1949, p. 95, gives a short account of Julio's life in connection with his painting *Bayou Landscape* and is the source of the biographical details cited.

6. Samuel M. Green, "Charles Caleb Ward, The Painter of 'The Circus Is Coming,'" *Art Quarterly,* Vol. 14 (Autumn, 1951) pp. 231-51.

7. Marion R. McNaughton, "James Walker—Combat Artist of Two American Wars," *Military Collector and Historian,* Vol. 7 (Summer, 1957) pp. 31 ff. gives the fullest available account of Walker's life, but does not state when he went to California, except that it was after the war. His birth date is given as 1818. See also Milton F. Perry, "Four Walker Paintings," *Military Collector and Historian,* Vol. 9 (Winter, 1957) p. 109.

8. This painting may be *Waiting for the Cars,* exhibited at the National Academy of Design in 1858, no. 391, as owned by W. J. Hays.

## CHAPTER 6

1. Wood studied at the Pennsylvania Academy of the Fine Arts from 1881 until 1883. He then entered the University of Pennsylvania, remaining there until 1885, when he enrolled for another year in the Academy. In 1887 he studied with Eakins at the Philadelphia Art Students League. Between 1887 and 1891 he studied in Paris at the Ecole des Beaux-Arts, and at the Julian Academy with Gérôme, Boulanger and Lefebvre. In 1892 he was instructor in art at the Drexel Institute in Philadelphia and later was made department head, a post he kept until 1905. He exhibited in Philadelphia from 1893 to 1905, when he apparently ceased to exhibit and teach. This summary is compiled from information furnished by Jacqueline Pearson of the Drexel Institute of Technology, Philadelphia.

2. Frederick B. Robinson, "George Newell Bowers," *Art in America,* Vol. 36 (July, 1948) pp. 141 ff.; and *Springfield Museum of Fine Arts Bulletin,* Springfield, Mass., Vol. 13 (April-May, 1947), n.p.

3. *Edwin Romanzo Elmer 1850-1923* (exhibition catalogue), Smith College Museum of Art (Oct. 1-24, 1952); and Maud Valona Elmer, "Edwin Romanzo Elmer as I Knew Him," published for the Smith College Museum of Art by *The Massachusetts Review* (Autumn-Winter, 1964/5), n.p.

4. Alfred Frankenstein, "Edwin Romanzo Elmer," *Magazine of Art,* Vol. 45 (October, 1952) p. 270.

5. This would appear to be the painting *Sport on the Beach,* exhibited as no. 140 in the Brooklyn Art Association, 1879.

6. Mary Bartlett Cowdrey, "The Discovery of Enoch Wood Perry," *The Old Print Shop Portfolio,* Vol. 4 (April, 1945) *passim.*

7. *The American Scene: A Survey of the Life and Landscape of the 19th Century* (exhibition catalogue), Hirschl and Adler Galleries (New York, 1969) p. 69, no. 85, illus.

8. *The Nude in American Painting* (exhibition catalogue), The Brooklyn Museum (New York, 1961) no. 7, illus., n.p.

9. The information about Chalfant's use of photography and the photograph reproduced were generously furnished by William H. Gerdts.

10. Elizabeth McCausland, *The Life and Work of Edward Lamson Henry NA 1841-1919* in: New York State Museum Bulletin Number 339, (Albany, September, 1945), 381 pp.

11. *James Wells Champney* (exhibition catalogue), Deerfield Academy (Deerfield, Mass., 1965) *passim.*

# INDEX